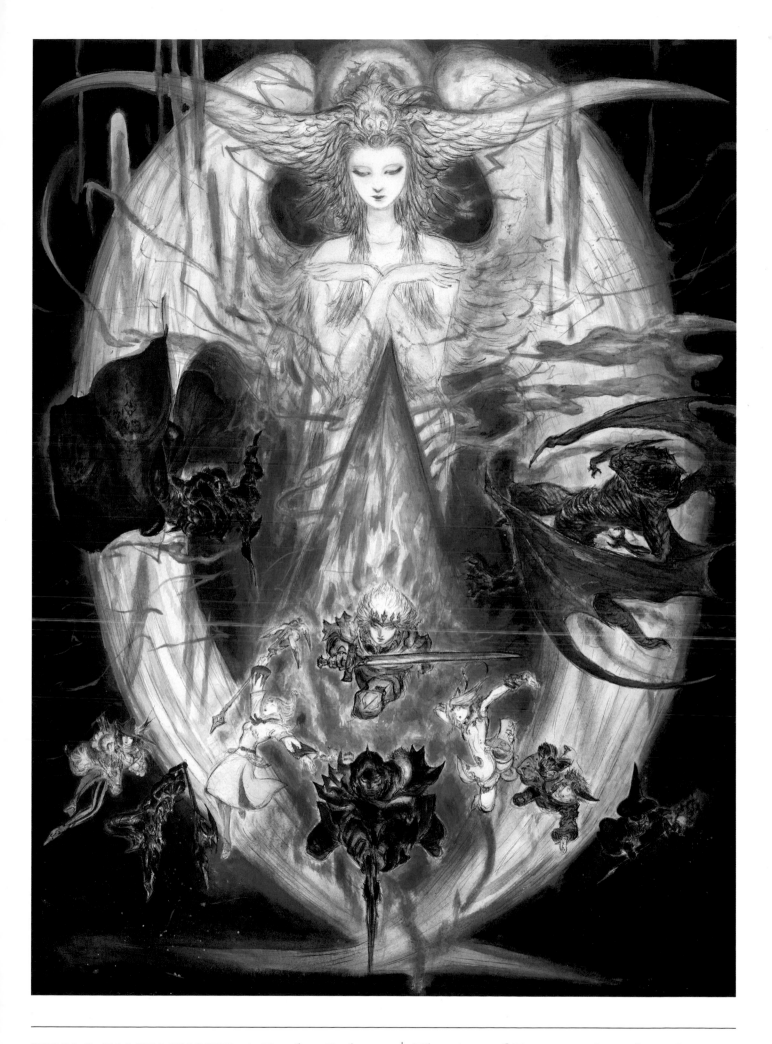

FINAL FANTASY XIV: A Realm Reborn │ The Art of Eorzea –Another Dawn–

FINAL FANTASY XIV: A Realm Reborn
The Art of Eorzea –Another Dawn–

Eorzea continues to evolve with the dawning of each new day.
This art book is a record of the many changes our realm has seen.

C O N T E N T S

•

CHARACTER CONCEPT ARTISTS

吉田 明彦　AKIHIKO YOSHIDA
生江 亜由美　AYUMI NAMAE
髙橋 和哉　KAZUYA TAKAHASHI
糟谷 茂雄　SHIGEO KASUYA
政尾 翼　TSUBASA MASAO
三原 庸嘉　NOBUYOSHI MIHARA
田中 昭子　AKIKO TANAKA
塚田 大悟　DAIGO TSUKADA
中沢 数宣　KAZUNORI NAKAZAWA

ENEMY CONCEPT ARTISTS

長嶺 裕幸　HIROYUKI NAGAMINE
塚本 哲　TETSU TSUKAMOTO

BACKGROUND CONCEPT ARTISTS

濱 栄一　EIICHI HAMA
大舘 隆幸　TAKAYUKI ODACHI
齋藤 六馬　ROKUMA SAITO
田中 健太　KENTA TANAKA
土屋 清　KIYOSHI TSUCHIYA
植田 佳久　YOSHIHISA UEDA
山手 清嗣　SEIJI YAMATE
新井 清志　KIYOSHI ARAI

※Throughout this volume, certain shorthand labels are used to indicate character design components. These include "Met" (head), "Top" (body), "Glv" (hands), "Dwn" (legs), and "Sho" (feet).

ARTWORKS

FINAL FANTASY XIV: A Realm Reborn
The Art of Eorzea -Another Dawn-

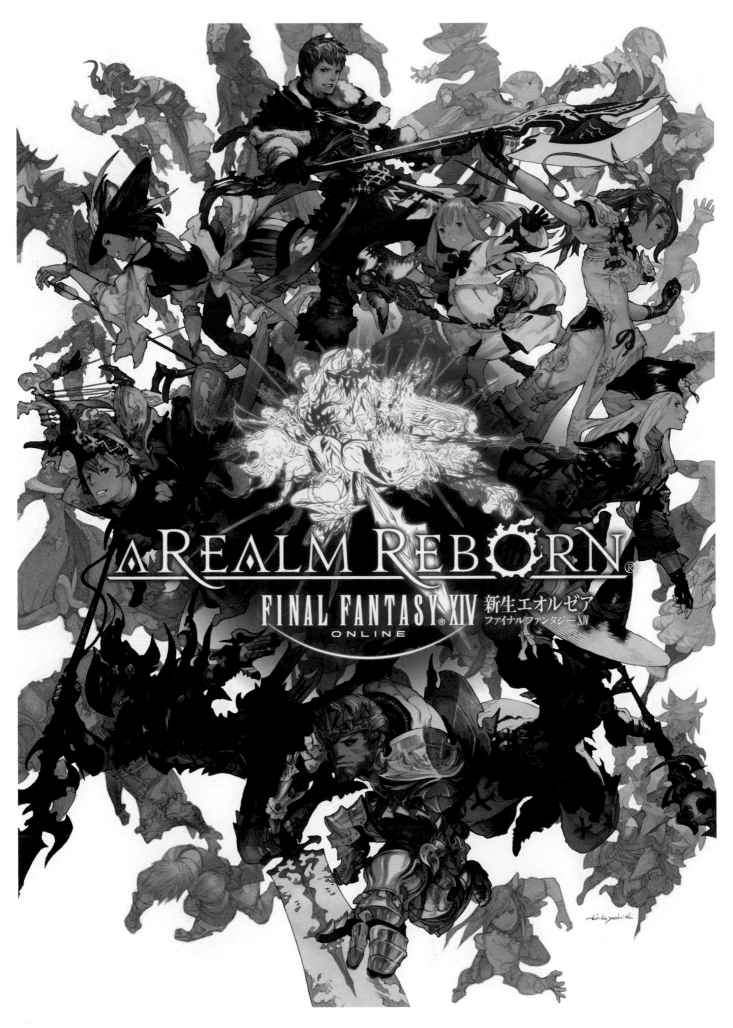

For good measure, I drew all of the characters in full so that they can be freely repositioned afterwards. (Akihiko Yoshida)

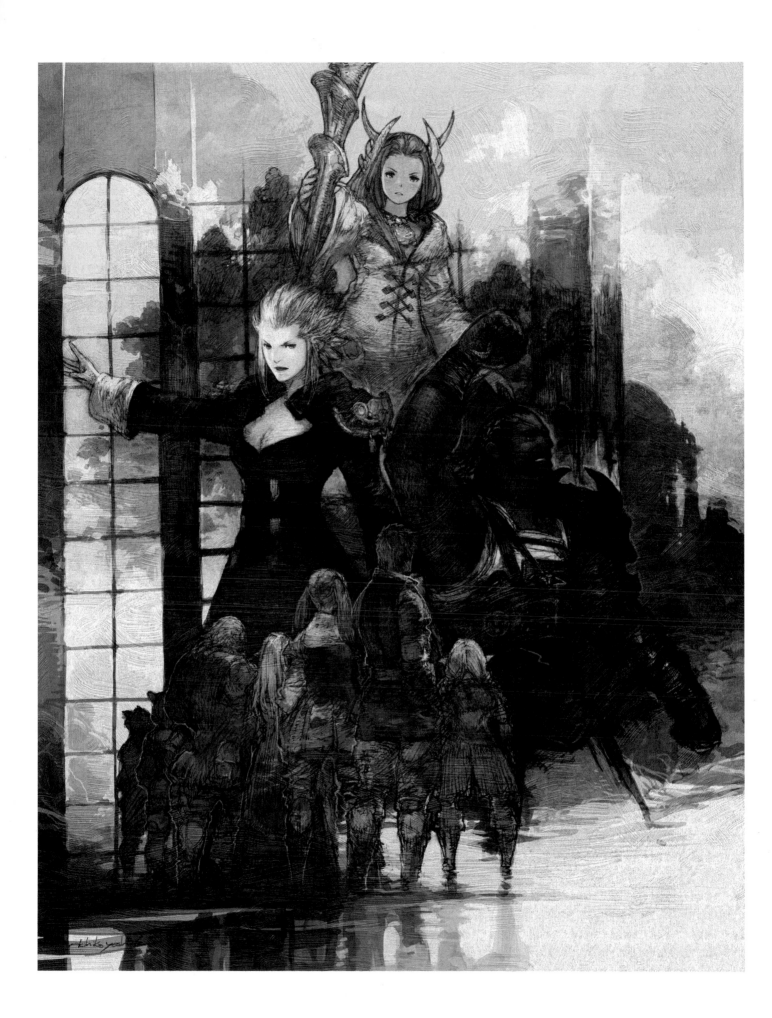

It was a challenge to combine the three speeches into a single composition. (Akihiko Yoshida)

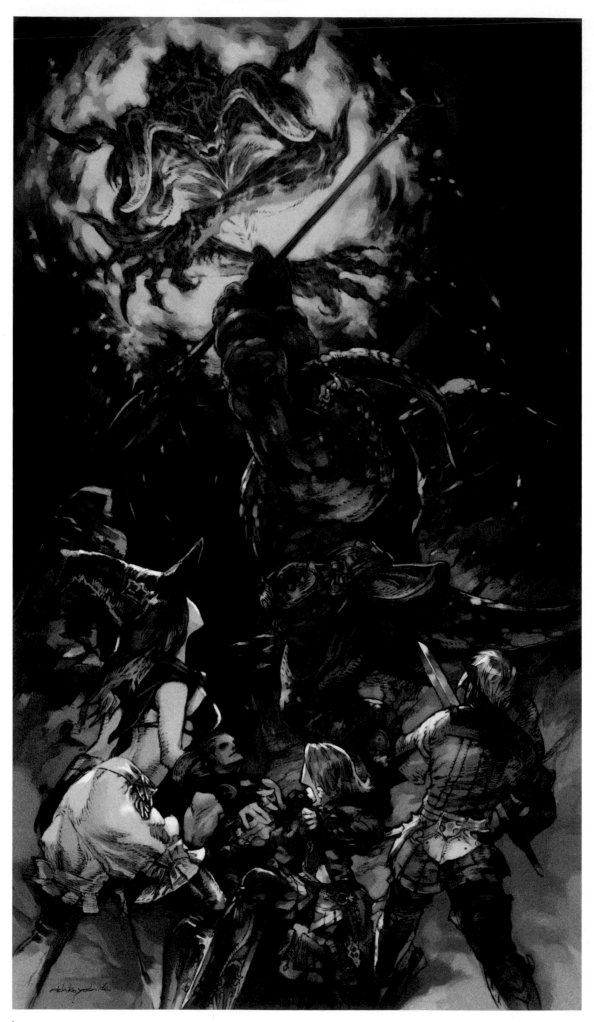

It's not because it's hot that the girl in front is lightly dressed. (Akihiko Yoshida)

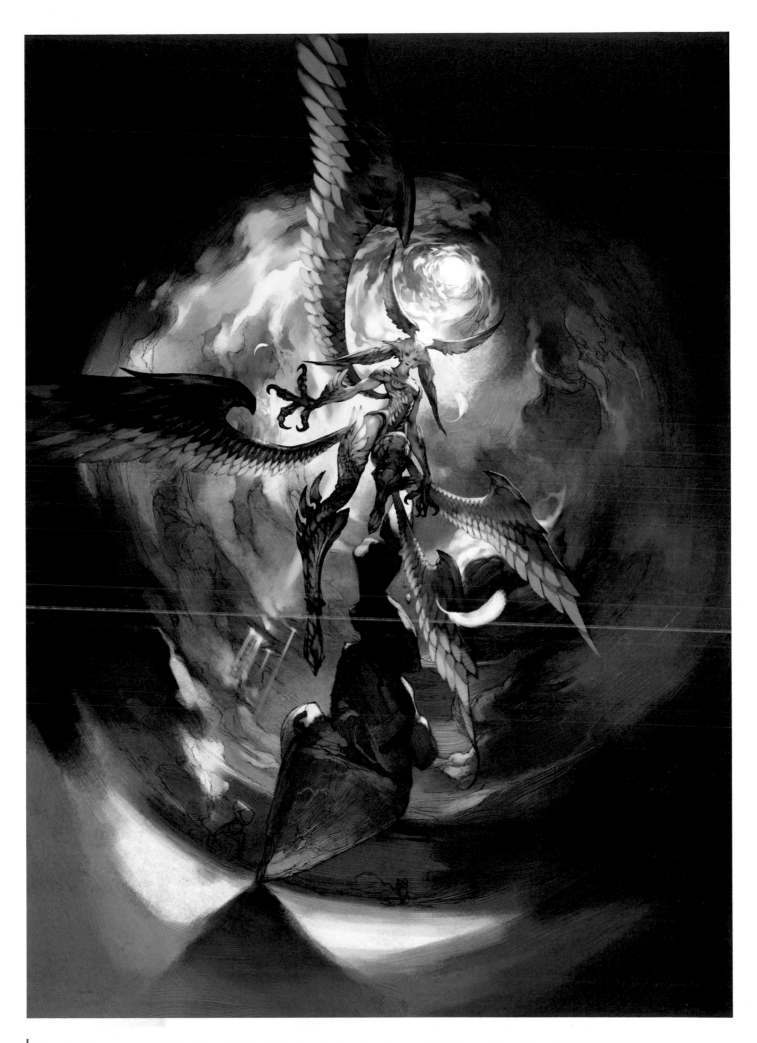

I drew this with extra room around the subject so that it could be trimmed and used in various ways. I like it best untrimmed, though. (Akihiko Yoshida)

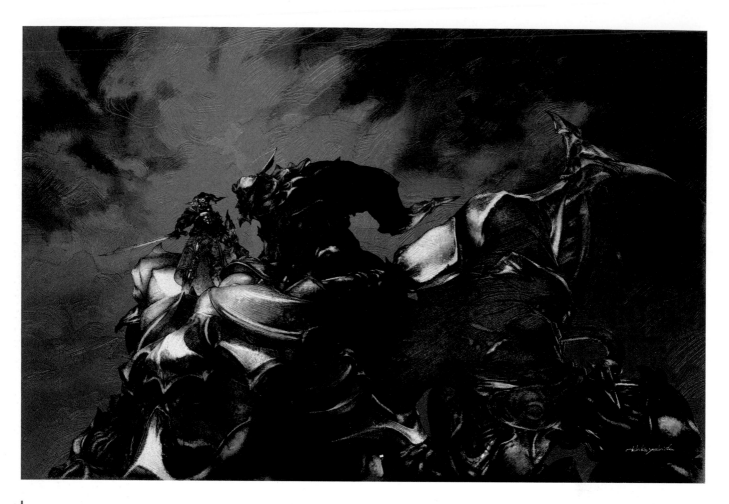

"Hey, did you know? He was going for an American comic look!" (Akihiko Yoshida)

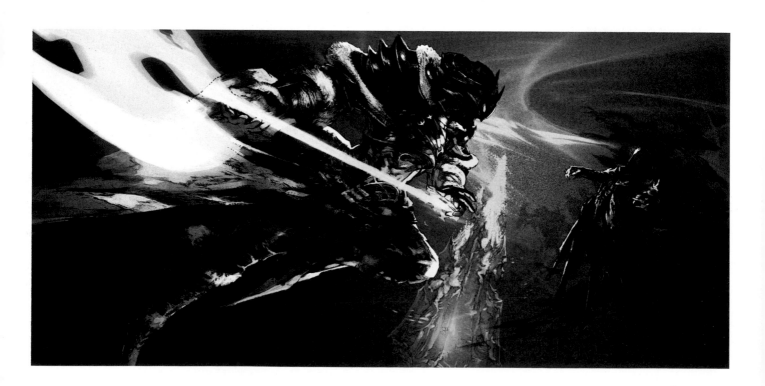

Aaah! If only I'd made that bit like *that*, it might've been more like *that*! (Akihiko Yoshida)

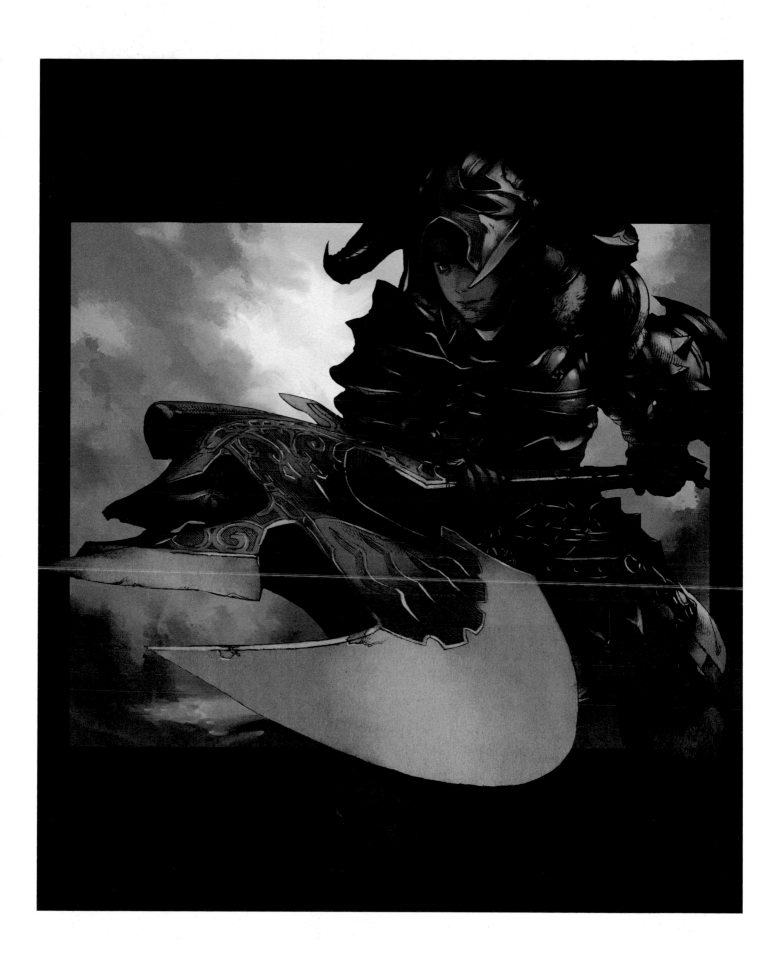

This was for a *Dengeki PlayStation* cover, so I went for something serious. (Akihiko Yoshida)

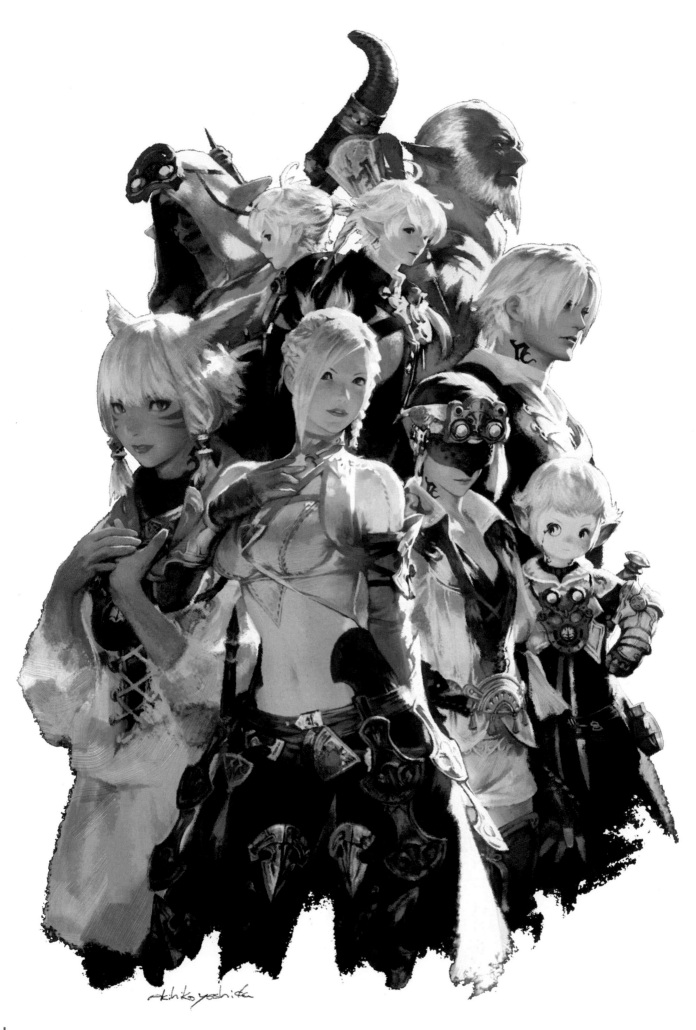

The techniques employed in this piece, created with the full cooperation of Keiichi Baba (*FFXIV* character team), will remain a secret. (Akihiko Yoshida)

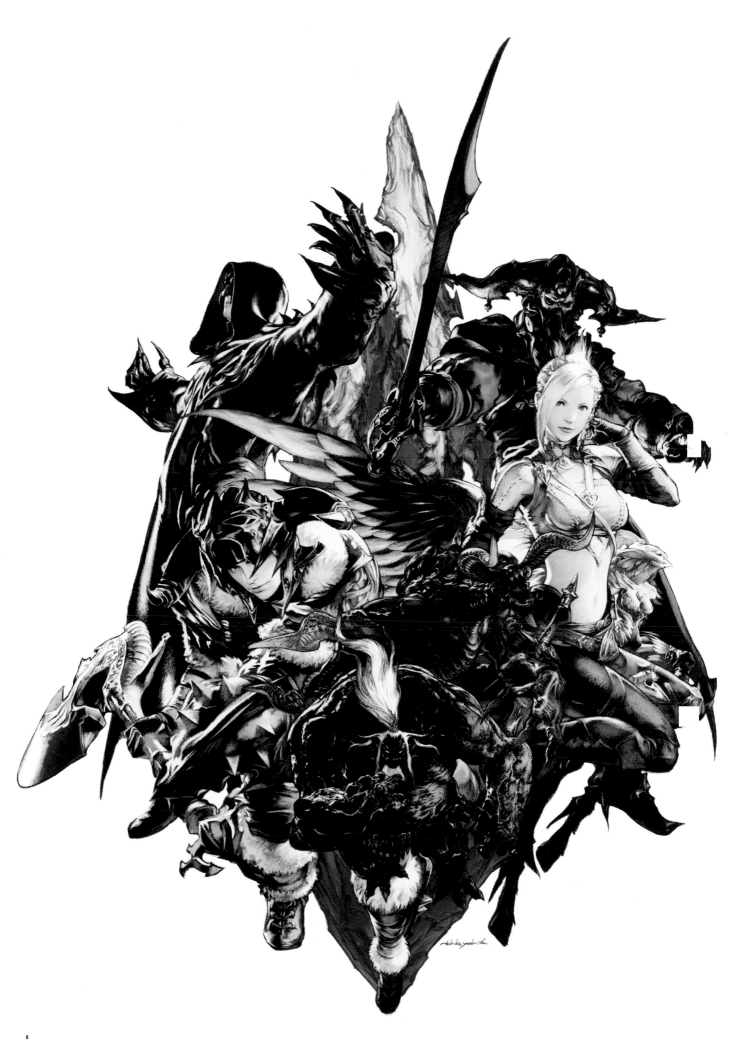

The techniques employed in this piece, created with the full cooperation of Shintaro Tamai (*FFXIV* animation team), will also remain a secret. (Akihiko Yoshida)

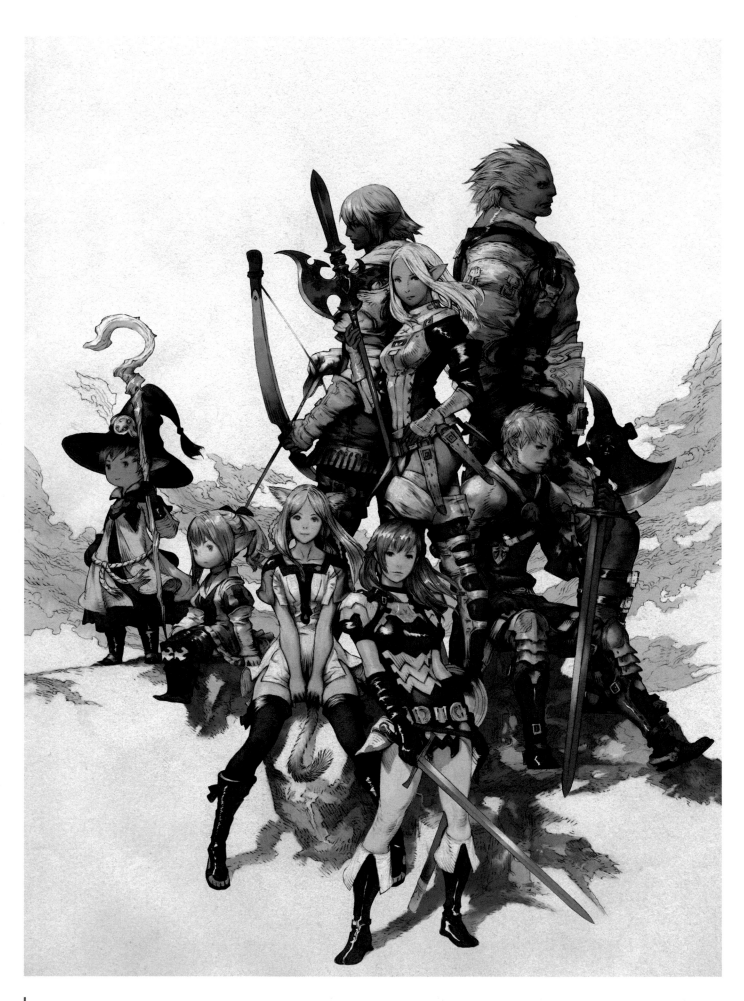

Among the *FF XIV* art pieces I've worked on, this one's my favorite! Just don't tell anyone I forgot to fill in some of the clouds... (Akihiko Yoshida)

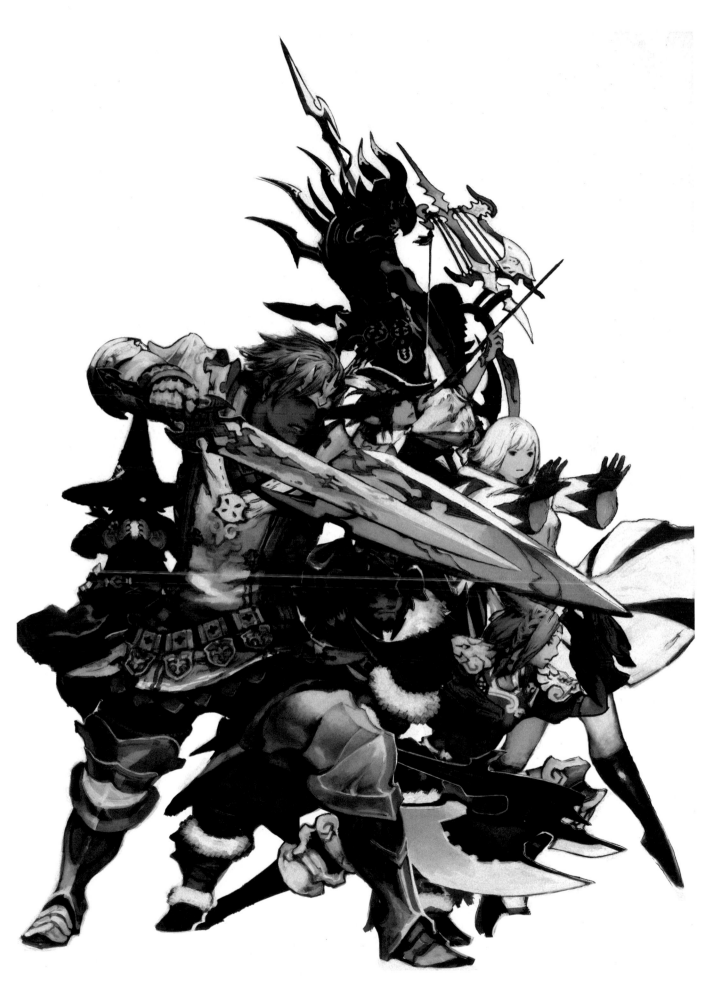

The white mage is twisting her upper body this way, but because her waist area is hidden, it appears as though her legs are also facing the front. Looks kind of freaky, doesn't it? It won't happen again. (Akihiko Yoshida)

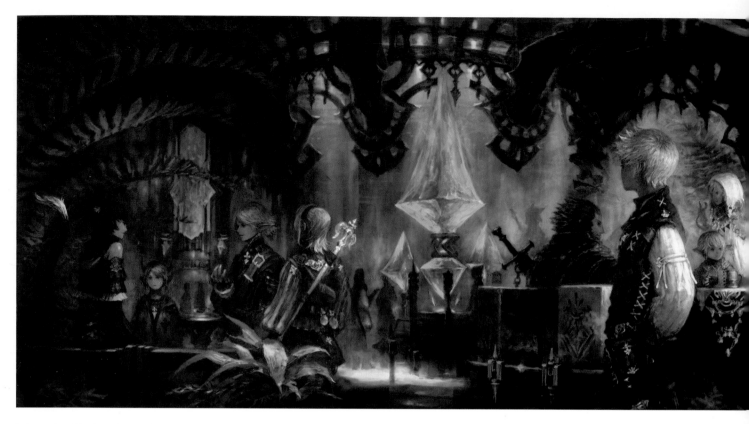

First order of business for a new town: a place where various people gather. This piece portrays the start of the adventurer's tale. For me, it really captures the spirit of *FFXIV*. (Takahashi)

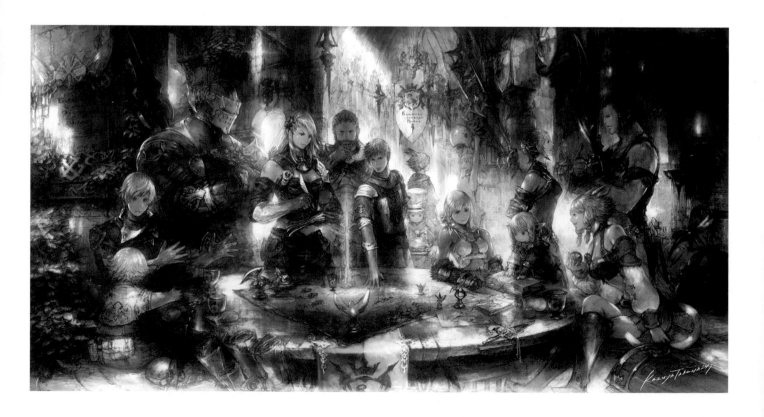

In an MMO, it's fun getting together with others. People looking things up, people making plans, people talking about fishing—that's what I wanted to portray here. (Takahashi)

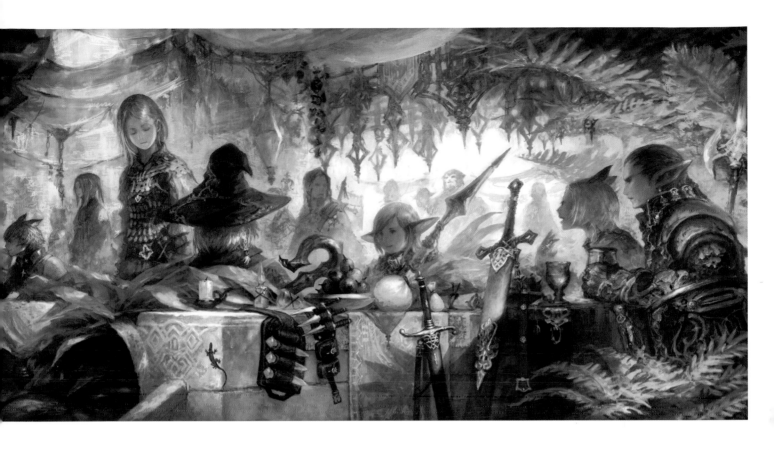

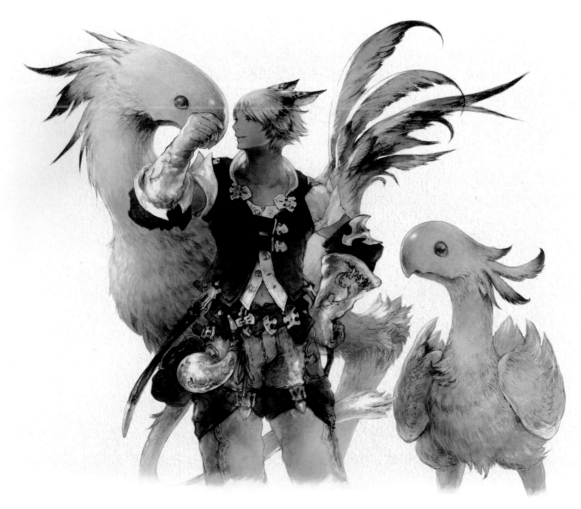

I drew this for the chocobo companion, and tried pairing our bird with a Miqo'te male. (Takahashi)

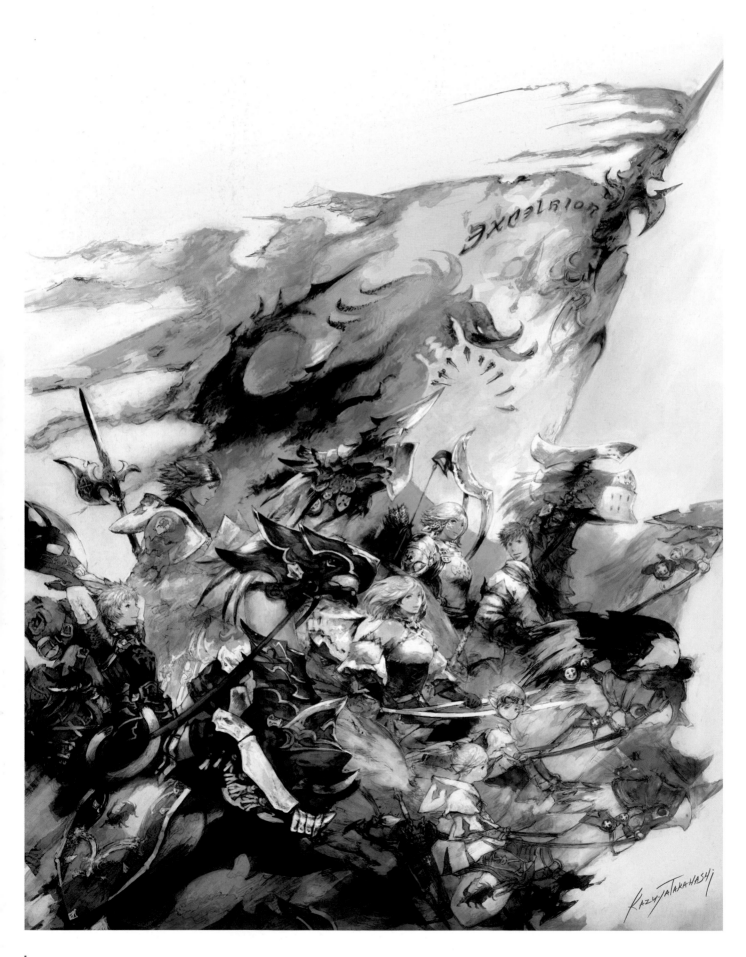

Beneath the standard! The standard was Yoshi-P's idea. (Takahashi)

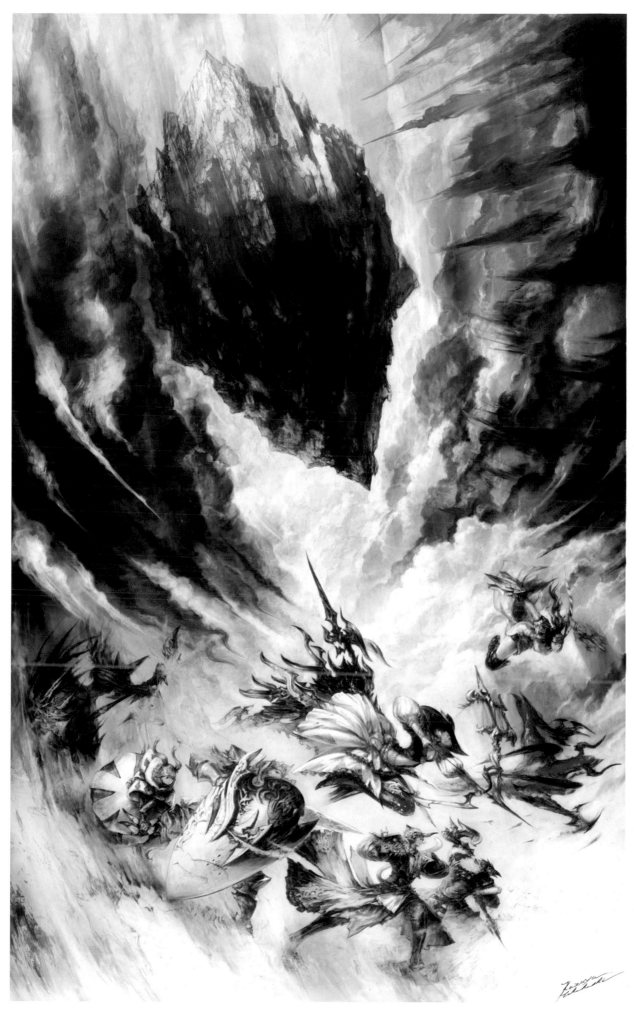

Meteor. It's big, like it should be! (Takahashi)

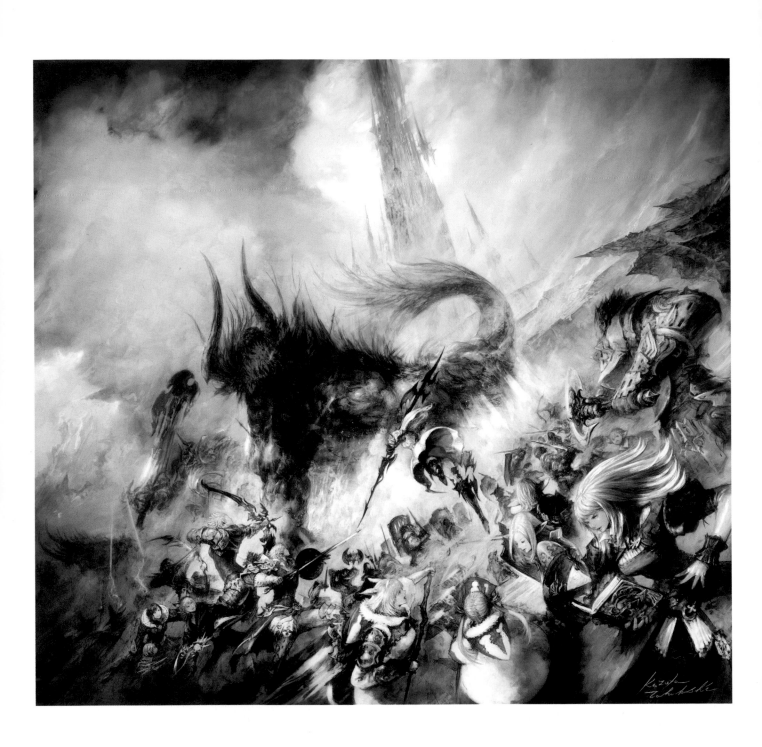

The behemoth has to be about this massive, I reckon. (Takahashi)

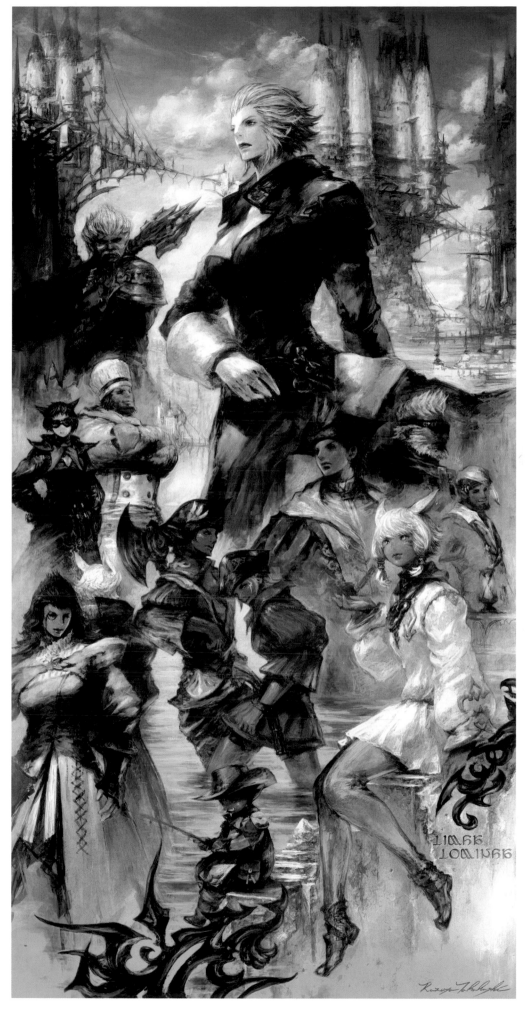

In Limsa Lominsa, the Admiral leads, but the people enjoy a fair amount of freedom. That's the impression I wanted to give. (Takahashi)

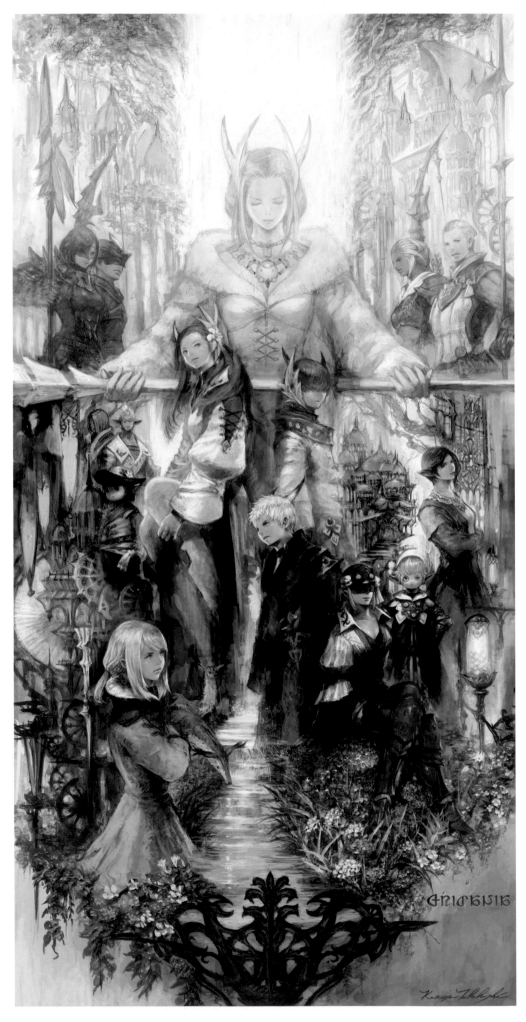

For Gridania, a harmonious layout with Kan-E-Senna at the heart. The light in the middle envelops the tree, and below it a river flows. (Takahashi)

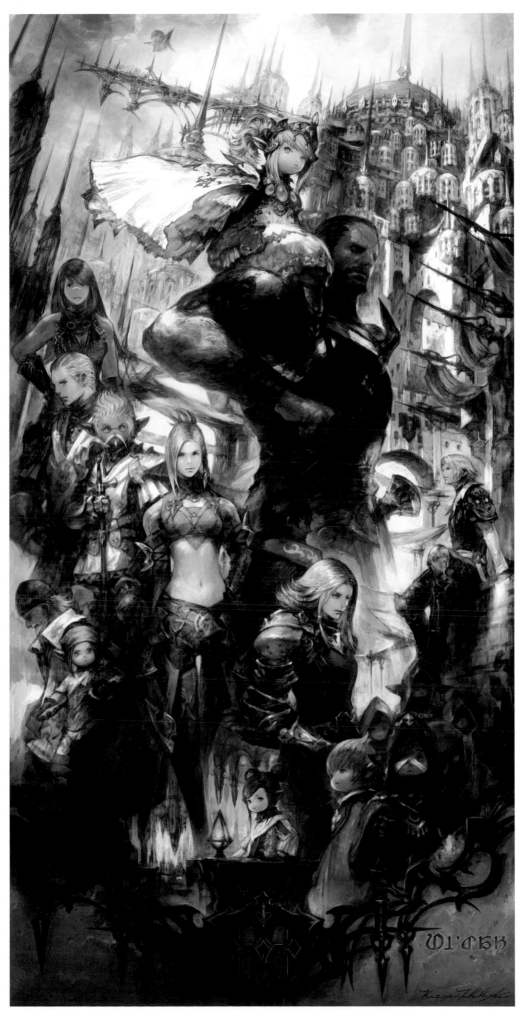

Nanamo and Raubahn gazing in the same direction—they come as a set in this piece. I gave Nanamo a cape so as to lend her a majesty befitting the ruler of Ul'dah. (Takahashi)

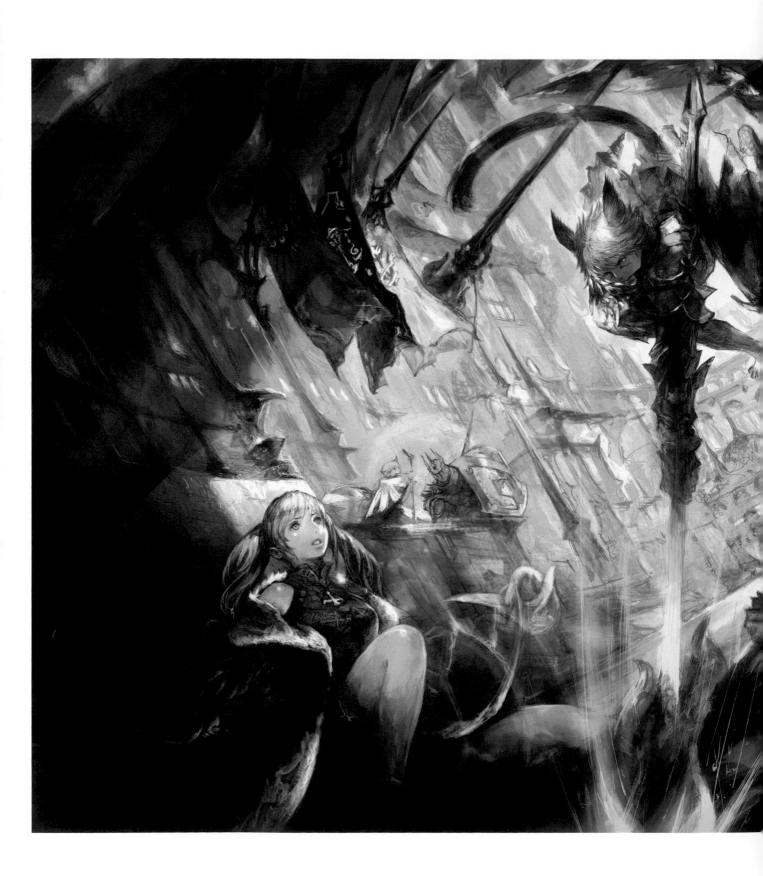

The first training battle in the Wolves' Den. (Takahashi)

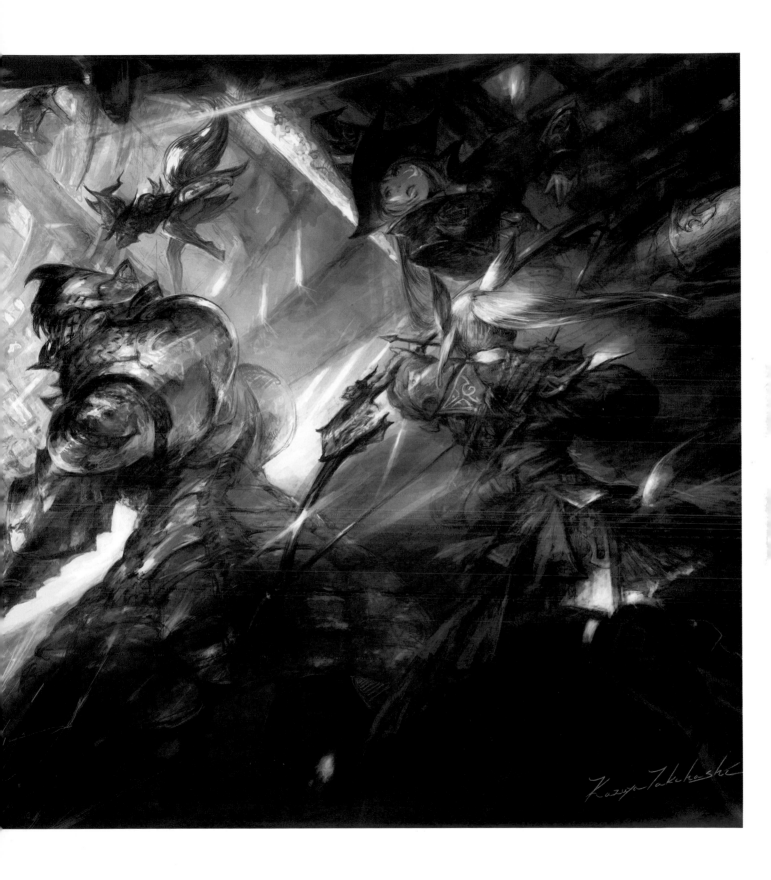

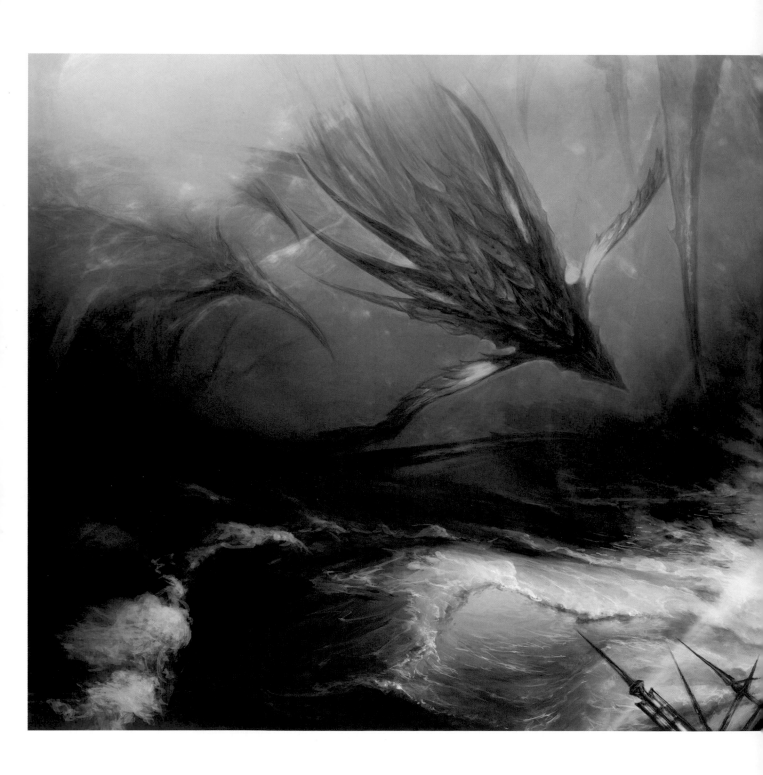

I tried for a layout that captures a turbulent sea in the clash against Leviathan. This was done back when the eagerly anticipated long hairstyles for Miqo'te arrived. (Takahashi)

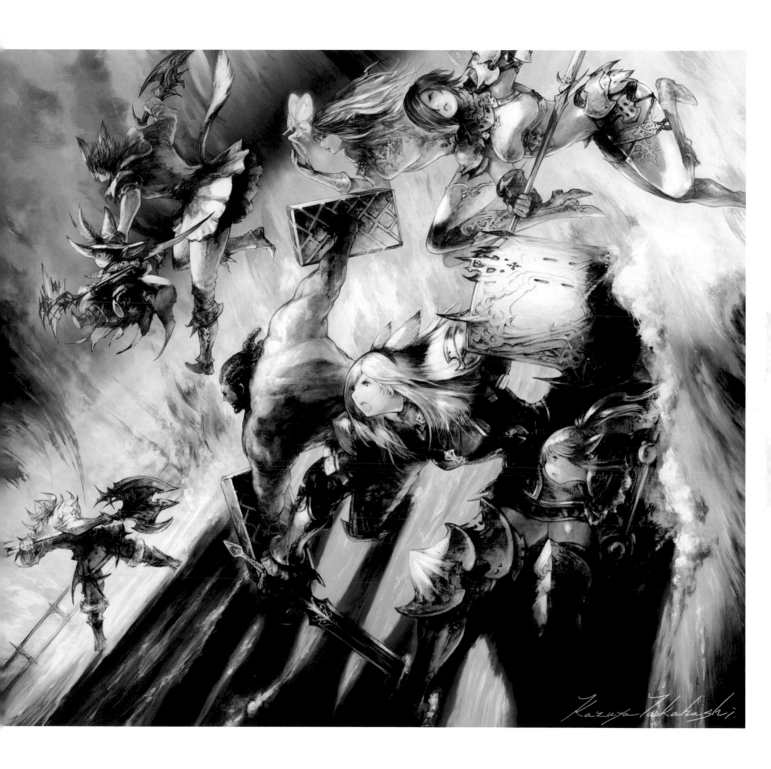

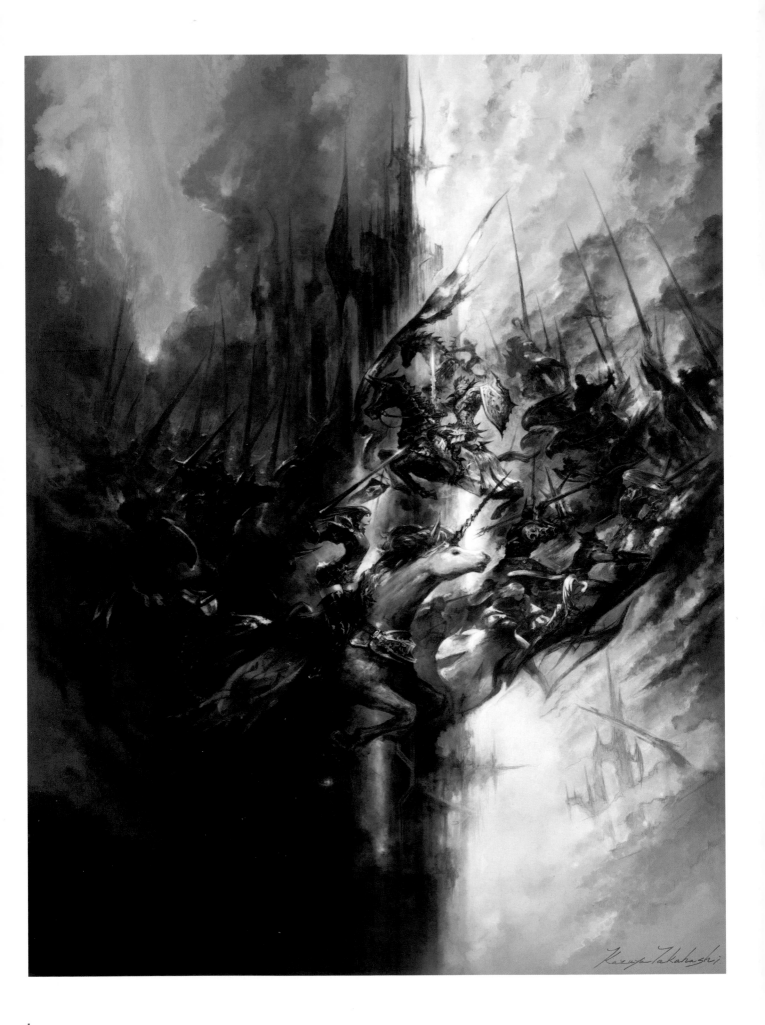

A group defending its base against two attacking factions in Frontline. I find this sort of situation thrilling. (Takahashi)

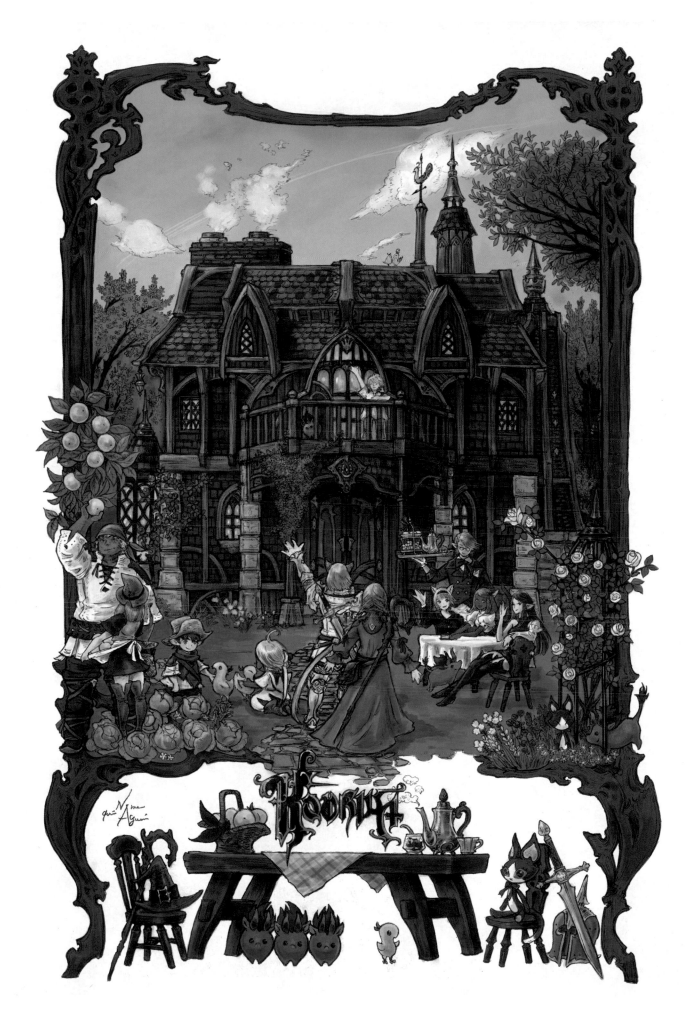

In seeking to create a lively, fun, and warm place for players to return to, I crammed in lots of elements, like a dollhouse. I normally work on character-related designs, so I found it fresh and fun to draw houses and furnishings. (Namae)

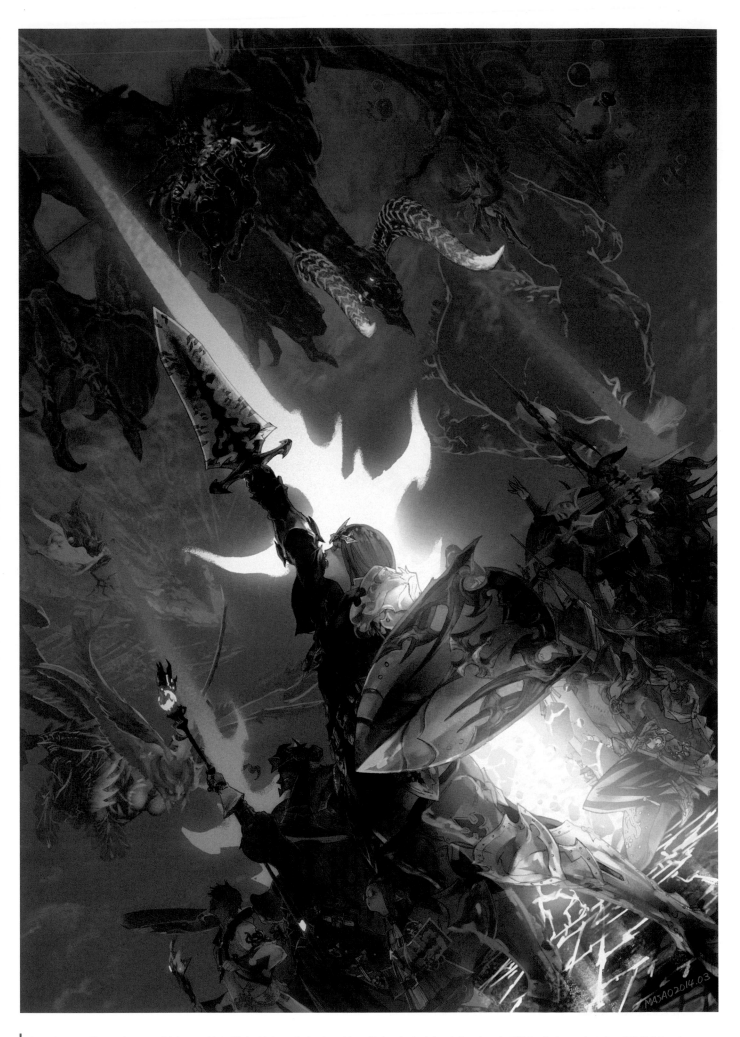

The order was "all primals versus all jobs," so this is filled with lots of primals and lots of jobs. The backdrop is based on the Ifrit battle, hence the Infernal Nail. (Masao)

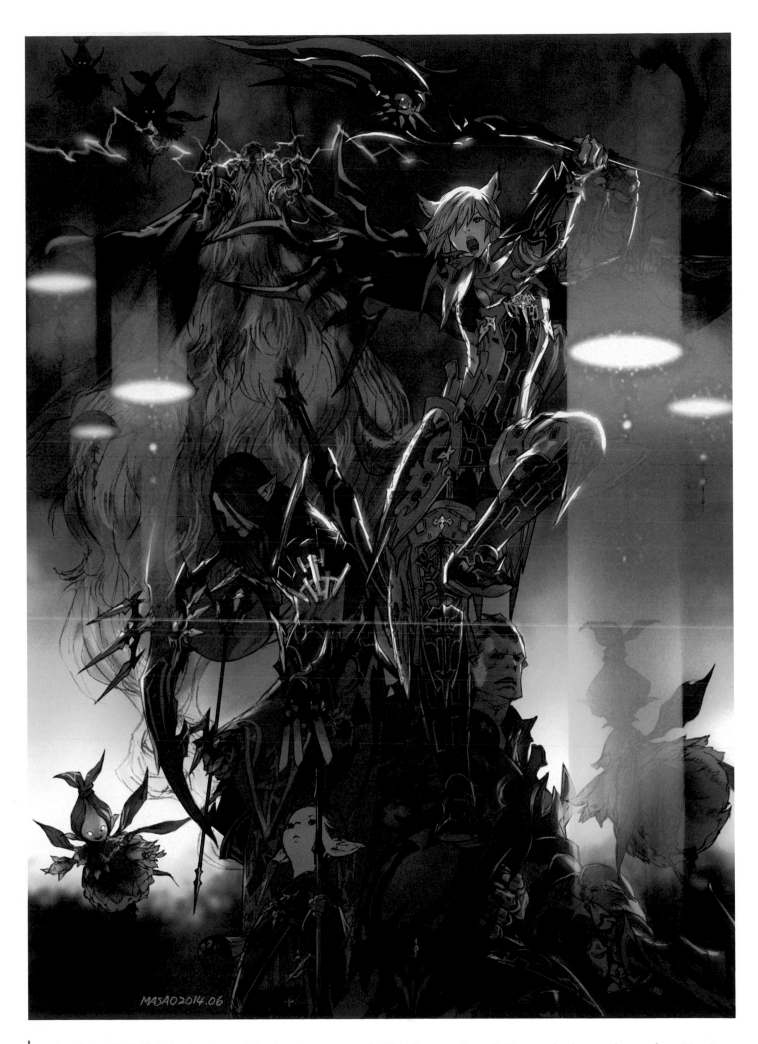

In order to distinguish this illustration from the rest, all the player characters are wearing High Allagan gear. Personally, I just wanted to draw complete sets of gear. (Masao)

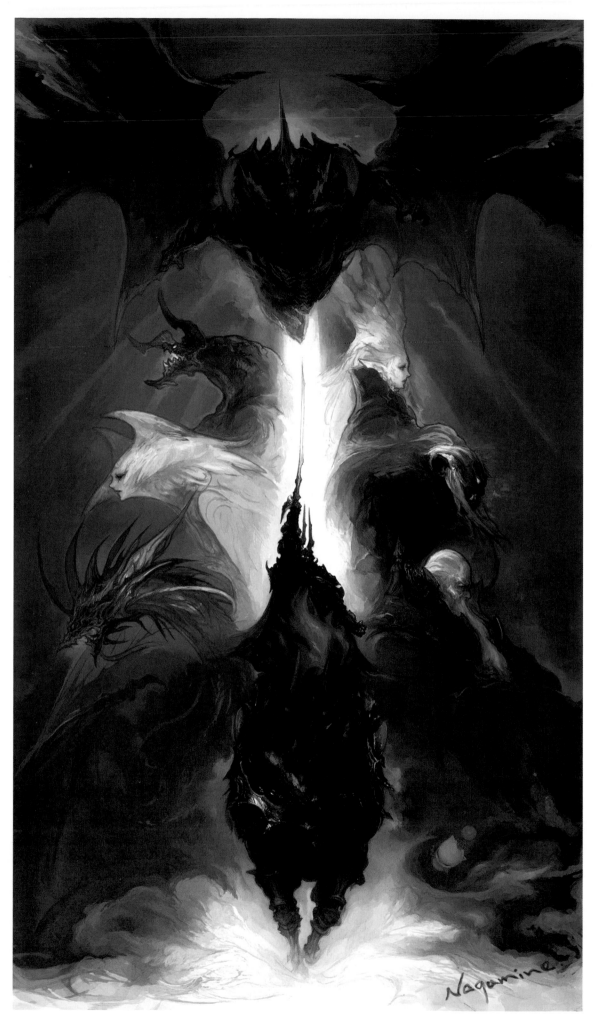

The order called for "the primals with Bahamut reigning over them." It was my first time drawing something big, and I had trouble with it. I feel that I got Odin's placement right. (Nagamine)

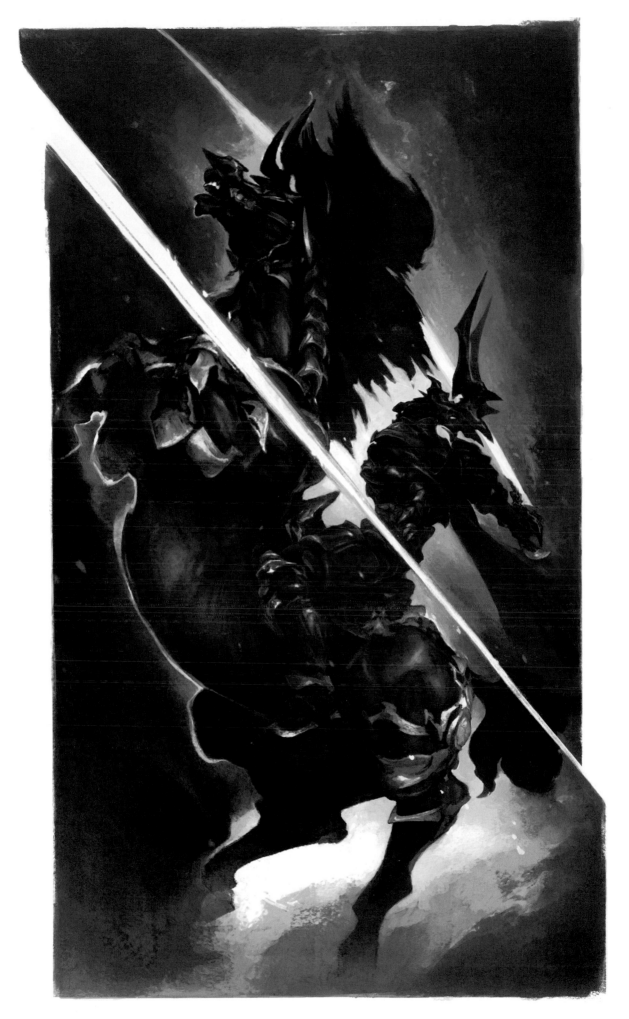

An illustration of Odin. In order to portray space itself being cut by Zantetsuken, I divided the top and bottom halves of the picture and shifted them slightly to the side. (Nagamine)

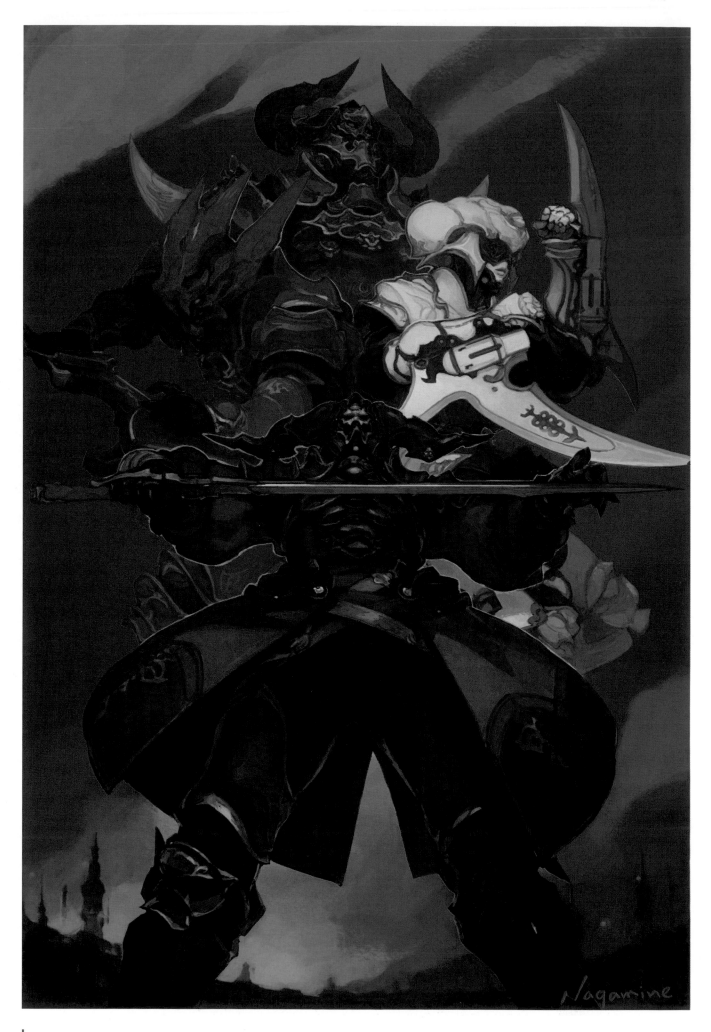

Gaius van Baelsar together with his three lieutenants. I made the gunblade shorter so that it fits better into the picture. (Nagamine)

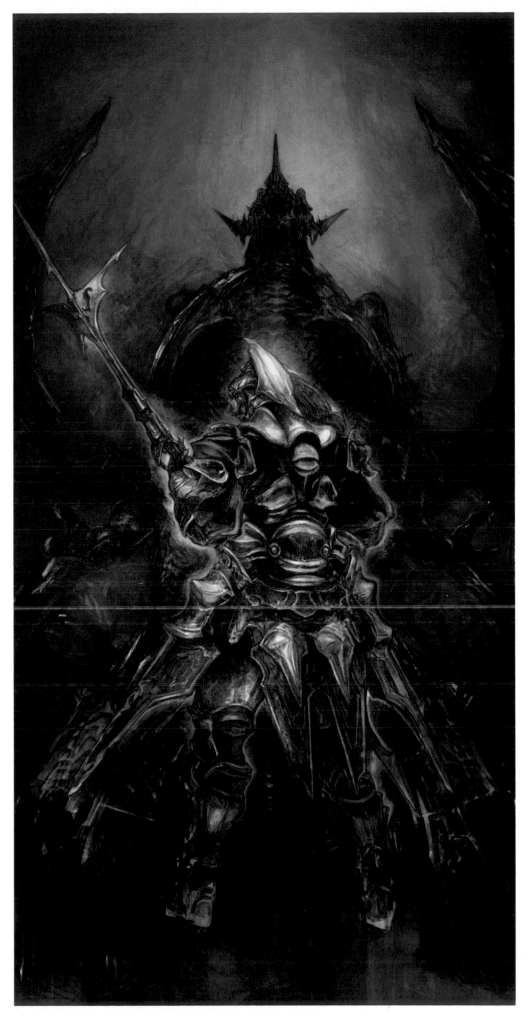

An illustration of Nael van Darnus standing with his back turned, with the silhouette of Bahamut behind. (Nagamine)

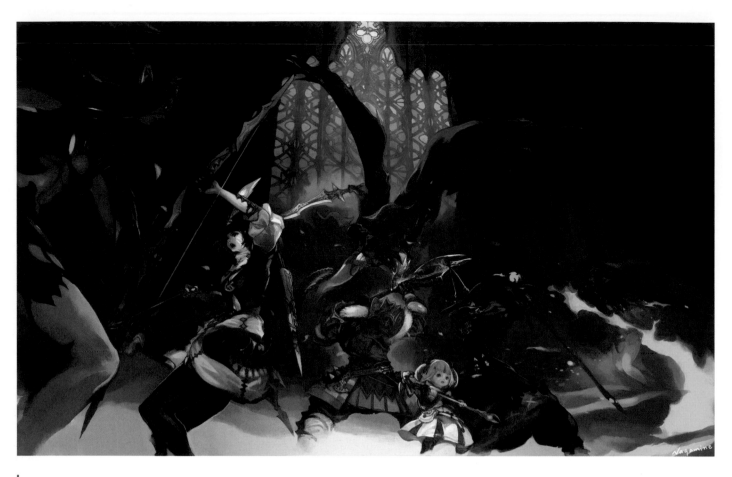

A party of four fighting its way through a dungeon. I don't draw human characters very often, so this was a nice change of pace. (Nagamine)

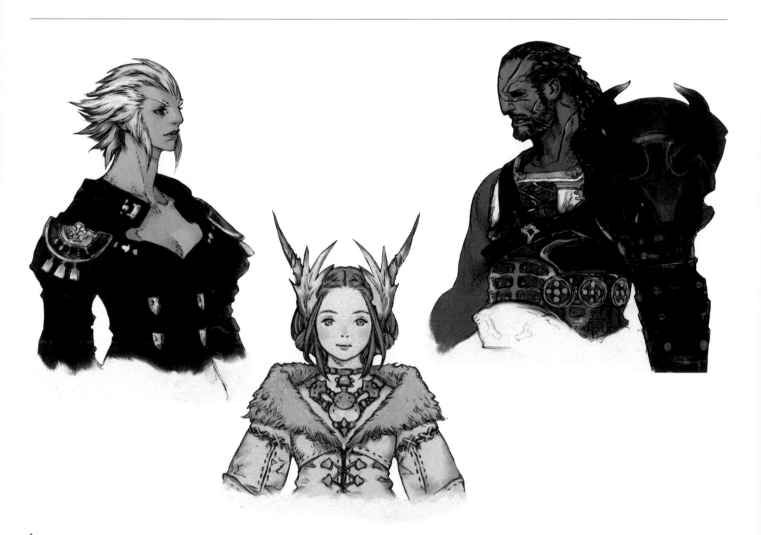

I drew the principal lines with a 2B pencil and scanned them. No mechanical pencils for me. (Akihiko Yoshida)

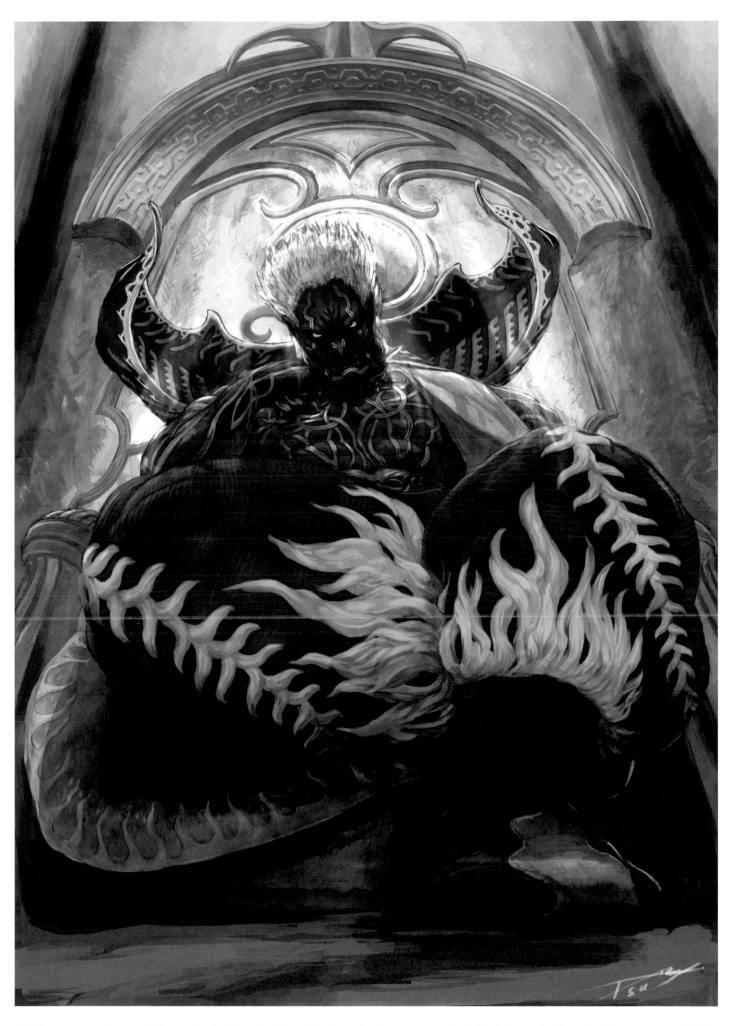

The focus was on ambience, which I cranked up double. For the father of the Allagan Empire, he went down kind of easily. But maybe it's just right if you're going to fight him over and over? (Tsukamoto)

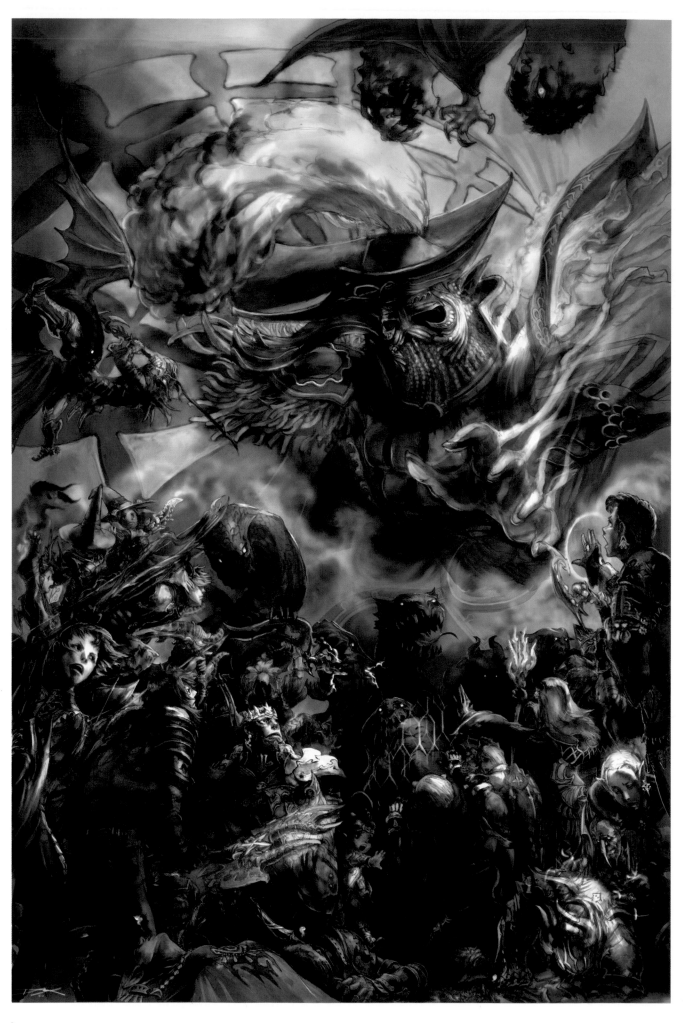

For the Crystal Tower, I tried to convey a sense of tragic heroism. Syrcus Tower is fun to play. I like how you get turned into a frog in the battle against Amon. (Tsukamoto)

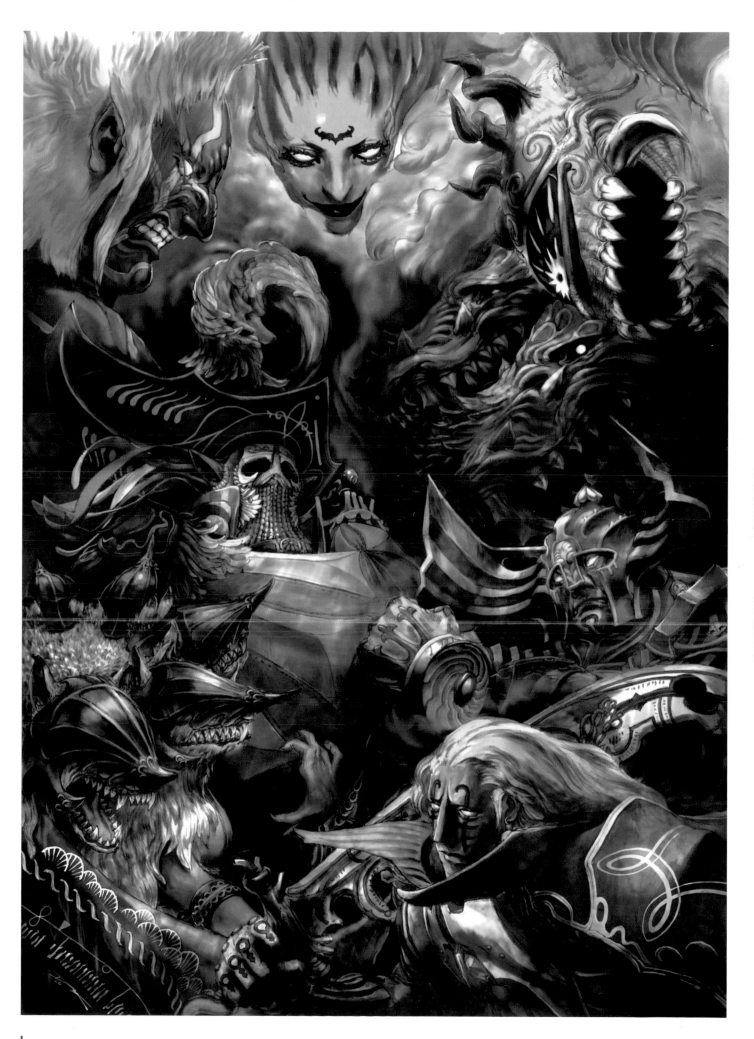

Having played *FFIII*, I was deeply moved to have the opportunity to draw this piece. There are spoilers in there, but it's cool, right? (Tsukamoto)

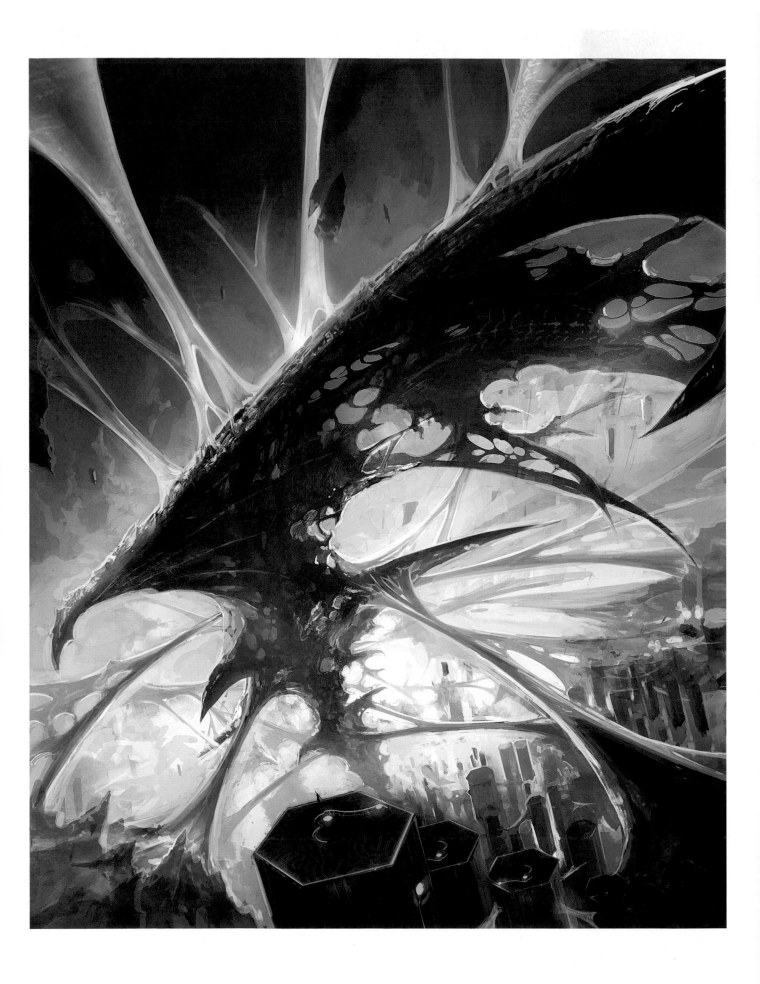

I put a lot of effort into making the aether look enticing. I have memories of going through trial and error to get a pleasant flow. The dominant color is yellow. (Yamate)

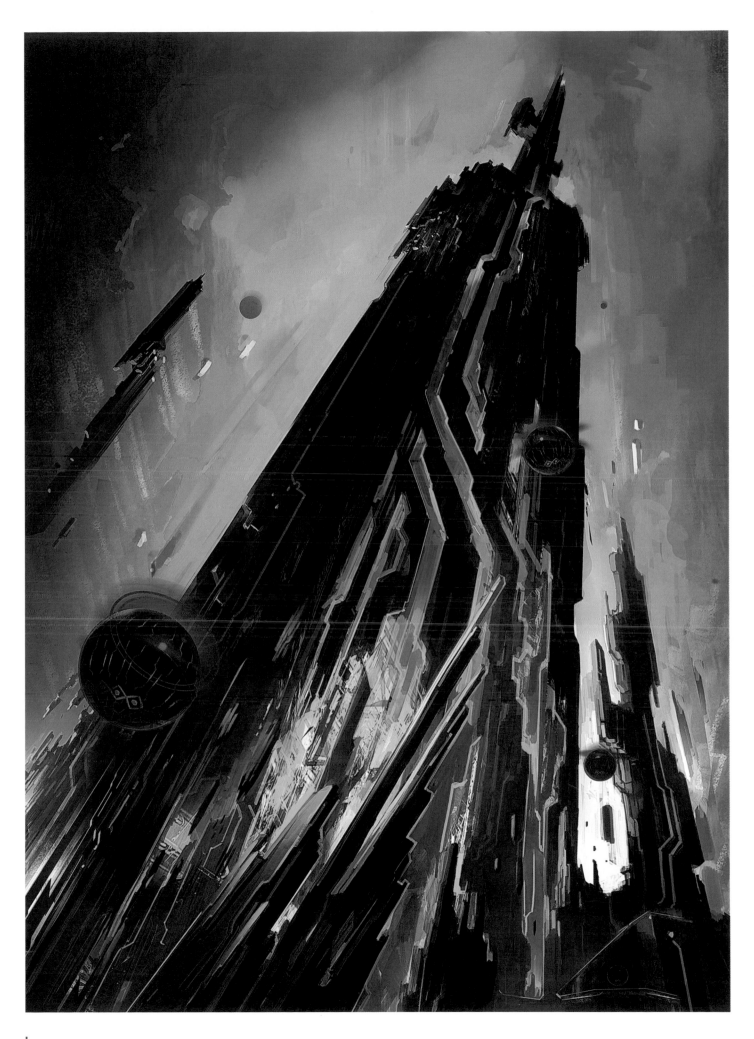

Like a giant blade piercing the earth. The dominant color is blue. (Yamate)

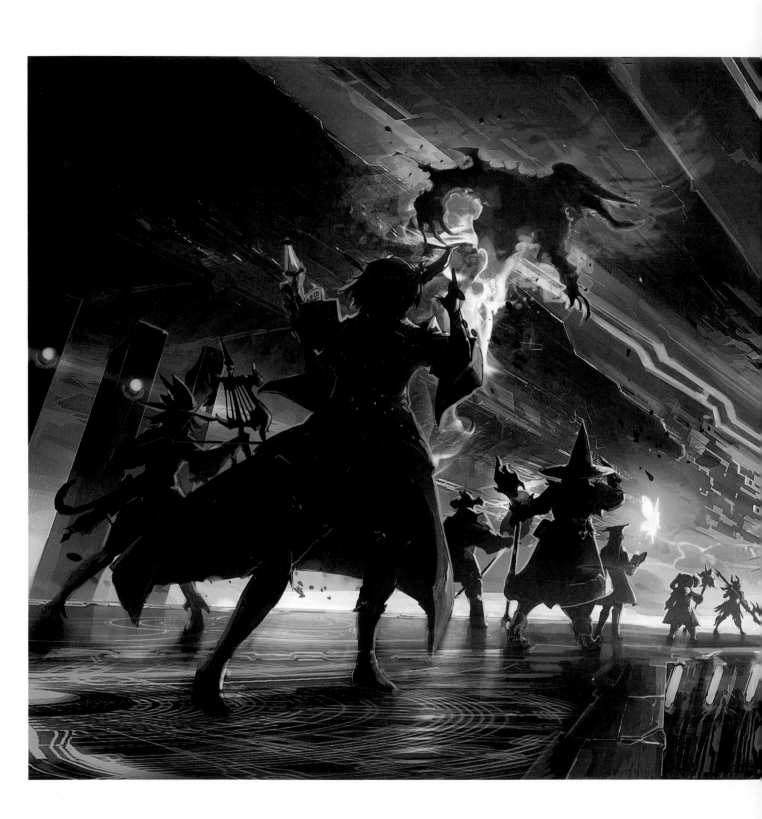

Bahamut undergoing regeneration via the heart-like core crystal. Tubes akin to veins twine around the crystal. The dominant color is red. (Yamate)

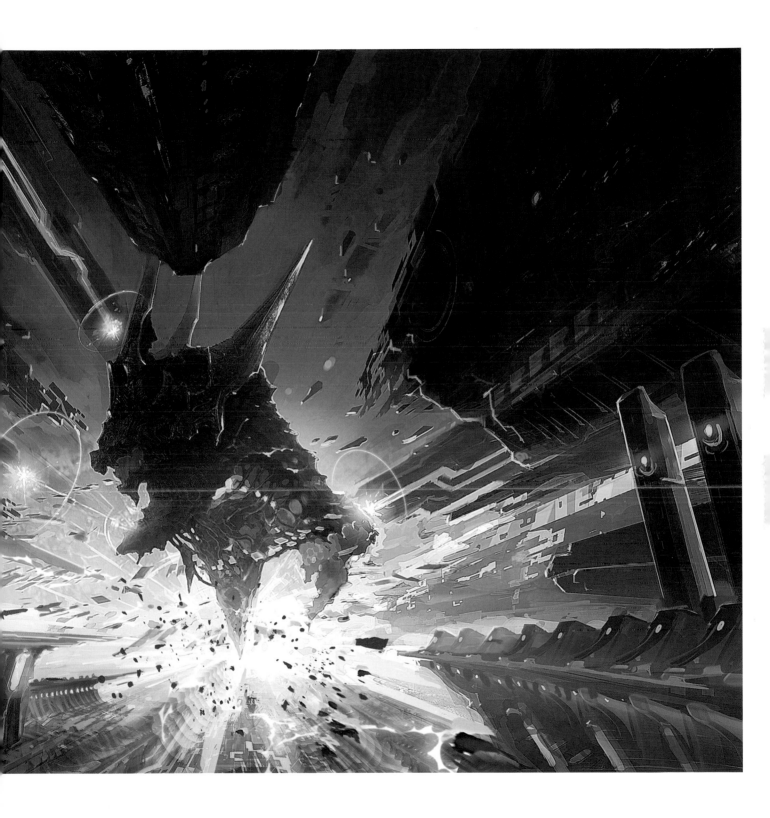

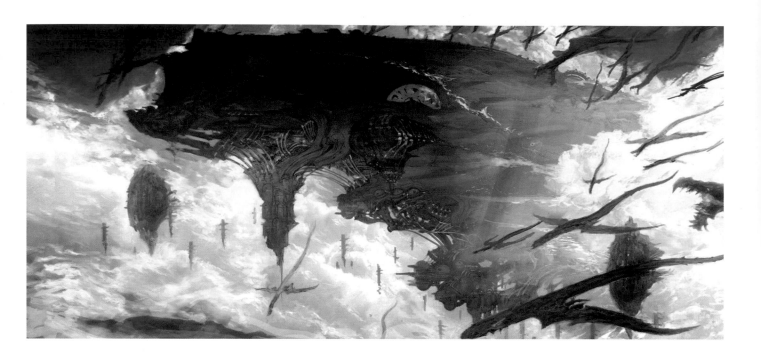

That thing you see sticking out of the lake in Mor Dhona, at the heart of Eorzea. Though it's supposed to be cutting-edge technology, we gave it cannons for a retro look. (Takahashi)

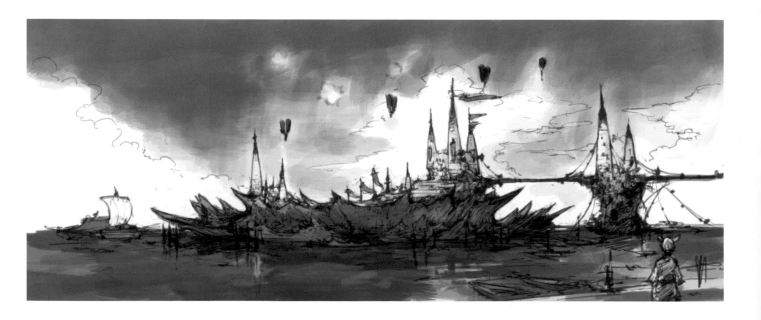

An early concept for the Wolves' Den. You can see how the shape was changed by the time it was implemented! (Kenta Tanaka)

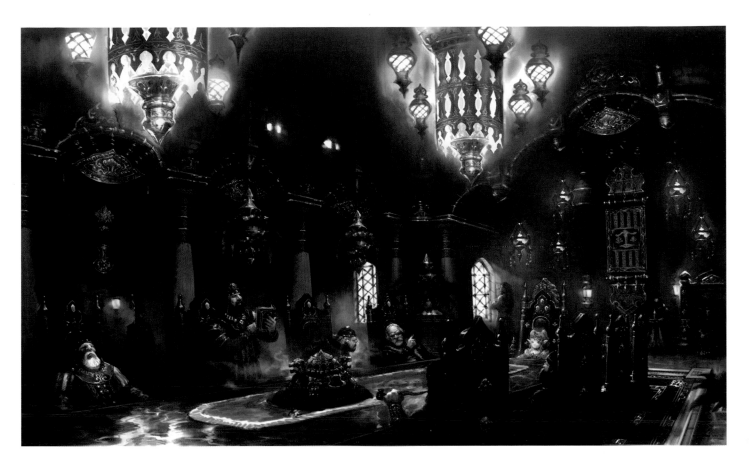

This concept art of Ul'dah's royal palace was drawn for the original *FFXIV*. Because it was so beautifully done, I had it tweaked for use in marketing for *A Realm Reborn*. It really captures Ul'dah's undercurrent of intrigue, don't you think? (Yoshi-P)

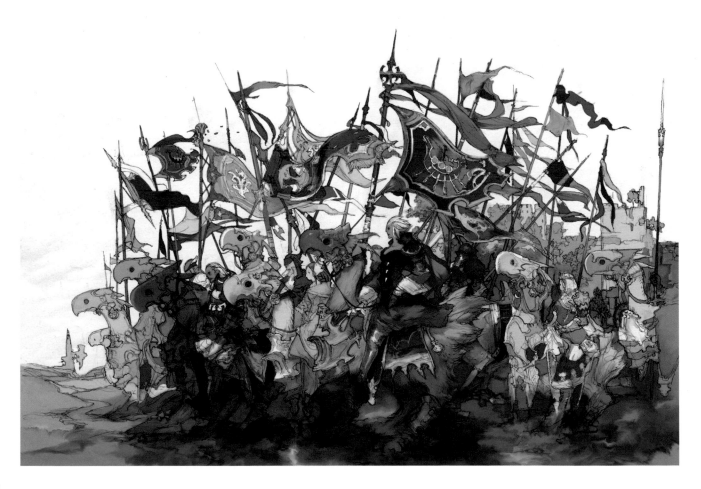

I like this touch! It's easy to draw, you see. (Akihiko Yoshida)

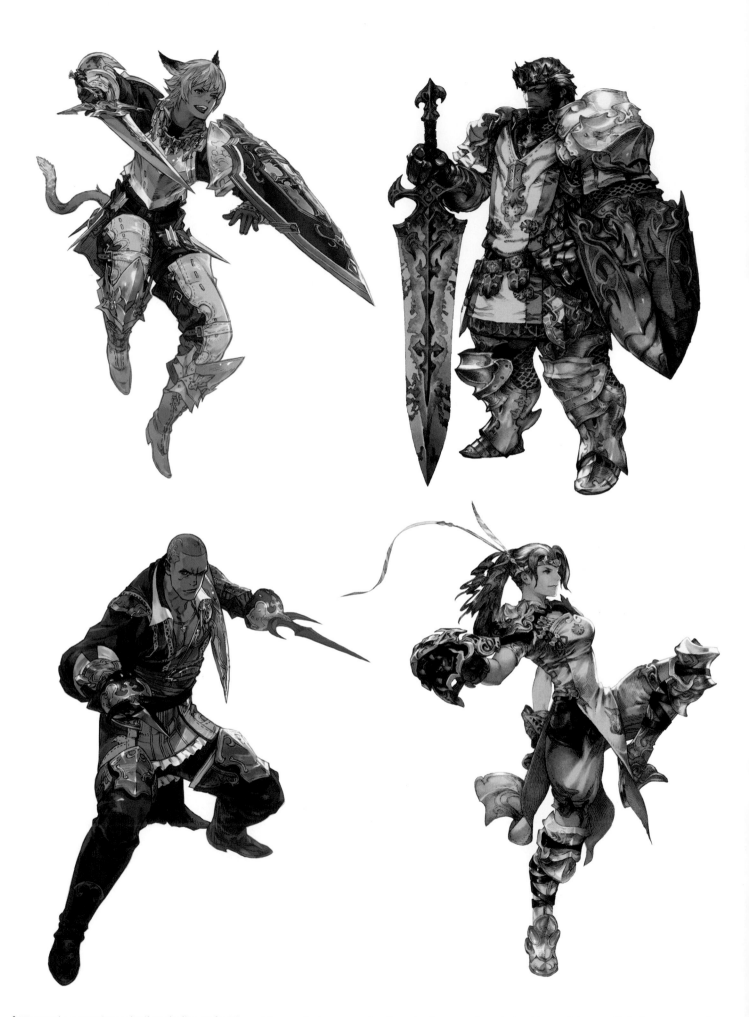

We spared no attention to detail on the line art for jobs, and it was quite time-consuming. Since the pieces were drawn by hand in pencil, it was really bothersome to tweak things afterwards. (Akihiko Yoshida)

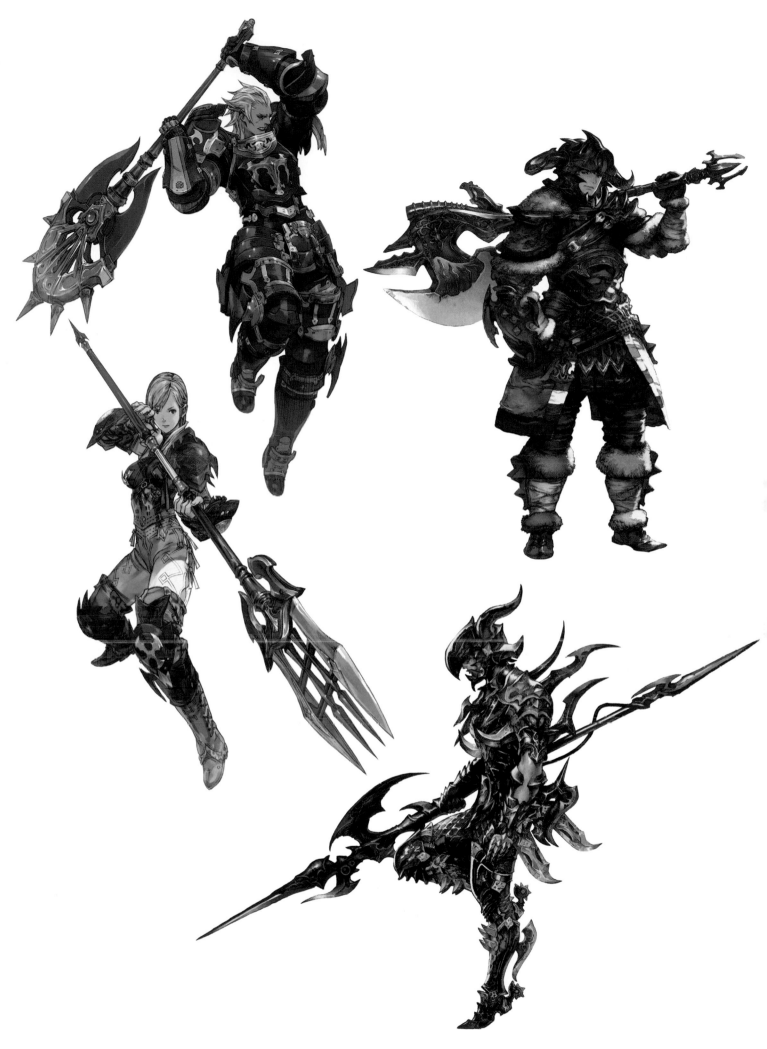

Having finished the job illustrations first, I consulted with Akihiko Yoshida on how to distinguish the class ones, and decided to do so by giving them dynamic poses. Also, I personally wanted to portray the differences in physique between the races. The result is reminiscent of what I drew in the past for *Tactics Ogre: Let Us Cling Together*. (Masao)

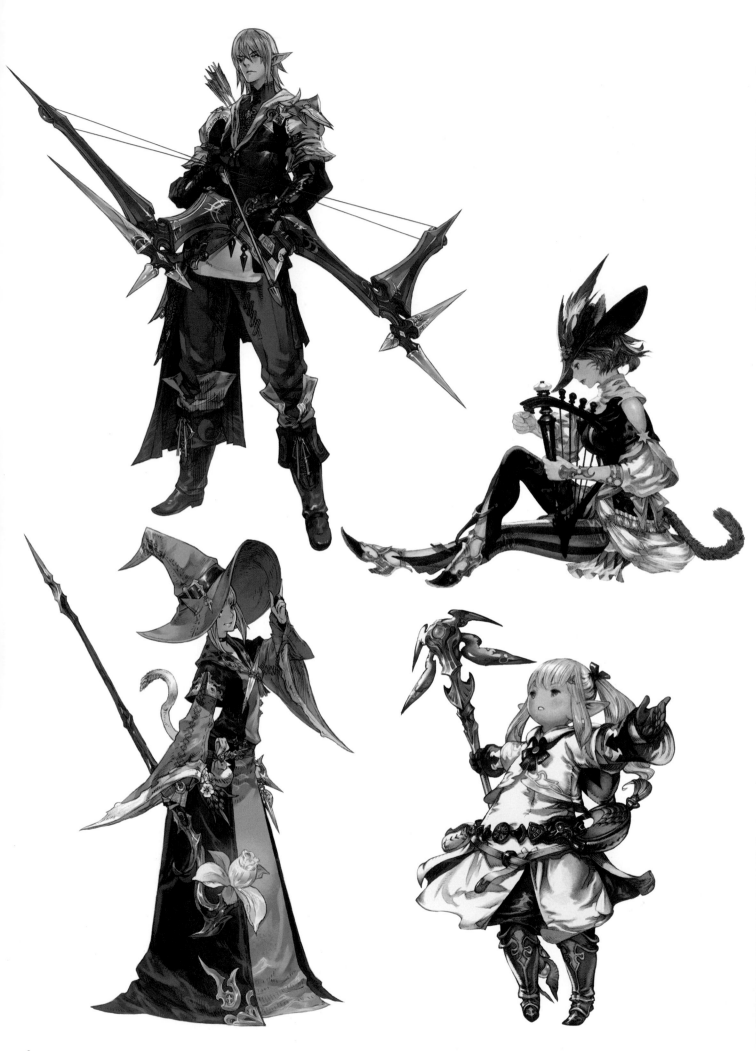

Classes don't have unique gear, so we had Oda (world lore creator) pick the weapons and attire for us. (Masao)

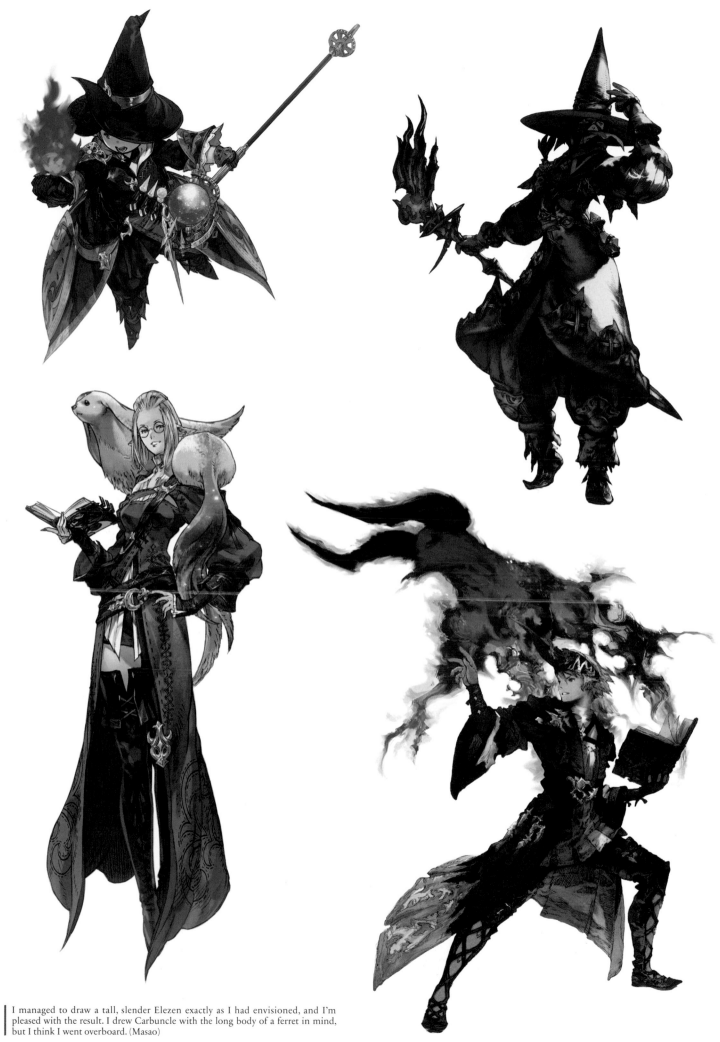

I managed to draw a tall, slender Elezen exactly as I had envisioned, and I'm pleased with the result. I drew Carbuncle with the long body of a ferret in mind, but I think I went overboard. (Masao)

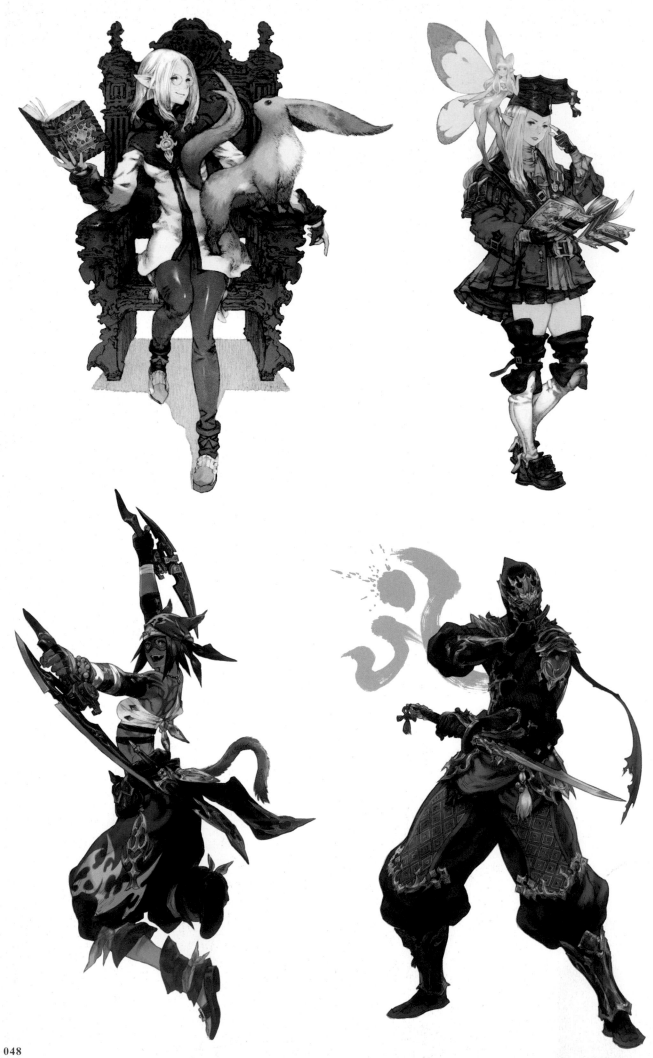

CHARACTERS

FINAL FANTASY XIV: A Realm Reborn
The Art of Eorzea -Another Dawn-

Hyuran Male

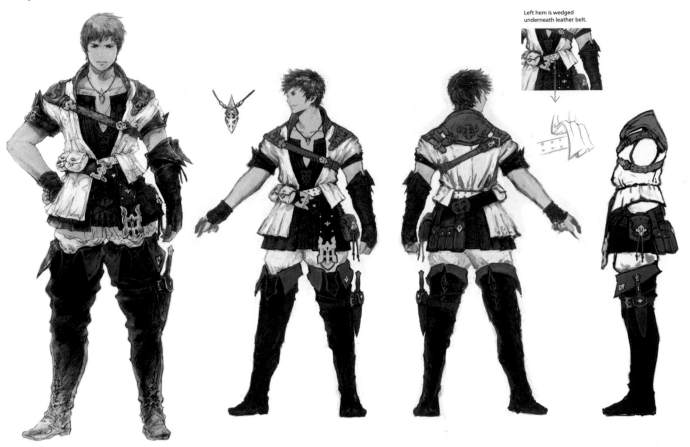

Left hem is wedged underneath leather belt.

| I tried to imbue a sense of new beginnings along with a *FF XIV* feel. In part because we didn't have much time to draw the races, I stayed close to the original design. (Takahashi)

Hyuran Female

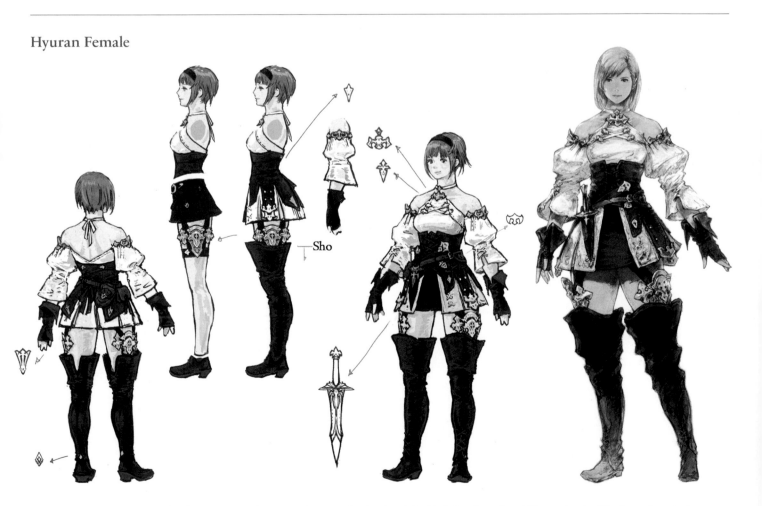

Sho

| In contrast to the Miqo'te's "pop idol" theme, we went with "princess" for Hyuran females (though the skirt is short for a princess). We ran a bunch of ideas by cosplayers in the company, and ended up going with this design. (Namae)

Elezen Male

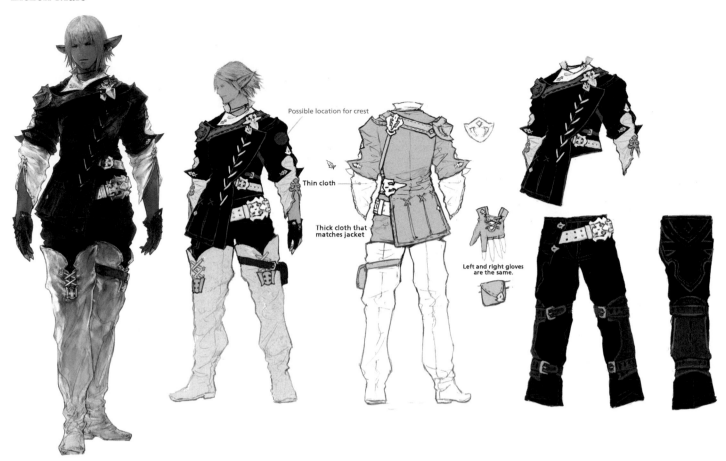

Possible location for crest

Thin cloth

Thick cloth that matches jacket

Left and right gloves are the same.

Leave it to an Elezen to look dignified in swanky gear! (Takahashi)

Elezen Female

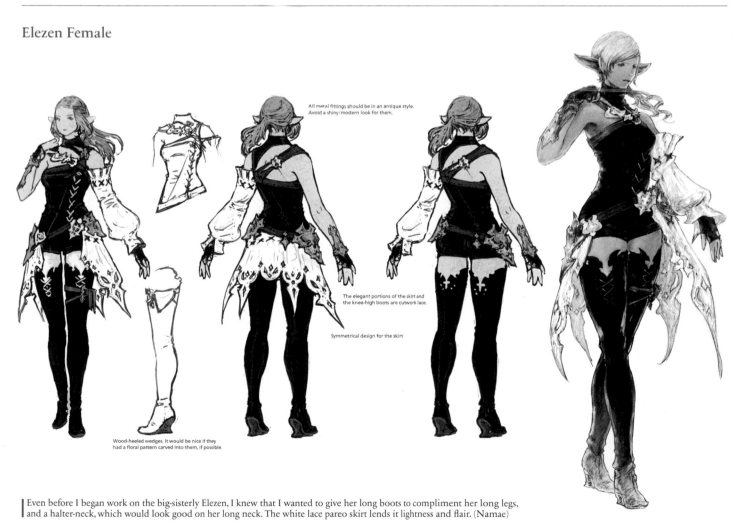

All metal fittings should be in an antique style. Avoid a shiny/modern look for them.

The elegant portions of the skirt and the knee-high boots are cutwork lace.

Symmetrical design for the skirt

Wood-heeled wedges. It would be nice if they had a floral pattern carved into them, if possible.

Even before I began work on the big-sisterly Elezen, I knew that I wanted to give her long boots to compliment her long legs, and a halter-neck, which would look good on her long neck. The white lace pareo skirt lends it lightness and flair. (Namae)

Lalafellin Male

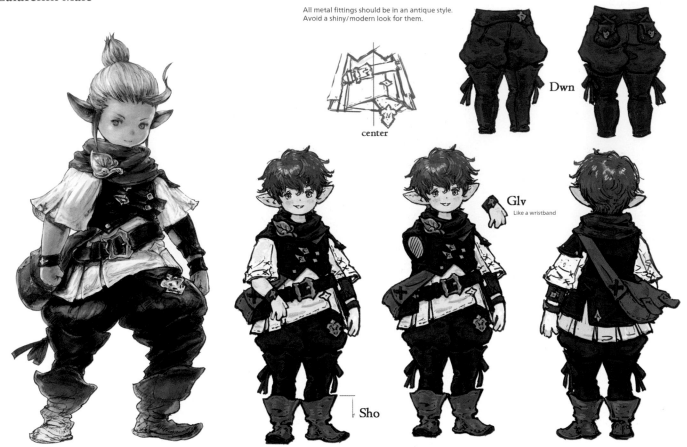

All metal fittings should be in an antique style.
Avoid a shiny/modern look for them.

center

Dwn

Glv
Like a wristband

Sho

Originally modeled on a spirited kindergarten-aged boy. The smock and satchel were adapted for adventuring. It occurred to me afterwards that, if Lalafells were taller, this might resemble a hero in *Dragon Quest*. (Namae)

Lalafellin Female

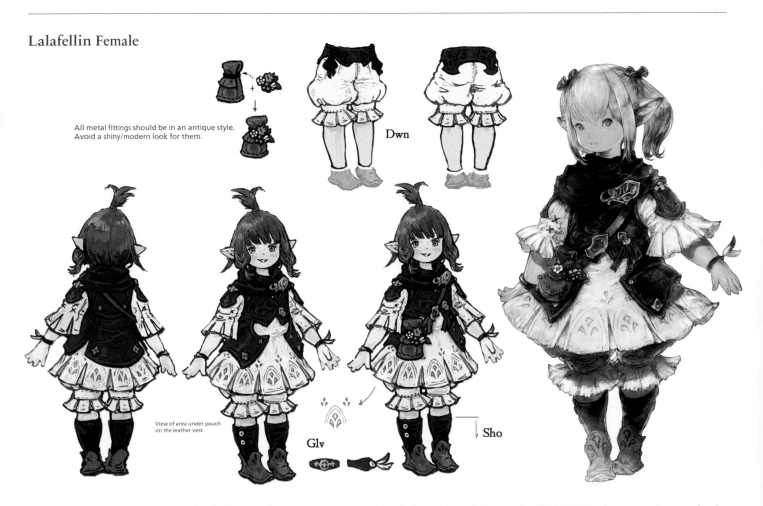

All metal fittings should be in an antique style.
Avoid a shiny/modern look for them.

Dwn

View of area under pouch
on the leather vest

Glv

Sho

I felt a pouch and bloomers were essential to this design. We had the opportunity to use this and other racial gear designs to make official *FFXIV* cosplay costumes. It was tough trying to make the pants puffy in real life. (Namae)

Miqo'te Male

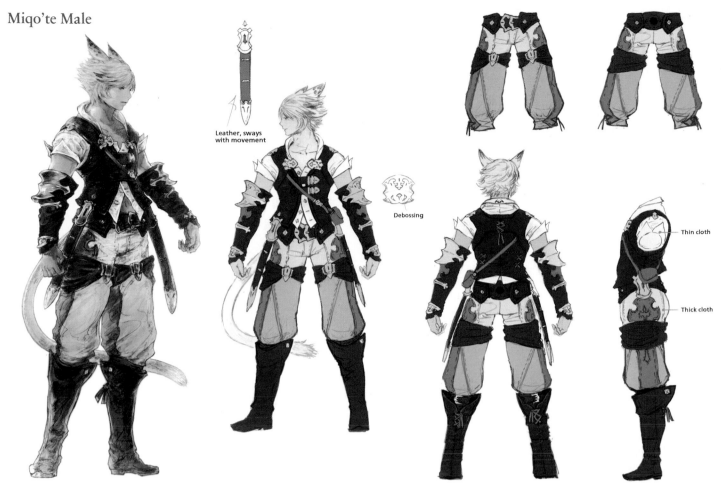

Leather, sways with movement

Debossing

Thin cloth

Thick cloth

The Miqo'te are supposed to be dynamic and spirited, which I sought to convey here. The design includes the face, and it came together well as a whole. The shirt's upturned sleeves provide an accent. (Takahashi)

Miqo'te Female

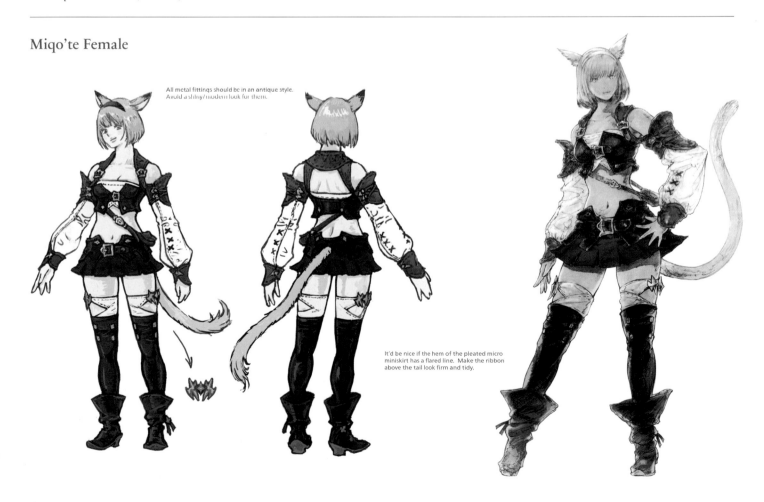

All metal fittings should be in an antique style. Avoid a shiny/modern look for them.

It'd be nice if the hem of the pleated micro miniskirt has a flared line. Make the ribbon above the tail look firm and tidy.

The Miqo'te's energetic "pop idol" image is embodied in this outfit. For all racial gear, we were instructed to "Think of the cosplayers!" and create designs that they could reproduce. I still have fond memories of poring over cosplay magazines with the others in a meeting room. (Namae)

Roegadyn Male

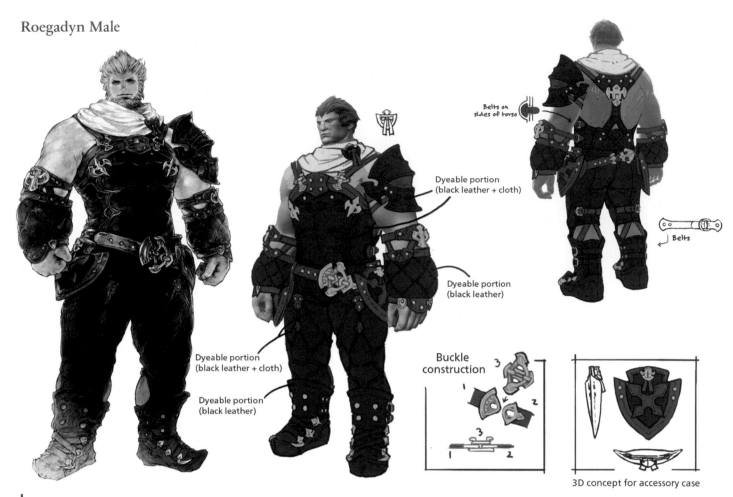

Dyeable portion
(black leather + cloth)

Dyeable portion
(black leather)

Dyeable portion
(black leather + cloth)

Dyeable portion
(black leather)

Belts on
sides of torso

Belts

Buckle
construction

3D concept for accessory case

Using black leather to accentuate their rugged bodies, I aimed for a brawny and slightly intimidating image. (Kasuya)

Roegadyn Female

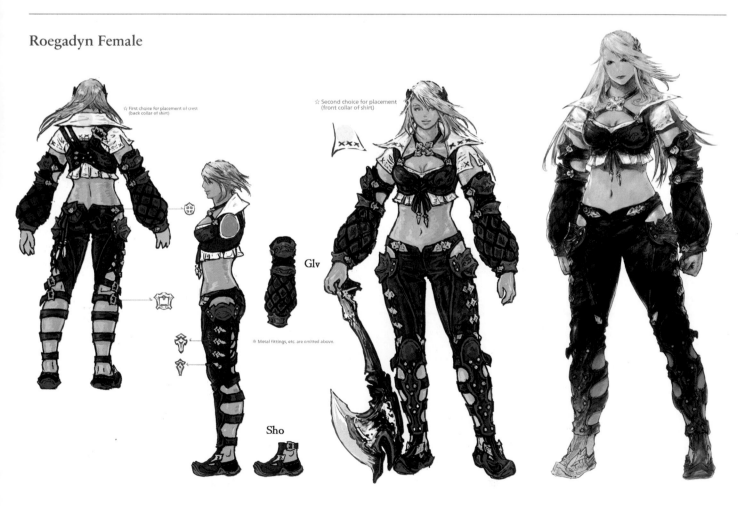

☆ First choice for placement of crest
(back collar of shirt)

☆ Second choice for placement
(front collar of shirt)

Glv

※ Metal fittings, etc. are omitted above.

Sho

Kasuya supplied the idea and I handled the design adjustments. We had very little time to work on the race-specific gear—about half the usual. As a result, the artwork in the series turned out rougher than what we typically produce. (Namae)

Admiral Merlwyb Bloefhiswyn

● Merlwyb's gun

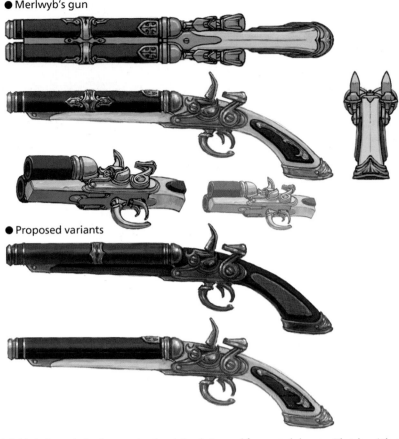

● Proposed variants

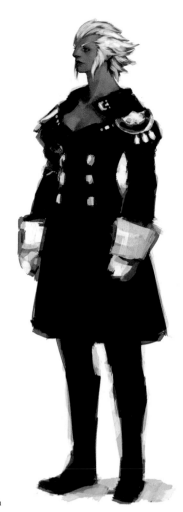

I scribbled this during early development, but it ended up being used for a central character. That doesn't happen very often. (Akihiko Yoshida)

Elder Seedseer Kan-E-Senna

☆ Hair ornaments are envisioned as silverwork.
Give them a blend of varied colors, like a shell.

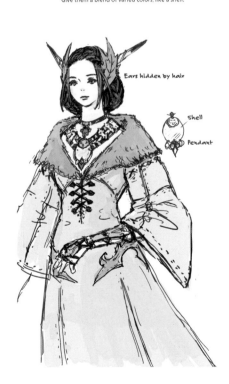

Ears hidden by hair

Shell

Pendant

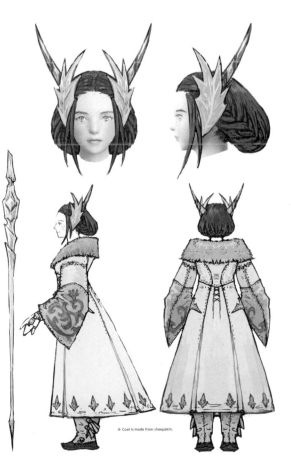

☆ Coat is made from sheepskin.

We considered making her hair long and loose, but ended up keeping it tidy, as she's supposed to be a mother figure. The story is that she listens to the voices of the forest, so I based her attire on an outdoor coat rather than something posh. (Namae)

Seedseer Raya-O-Senna

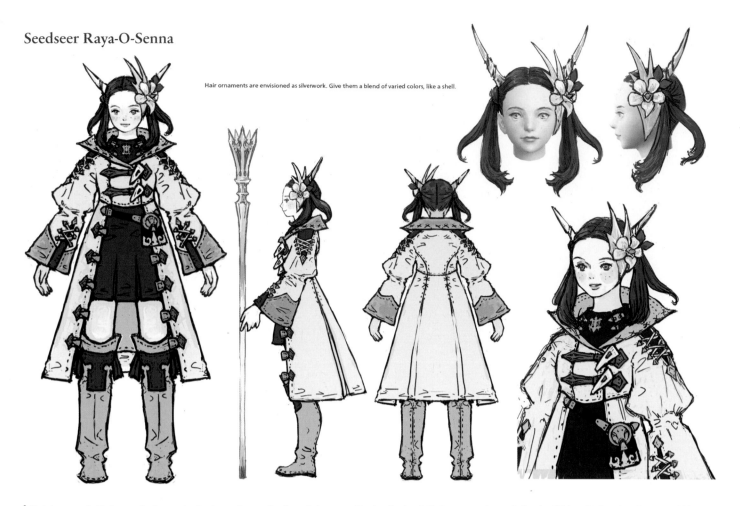

Hair ornaments are envisioned as silverwork. Give them a blend of varied colors, like a shell.

Opinion was divided over whether to give her bangs, but we finally settled on revealing her forehead. She's meant to be spoiled and willful, and I drew her that way. I'd like to see her grow independent in the course of the story. (Namae)

Seedseer A-Ruhn-Senna

☆ Bangs are long enough to completely hide the silver.
☆ Hair ornaments are envisioned as silverwork. Give them a blend of varied colors, like a shell. However, make it overall more blue-hued compared to his sister's.
☆ Apply a slightly round silhouette to bring out a youthful vibe.

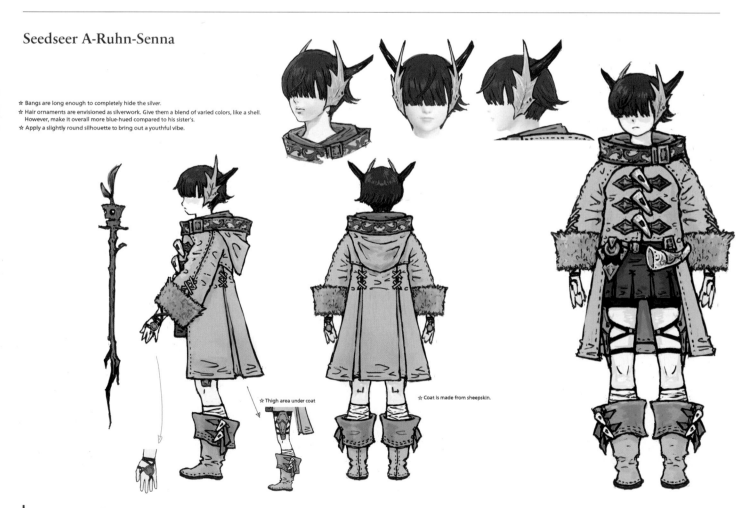

☆ Thigh area under coat

☆ Coat is made from sheepskin.

I wanted him to give the impression that he's quiet and timid, yet perhaps harboring tremendous power. To complete the look, I gave him long bangs to cover his eyes. (Namae)

Sultana Nanamo Ul Namo

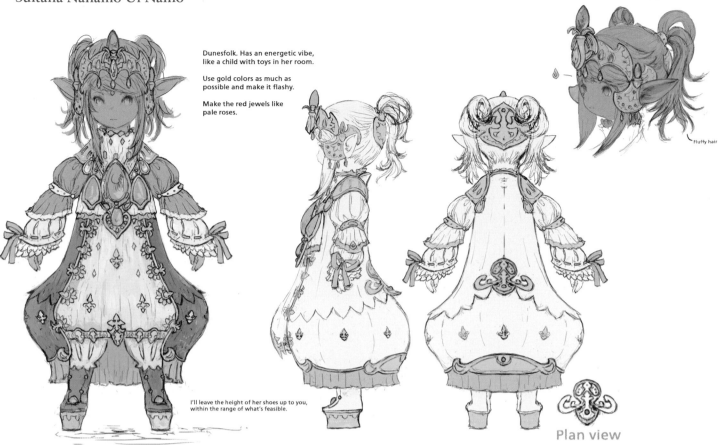

Dunesfolk. Has an energetic vibe, like a child with toys in her room.

Use gold colors as much as possible and make it flashy.

Make the red jewels like pale roses.

I'll leave the height of her shoes up to you, within the range of what's feasible.

Fluffy hair

Plan view

I tried for a sumptuous outfit that accentuates the unique Lalafellin physique. It's all set off with big jewels after the fashion of Ul'dah, which has a flourishing mining industry. (Takahashi)

Flame General Raubahn Aldynn

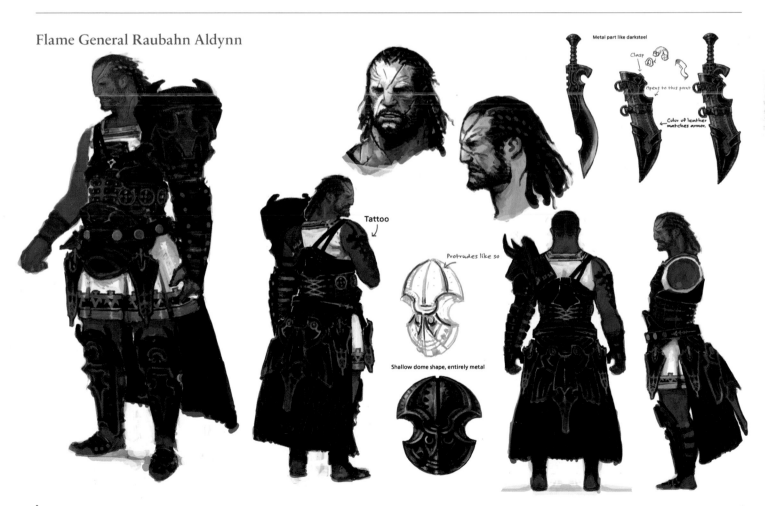

Metal part like darksteel

Clasp

Opens to this point

Color of leather matches armor.

Tattoo

Protrudes like so

Shallow dome shape, entirely metal

I really like Raubahn's design! That said, it might have been better if his right shoulder wasn't exposed. (Akihiko Yoshida)

Minfilia

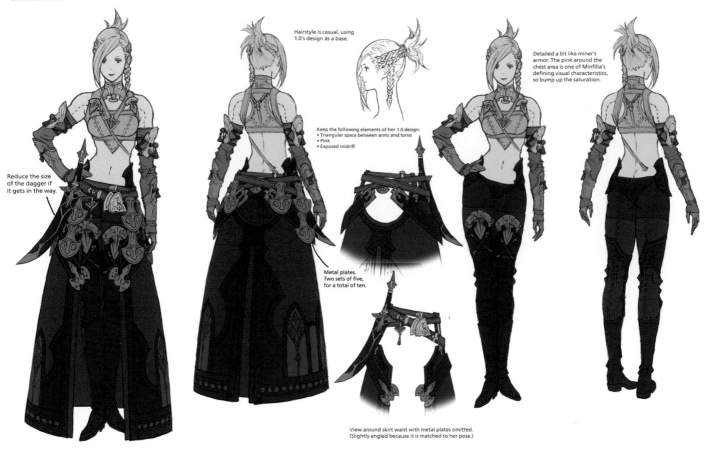

Hairstyle is casual, using 1.0's design as a base.

Keep the following elements of her 1.0 design:
• Triangular space between arms and torso
• Pink
• Exposed midriff

Detailed a bit like miner's armor. The pink around the chest area is one of Minfilia's defining visual characteristics, so bump up the saturation.

Reduce the size of the dagger if it gets in the way.

Metal plates. Two sets of five, for a total of ten.

View around skirt waist with metal plates omitted. (Slightly angled because it is matched to her pose.)

I preserved the Version 1.0 design while adding new distinguishing features. Some players poke fun at the fact you can clearly see her backside, but I remember discussing it with Akihiko Yoshida. I said, "It's not bad open, eh?" He said something like "Sure, it looks good to me." (Masao)

Alphinaud & Alisaie Leveilleur

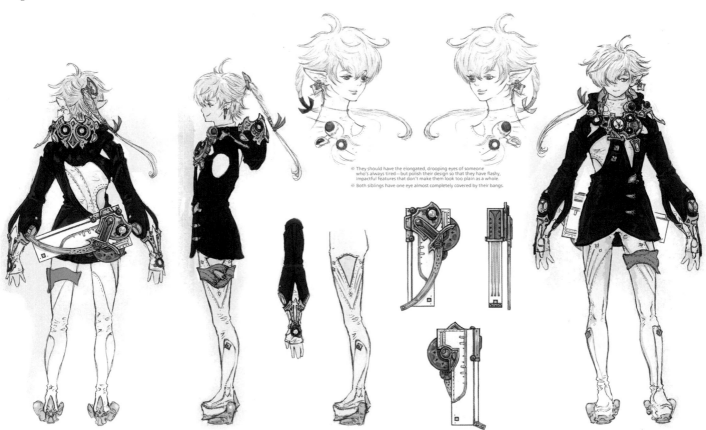

◉ They should have the elongated, drooping eyes of someone who's always tired—but polish their design so that they have flashy, impactful features that don't make them look too plain as a whole.
◉ Both siblings have one eye almost completely covered by their bangs.

Alphinaud and Alisaie are currently known as prodigies, but originally the design order called for "maverick twins from an otherworldly place." Instead of medieval fantasy, I went for a look that incorporates elements from sci-fi and the Vienna Secession art movement. (Namae)

Cid nan Garlond

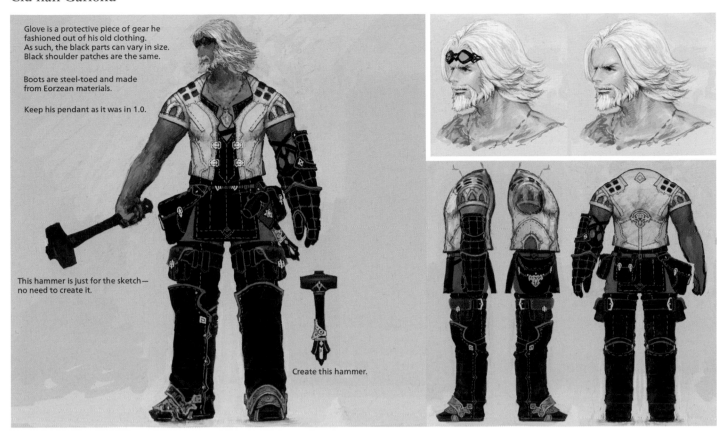

Glove is a protective piece of gear he fashioned out of his old clothing. As such, the black parts can vary in size. Black shoulder patches are the same.

Boots are steel-toed and made from Eorzean materials.

Keep his pendant as it was in 1.0.

This hammer is just for the sketch— no need to create it.

Create this hammer.

His original design had a beard, but we decided to remove it in Version 1.0 so we could show the passage of time when the realm was reborn. (Takahashi)

Young Cid

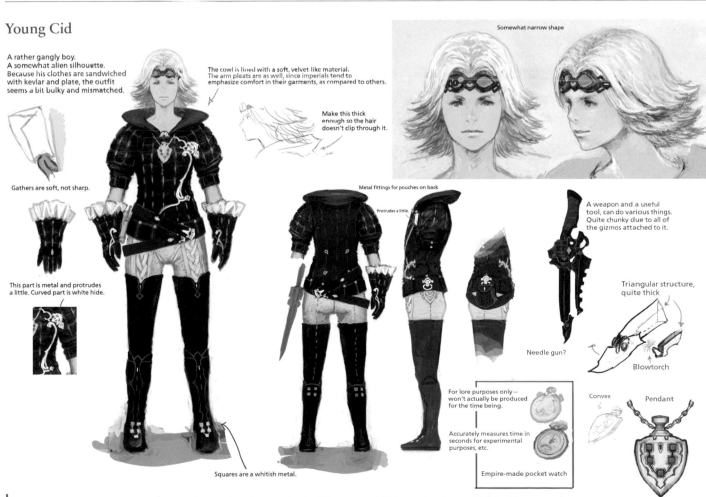

A rather gangly boy. A somewhat alien silhouette. Because his clothes are sandwiched with kevlar and plate, the outfit seems a bit bulky and mismatched.

The cowl is lined with a soft, velvet-like material. The arm pleats are as well, since imperials tend to emphasize comfort in their garments, as compared to others.

Make this thick enough so the hair doesn't clip through it.

Somewhat narrow shape

Gathers are soft, not sharp.

This part is metal and protrudes a little. Curved part is white hide.

Metal fittings for pouches on back

Protrudes a little.

A weapon and a useful tool, can do various things. Quite chunky due to all of the gizmos attached to it.

Triangular structure, quite thick

Blowtorch

Needle gun?

Squares are a whitish metal.

For lore purposes only— won't actually be produced for the time being.

Accurately measures time in seconds for experimental purposes, etc.

Empire-made pocket watch

Convex Pendant

This is Cid from his childhood years. I like Garlean clothing because I feel it still has potential for interesting designs. (Takahashi)

Yugiri

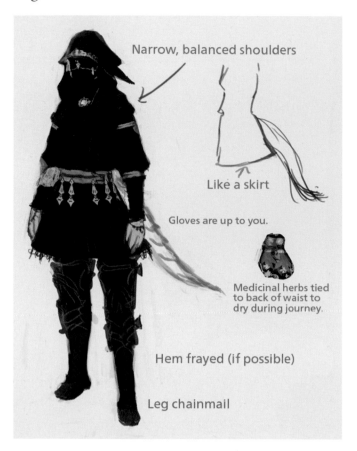

Narrow, balanced shoulders

Like a skirt

Gloves are up to you.

Medicinal herbs tied to back of waist to dry during journey.

Hem frayed (if possible)

Leg chainmail

A mysterious new race, conveying a foreign air. (Takahashi)

Iceheart

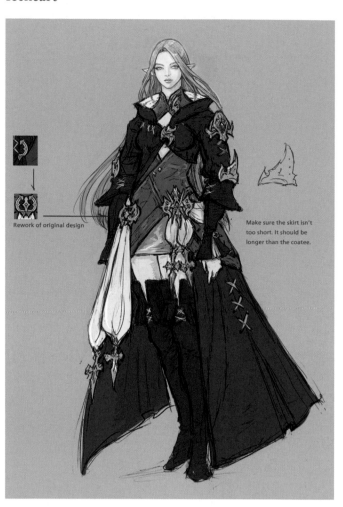

Rework of original design

Make sure the skirt isn't too short. It should be longer than the coatee.

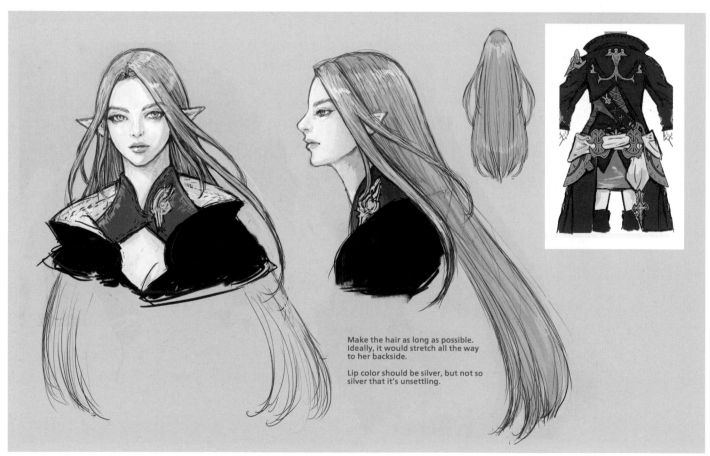

Make the hair as long as possible. Ideally, it would stretch all the way to her backside.

Lip color should be silver, but not so silver that it's unsettling.

The image I had was that of a strong, mysterious woman. From that base, I aimed to create a cool beauty unlike any existing NPC in *FFXIV*. It was difficult implementing a character with such long hair, but the animators pulled through for us. (Namae)

The Archbishop

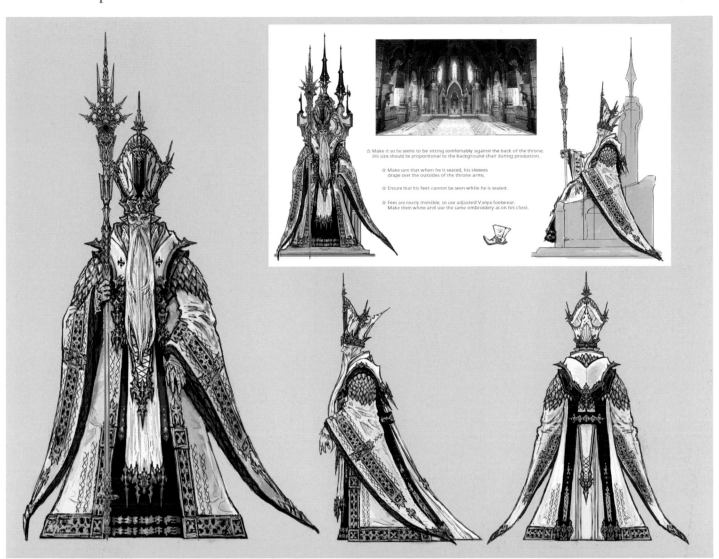

☆ Make it so he seems to be sitting comfortably against the back of the throne. His size should be proportional to the background chair during production.

☆ Make sure that when he is seated, his sleeves drape over the outsides of the throne arms.

☆ Ensure that his feet cannot be seen while he is seated.

☆ Feet are nearly invisible, so use adjusted Vanya footwear. Make them white and use the same embroidery as on his chest.

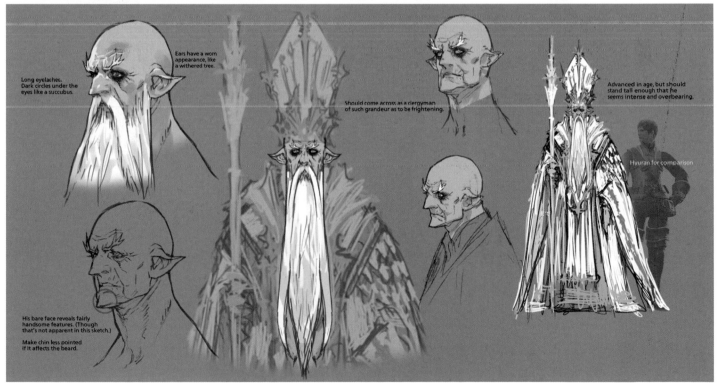

Long eyelashes. Dark circles under the eyes like a succubus.

Ears have a worn appearance, like a withered tree.

Should come across as a clergyman of such grandeur as to be frightening.

Advanced in age, but should stand tall enough that he seems intense and overbearing.

Hyuran for comparison

His bare face reveals fairly handsome features. (Though that's not apparent in this sketch.)

Make chin less pointed if it affects the beard.

Masao designed his face and I designed his clothing in a collaborative effort. I tried to invoke an Ishgardian sternness and strength while retaining a traditional papal style. The area around the neck and shoulders is made from dragon scales, creating a robust silhouette. (Namae)

I drew several sketches for the face, and Maehiro selected one. Aside from the elongated ears, the nose is also characteristic of Elezens. (Masao)

Gallant Armor

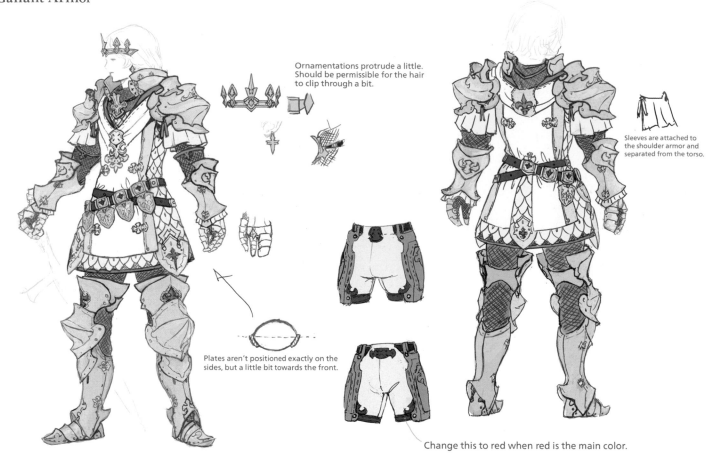

Ornamentations protrude a little. Should be permissible for the hair to clip through a bit.

Sleeves are attached to the shoulder armor and separated from the torso.

Plates aren't positioned exactly on the sides, but a little bit towards the front.

Change this to red when red is the main color.

To make this gear stand out, I strongly emphasized the knightly qualities. I like the contours from the thighs to the knees. (Takahashi)

Temple Attire

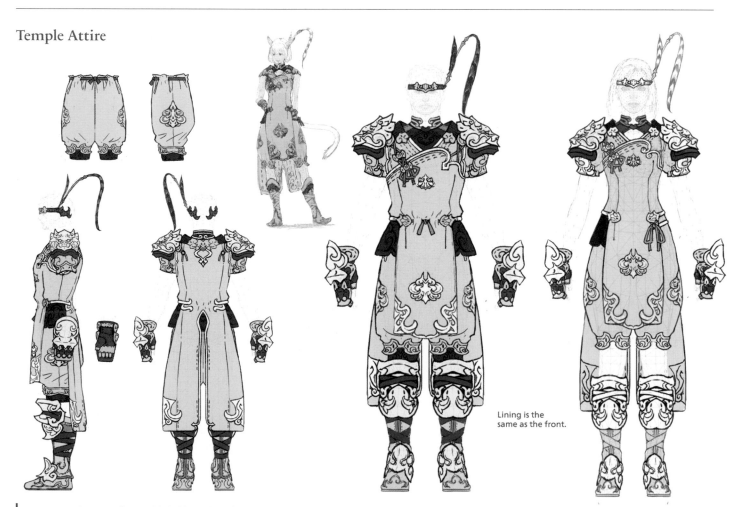

Lining is the same as the front.

In previous titles we've often used light blue and red for monks, but I chose yellow out of personal preference. (Takahashi)

Fighter's Armor

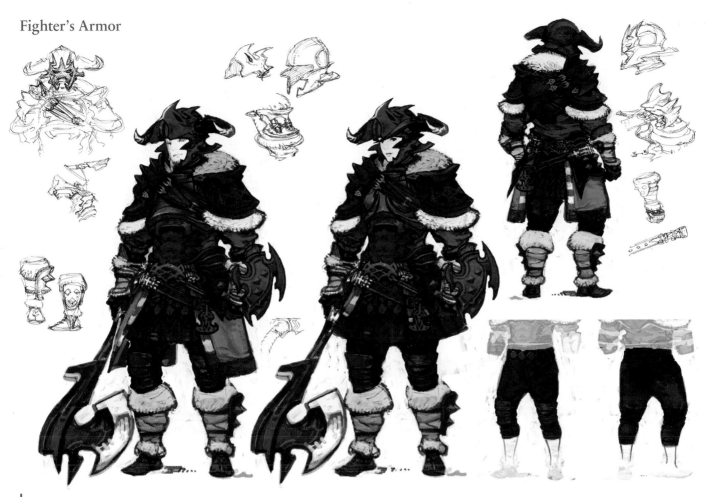

The models for *FFXIV* gear have complicated specs, and it's hard to keep them all in mind when coming up with designs! (Akihiko Yoshida)

Drachen Armor

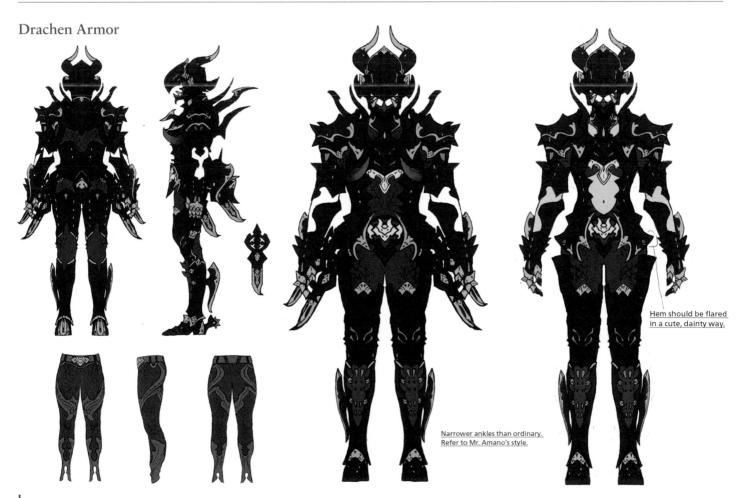

Hem should be flared in a cute, dainty way.

Narrower ankles than ordinary. Refer to Mr. Amano's style.

A lot of work went into the design and placement of the spines. I put some spines on the upper arms so they would move when the player strikes a pose. (Takahashi)

Choral Attire

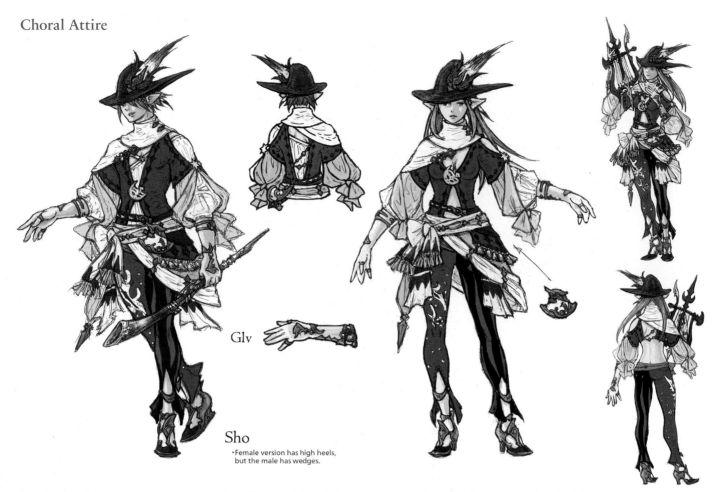

Glv

Sho
• Female version has high heels, but the male has wedges.

I took my inspiration from the sensitive, ethereal lines of Amano's designs. Archer to bard represented a marked change compared to other jobs, and with it being the most flashy design among the more grounded visuals of Version 1.0, I was anxious as to how players would react. (Namae)

Healer's Attire

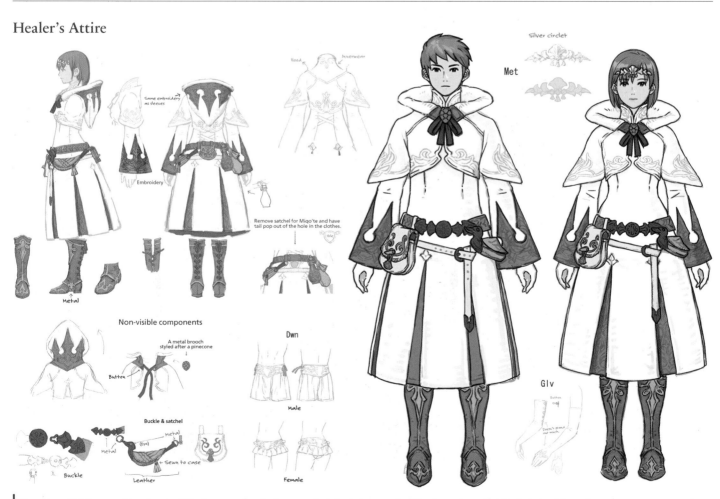

Same embroidery as sleeves

Embroidery

Remove satchel for Miqo'te and have tail pop out of the hole in the clothes.

Metal

Non-visible components

A metal brooch styled after a pinecone

Button

Buckle & satchel

Metal
Metal
(Eye)
Sewn to case
Buckle
Leather

Dwn

Male

Female

Hood
Innerwear

Silver circlet

Met

Glv

The order called for something that would look cute on female characters. I tried to bring out a familiar charm through a simple design. (Kasuya)

Wizard's Attire

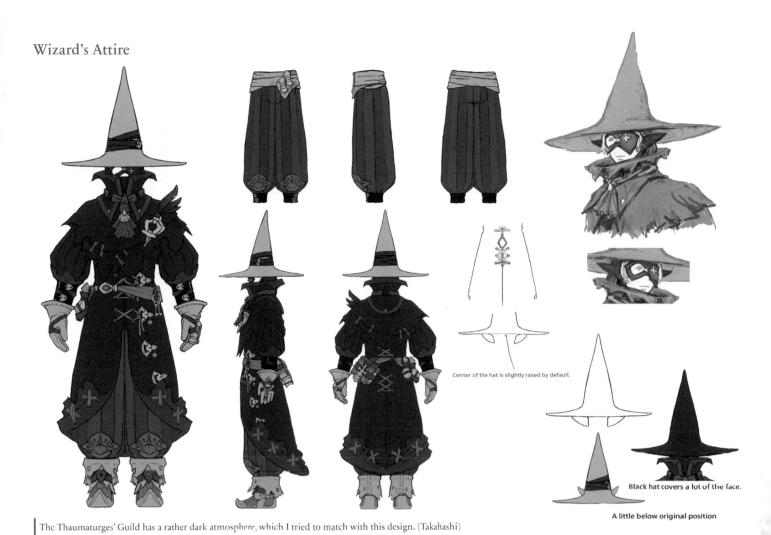

Center of the hat is slightly raised by default.

Black hat covers a lot of the face.

A little below original position

The Thaumaturges' Guild has a rather dark atmosphere, which I tried to match with this design. (Takahashi)

Evoker's Attire

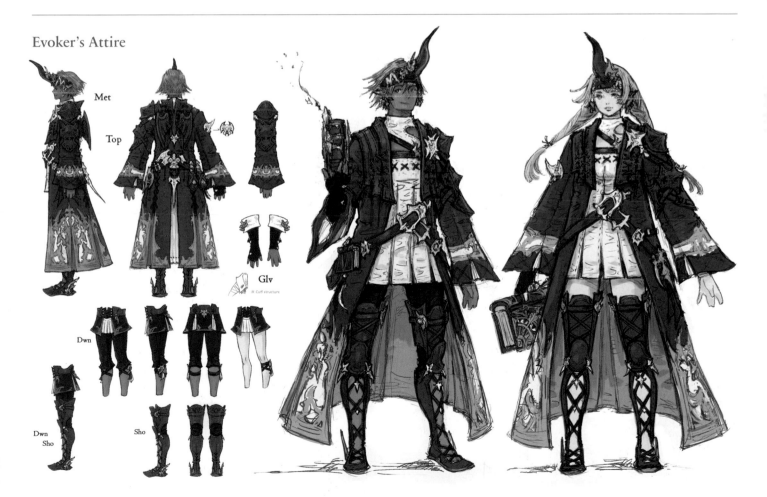

Met

Top

Glv
Cuff structure

Dwn

Dwn
Sho

Sho

I remember designing these and the weapons in a rush, as they were needed for the summoner character art. I was really looking forward to seeing my designs in Akihiko Yoshida's artwork. Even with the same base design, he was able to bring out beautiful lines that were beyond me—it was an amazing learning experience! (Namae)

Scholar's Attire

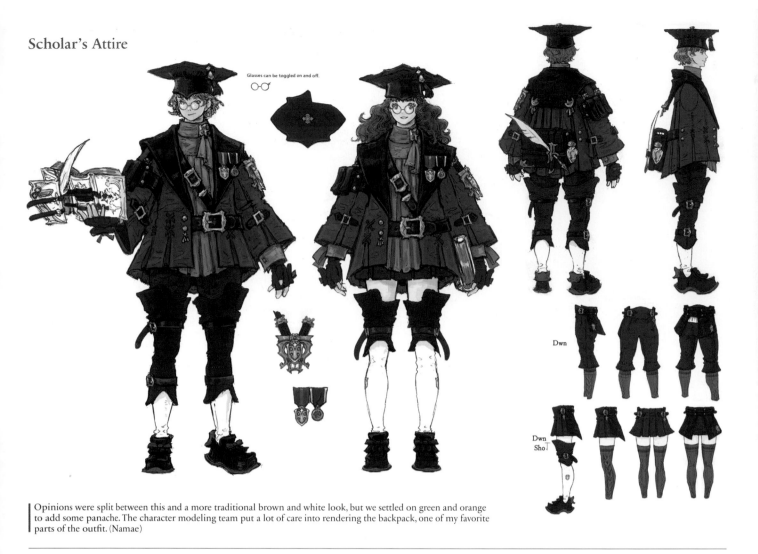

Glasses can be toggled on and off.

Dwn

Dwn Sho

Opinions were split between this and a more traditional brown and white look, but we settled on green and orange to add some panache. The character modeling team put a lot of care into rendering the backpack, one of my favorite parts of the outfit. (Namae)

Rappa Garb

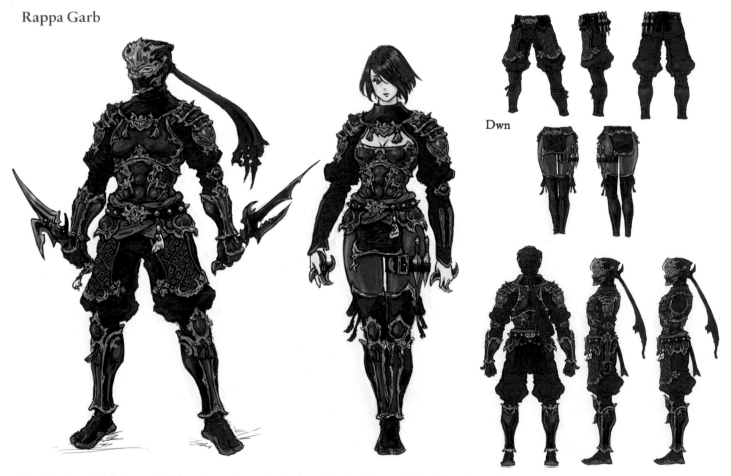

Dwn

In designing a ninja for the world of Eorzea, I went for an orthodox, form-fitting look that emphasizes agility, and added a few organic adornments. The order called for purple, but I personally preferred black, and tried to use as much of it as possible. (Namae)

Carpenter's Attire

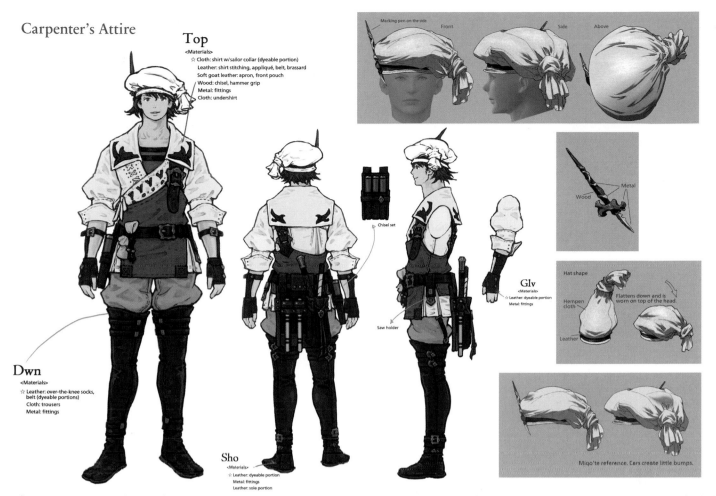

Top
<Materials>
- ☆ Cloth: shirt w/sailor collar (dyeable portion)
- Leather: shirt stitching, appliqué, belt, brassard
- Soft goat leather: apron, front pouch
- Wood: chisel, hammer grip
- Metal: fittings
- Cloth: undershirt

Dwn
<Materials>
- ☆ Leather: over-the-knee socks, belt (dyeable portions)
- Cloth: trousers
- Metal: fittings

Sho
<Materials>
- ☆ Leather: dyeable portion
- Metal: fittings
- Leather: sole portion

Glv
<Materials>
- ☆ Leather: dyeable portion
- Metal: fittings

Marking pen on the side — Front — Side — Above

Chisel set

Saw holder

Wood — Metal

Hat shape
Hempen cloth
Leather
Flattens down and is worn on top of the head.

Miqo'te reference. Ears create little bumps.

A Japanese carpenter with a Western twist. I sought to give it a sleek and stylish impression, using simple elements for the base. The shoes have separate compartments for the big toes. (Namac)

Blacksmith's Attire

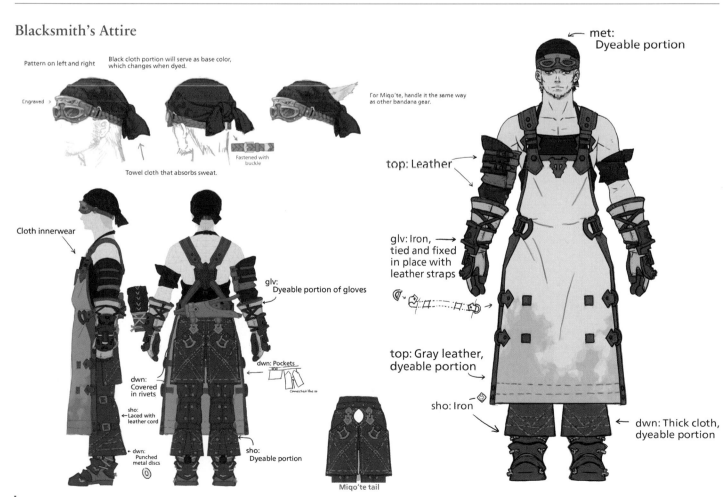

Pattern on left and right

Black cloth portion will serve as base color, which changes when dyed.

Engraved >

Fastened with buckle

Towel cloth that absorbs sweat.

For Miqo'te, handle it the same way as other bandana gear.

Cloth innerwear

glv: Dyeable portion of gloves

dwn: Pockets
Connected like so

dwn: Covered in rivets

sho: Laced with leather cord

dwn: Punched metal discs

sho: Dyeable portion

Miqo'te tail

met: Dyeable portion

top: Leather

glv: Iron, tied and fixed in place with leather straps

top: Gray leather, dyeable portion

sho: Iron

dwn: Thick cloth, dyeable portion

The apron sitting on top of exposed flesh gives it a rugged look. (Kasuya)

Armorer's Attire

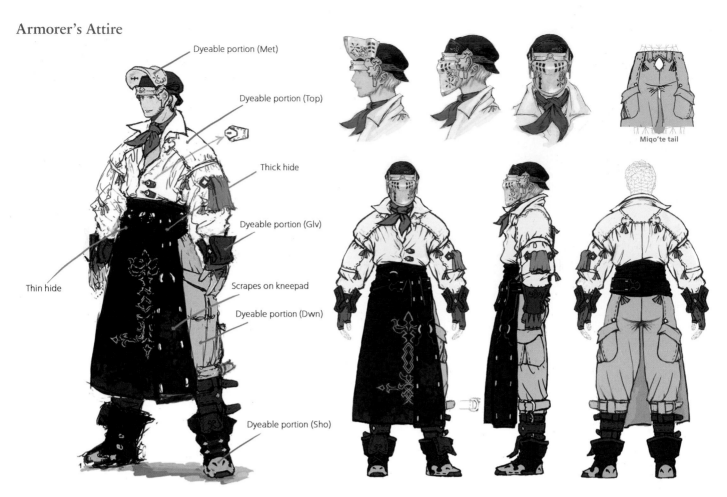

Dyeable portion (Met)

Dyeable portion (Top)

Thick hide

Dyeable portion (Glv)

Scrapes on kneepad

Dyeable portion (Dwn)

Thin hide

Dyeable portion (Sho)

Miqo'te tail

The top is loose-fitting and easy to move in. In order to keep the impression of roundness in check, I set the apron high on the waist, and it helps to balance things out. (Takahashi)

Goldsmith's Attire

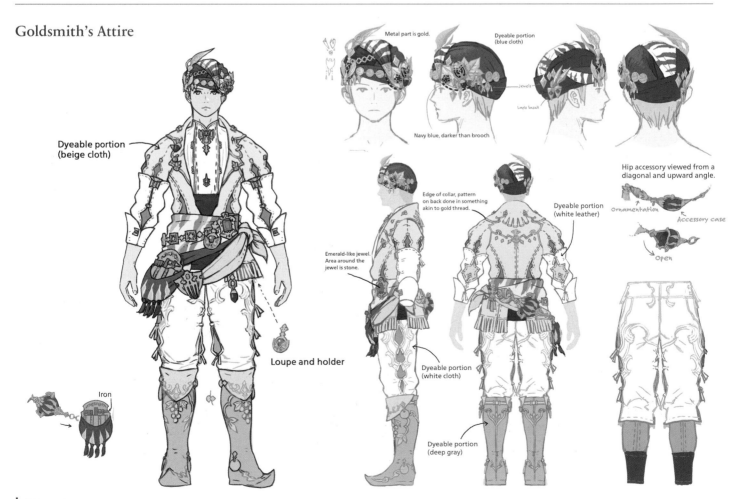

Dyeable portion (beige cloth)

Loupe and holder

Iron

Metal part is gold.

Dyeable portion (blue cloth)

Jewels

Lapis lazuli

Navy blue, darker than brooch

Edge of collar, pattern on back done in something akin to gold thread.

Emerald-like jewel. Area around the jewel is stone.

Dyeable portion (white leather)

Hip accessory viewed from a diagonal and upward angle.

Ornamentation

Accessory case

Open

Dyeable portion (white cloth)

Dyeable portion (deep gray)

First, I designed an exquisite headpiece—a turban with metal trimmings. The parts below the neck are refined versions of Takahashi's drafts. (Kasuya)

Leatherworker's Attire

Fur.
Color around neck is an off-white/beige gradation.

Braided leather straps

The leather color in the center has a gradation that shifts to black.

Miqo'te tail

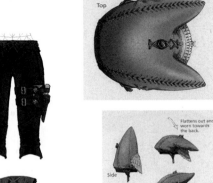

Front

Side

Top

Side

Flattens out and worn towards the back.

Ear sections stick up a little on Miqo'te.

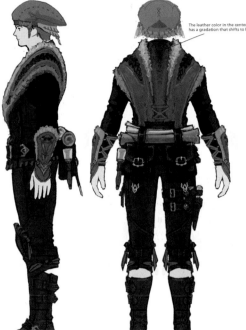

Weaver's Attire

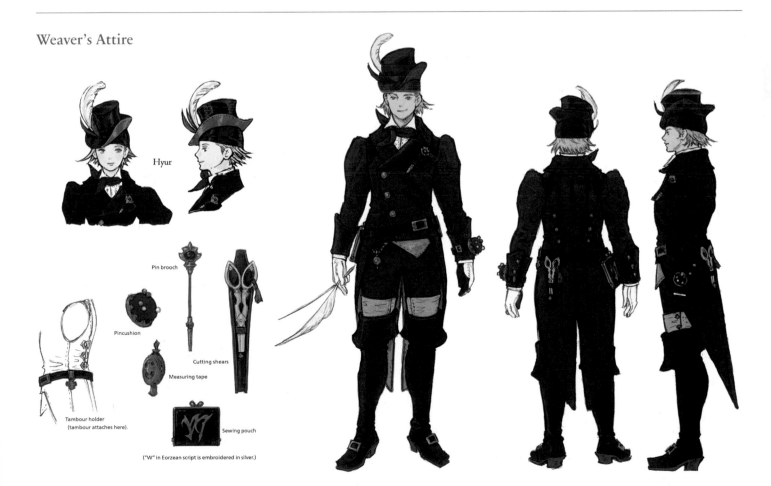

Hyur

Pin brooch

Pincushion

Cutting shears

Measuring tape

Tambour holder
(tambour attaches here).

Sewing pouch

("W" in Eorzean script is embroidered in silver.)

The look is modern, so as to be fitting for a profession that stands at the forefront of fashion. Starting with the tailcoat, I went for a simple yet elegant design. I paid attention to those accessories that define tailors. In order to comply with the specs, the black inner piece had to be added to the slanted hat. (Namae)

Alchemist's Attire

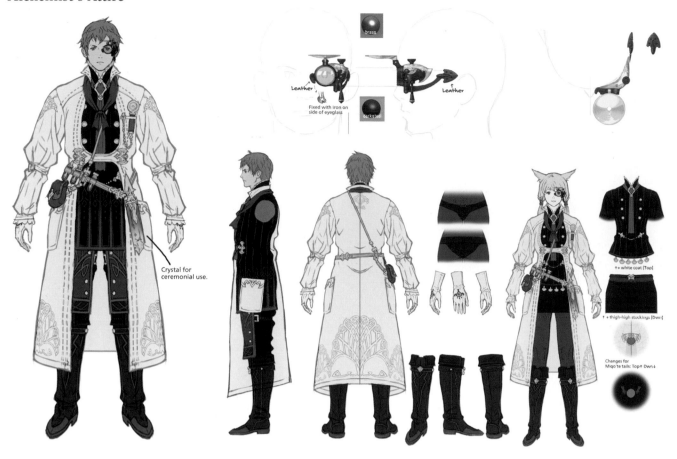

brass

Leather

Fixed with iron on side of eyeglass

darksteel

Leather

Crystal for ceremonial use.

↑+ white coat [Top]

↑ + thigh-high stockings [Dwn]

Changes for Miqo'te tails: Top↑ Dwn↓

The headgear and the full-body draft are by Kasuya. When I was working on the details, I recall wondering what the *FFXIV* world would be like, and fumbling my way through. This is one of the first designs I worked on after joining the *FFXIV* team. (Masao)

Culinarian's Attire

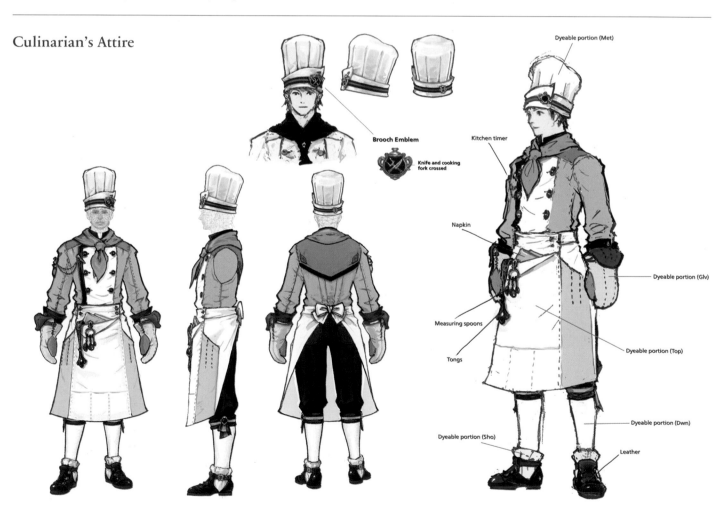

Dyeable portion (Met)

Brooch Emblem

Knife and cooking fork crossed

Kitchen timer

Napkin

Measuring spoons

Tongs

Dyeable portion (Glv)

Dyeable portion (Top)

Dyeable portion (Dwn)

Dyeable portion (Sho)

Leather

Miner's Attire

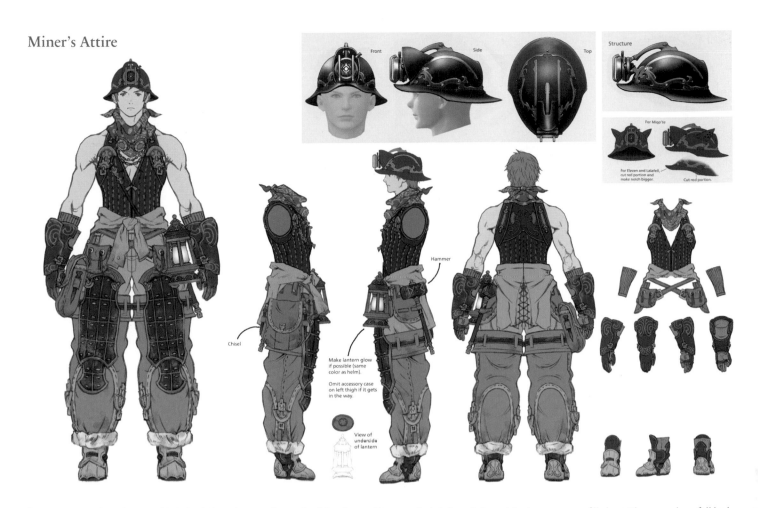

Front
Side
Top
Structure
For Miqo'te
For Elezen and Lalafell, cut red portion and make notch bigger.
Cut red portion.

Chisel

Hammer

Make lantern glow if possible (same color as helm).

Omit accessory case on left thigh if it gets in the way.

View of underside of lantern

The headgear is by Nakazawa. This design is from the same time as the alchemist one. The upper body is form fitting, while the trousers are filled out. There was also a full body draft by Nakazawa, but I couldn't put it together very well, and ended up changing it. (Masao)

Botanist's Attire

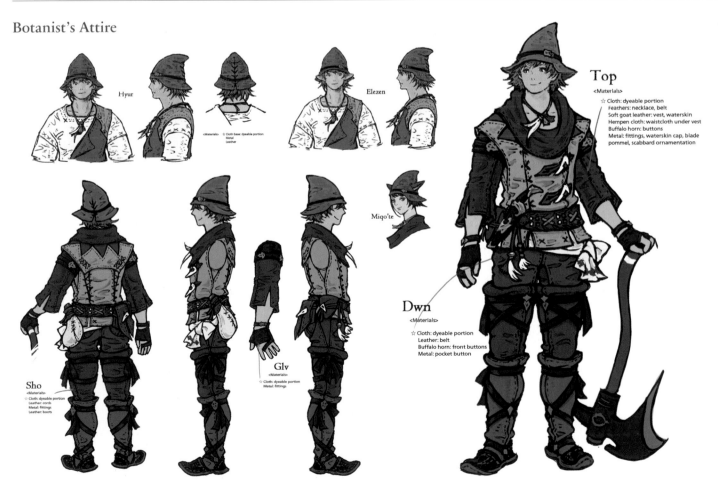

Hyur

Elezen

<Materials>
☆ Cloth base: dyeable portion
Metal
Leather

Miqo'te

Top
<Materials>
☆ Cloth: dyeable portion
Feathers: necklace, belt
Soft goat leather: vest, waterskin
Hempen cloth: waistcloth under vest
Buffalo horn: buttons
Metal: fittings, waterskin cap, blade pommel, scabbard ornamentation

Dwn
<Materials>
☆ Cloth: dyeable portion
Leather: belt
Buffalo horn: front buttons
Metal: pocket button

Glv
<Materials>
☆ Cloth: dyeable portion
Metal: fittings

Sho
<Materials>
☆ Cloth: dyeable portion
Leather: cords
Metal: fittings
Leather: boots

The design is based on a classical woodsman. I intended for it to be formed of symbolic elements. The botanist is prone to go in the direction of homely, but the red shirt lends a relaxed kind of flair. (Namae)

Fisher's Attire

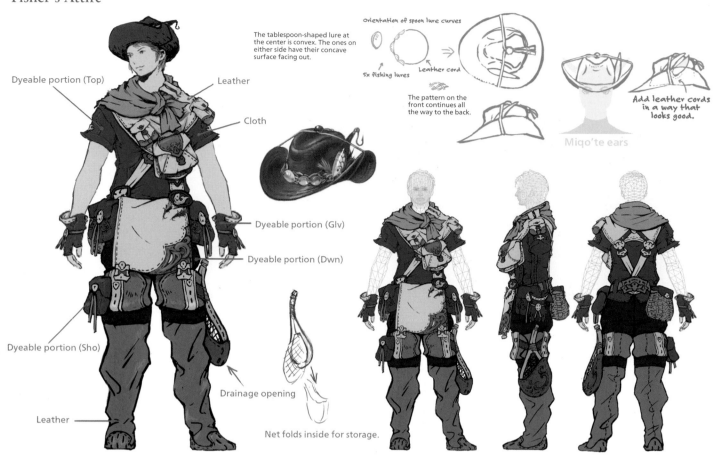

Dyeable portion (Top)

Leather

Cloth

The tablespoon-shaped lure at the center is convex. The ones on either side have their concave surface facing out.

Orientation of spoon lure curves

5x fishing lures

Leather cord

The pattern on the front continues all the way to the back.

Add leather cords in a way that looks good.

Miqo'te ears

Dyeable portion (Glv)

Dyeable portion (Dwn)

Dyeable portion (Sho)

Drainage opening

Leather

Net folds inside for storage.

I took cues from mountain stream fishing. This design might be number one in terms of the number of pockets. (Takahashi)

Foestriker's Attire

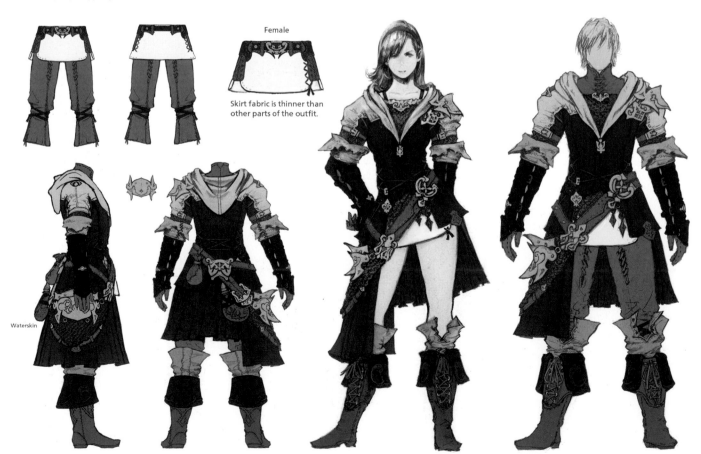

Female

Skirt fabric is thinner than other parts of the outfit.

Waterskin

The concept called for gear for low-level adventurers, a set that would be simple yet appealing. (Takahashi)

Acolyte's Attire

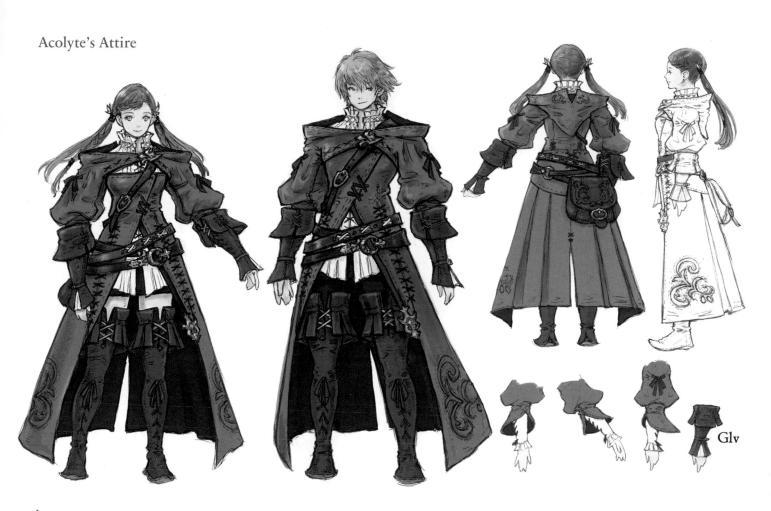

I took a traditional medieval robe and gave it a modern twist. Because it's lower-level equipment, I focused on giving it flair while limiting the number of elements. (Namae)

Cavalry Armor

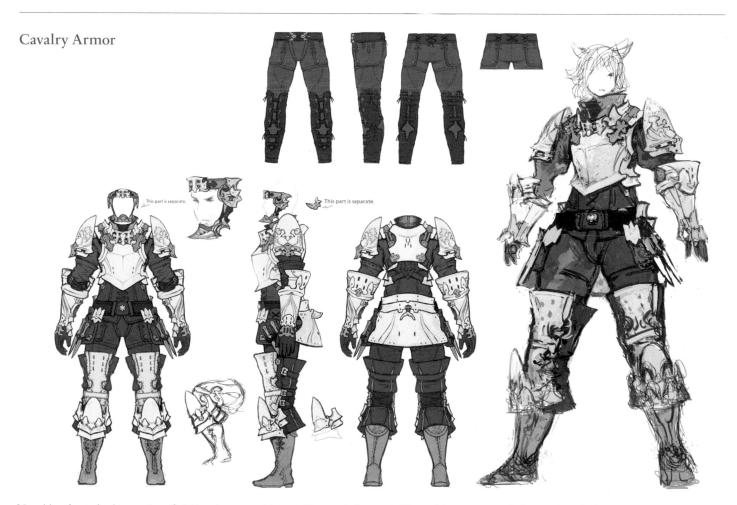

This part is separate.

This part is separate.

I envisioned entry-level armor that a fledgling adventurer might wear. There are knives on the hips, and the armor extends down only to the knees, so as to allow for greater movement. (Takahashi)

Infantry Attire

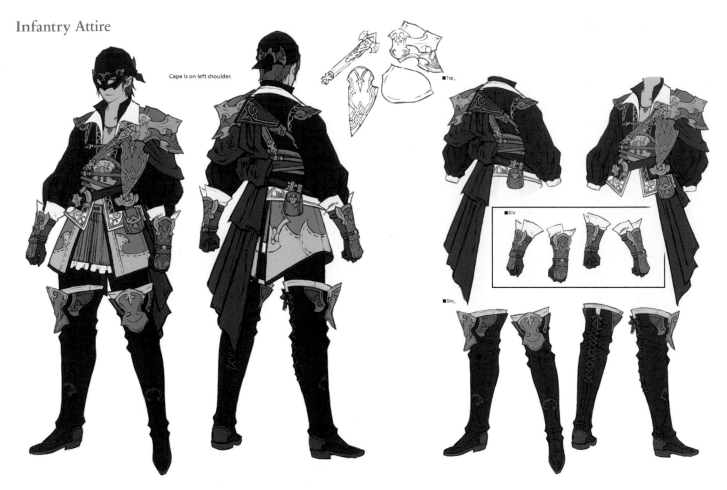

This one's inspired by the "gentleman thief" archetype. Spec-wise, it's difficult to make a mantle for players. To get around this, I designed a one-winged cape that's bound to the body, and so wouldn't look strange without motion algorithms. It worked out pretty well, I think. (Masao)

Battlemage's Attire

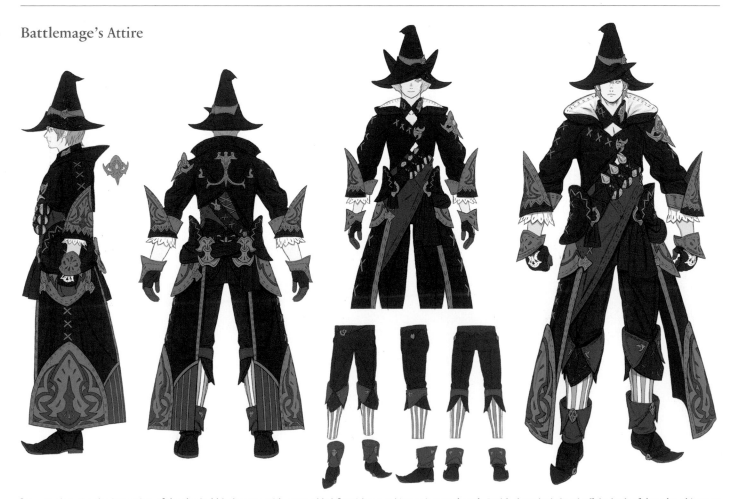

I wanted to give the impression of the classical black mage, with some added flourishes. Looking at it now, though, I wish that I had closed off the back of the robe a bit more. (Mihara)

Storm Elite's Uniform

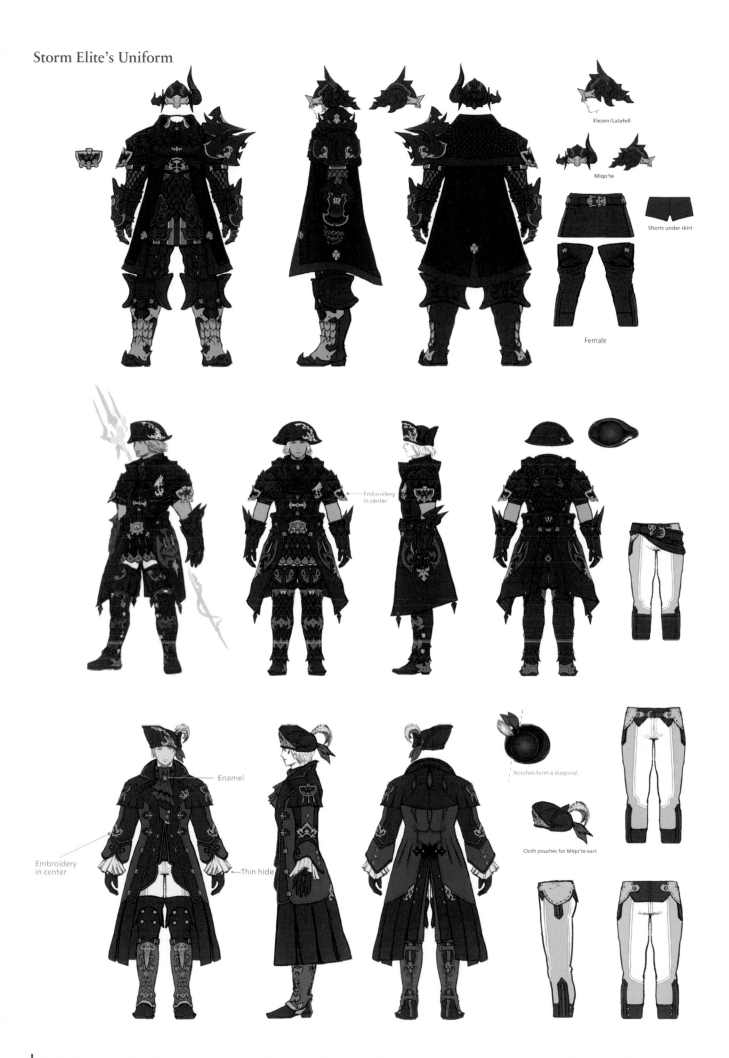

Elezen/Lalafell

Miqo'te

Shorts under skirt

Female

Embroidery in center

Enamel

Embroidery in center

Thin hide

Notches form a diagonal

Cloth pouches for Miqo'te ears

The shoulder guard on the scale mail is designed to resemble the prow of a Lominsan ship, while the scale coat features a badge with a falcon and anchor. (Takahashi)

Serpent Elite's Uniform

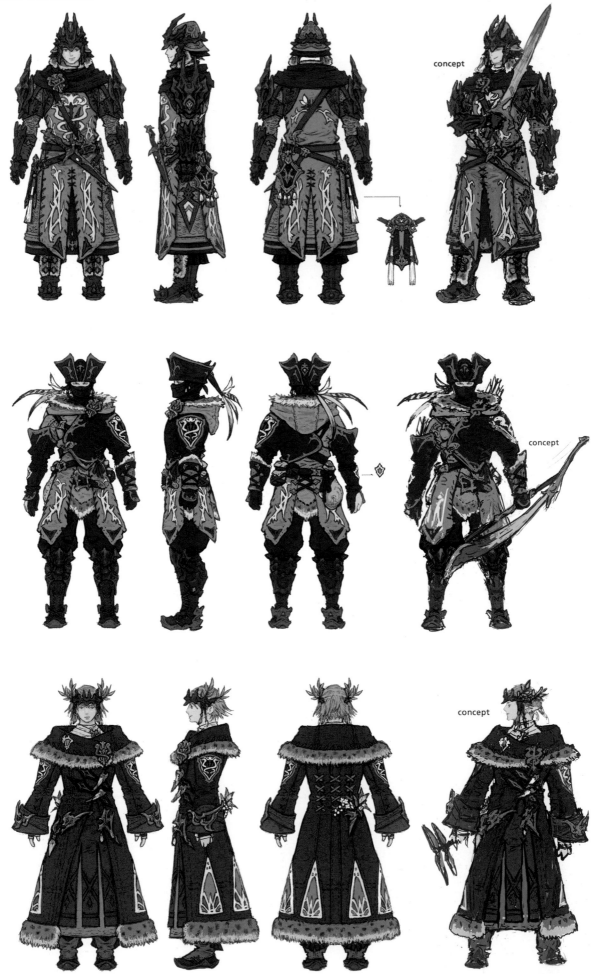

concept

concept

concept

| It was a challenge to incorporate the yellow of the Gridanian standard. I like the attire that was designed to look good with a bow. (Namae)

Flame Elite's Uniform

All three types of Flame Elite gear share the following elements:
- Raubahn/bull
- Asymmetry
- Ul'dah standard
- Light blue rank badges

Match the texture of the black metal with Raubahn's armor.

Rank badges

All three types of Flame Elite gear share the following elements:
- Raubahn/bull
- Asymmetry
- Ul'dah standard
- Light blue rank badges

Innerwear on female version

Rank badges

Match the texture of the black metal with Raubahn's armor.

Rough sketch (details differ)

All three types of Flame Elite gear share the following elements:
- Raubahn/bull
- Asymmetry
- Ul'dah standard
- Light blue rank badges

Rank badges

View of neck area

■Top

Innerwear on female version

■Sho_

■Glv_

Raubahn, bull, Ul'dahn standard, asymmetry—guided by these common elements, we worked with black, gold, and the light blue of rank badges. Overall, the designs are meant to be reminscent of Rome and gladiators. They're among my earlier works, and there are many areas that could be improved, but at the same time I think they do the job. (Masao)

Armor of Light

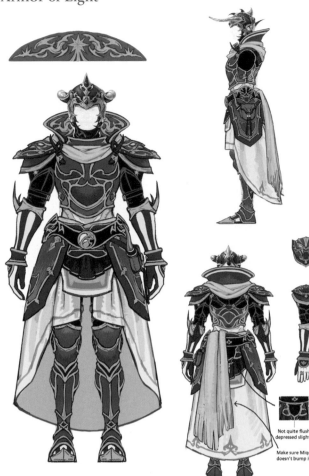

Not quite flush; depressed slightly.

Make sure Miqo'te tail doesn't bump into this.

Fuma Attire

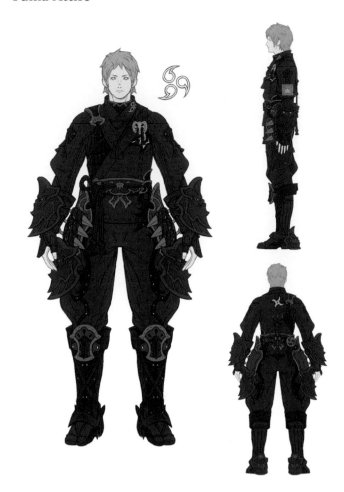

Onion Armor

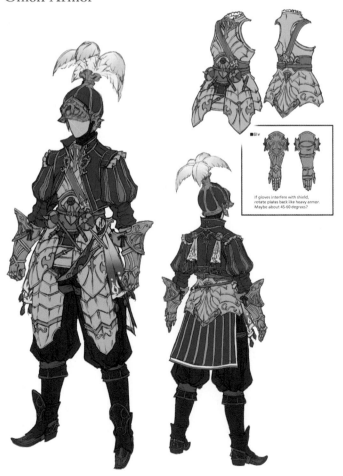

■Glv

If gloves interfere with shield, rotate plates back like heavy armor. Maybe about 45-60 degrees?

Crimson Attire

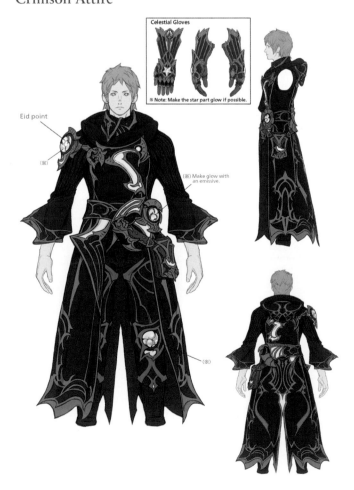

Celestial Gloves

※ Note: Make the star part glow if possible.

Eid point

(※)

(※) Make glow with an emissive.

(※)

Divine War Armor

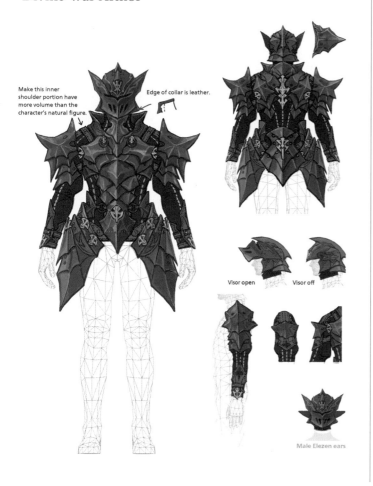

Make this inner shoulder portion have more volume than the character's natural figure.

Edge of collar is leather.

Visor open

Visor off

Male Elezen ears

Divine Hero Attire

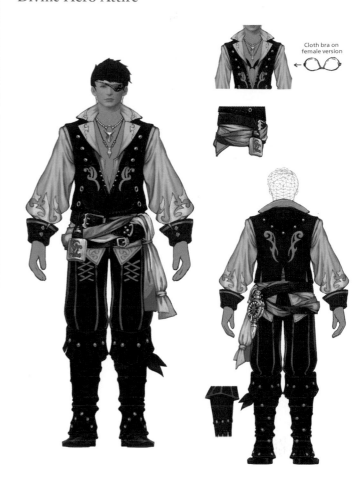

Cloth bra on female version

Divine Wisdom Armor

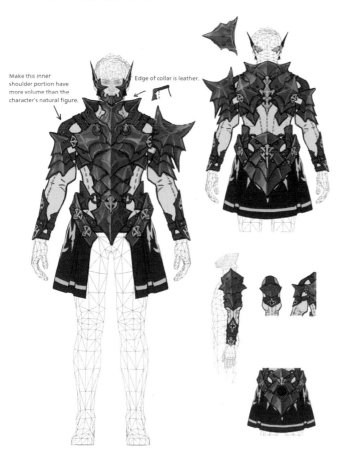

Make this inner shoulder portion have more volume than the character's natural figure.

Edge of collar is leather.

Divine Death Attire

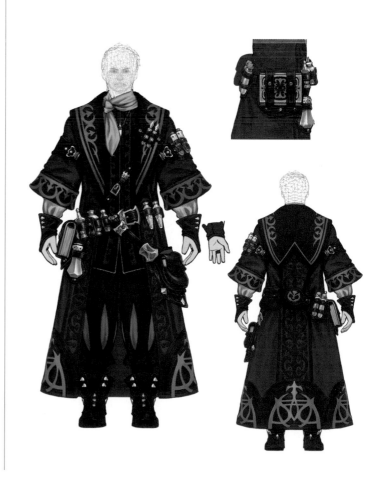

Heavy Allagan Armor

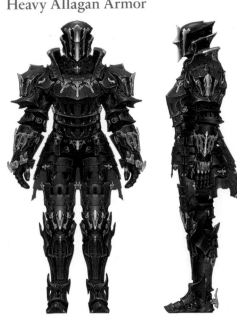
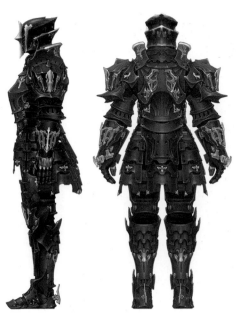
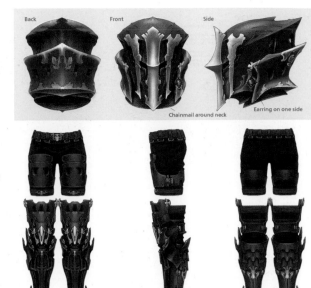

Back Front Side

Chainmail around neck Earring on one side

Allagan Armor of Striking

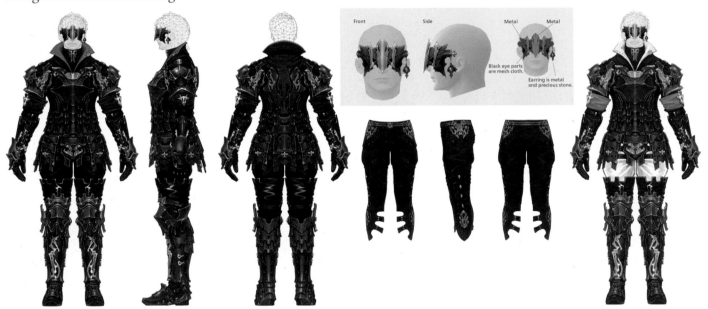

Front Side Metal Metal

Black eye parts are mesh cloth.

Earring is metal and precious stone.

Allagan Attire of Healing

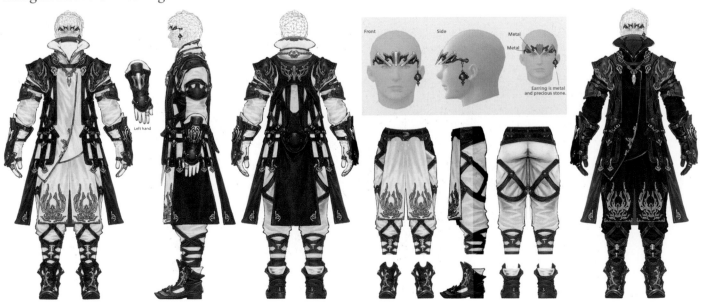

Left hand

Front Side Metal

Metal

Earring is metal and precious stone.

Noct Armor

Silhouette and details reminiscent of Geroit, the creator.

- Geroit's Masterworks, accented with the red triangles used on casters. The two points above were the core concept, brought together with a heavyweight silhouette.
- The Geroit elements are (though it might be odd in an in-universe context): muscular mold, head tattoo, bald, beard, and arm charm. Armor itself is done in an ancient Roman lorica segmentata style.

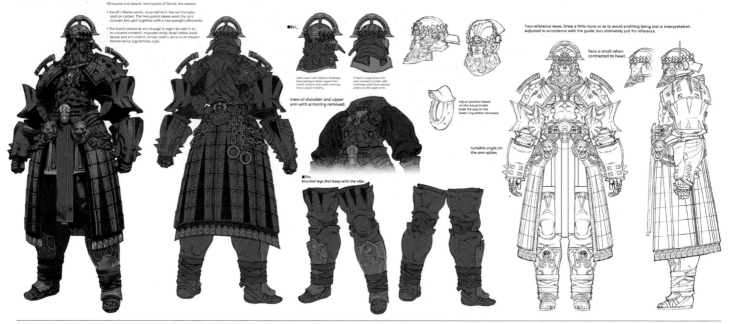

Leaf crown, Lion relief on forehead. Face carving is more rugged than Geroit. Bottom and cheek covering have a beard molding.

If there's a gap where the neck connects to helm, add innerwear cloth that matches what's on the upper arms.

View of shoulder and upper arm with armoring removed.

Muscled legs that keep with the vibe.

Adjust position based on the actual model. Scale the size on the lower ring where necessary.

Suitable angle on the arm spikes

Two reference views. Drew a little more so as to avoid anything being lost in interpretation. Adjusted in accordance with the guide, but ultimately just for reference.

Face is small when contrasted to head.

Gloam Attire

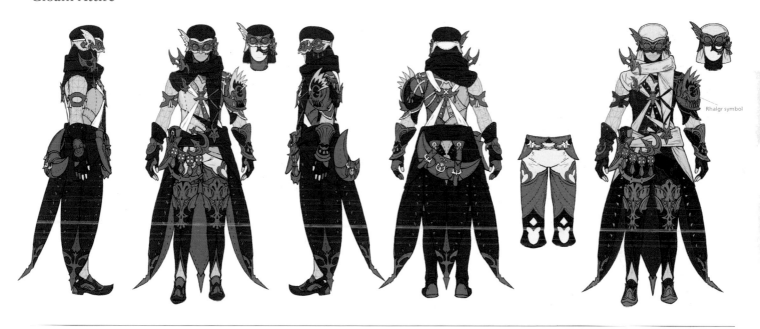

Rhalgr symbol

Astrum Armor

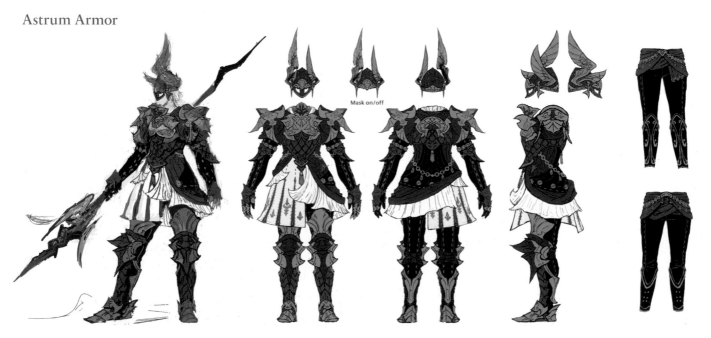

Mask on/off

Evenstar Attire

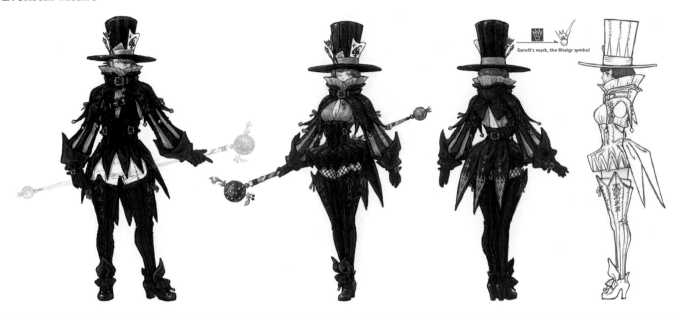

Gerolt's mark, the Rhalgr symbol

Daystar Attire

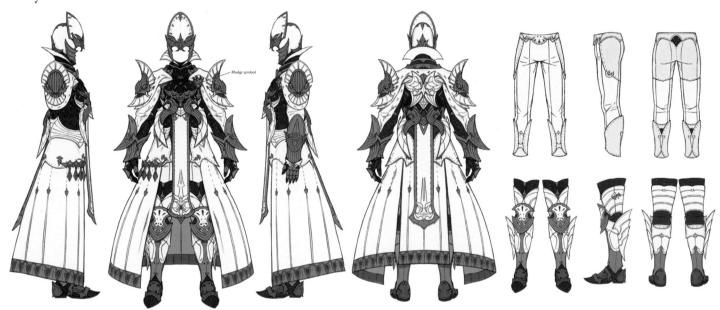

Rhalgr symbol

Lionsmane Armor

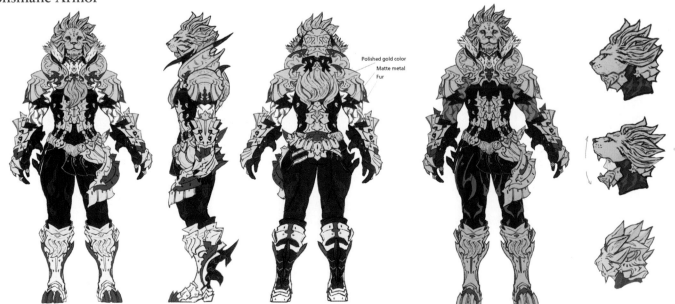

Polished gold color

Matte metal

Fur

Bearsmaw Armor

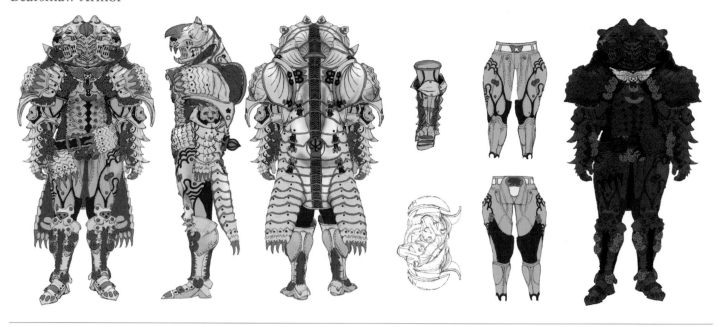

Hawkwing Attire

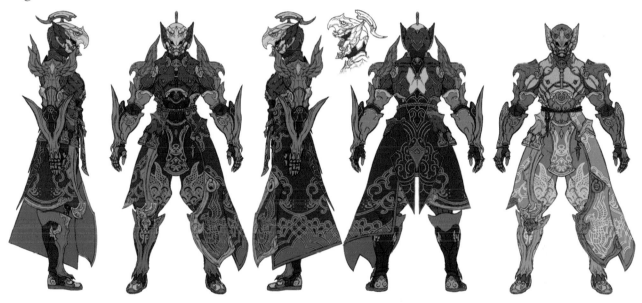

Snakestongue Armor

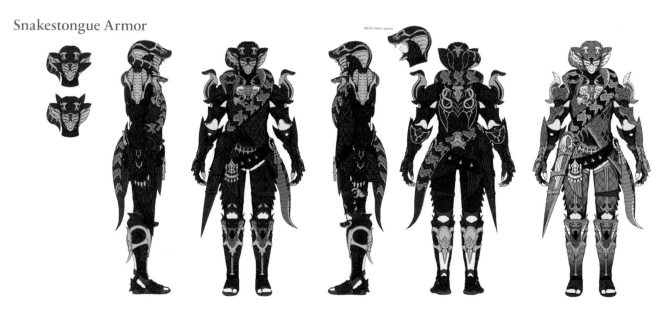

With helm open

Tsukamoto's birdsong attire set the tone for the series. Some of the creatures don't exist in Eorzea, and their appearance is the fruit of Eorzean imagination. Takahashi: lion and swan; Tsukamoto: bear and bird; Masao: hawk and wolf; Mihara: snake; Namae: elk. (Masao)

Birdsong Attire

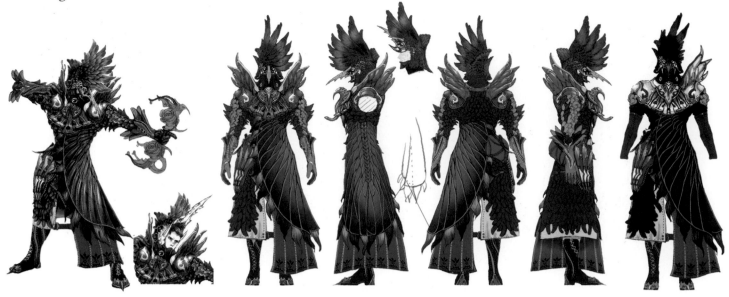

Swansgrace Attire

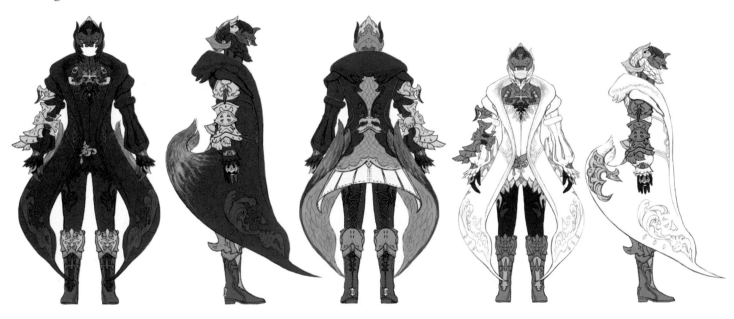

Wolfseye Attire

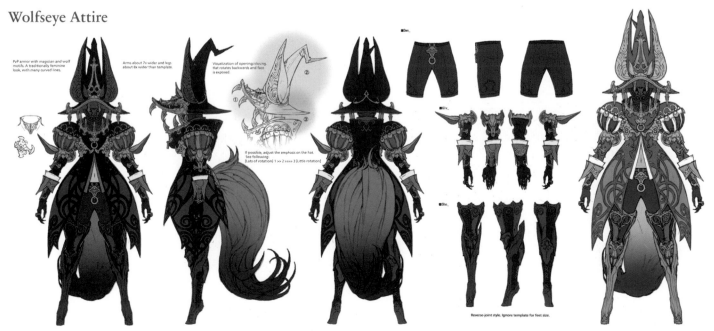

PvP armor with magician and wolf motifs. A traditionally feminine look, with many curved lines.

Arms about 7x wider and legs about 8x wider than template.

Visualization of opening/closing. Hat rotates backwards and face is exposed.

If possible, adjust the emphasis on the hat. See following:
[Lots of rotation] 1 >> 2 >>>> 3 [Little rotation]

Reverse-joint style. Ignore template for feet size.

Elktail Attire

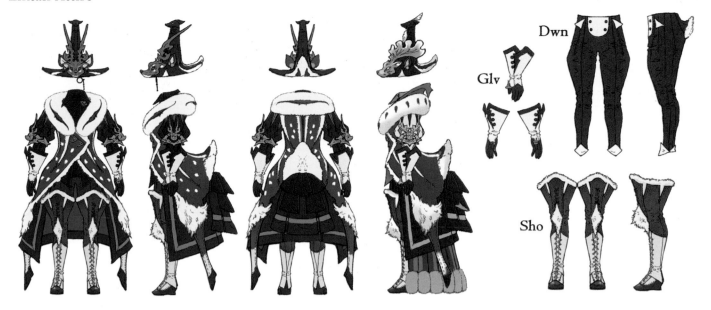

Glv

Dwn

Sho

Phlegethon's Armor

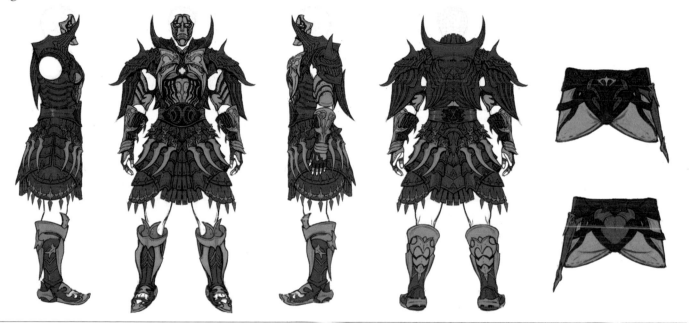

The Guardian's Armor of Striking

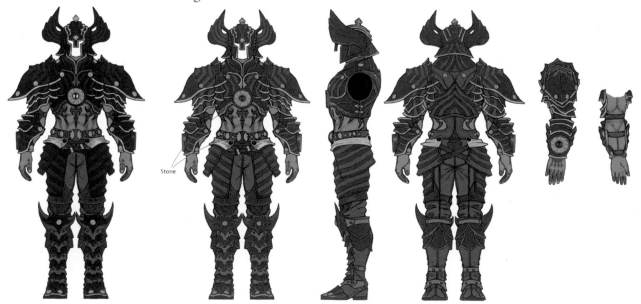

Stone

Amon's Attire

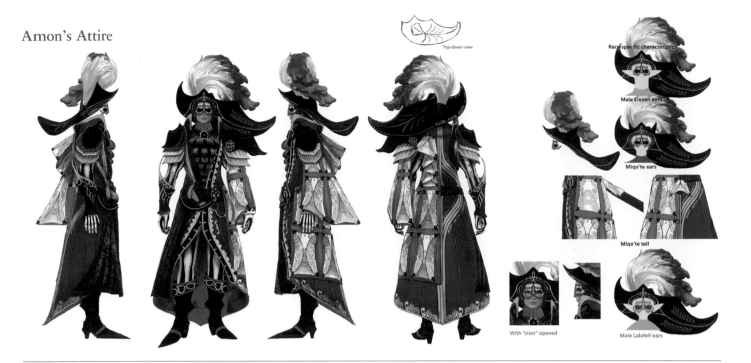

Top-down view

Race-specific characteristics

Male Elezen ears

Miqo'te ears

Miqo'te tail

With "visor" opened

Male Lalafell ears

Scylla's Attire of Casting

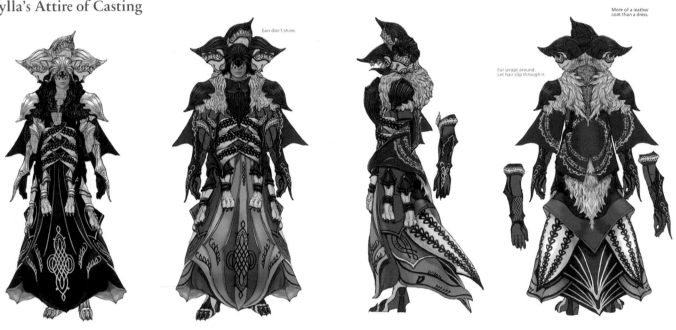

Ears don't show.

More of a leather coat than a dress.

Fur wraps around. Let hair clip through it.

Heavy High Allagan Armor

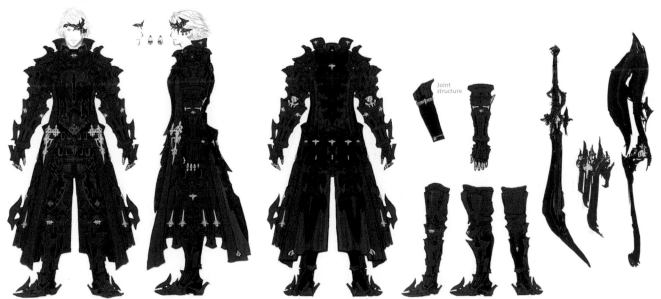

Joint structure

High Allagan Armor of Striking

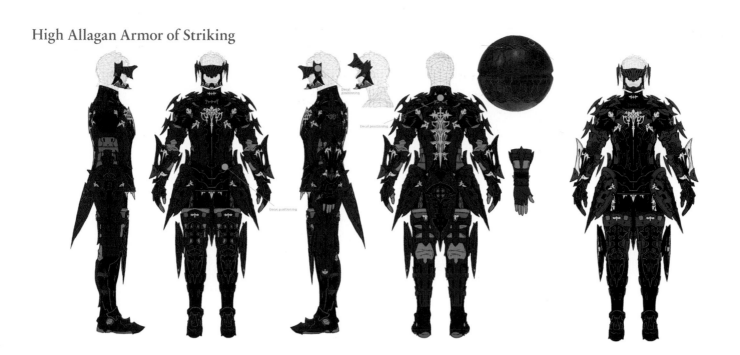

Decal positioning

Decal positioning

Decal positioning

High Allagan Attire of Aiming

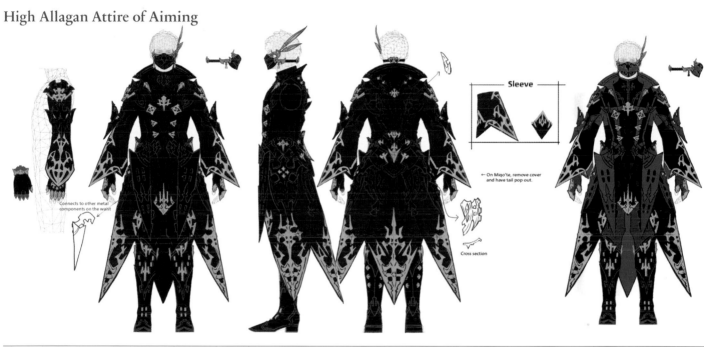

Connects to other metal components on the waist

Sleeve

← On Miqo'te, remove cover and have tail pop out.

Cross section

High Allagan Attire of Healing

☆ Under the sleeve, use a nondescript green arm warmer that matches glove color.

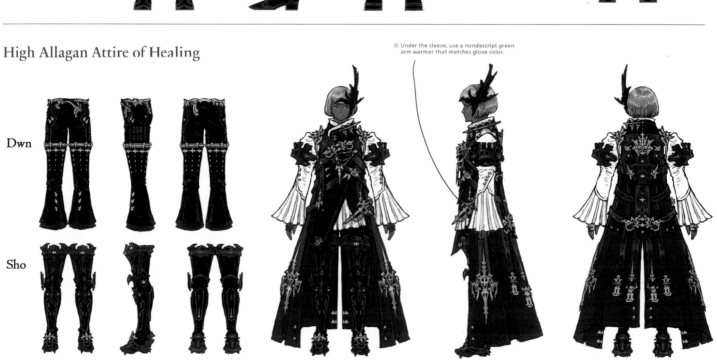

Dwn

Sho

Light Steel Galerus

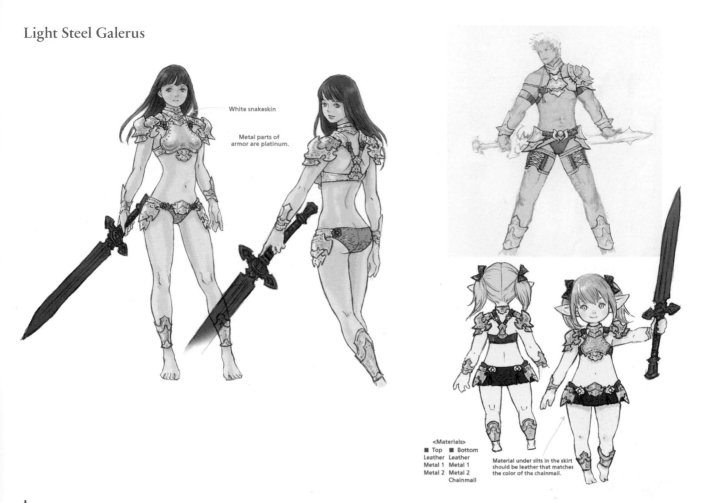

White snakeskin

Metal parts of armor are platinum.

<Materials>
■ Top ■ Bottom
Leather Leather
Metal 1 Metal 1
Metal 2 Metal 2
 Chainmail

Material under slits in the skirt should be leather that matches the color of the chainmail.

The order called for an '80s fantasy–inspired, skin-baring design. I worked on the taffeta shawl at the same time. The male variant is by Takahashi. (Namae)

Taffeta Shawl

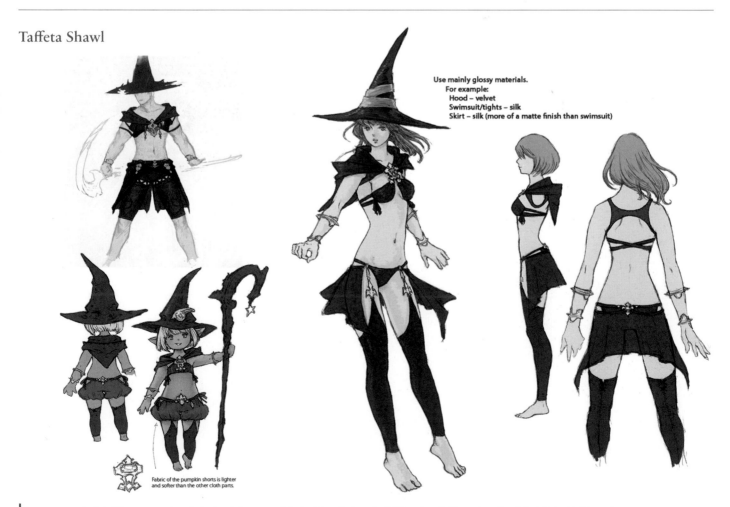

Use mainly glossy materials.
For example:
Hood – velvet
Swimsuit/tights – silk
Skirt – silk (more of a matte finish than swimsuit)

Fabric of the pumpkin shorts is lighter and softer than the other cloth parts.

I try not to make Lalafells too sexy when designing their gear, and the look here is that of a child's swimsuit. The male variant is by Takahashi. (Namae)

Highland Smock

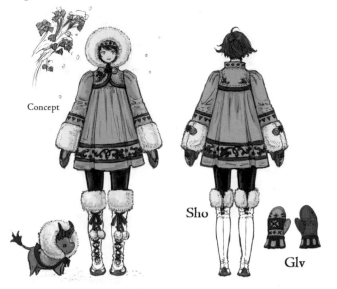

Concept

Sho

Glv

Glacial Coat

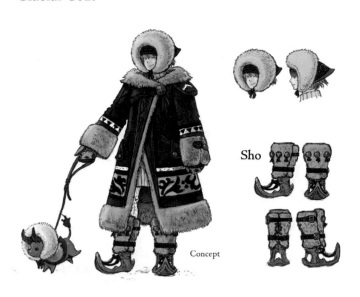

Sho

Concept

Sailor Shirt

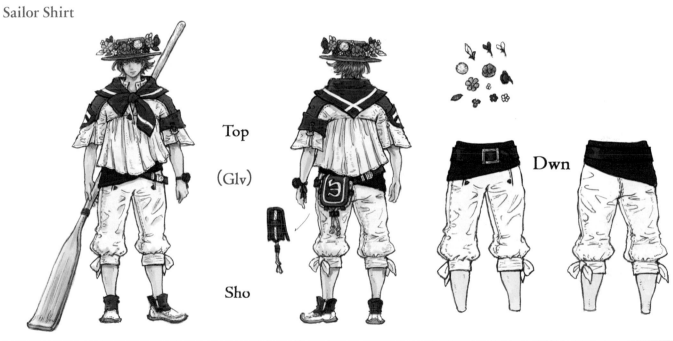

Top

(Glv)

Sho

Dwn

Crescent Moon Nightgown

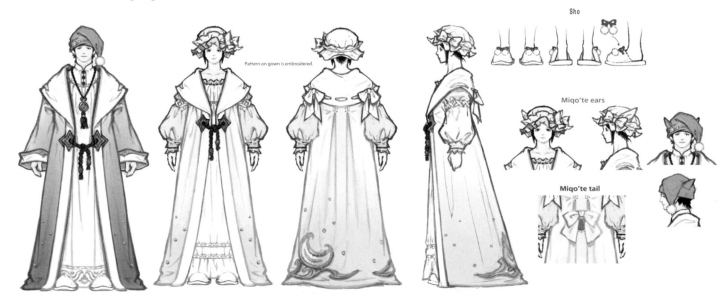

Pattern on gown is embroidered.

Sho

Miqo'te ears

Miqo'te tail

Cascadier Uniform and Swimwear

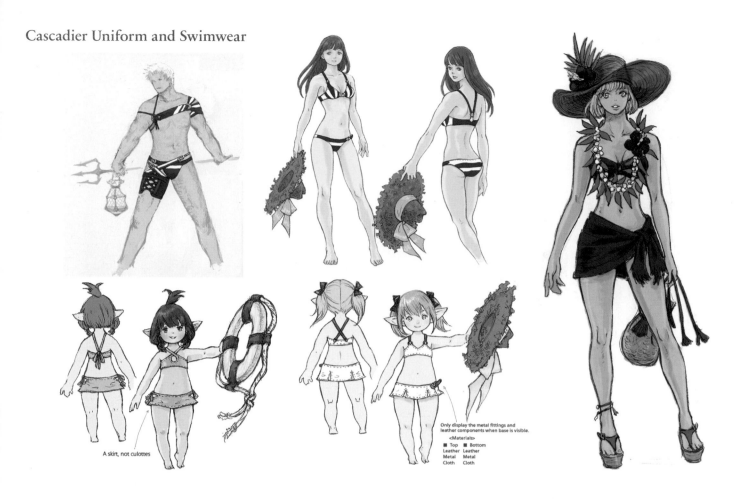

A skirt, not culottes

Only display the metal fittings and leather components when base is visible.

<Materials>
■ Top	■ Bottom
Leather	Leather
Metal	Metal
Cloth	Cloth

We design swimwear every year, and I hope that a one-piece variety will be implemented in the future. The broad-brimmed straw hat wasn't actually part of the plan, but the implementation team found the time to make it for us. The male variant is by Takahashi. (Namae)

Spring Dress

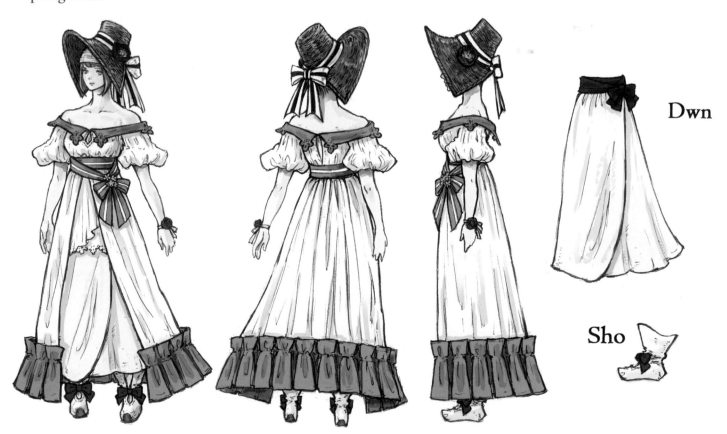

Dwn

Sho

Part of the casual wear collection, and one of the designs based on the concept of winter (glacial and highland) and spring (sailor and spring) garments in Eorzea. I wanted to bring out the season in the patch, and my wish came true. (Namae)

Chocobo Suit

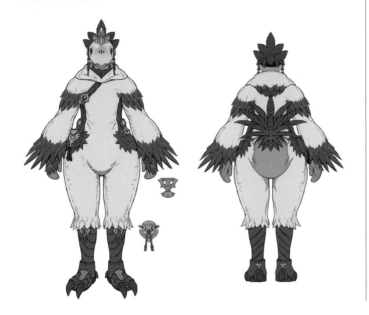

The Wailing Spirit

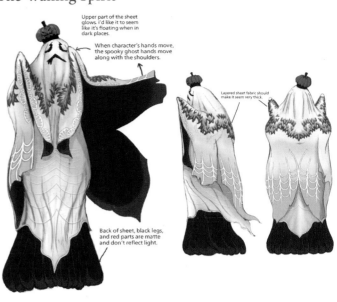

Upper part of the sheet glows. i'd like it to seem like it's floating when in dark places.

When character's hands move, the spooky ghost hands move along with the shoulders.

Layered sheet fabric should make it seem very thick.

Back of sheet, black legs, and red parts are matte and don't reflect light.

Snowman Suit

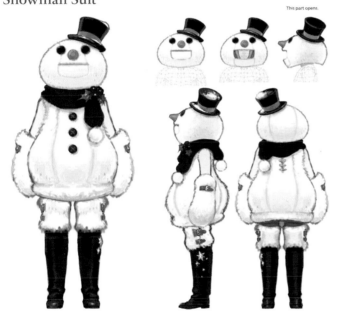

This part opens.

Reindeer Suit

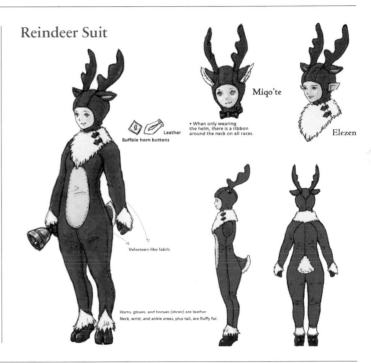

Leather

Buffalo horn buttons

Miqo'te

• When only wearing the helm, there is a ribbon around the neck on all races.

Elezen

Velveteen-like fabric

Horns, gloves, and hooves (shoes) are leather.
Neck, wrist, and ankle areas, plus tail, are fluffy fur.

Valentione Attire

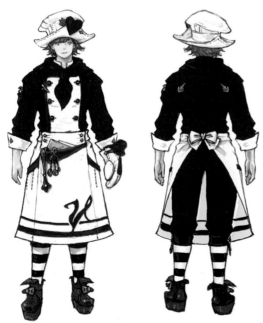

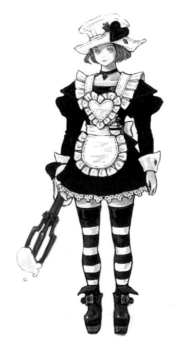

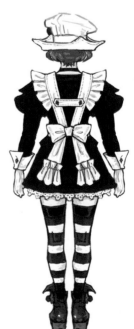

Achievement Crowns

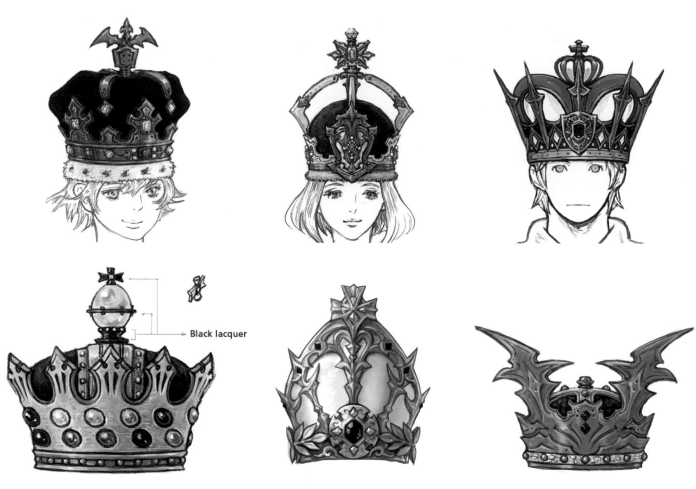

Black lacquer

Seasonal Event Headgear

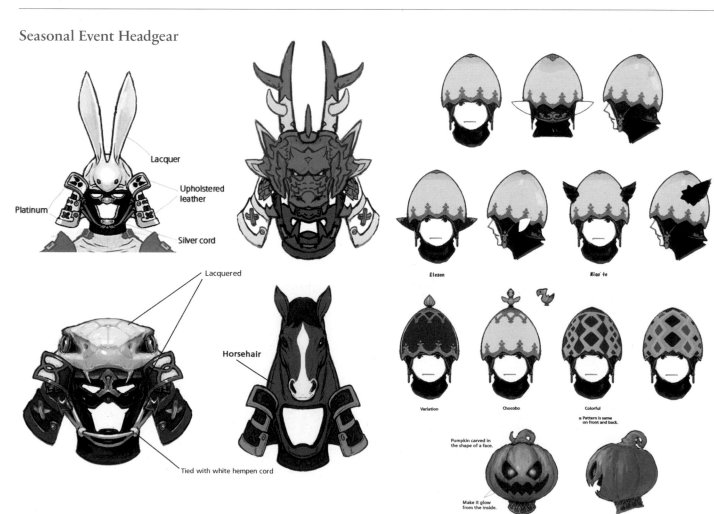

Lacquer

Upholstered leather

Platinum

Silver cord

Elezen

Miqo'te

Lacquered

Horsehair

Tied with white hempen cord

Variation

Chocobo

Colorful

※ Pattern is same on front and back.

Pumpkin carved in the shape of a face.

Make it glow from the inside.

Moogle Cap

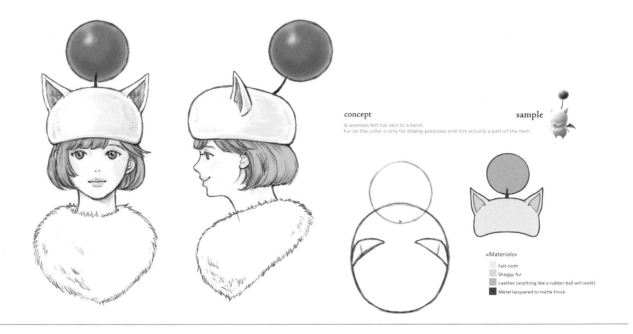

concept

A seamless felt hat akin to a beret.
Fur on the collar is only for display purposes and not actually a part of the item.

sample

<Materials>
Felt cloth
Shaggy fur
Leather (anything like a rubber ball will work)
Metal lacquered to matte finish

Goblin Cap

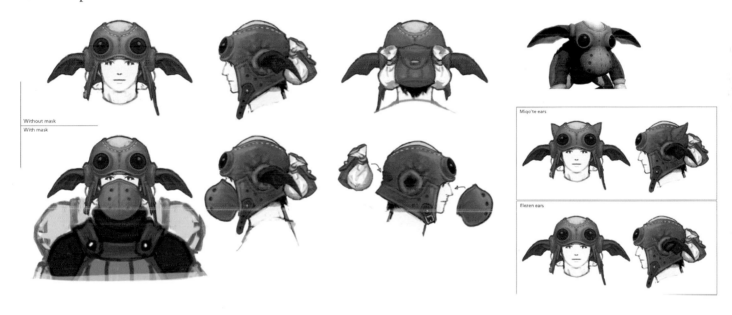

Without mask
With mask

Miqo'te ears

Elezen ears

Thug's Mug

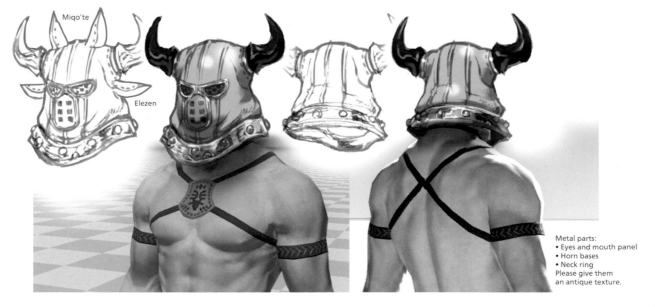

Miqo'te
Elezen

Metal parts:
• Eyes and mouth panel
• Horn bases
• Neck ring
Please give them
an antique texture.

Curtana and Holy Shield

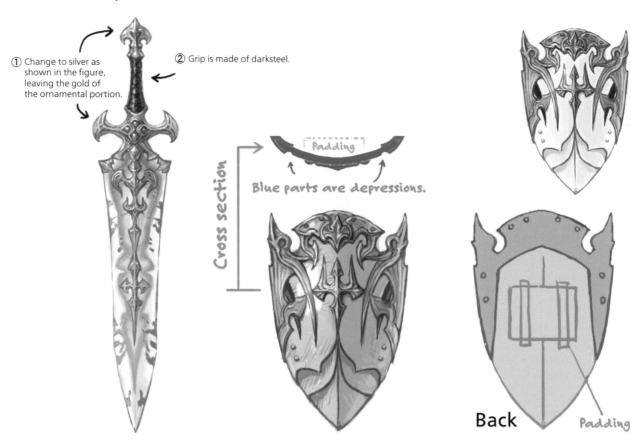

① Change to silver as shown in the figure, leaving the gold of the ornamental portion.

② Grip is made of darksteel.

Cross section

Padding

Blue parts are depressions.

Back

Padding

Instead of the usual steel, I tried giving Curtana a mysterious blade that looks as though it was carved from stone. (Kasuya)

Sphairai

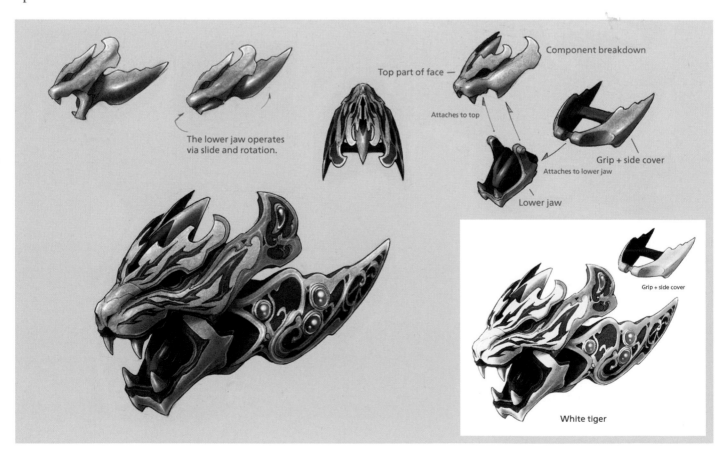

The lower jaw operates via slide and rotation.

Top part of face —

Component breakdown

Attaches to top

Grip + side cover

Attaches to lower jaw

Lower jaw

Grip + side cover

White tiger

The planner wanted a tiger's face attached to the fist, and that's exactly what I came up with. (Nakazawa)

Bravura

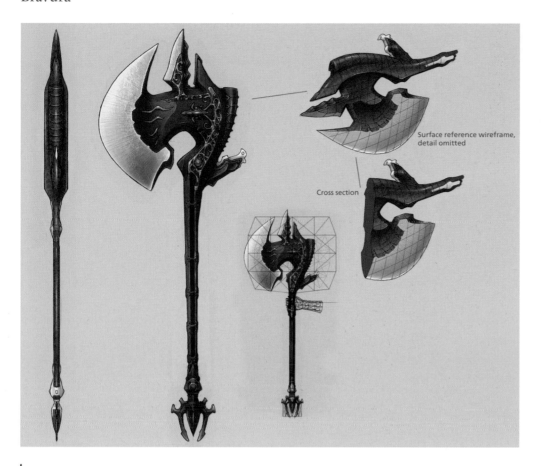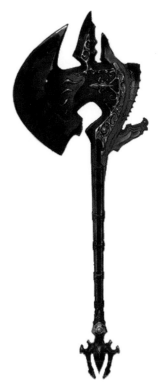

The order called for power, so I came up with a jointless design that looks as though it was hammered and carved out of a single piece of metal. (Nakazawa)

Gae Bolg

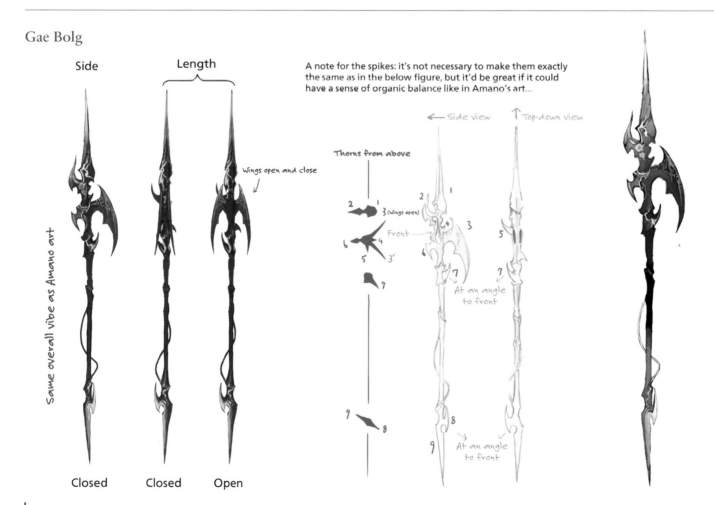

Side

Length

A note for the spikes: it's not necessary to make them exactly the same as in the below figure, but it'd be great if it could have a sense of organic balance like in Amano's art...

Wings open and close

← Side view ↑ Top-down view

Thorns from above

2 1

3 (wings open)

Front

At an angle to front

At an angle to front

Same overall vibe as Amano art

Closed Closed Open

When I think dragoon, I picture Kain from *FFIV*. I tried to bring out an Amano-esque feel with this design. (Kasuya)

Artemis Bow

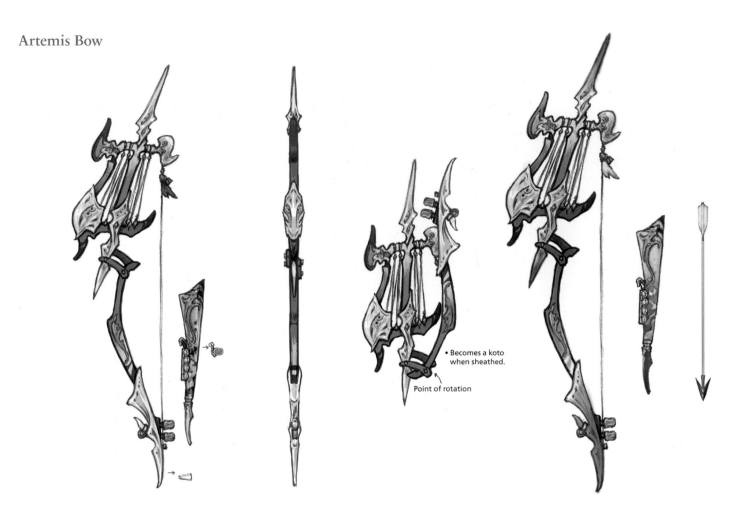

- Becomes a koto when sheathed.

Point of rotation

When I heard that the job for archer would be bard, to be honest, I thought that was going too far. Still, I managed to combine the elements of a bow and a harp into a single weapon, and I really like the design that came out of it. (Namae)

Thyrus

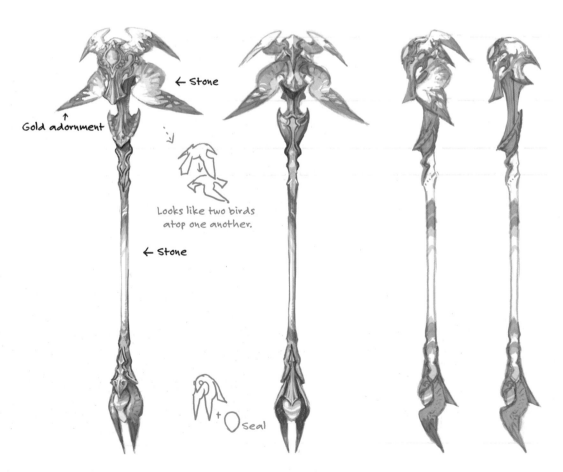

← Stone

↑ Gold adornment

Looks like two birds atop one another.

← Stone

+ ○ seal

The idea here is like two birds overlapping. Before the sketch was colored, people told me it was creepy, perhaps because the gemstone resembled an eye. (Kasuya)

Stardust Rod

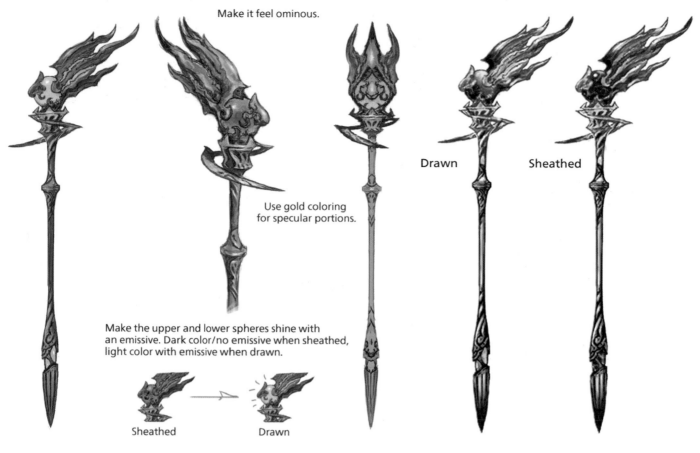

Make it feel ominous.

Use gold coloring for specular portions.

Drawn

Sheathed

Make the upper and lower spheres shine with an emissive. Dark color/no emissive when sheathed, light color with emissive when drawn.

Sheathed → Drawn

I went for a straightforward depiction of a comet. (Takahashi)

The Veil of Wiyu

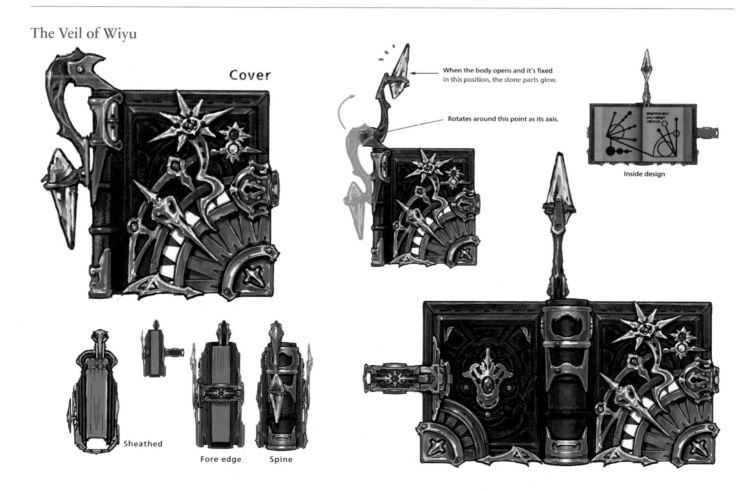

Cover

When the body opens and it's fixed in this position, the stone parts glow.

Rotates around this point as its axis.

Inside design

Sheathed

Fore edge

Spine

I came up with the draft, and Akiko Tanaka refined it. Though the shape is orthodox, I incorporated fantasy elements into it, and I quite like it. The crystal light gives it flair. I'm really impressed with how Tanaka rendered the textures. (Namae)

Omnilex

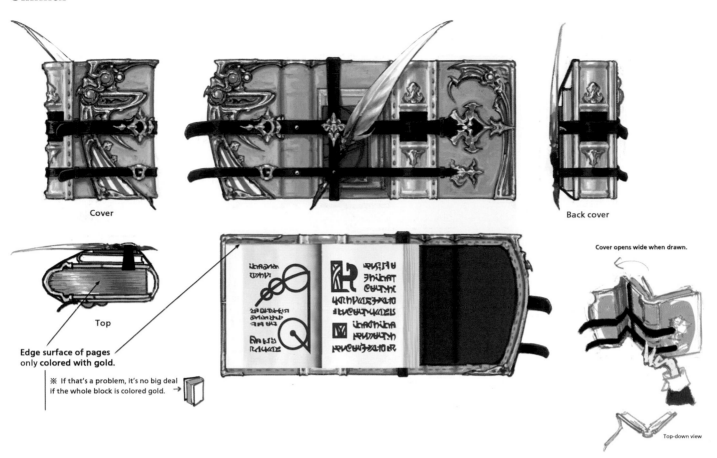

Cover

Back cover

Top

Edge surface of pages
only **colored with gold.**

※ If that's a problem, it's no big deal
if the whole block is colored gold. →

Cover opens wide when drawn.

Top-down view

Akiko Tanaka designed this grimoire—rather, this grimoire, notebook, and journal (I think?) bound together. The difference between it and the Veil of Wiyu is quite pronounced.
(Namae)

Ifrit Arms

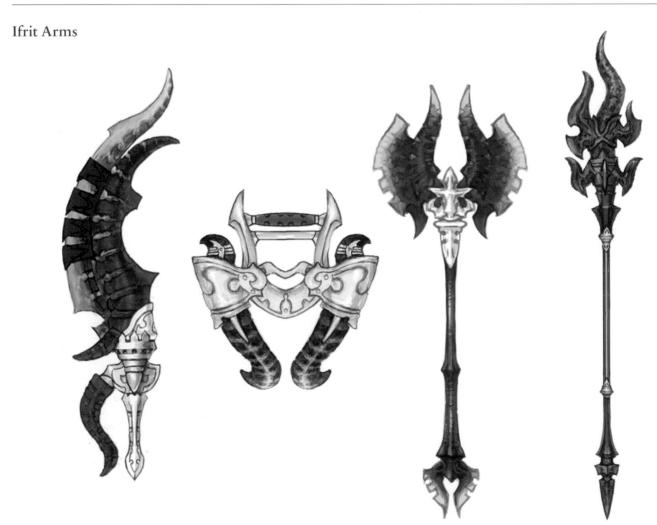

Yoshimitsu

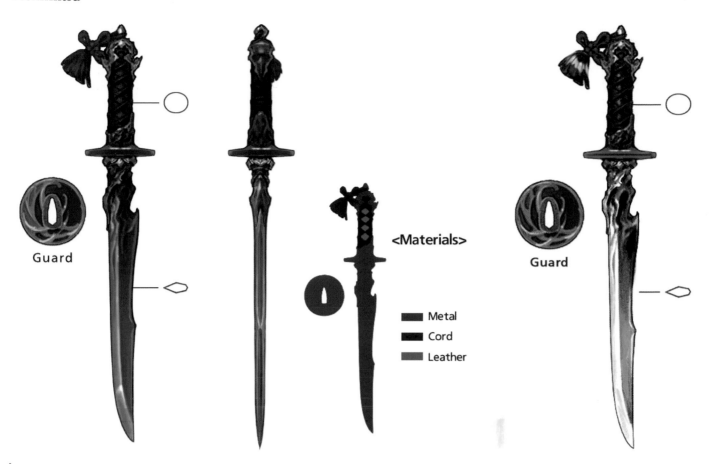

Guard

Guard

<Materials>

- Metal
- Cord
- Leather

Akiko Tanaka designed this weapon. She started with a basic Japanese blade design and added decorative features to make it match the design of rappa garb. (Namae)

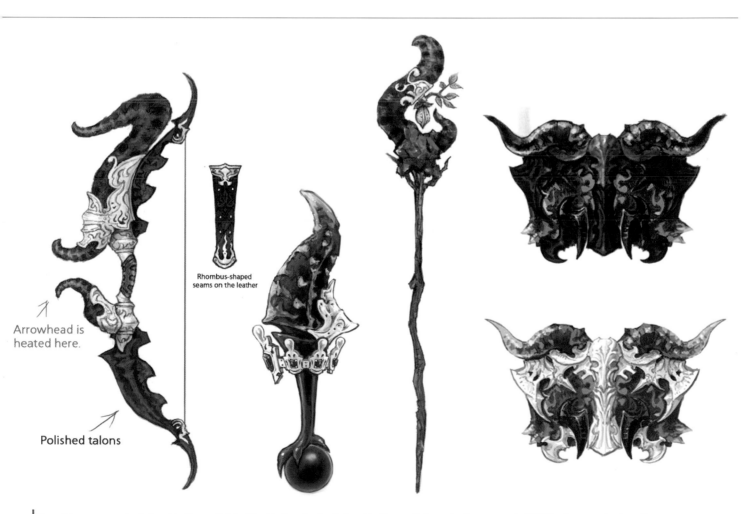

Arrowhead is heated here.

Polished talons

Rhombus-shaped seams on the leather

Part of the weapon series designed by Kazuya Takahashi, with the grimoire designed by Kasuya. This was the first weapon in *FFXIV* to feature a glowing effect. (Namae)

Moogle Arms

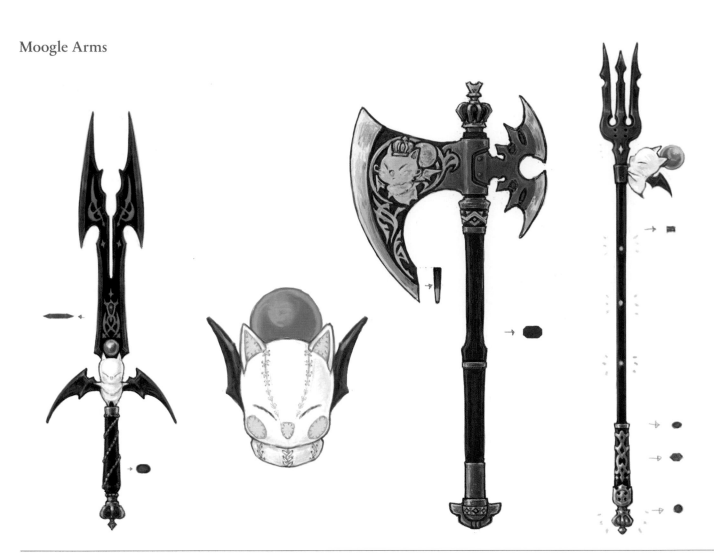

Garuda Arms

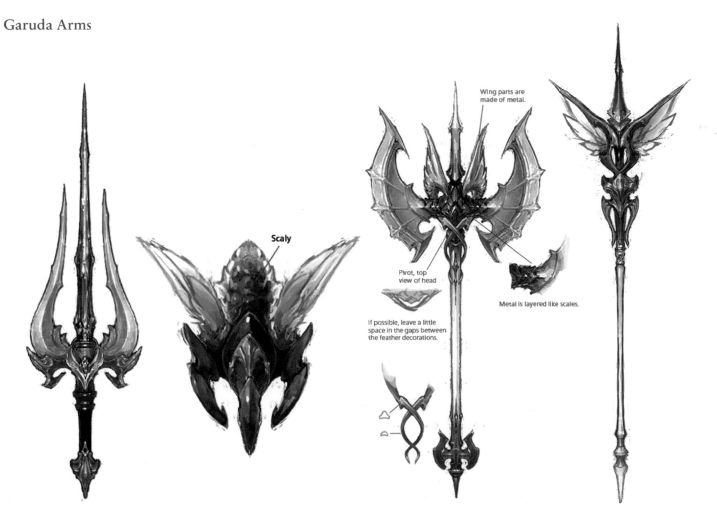

Scaly

Wing parts are
made of metal.

Pivot, top
view of head

Metal is layered like scales.

If possible, leave a little
space in the gaps between
the feather decorations.

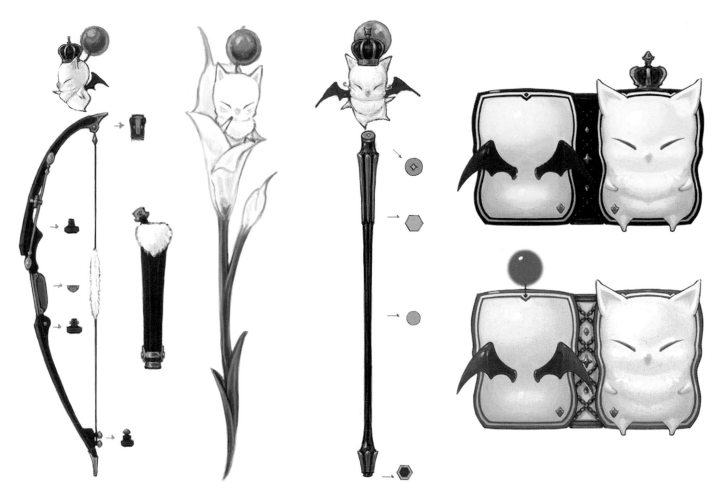

My goal was to make a moogle-themed set that players would find fun. I attempted to do this in different ways with each weapon. I'm particularly fond of the Malevolent Mogwand, the Melancholy Mogfork, and the Murderous Mogfists. (Namae)

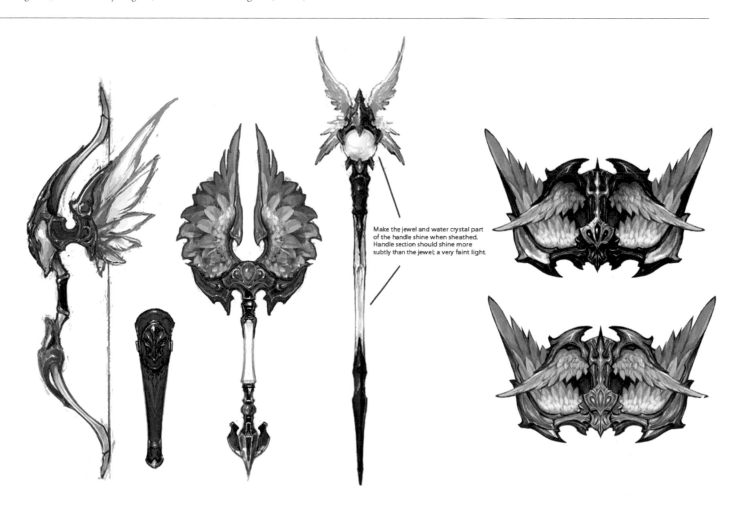

Make the jewel and water crystal part of the handle shine when sheathed. Handle section should shine more subtly than the jewel; a very faint light.

We often chose one artist to oversee the design of all weapons in a particular set—in this case, Akiko Tanaka. Like all primal weapons, the design of this set reflects the design of the primal who drops them, which is why these elegant weapons make use of Garuda's white and green colors. (Namae)

Titan Arms

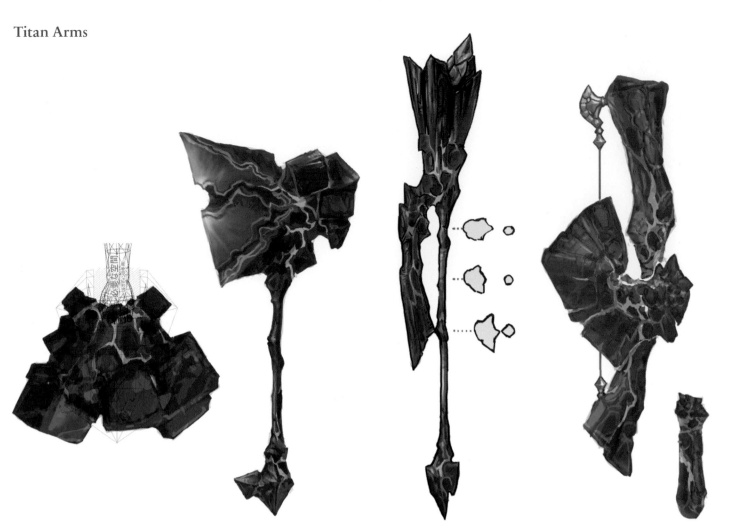

Leviathan Arms

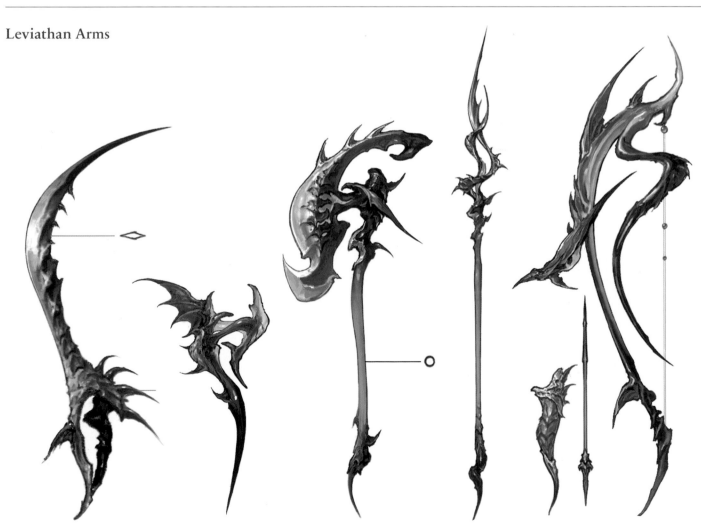

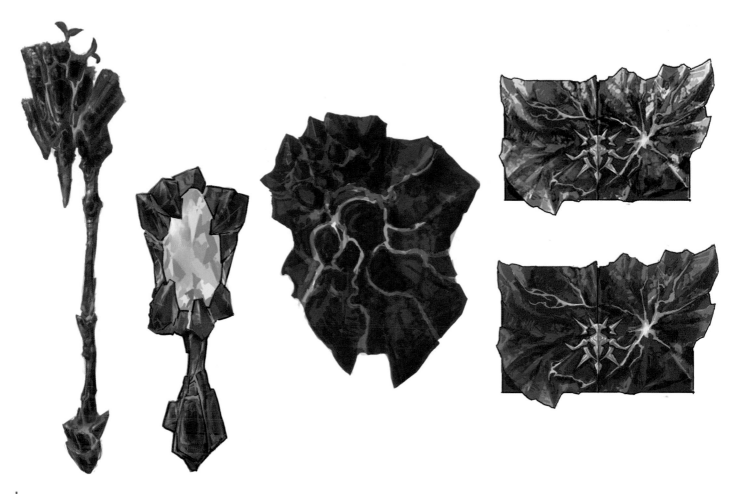

Naturally, we made thick, weighty weapons evocative of Titan. (Kasuya)

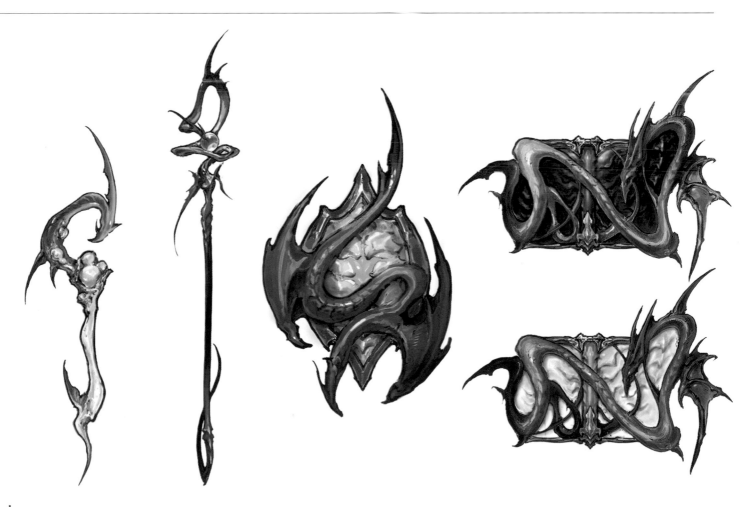

I remember thinking that it would be difficult to make Leviathan-themed weapons, but Akiko Tanaka managed to create stylish designs. (Namae)

Ramuh Arms

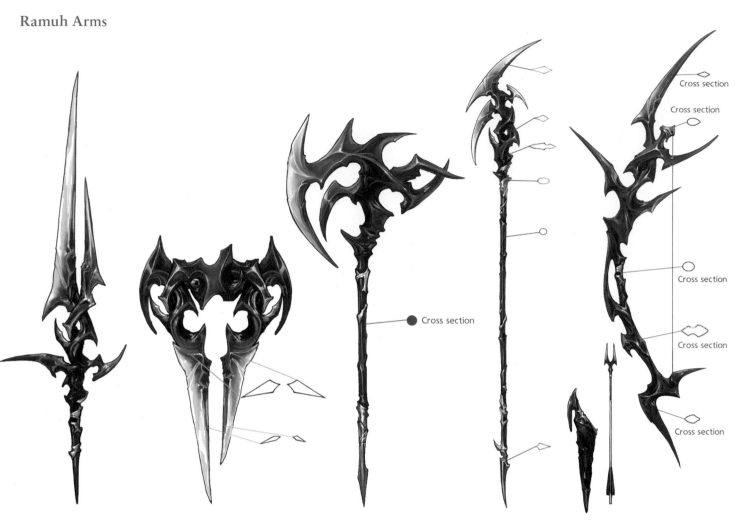

Cross section

Cross section

Cross section

Cross section

Cross section

Cross section

Cross section

Gerolt's Masterworks

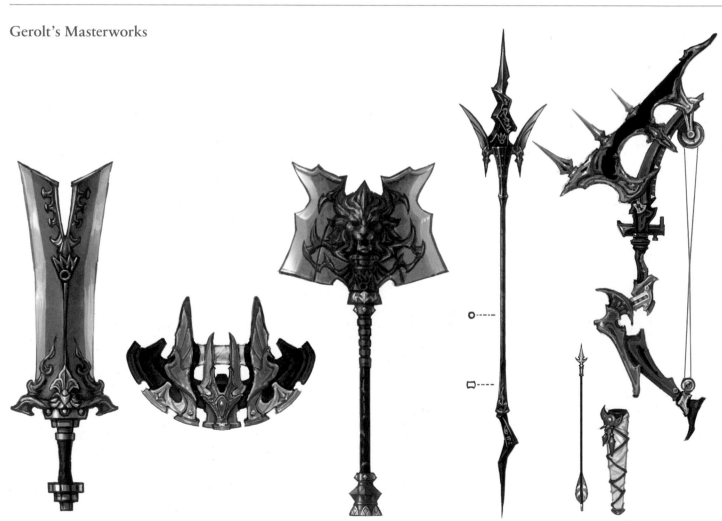

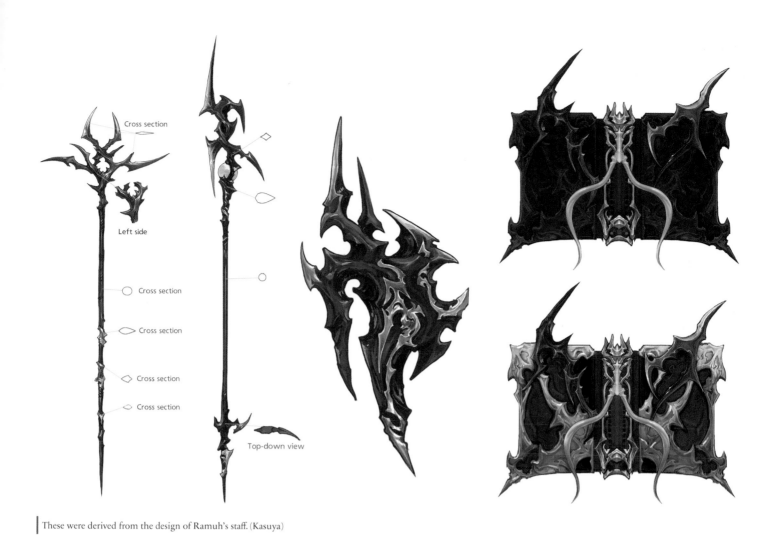

These were derived from the design of Ramuh's staff. (Kasuya)

Symbol

Gerolt's mark,
the Rhalgr symbol

Kasuya and Akiko Tanaka were in charge of this series. Since Gerolt is an accomplished craftsman capable of making just about anything, they deviated from traditional designs and created a diverse set of arms. (Namae)

We designed these arms to match noct armor. (Kasuya)

Lominsan Officer's Arms

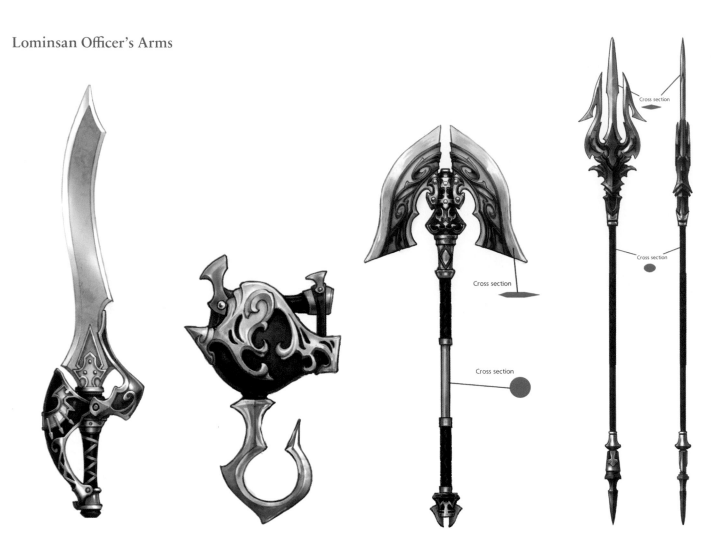

Cross section

Cross section

Cross section

Cross section

Storm Elite's Arms

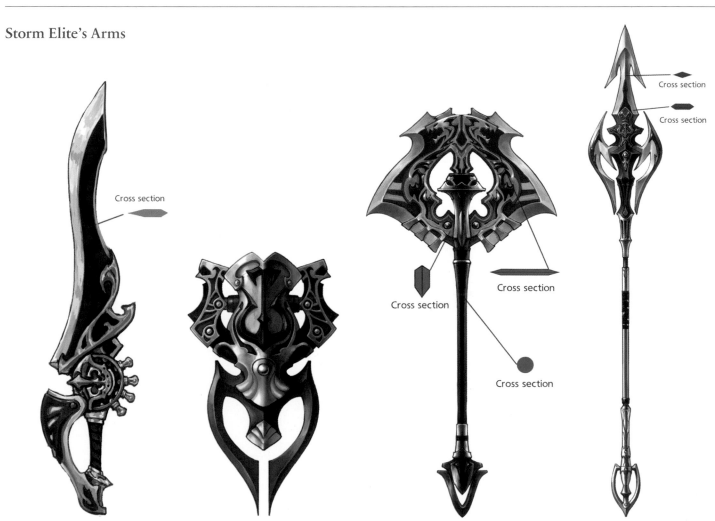

Cross section

Cross section

Cross section

Cross section

Cross section

Cross section

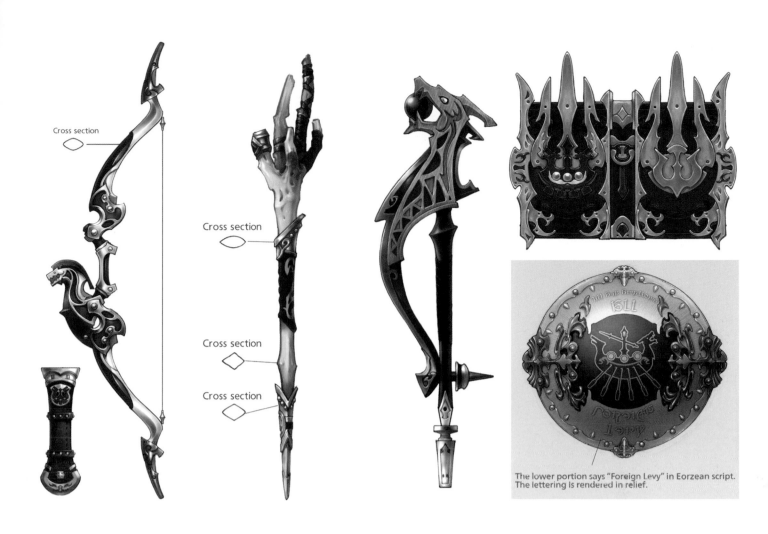

Cross section

Cross section

Cross section

Cross section

The lower portion says "Foreign Levy" in Eorzean script. The lettering is rendered in relief.

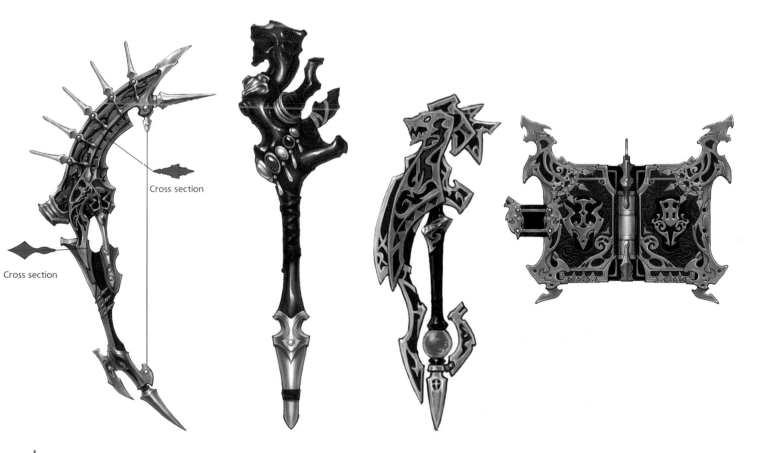

Cross section

Cross section

Cross section

A different artist was charged with overseeing the development of each Grand Company arms set. (Namae)

Gridanian Officer's Arms

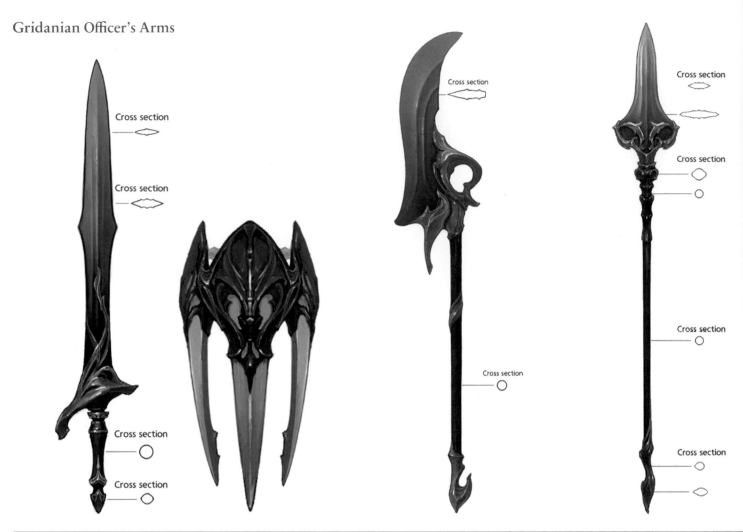

Cross section

Cross section

Cross section

Cross section

Cross section

Cross section

Cross section

Cross section

Cross section

Cross section

Serpent Elite's Arms

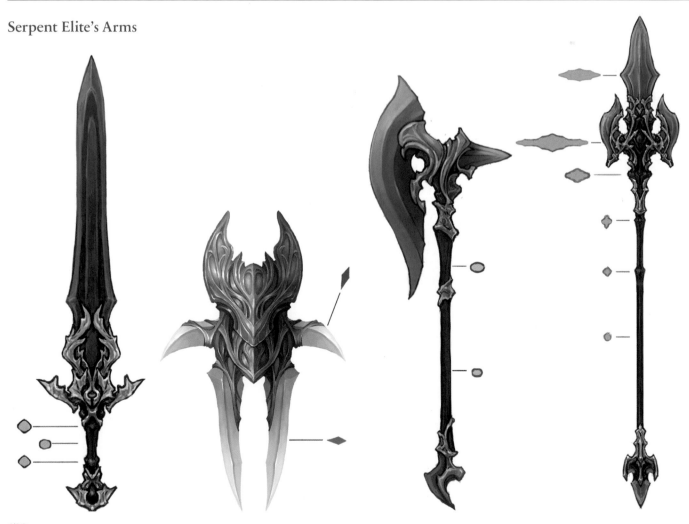

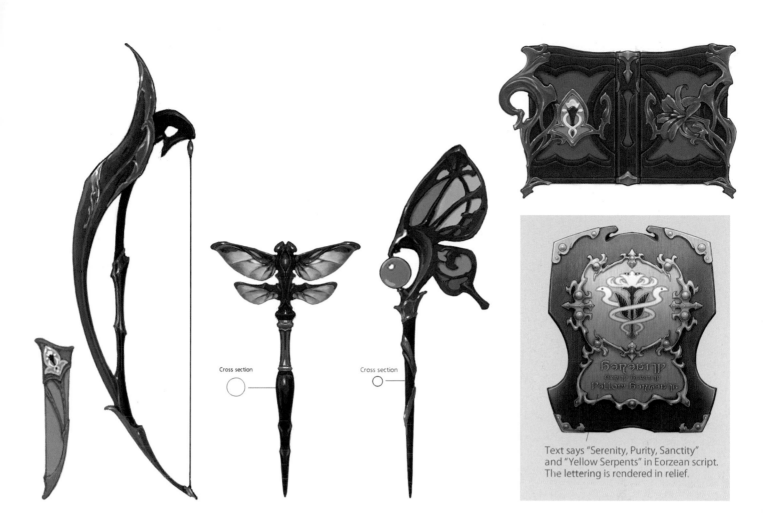

Text says "Serenity, Purity, Sanctity" and "Yellow Serpents" in Eorzean script. The lettering is rendered in relief.

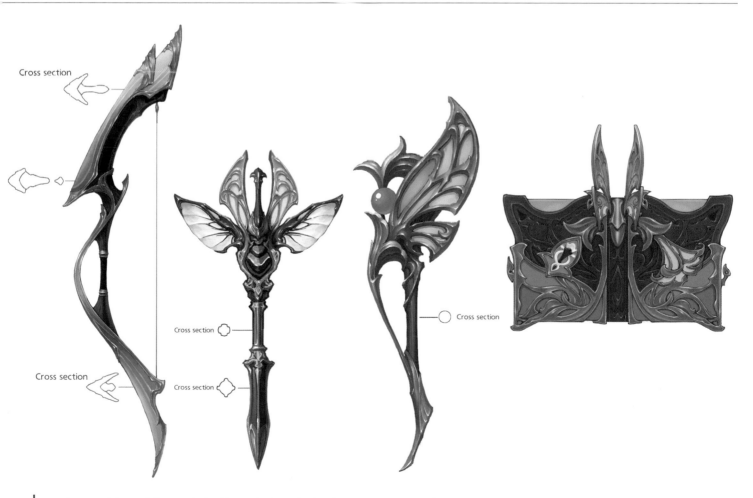

Nagamine created the rough designs, which Akiko Tanaka then refined. Each weapon is comprised of natural materials, giving the set a strong Gridanian feel. (Namae)

Ul'dahn Officer's Arms

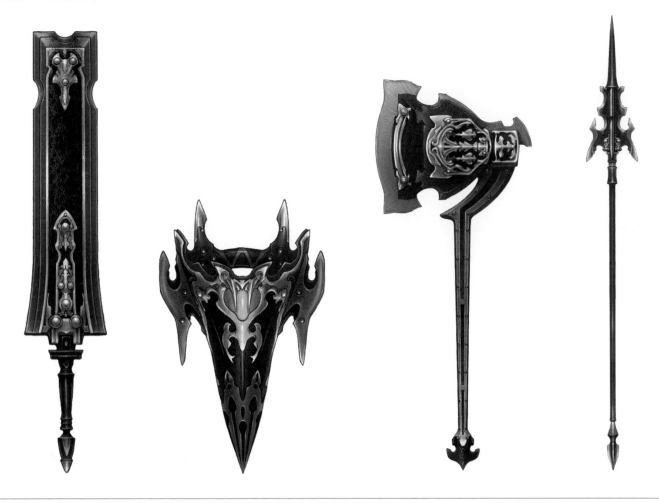

Flame Elite's Arms

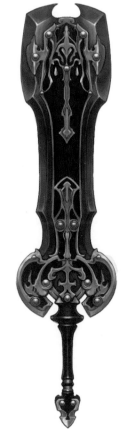

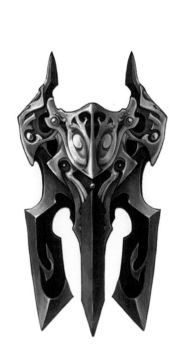

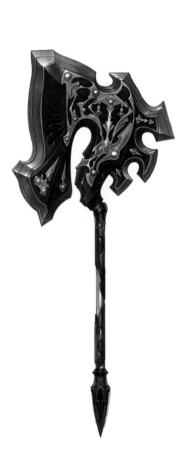

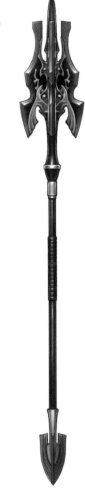

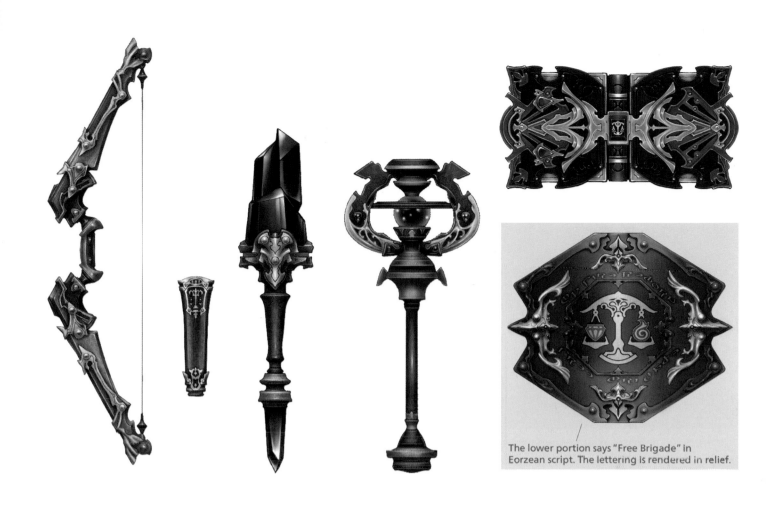

The lower portion says "Free Brigade" in Eorzean script. The lettering is rendered in relief.

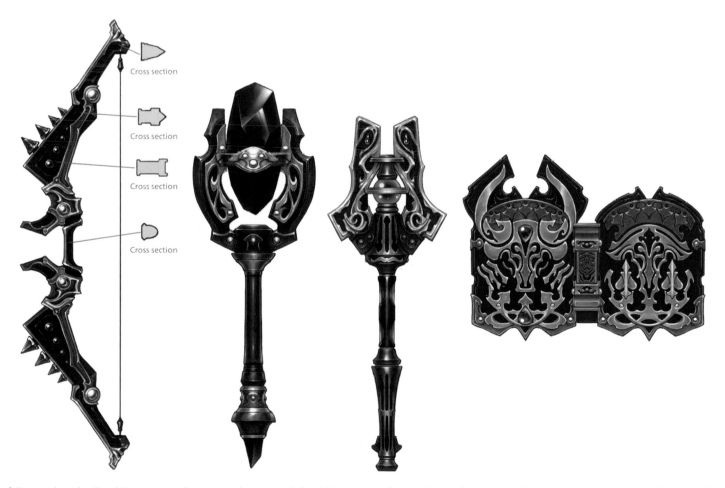

Cross section

Cross section

Cross section

Cross section

Compared to other Grand Company sets, these weapons have a more industrial image due to their metal and bolt construction. I chose to use simple geometric shapes to make these weapons seem less decorative and more practical. (Nakazawa)

Allagan Arms

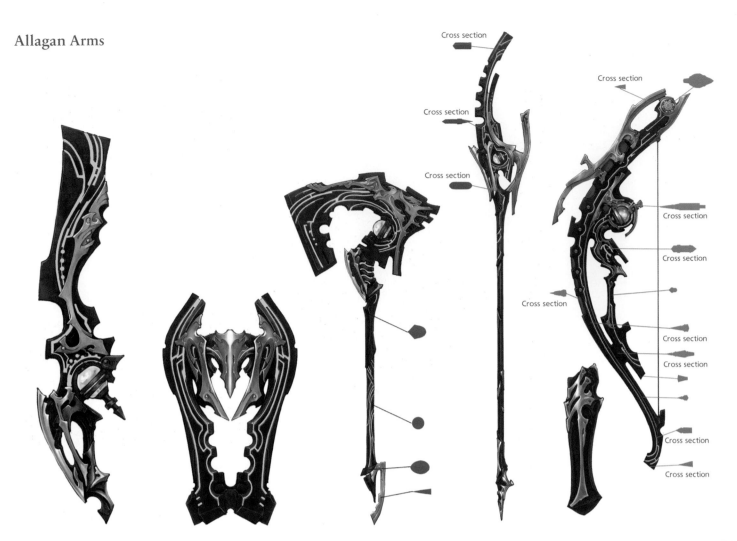

Cross section

High Allagan Arms

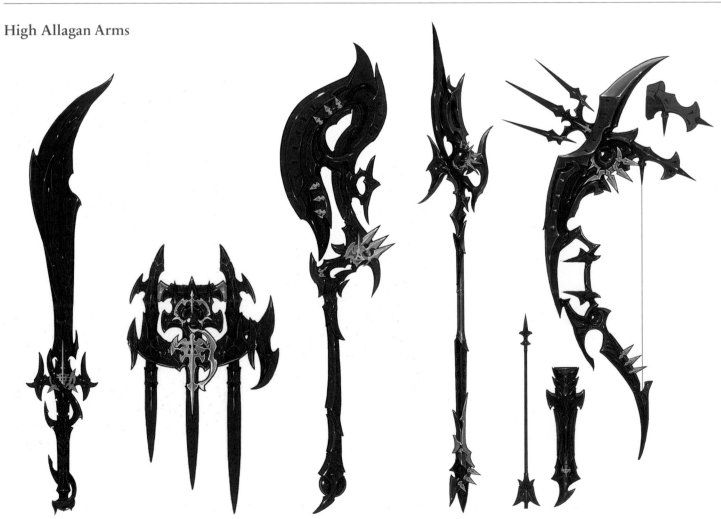

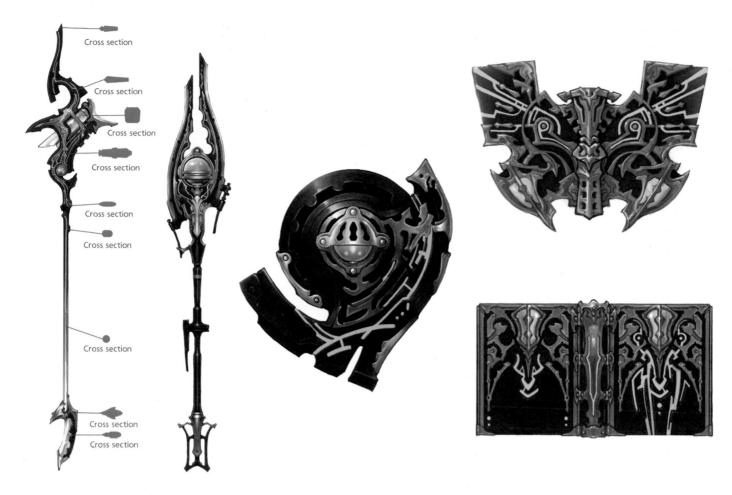

Cross section
Cross section
Cross section
Cross section
Cross section
Cross section
Cross section
Cross section

Akiko Tanaka and Kasuya handled a weapon each, as I recall; I wasn't in charge of this particular set. Although there are some science fiction elements present as well, the Allagan set is the product of an ancient civilization, and their design is intended to reflect that. (Namae)

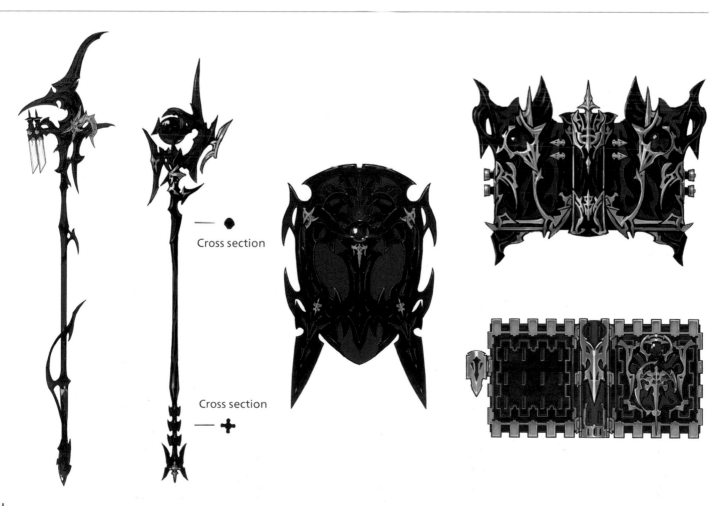

Cross section

Cross section

The High Allagan gear was designed first, so I took inspiration from them for the weapons. Mind the pointy ends when you're wielding them in battle! (Mihara)

Extreme Primal Arms

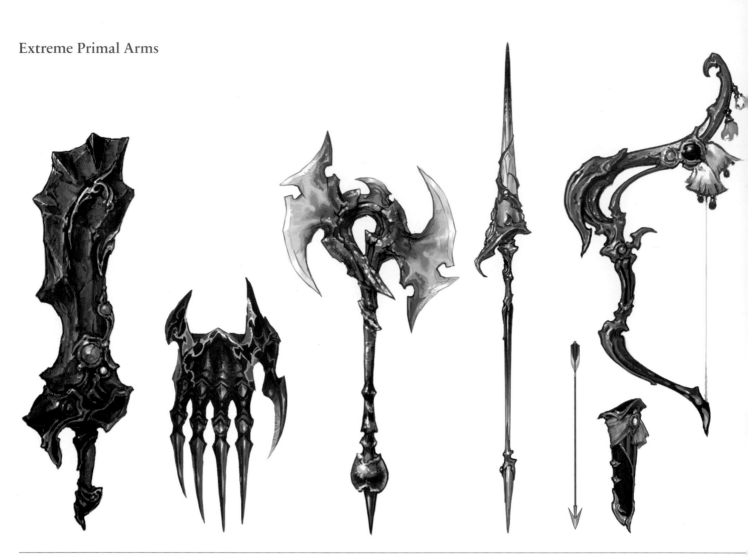

Bestial Arms

Should look like a paw.

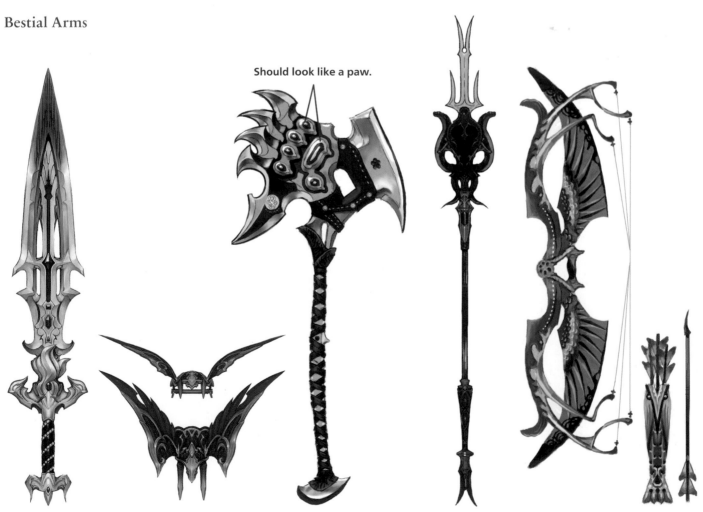

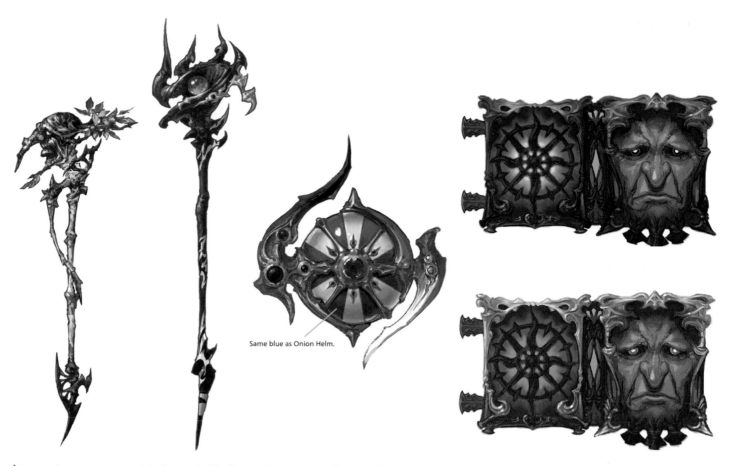

Same blue as Onion Helm.

Because these weapons were originally intended for the Crystal Tower, I strove for a high fantasy concept based on Amano's artwork. When it came time to implement them, however, they were changed to extreme primal weapons... (Namae)

I think it's nice to add faces to weapons every once in a while, like with the grimoires. (Kasuya)

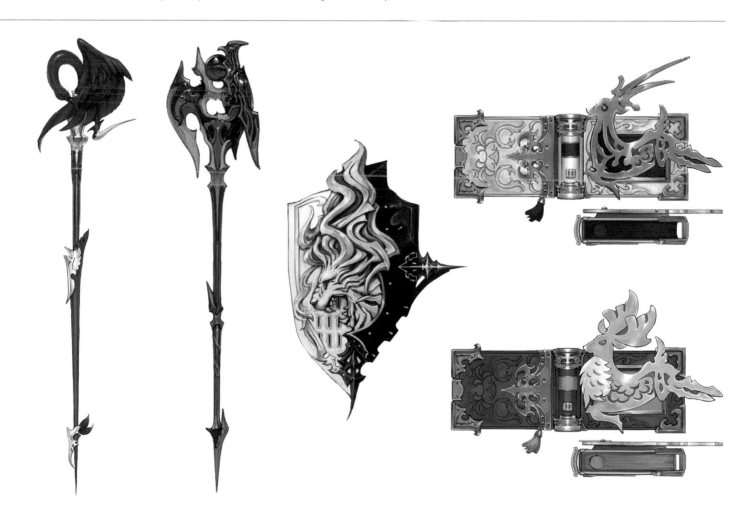

Mailbreaker

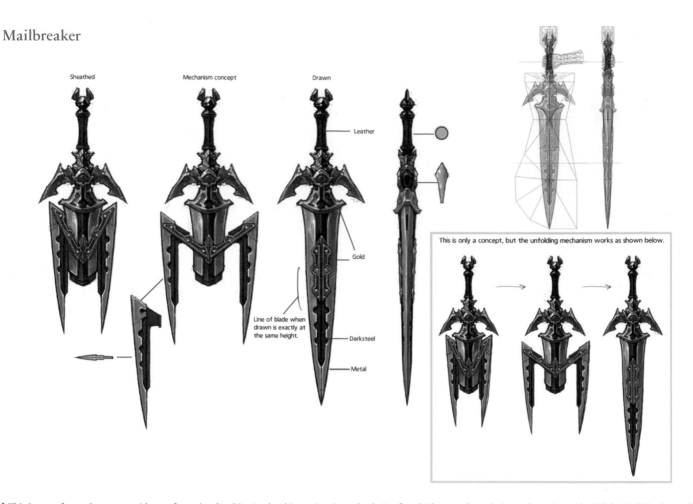

Sheathed

Mechanism concept

Drawn

Leather

Gold

Line of blade when drawn is exactly at the same height.

Darksteel

Metal

This is only a concept, but the unfolding mechanism works as shown below.

This is one of several weapons with transformative sheathing/unsheathing animations, the design for which came about during a discussion with Akihiko Yoshida about what the shape of the strongest weapons might be. This sword was designed by Akiko Tanaka. (Namae)

Avengers

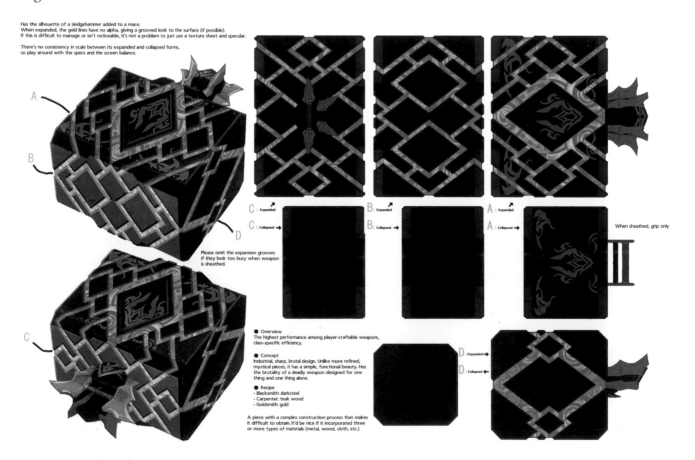

Has the silhouette of a sledgehammer added to a mace.
When expanded, the gold lines have no alpha, giving a grooved look to the surface (if possible).
If this is difficult to manage or isn't noticeable, it's not a problem to just use a texture sheet and specular.

There's no consistency in scale between its expanded and collapsed forms, so play around with the specs and the screen balance.

A

B

D

C

C : Expanded
C : Collapsed

B : Expanded
B : Collapsed

A : Expanded
A : Collapsed

When sheathed, grip only

Please omit the expansion grooves if they look too busy when weapon is sheathed.

● Overview
The highest performance among player-craftable weapons, class-specific efficiency.

● Concept
Industrial, sharp, brutal design. Unlike more refined, mystical pieces, it has a simple, functional beauty. Has the brutality of a deadly weapon designed for one thing and one thing alone.

● Recipe
· Blacksmith: darksteel
· Carpenter: teak wood
· Goldsmith: gold

A piece with a complex construction process that makes it difficult to obtain. It'd be nice if it incorporated three or more types of materials (metal, wood, cloth, etc.).

D : Expanded
D : Collapsed

"Monk weapons always seem to have blades attached, so this time we want a blunt weapon suited for striking." As you can see, I went for something that was a cross between a sledgehammer and a mace. The gold lines are engraved with cogwheel imagery. (Masao)

Rampager

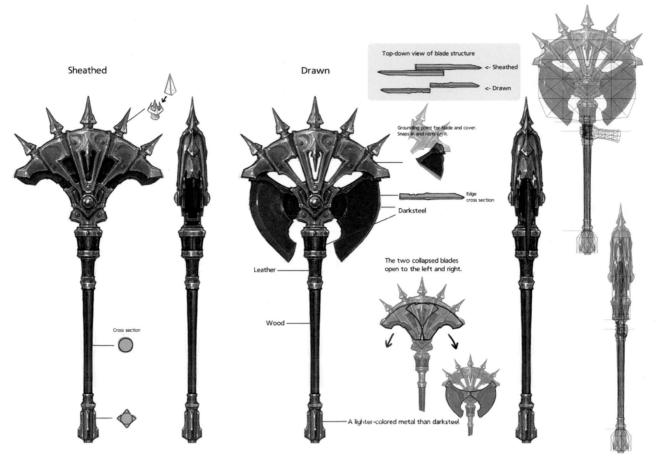

Sheathed

Drawn

Top-down view of blade structure

<- Sheathed

<- Drawn

Grounding point for blade and cover.
Snaps in and rests on it.

Edge cross section

Darksteel

The two collapsed blades open to the left and right.

Leather

Wood

Cross section

A lighter-colored metal than darksteel.

When sheathed, the blades retract into the head of the weapon. I created the rough design, and Akiko Tanaka handled the rest. (Namae)

Obelisk

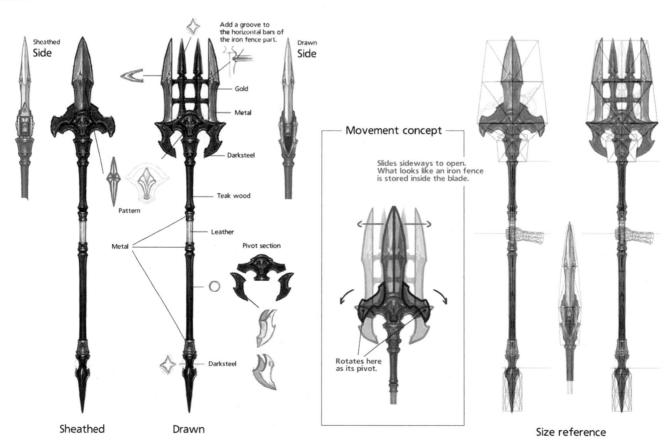

Sheathed
Side

Drawn
Side

Add a groove to the horizontal bars of the iron fence part.

Gold

Metal

Darksteel

Teak wood

Pattern

Leather

Metal

Pivot section

Movement concept

Slides sideways to open. What looks like an iron fence is stored inside the blade.

Darksteel

Rotates here as its pivot.

Sheathed

Drawn

Size reference

The spearhead design was inspired by gothic iron fences. I provided the original concept, and Akiko Tanaka completed the design. (Namae)

Sarnga

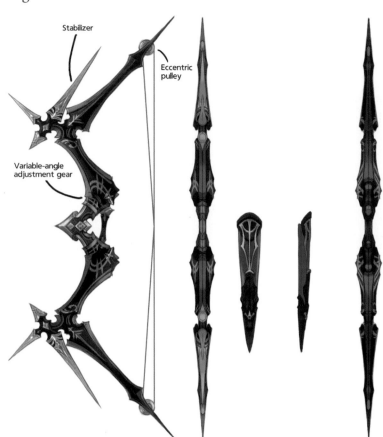

Stabilizer

Eccentric pulley

Variable-angle adjustment gear

● Overview
The highest performance among player-craftable weapons, class-specific efficiency.

● Concept
Industrial, sharp, brutal design. Unlike more refined, mystical pieces, it has a simple, functional beauty. Has the brutality of a deadly weapon designed for one thing and one thing only.

● Recipe
· Blacksmith: darksteel
· Carpenter: teak wood
· Goldsmith: gold

A piece with a complex construction process that makes it difficult to obtain. It'd be nice if it incorporated three or more types of materials (metal, wood, cloth, and so forth).

Concepts: square silhouette when sheathed; has thorn-like edges. Change the size if there are any technical issues.

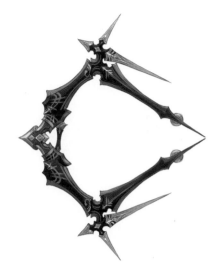

My main concern was how the bow would change shape when being drawn or sheathed. The design is similar to modern compound bows due to the moving parts. (Masao)

Alkalurops

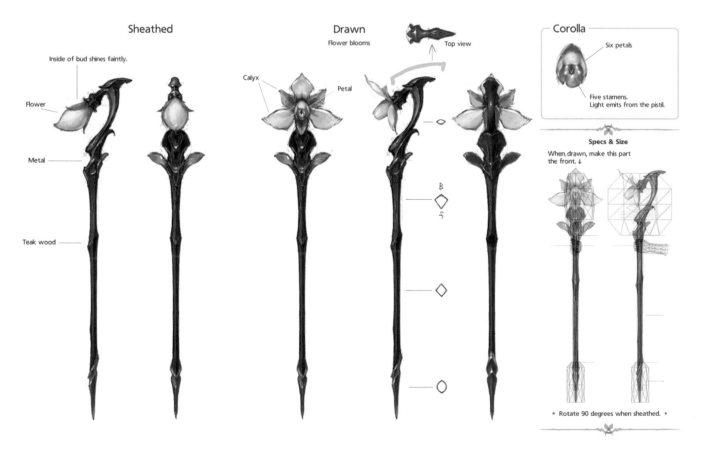

Sheathed

Inside of bud shines faintly.

Flower

Metal

Teak wood

Drawn

Flower blooms

Top view

Calyx

Petal

Corolla

Six petals

Five stamens.
Light emits from the pistil.

Specs & Size

When drawn, make this part the front. ↓

* Rotate 90 degrees when sheathed. *

Akiko Tanaka designed this weapon. As a rule, conjurer arms should be made with natural materials in order to distinguish them from thaumaturge arms. This usage of a flower as a staff head was in accordance with this rule. (Namae)

Astrolabe

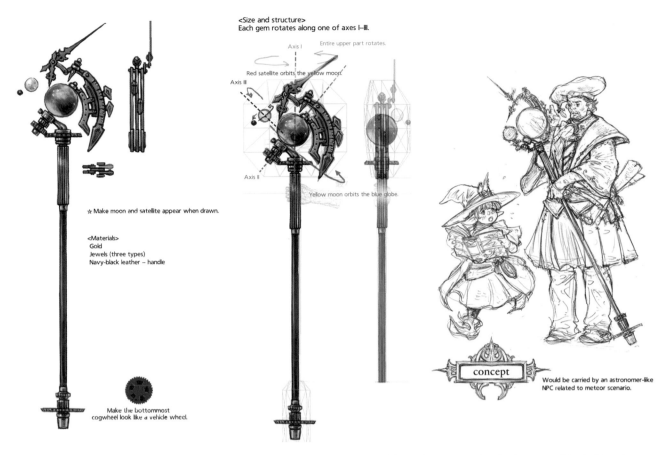

<Size and structure>
Each gem rotates along one of axes I–III.

Axis I

Entire upper part rotates.

Red satellite orbits the yellow moon.

Axis III

Axis II

Yellow moon orbits the blue globe.

☆ Make moon and satellite appear when drawn.

<Materials>
Gold
Jewels (three types)
Navy-black leather – handle

Make the bottommost
cogwheel look like a vehicle wheel.

concept

Would be carried by an astronomer-like
NPC related to meteor scenario.

I have a number of designs I want to propose but keep in reserve until the time is right. This was one of them. The accompanying sketch was something I whipped up on a whim one day. (Namae)

Deus ex Verbis

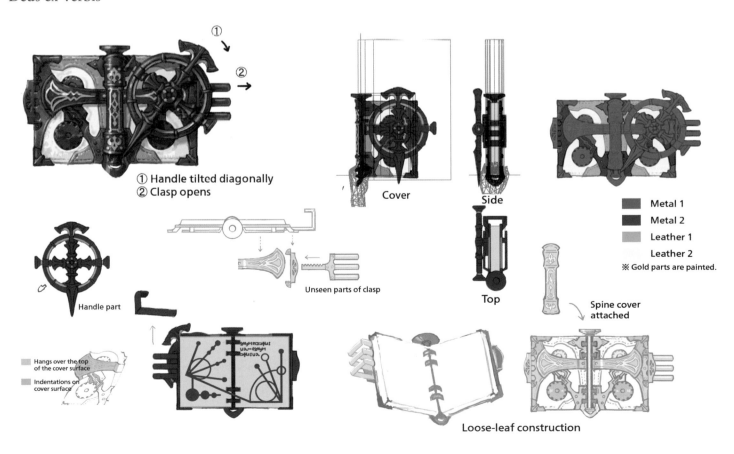

①
②

① Handle tilted diagonally
② Clasp opens

Cover

Side

Top

Metal 1
Metal 2
Leather 1
Leather 2
※ Gold parts are painted.

Handle part

Unseen parts of clasp

Spine cover
attached

Hangs over the top
of the cover surface

Indentations on
cover surface

Loose-leaf construction

I patterned this grimoire after a metal safe. (Kasuya)

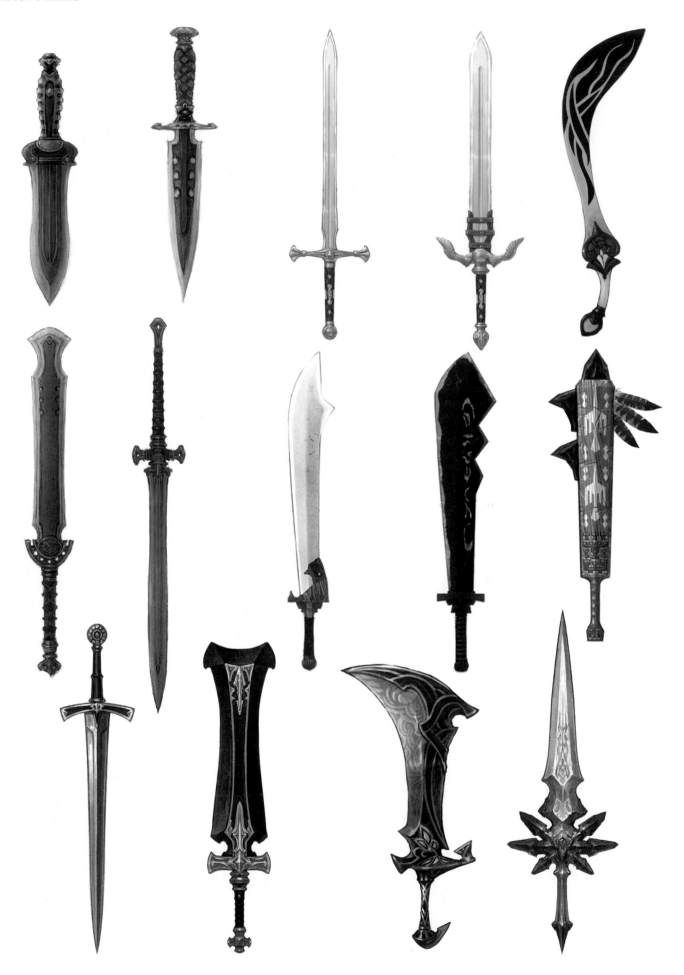

I designed many of the gladiator arms, like the gladius and the bastard sword for Version 1.0. Several artists from other projects contributed during development of 2.0, and their influences can be seen in the variety of weapons we have today. (Namae)

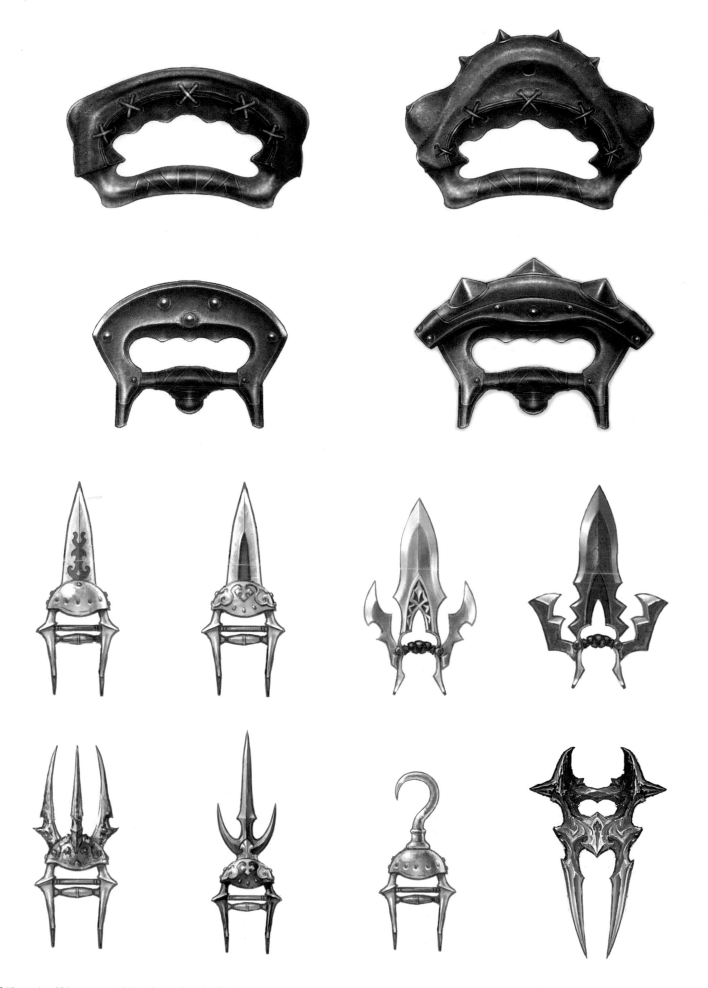

The cesti and himantes were designed with the help of Nakazawa, who works primarily on another project. Despite their simple shape, I feel the lines are rather dynamic. These weapons were designed by several artists. (Namae)

Marauder's Arms

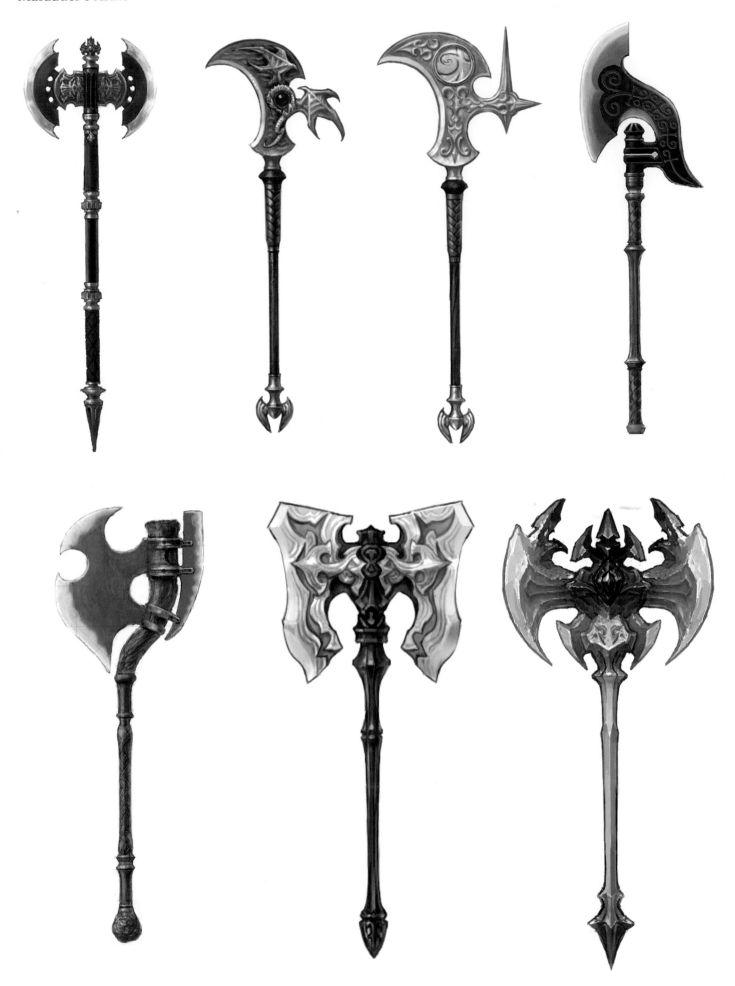

I'm fond of the simple, heavy design of marauder arms, which I feel are well suited to a tank class. These weapons were designed by several artists. (Namae)

Lancer's Arms

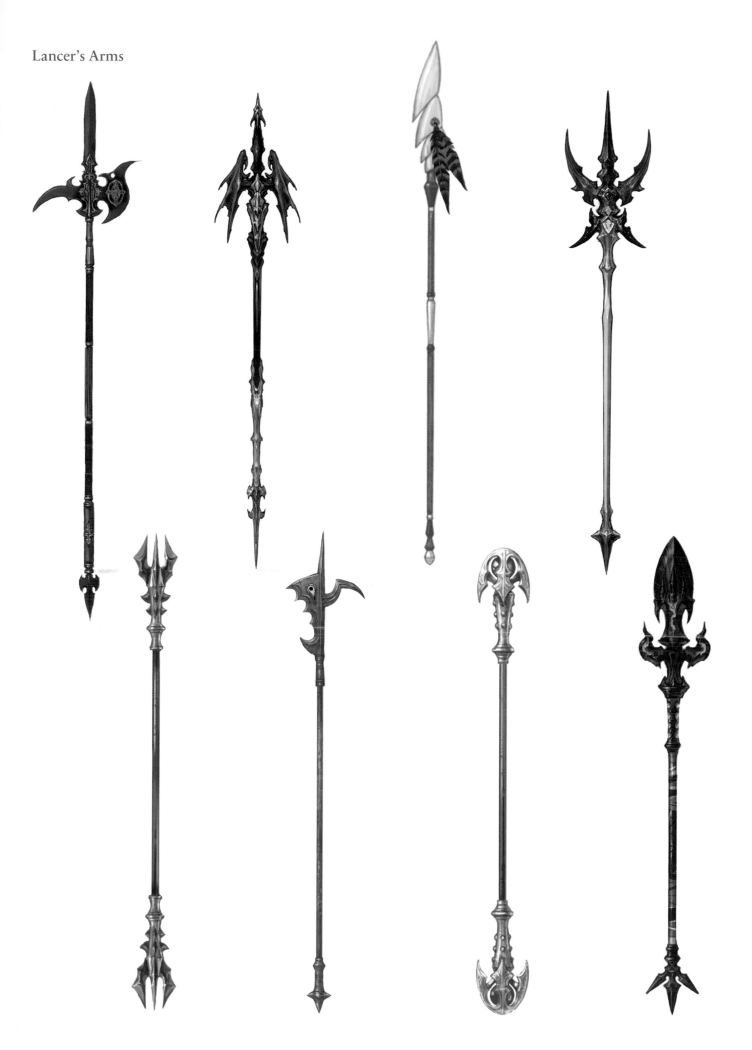

When we first started developing *FFXIV*, we designed all our weapons with specific criteria in mind. As work continued, we began to expand our limitations and challenge ourselves to find new ways to work within our restrictions, which I found to be a rewarding experience. These weapons were designed by several artists. (Namae)

Archer's Arms

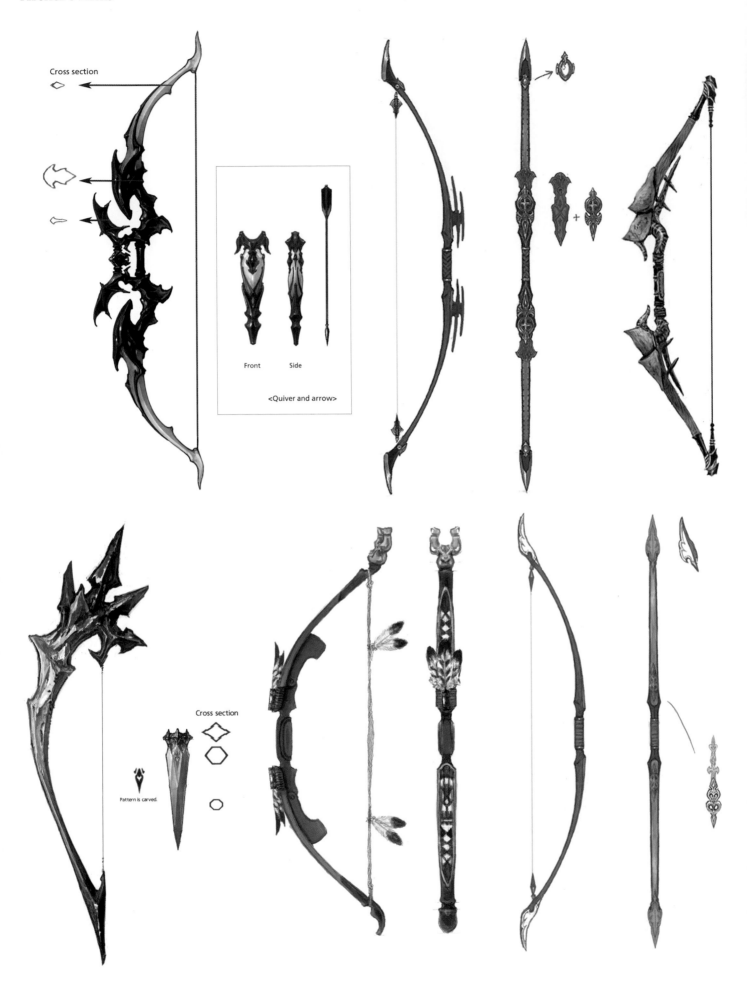

Cross section

Front Side

<Quiver and arrow>

Cross section

Pattern is carved.

For 2.0, we were able to design quivers and arrows unique to each weapon. These weapons were designed by several artists. (Namae)

Conjurer's Arms

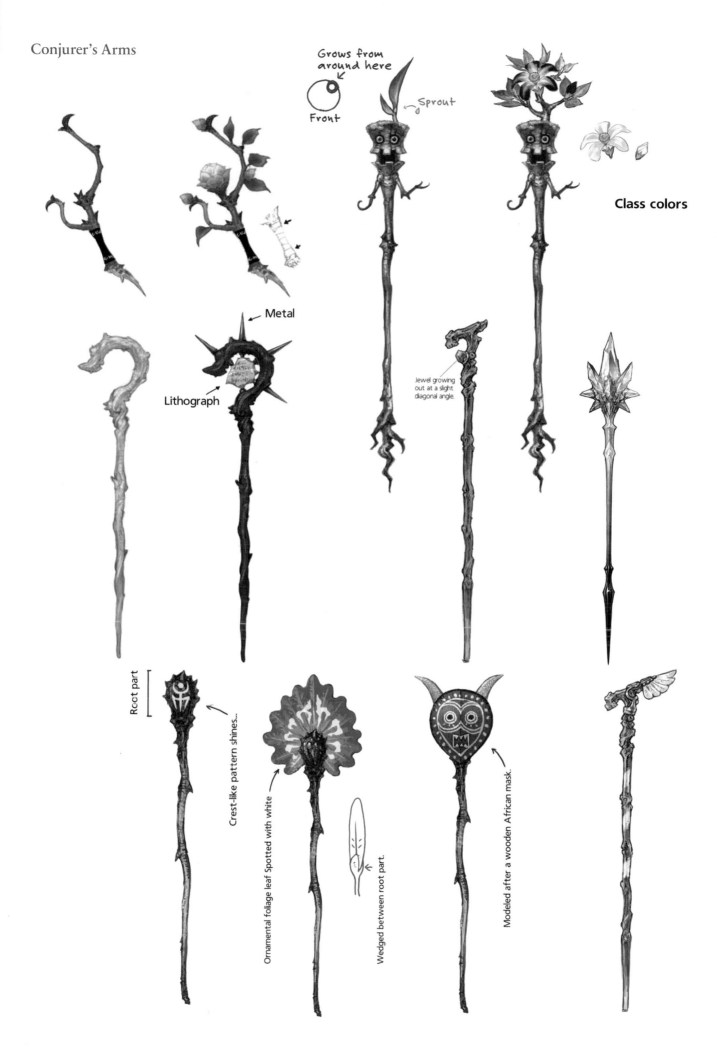

Grows from around here

Front

Sprout

Class colors

Metal

Lithograph

Jewel growing out at a slight diagonal angle.

Root part

Crest-like pattern shines...

Ornamental foliage leaf Spotted with white

Wedged between root part.

Modeled after a wooden African mask.

As a design rule, conjurer arms incorporate natural materials in their design, which helps emphasize a nature motif. It can be frustrating at times, but crafting new designs within these restrictions is one of the interesting aspects of this job. These weapons were designed by several artists. (Namae)

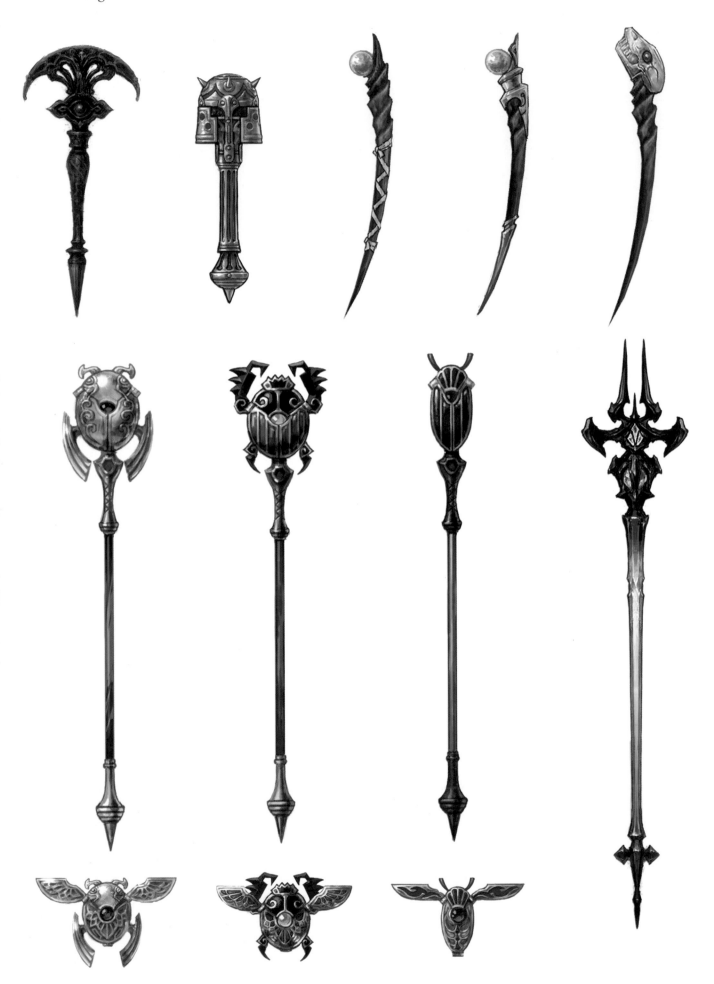

As a design rule, thaumaturge arms incorporate gemstones in order to distinguish them from conjurer arms. These weapons were designed by several artists. (Namae)

Arcanist's Grimoire

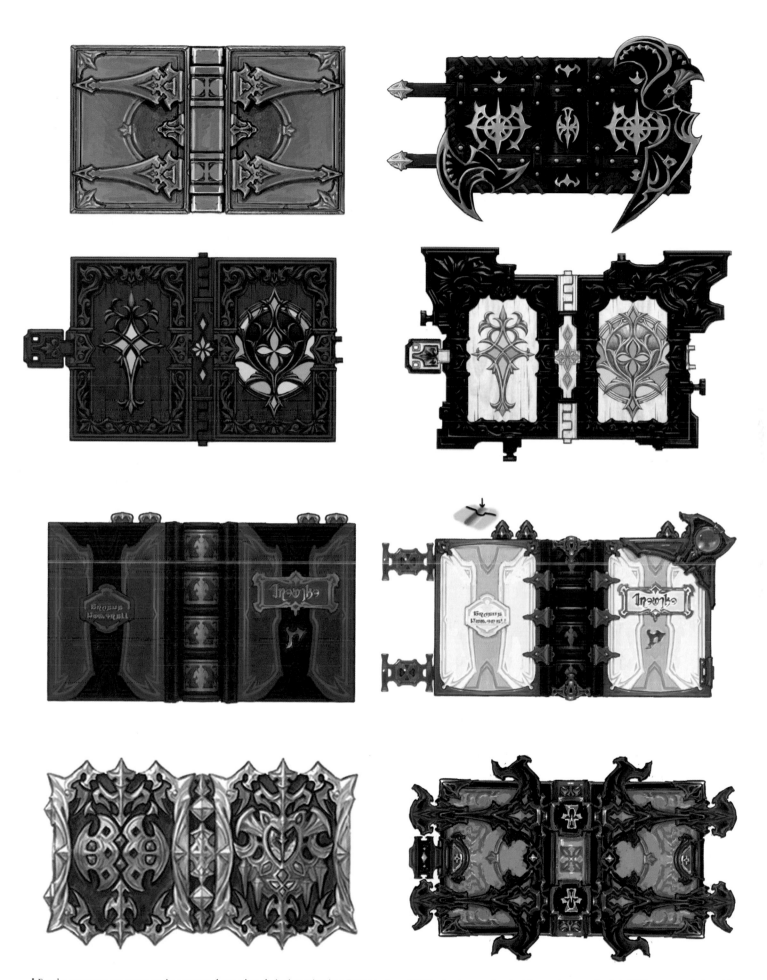

For the most part, we try to retain a square shape when designing grimoires. Even so, many *FFXIV* grimoires aren't suited for storing on a bookshelf. These were designed by several artists. (Namae)

Carpenter's Tools

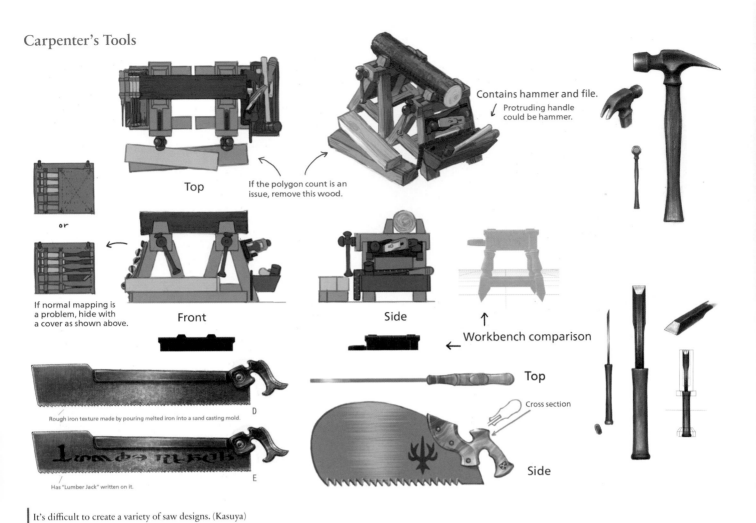

Contains hammer and file.

Protruding handle could be hammer.

Top

If the polygon count is an issue, remove this wood.

or

If normal mapping is a problem, hide with a cover as shown above.

Front

Side

Workbench comparison

Top

Cross section

Side

Rough iron texture made by pouring melted iron into a sand casting mold.

Has "Lumber Jack" written on it.

It's difficult to create a variety of saw designs. (Kasuya)

Blacksmith's Tools

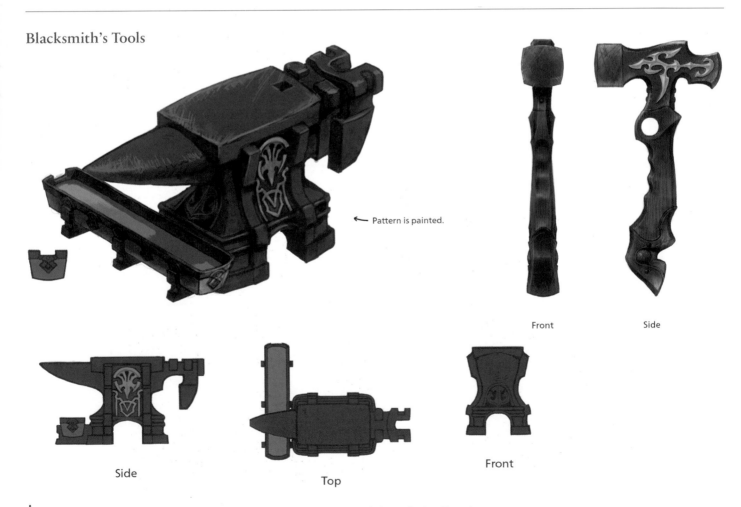

Pattern is painted.

Front

Side

Side

Top

Front

I took Nakazawa's suggestions verbatim. The long bucket is for quenching your metals during forging. (Kasuya)

Armorer's Tools

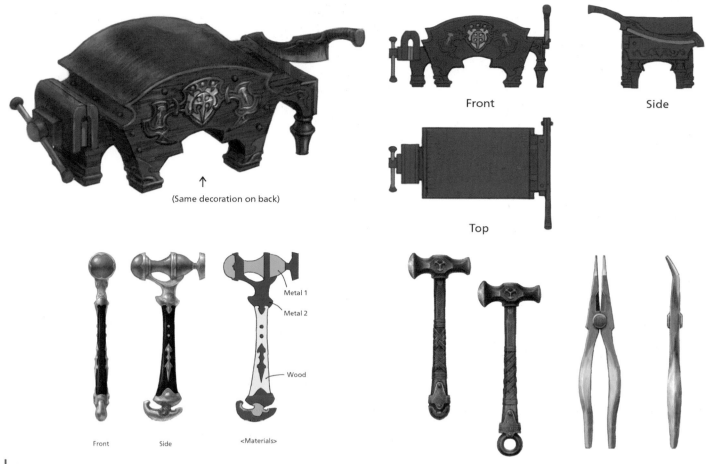

(Same decoration on back)

Front

Side

Top

Front　Side　<Materials>

Metal 1

Metal 2

Wood

This is also essentially Nakazawa's idea verbatim, complete with vise and sheet metal cutter. (Kasuya)

Goldsmith's Tools

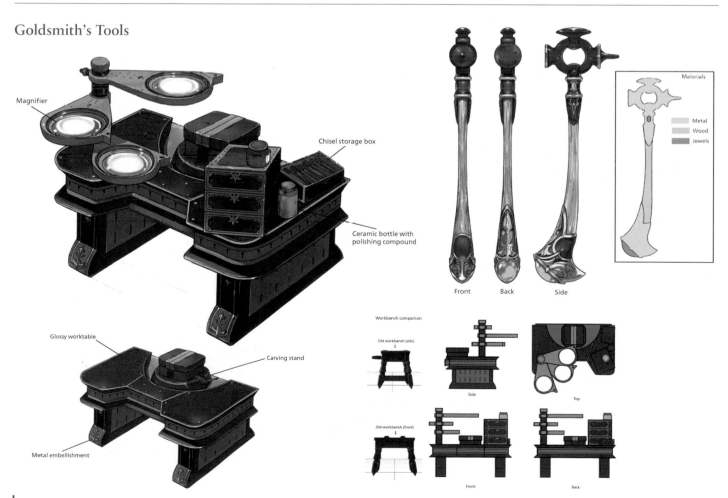

Magnifier

Chisel storage box

Ceramic bottle with polishing compound

Glossy worktable

Carving stand

Metal embellishment

Front　Back　Side

Materials

Metal
Wood
Jewels

Workbench comparison

Old workbench (side)

Side

Top

Old workbench (front)

Front

Back

Since goldsmithing involves precision work, I added several magnifying glasses. (Mihara)

Leatherworker's Tools

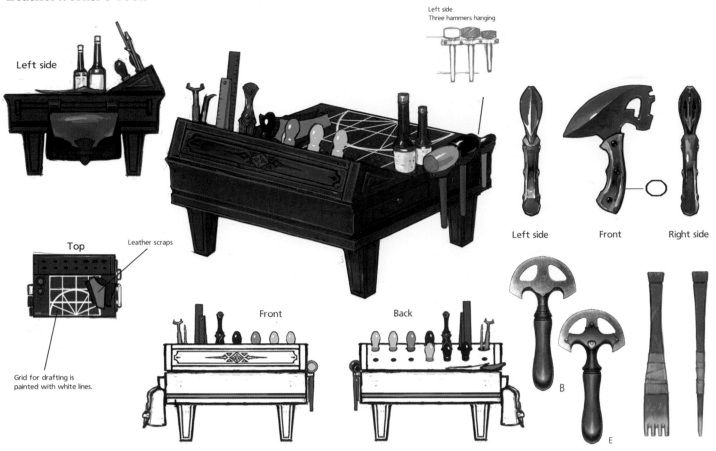

Left side

Left side
Three hammers hanging

Top

Leather scraps

Grid for drafting is painted with white lines.

Front

Back

Left side Front Right side

B

E

It's difficult to design tools that could be plausibly used by a crafter or gatherer but are still stylish enough for a game. I especially struggled to come up with ideas for the second set of primary tools. (Namae)

Weaver's Tools

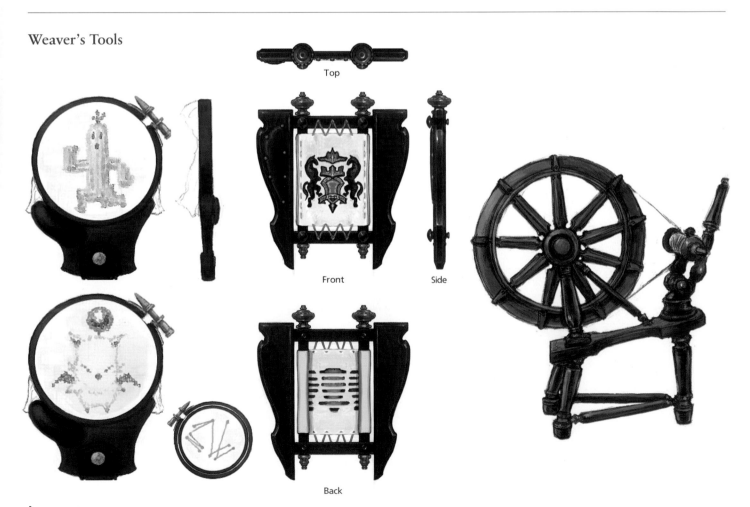

Top

Front Side

Back

I'm going to improve my embroidery designs. I rather like the weaver class, and I think it's a shame they didn't get a workspace like other crafting classes. (Namae)

Alchemist's Tools

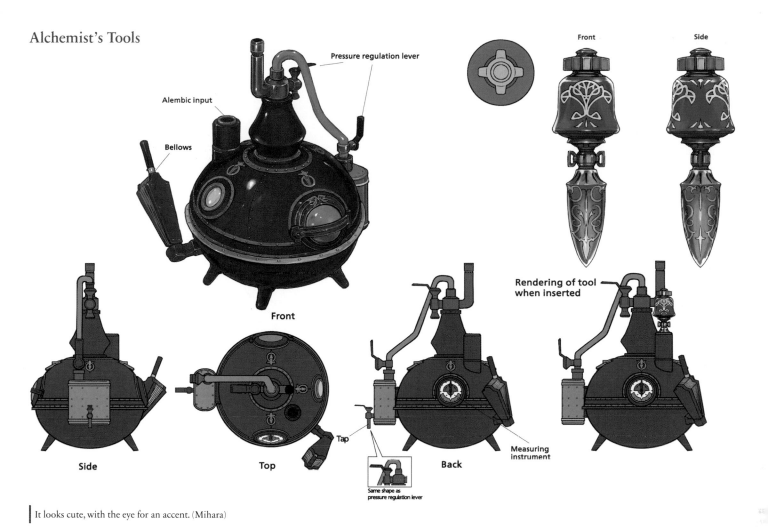

Pressure regulation lever

Alembic input

Bellows

Front

Side

Top

Tap

Same shape as pressure regulation lever

Back

Measuring instrument

Front

Side

Rendering of tool when inserted

It looks cute, with the eye for an accent. (Mihara)

Culinarian's Tools

Outer frame of top surface is made of stone.

Front

Smoke pouring from chimney
↓

Pan surface has a row of ridges.

Top

Side

Back

Put a square block behind the grate and make it glow red.

Top

Left side

Bottom

Akiko Tanaka designed these tools. The antique stove provides a simple workspace where a culinarian could conceivably prepare anything. It proved difficult to create in the game due to the high polygon count, but thanks to our modeling team, the design was largely realized. (Namae)

Miner's Primary Tools

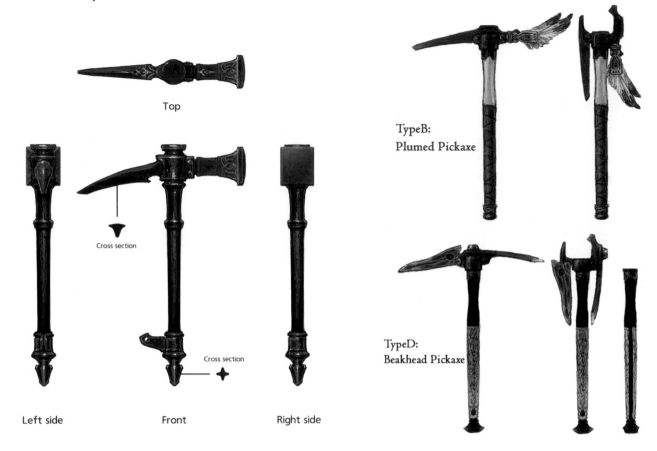

Top

Cross section

Cross section

Left side

Front

Right side

TypeB:
Plumed Pickaxe

TypeD:
Beakhead Pickaxe

Since gatherers don't have anything comparable to a crafting workspace, I think it would be great if we could add additional tools, like a chair for fishermen. (Namae)

Botanist's Primary Tools

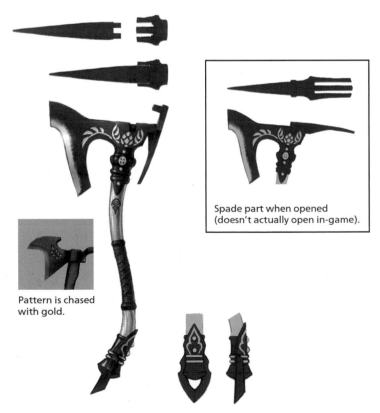

Spade part when opened
(doesn't actually open in-game).

Pattern is chased
with gold.

I combined elements of hatchet and axe designs. (Kasuya)

Envisioning Type D to have a thick blade
as shown below, but if it's not going to
look substantially different, you can just
reuse the blades from Types A~C.

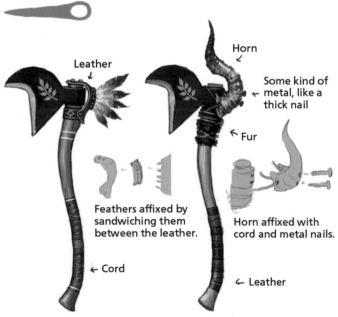

Leather

Horn

Some kind of
metal, like a
thick nail

Fur

Feathers affixed by
sandwiching them
between the leather.

Horn affixed with
cord and metal nails.

← Cord

← Leather

Type D:
Painted Hatchet

Type E:
Barbaric Hatchet

Gatherer's Secondary Tools

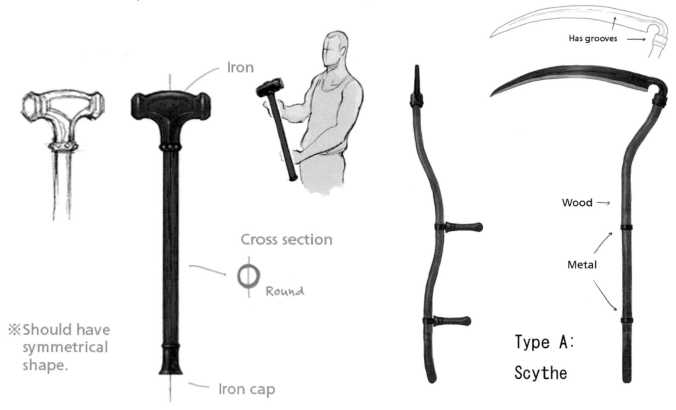

Iron

Cross section

Round

※Should have symmetrical shape.

Iron cap

Has grooves →

Wood →

Metal

Type A: Scythe

The scythe is of a comparable size. (Kasuya)

Fisher's Primary Tools

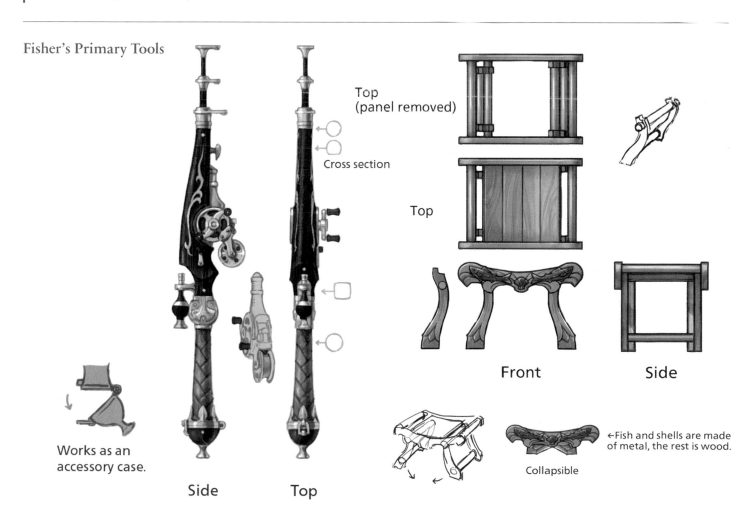

Top (panel removed)

Cross section

Top

Works as an accessory case.

Side

Top

Front

Side

Collapsible

←Fish and shells are made of metal, the rest is wood.

That's a rather extravagant reel. (Kasuya)

Accessories

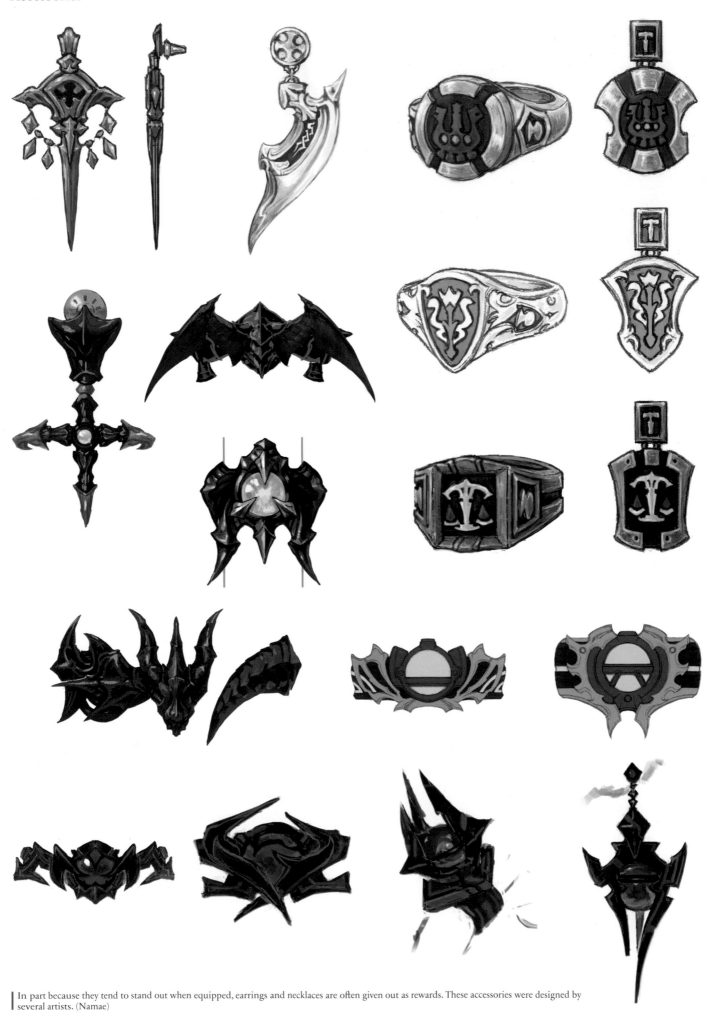

In part because they tend to stand out when equipped, earrings and necklaces are often given out as rewards. These accessories were designed by several artists. (Namae)

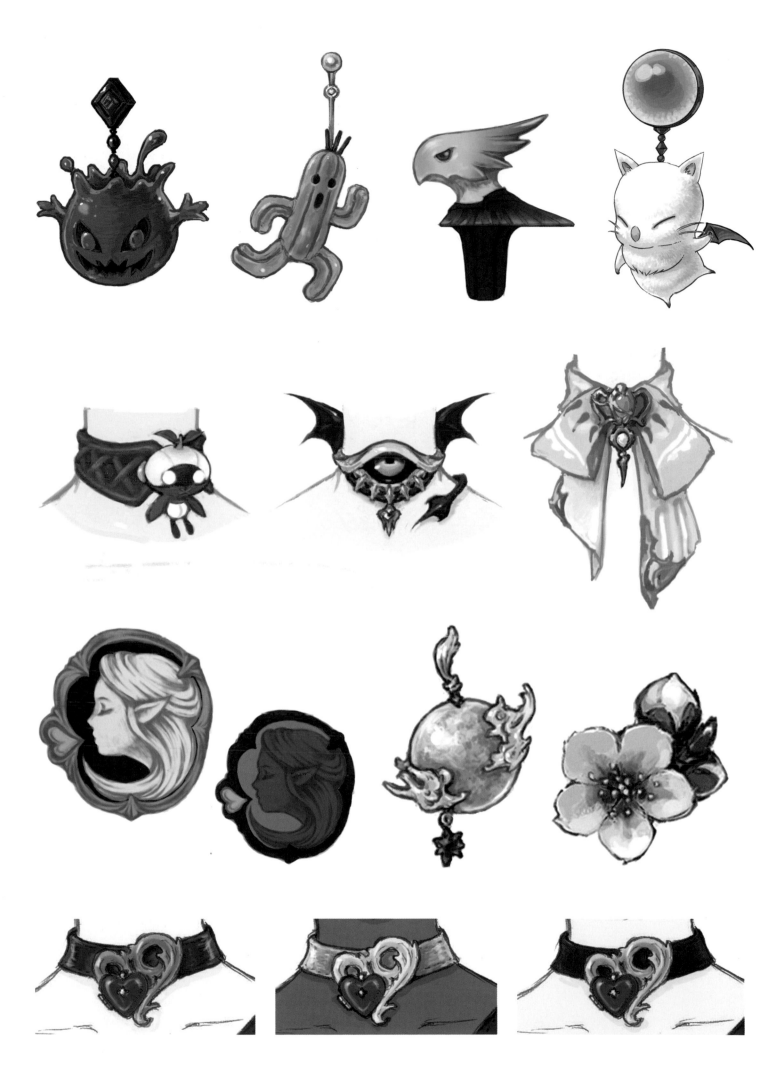

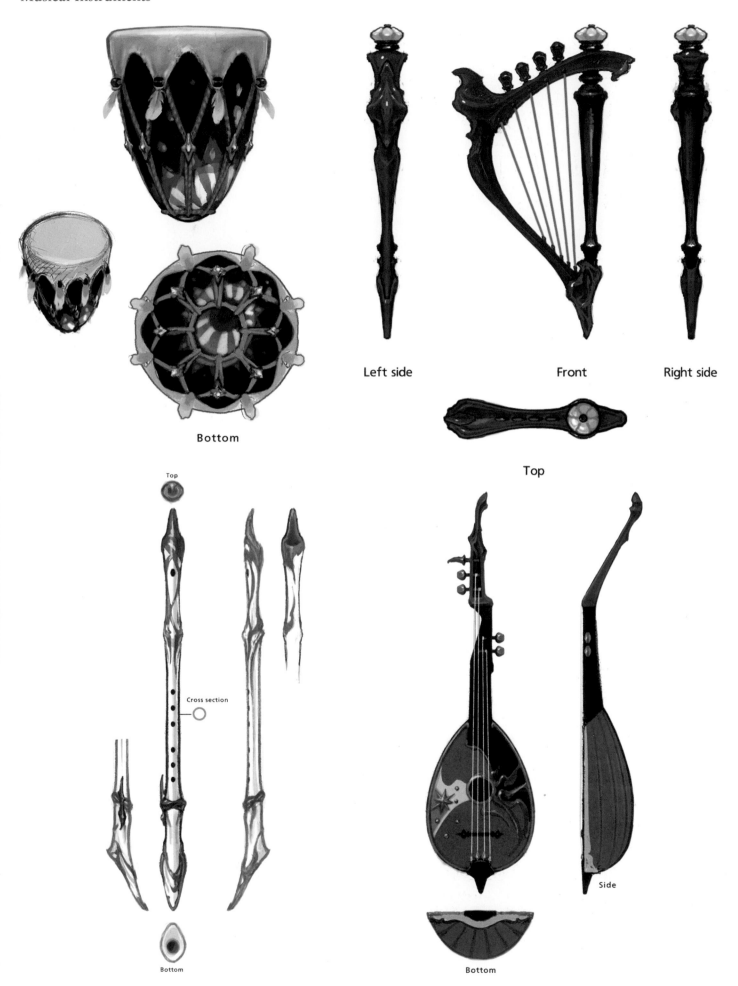

Bottom

Left side Front Right side

Top

Top

Cross section

Bottom

Side

Bottom

We added an extra touch to bring out the characteristics of each instrument: elegance for the flute, playfulness for the drum, and panache for the lute. (Namae)

Cutscene Miscellany

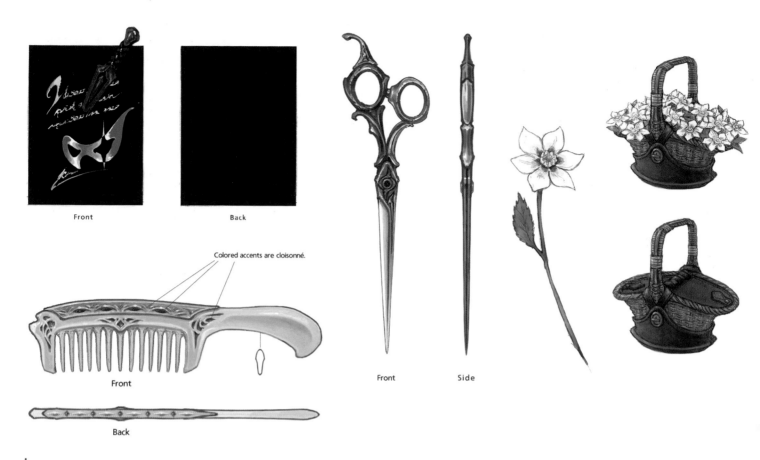

Front

Back

Colored accents are cloisonné.

Front

Back

Front

Side

A great deal of care goes into designing even the smallest items in *FFXIV*, in order to help the world come alive. This is but a small selection of those items. (Namae)

Delivery Moogle

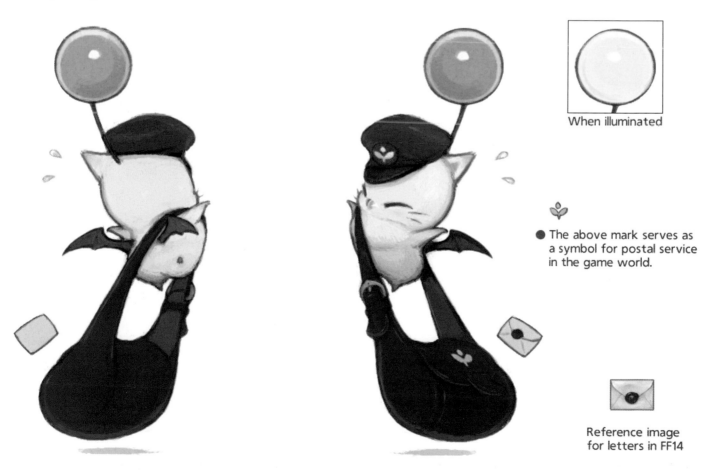

When illuminated

● The above mark serves as a symbol for postal service in the game world.

Reference image for letters in FF14

Carbuncle

Egi

Has same horns as Ifrit's.

Texture of body is like magma.

Burning effect surrounds the hands and shoulders.

Consider a hazy effect around the legs.

Knees

Fairy

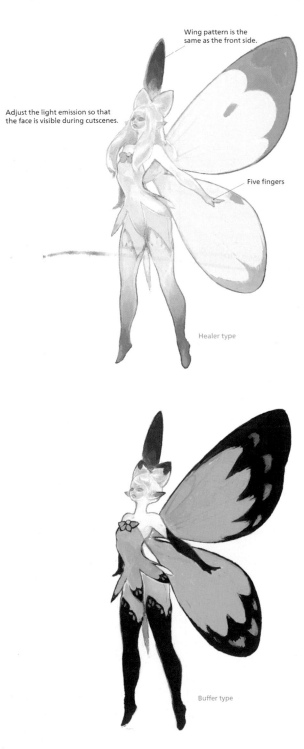

Wing pattern is the same as the front side.

Adjust the light emission so that the face is visible during cutscenes.

Five fingers

Healer type

Buffer type

ENEMIES

FINAL FANTASY XIV: A Realm Reborn
The Art of Eorzea —Another Dawn—

Ifrit, Lord of the Inferno

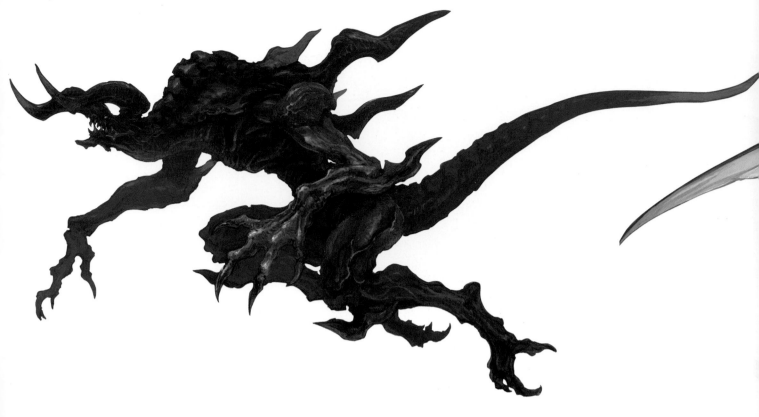

This is one of the first designs I worked on after joining the *FFXIV* team. At the time, I was struggling to design monsters for this world. I envisoned Ifrit as a floating entity when I drew this, so it has a different feel than the in-game enemy. (Nagamine)

Titan, Lord of Crags

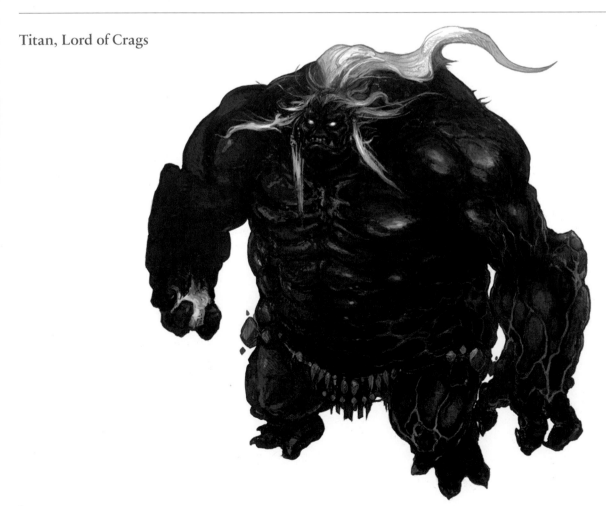

Like Ifrit, this was one of my first designs. My idea was to transform a Buddhist statue into a hulking mass. (Nagamine)

Garuda, Lady of the Vortex

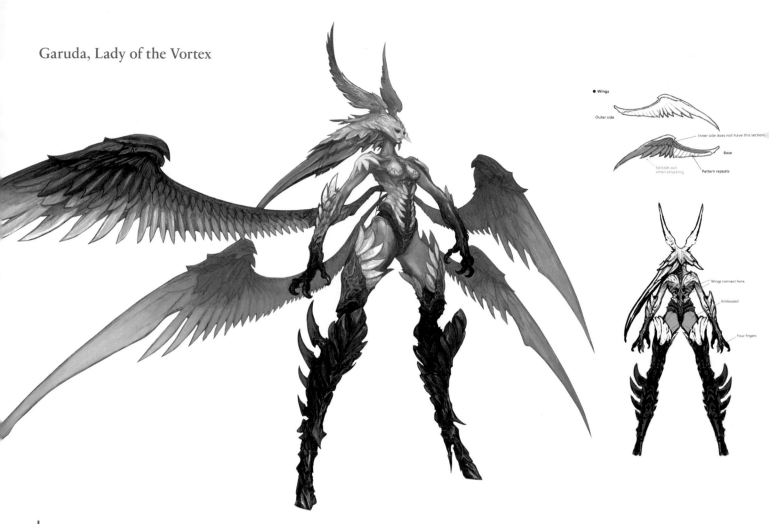

- Wings

Outer side

Inner side does not have this section.

Base

Spreads out when attacking.

Pattern repeats

Wings connect here.

Embossed

Four fingers

I based this on the female model from *FFXI*. I lengthened her legs and drew her in this imposing pose to convey a haughty feeling. (Nagamine)

Leviathan, Lord of the Whorl

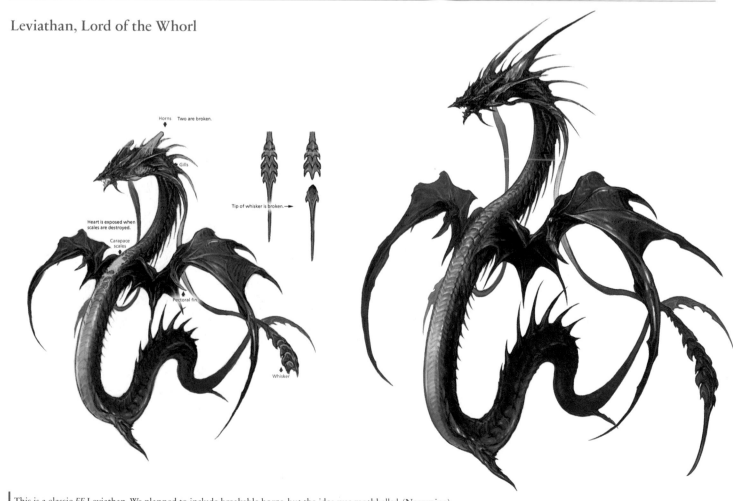

Horns Two are broken.

Gills

Tip of whisker is broken. →

Heart is exposed when scales are destroyed.

Carapace scales

Pectoral fin

Whisker

This is a classic *FF* Leviathan. We planned to include breakable horns, but the idea was mothballed. (Nagamine)

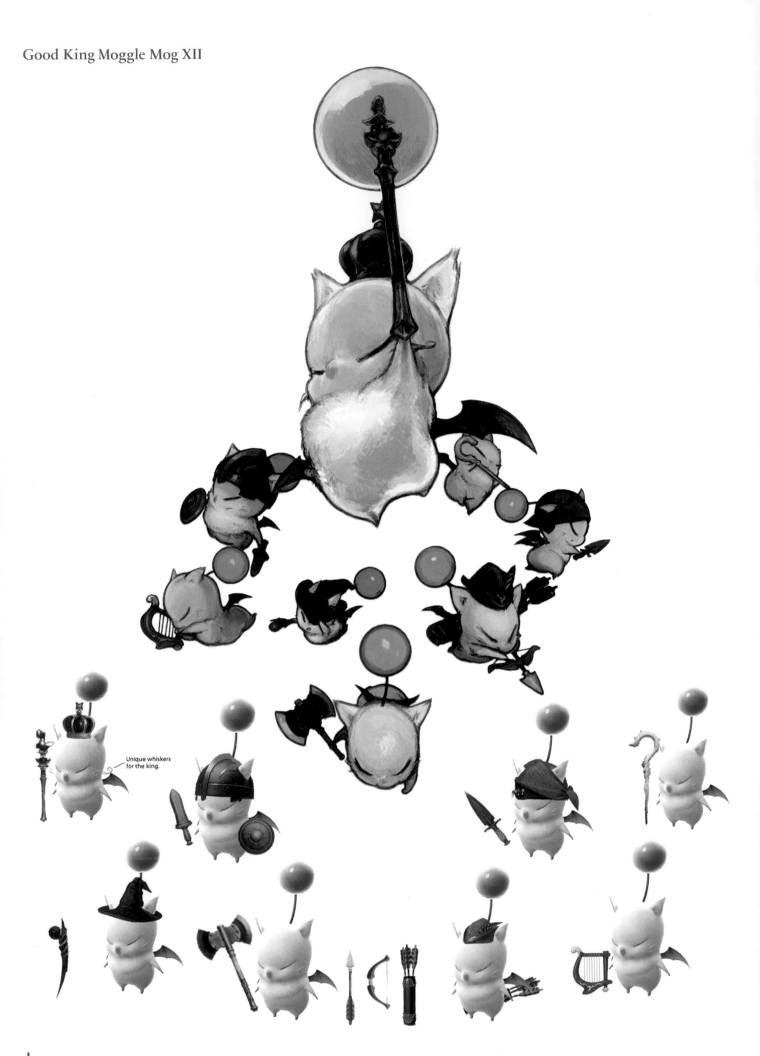

Unique whiskers
for the king.

The moogle king and moogles as various *FF* jobs. It was a lot of fun designing weapons for the moogles to use. (Nagamine)

Ramuh, Lord of Levin

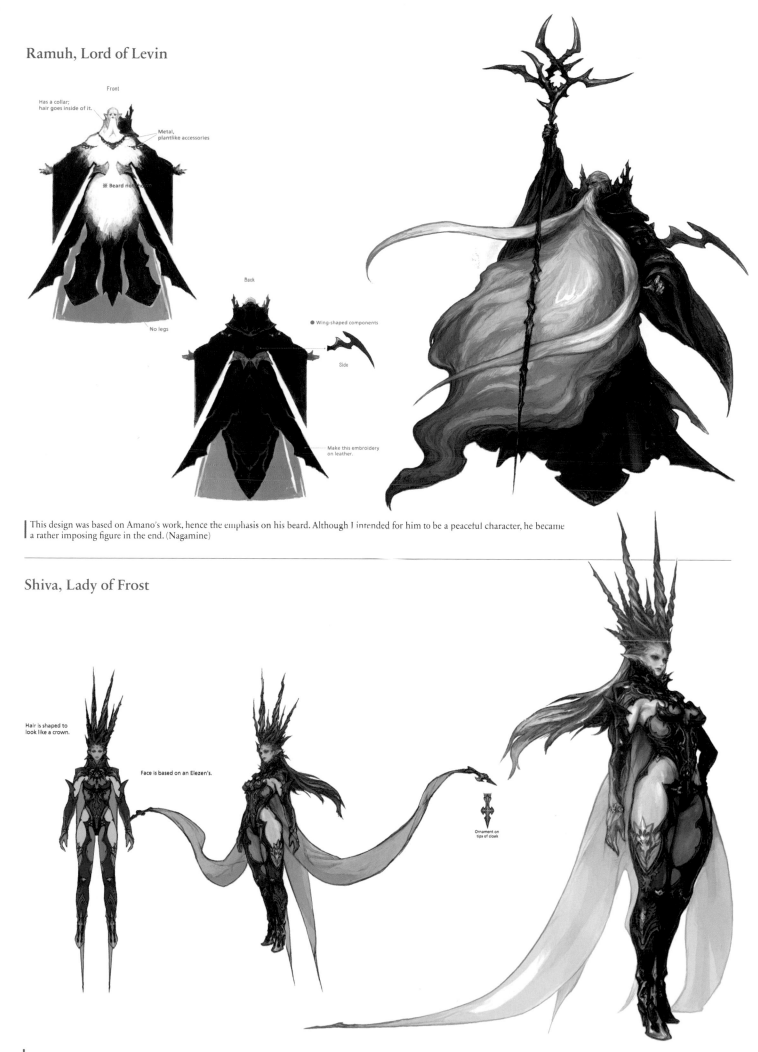

Front

Has a collar;
hair goes inside of it.

Metal,
plantlike accessories

※ Beard not shown

No legs

Back

● Wing-shaped components

Side

Make this embroidery
on leather.

This design was based on Amano's work, hence the emphasis on his beard. Although I intended for him to be a peaceful character, he became a rather imposing figure in the end. (Nagamine)

Shiva, Lady of Frost

Hair is shaped to
look like a crown.

Face is based on an Elezen's.

Ornament on
tips of cloak

Shiva's clothing is modeled after older *FF* appearances, and her hair was designed to resemble a crown formed of ice pillars. (Nagamine)

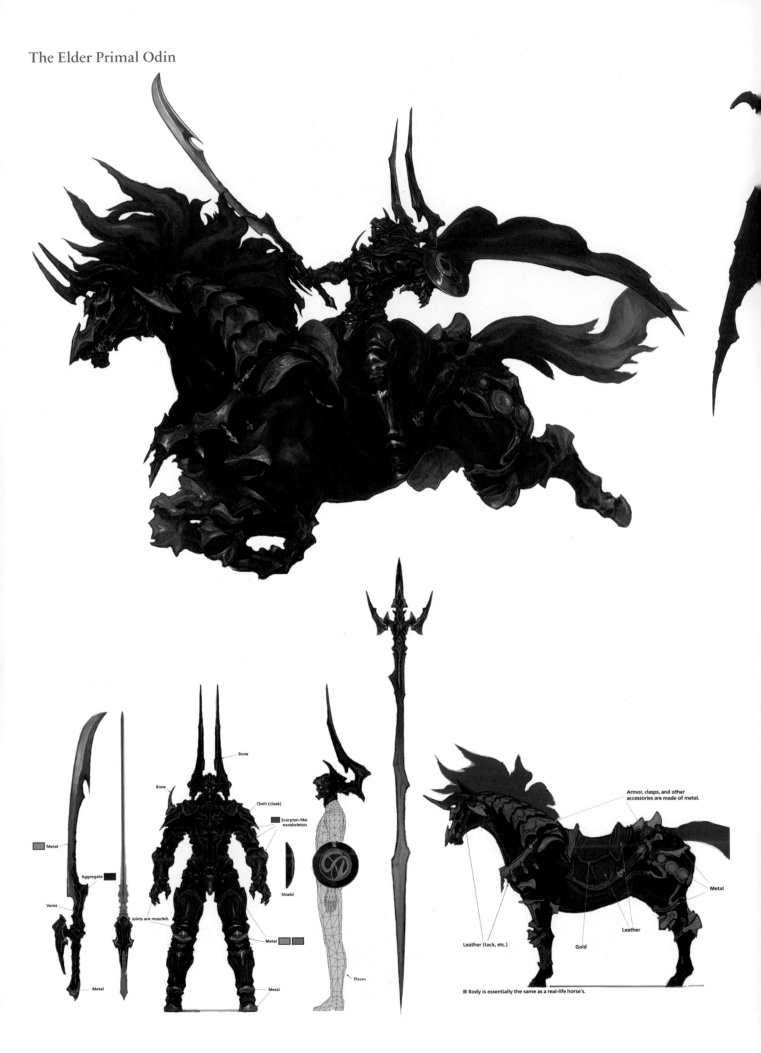

Metal

Aggregate

Veins

Metal

Bone

Bone

Cloth (cloak)

Scorpion-like exoskeleton

Joints are muscled.

Metal

Metal

Shield

Metal

Elezen

Armor, clasps, and other accessories are made of metal.

Metal

Leather

Leather (tack, etc.)

Gold

※ Body is essentially the same as a real-life horse's.

Since Odin was designed as a knight in white armor in *FFXI*, I chose to draw him as a figure clad in black, menacing armor that could be either metallic or organic. (Nagamine)

The Elder Primal Bahamut

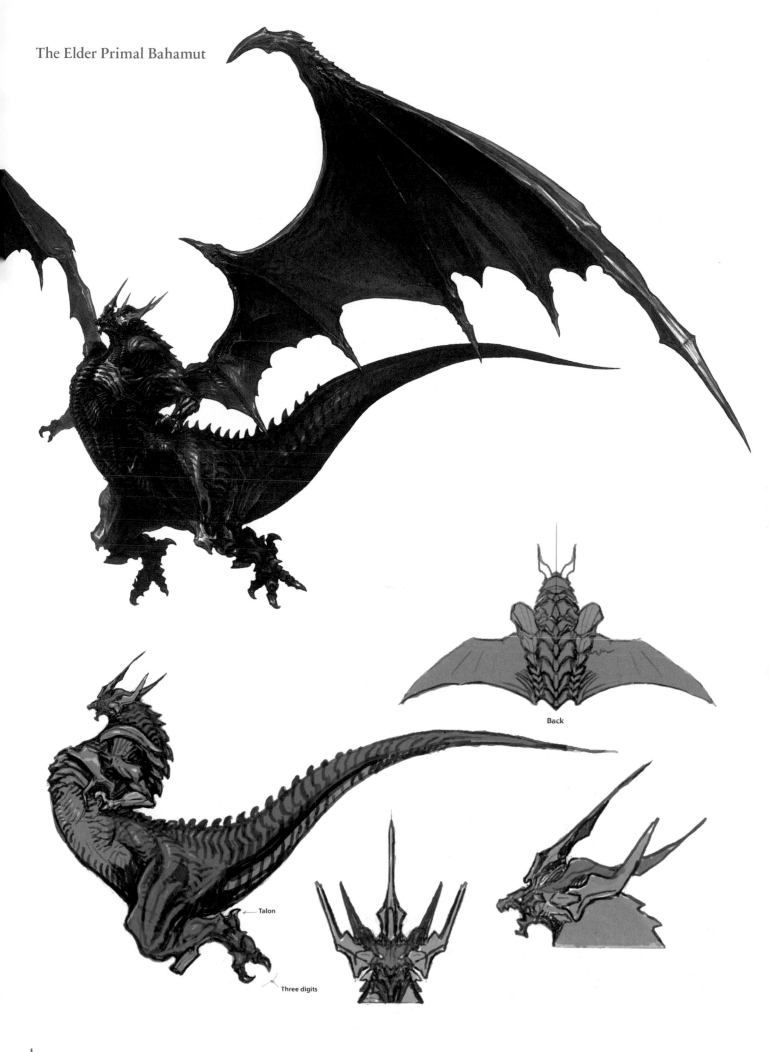

Back

Talon

Three digits

This is Bahamut, who emerged from within Dalamud. I agonized over being unable to make him look cool while preserving his restraints. (Nagamine)

Flamecrest Afajj Koh

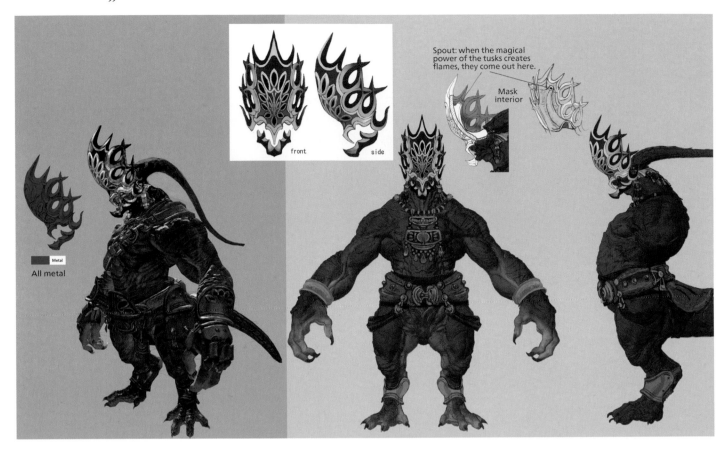

Spout: when the magical power of the tusks creates flames, they come out here.

Mask interior

front

side

Metal

All metal

The Amalj'aa's design has Buddhist influences, so I tried rendering the deity Acala's fiery halo as a crown. (Tsukamoto)

Fifth Order Patriarch Ze Bu

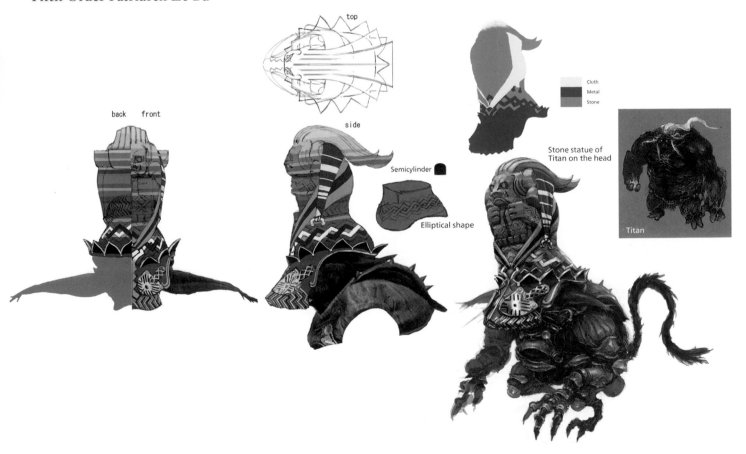

top

side

back front

Semicylinder

Elliptical shape

Cloth

Metal

Stone

Stone statue of Titan on the head

Titan

I added a garden shovel to the hood covering his eyes since kobolds are hole diggers. I threw Titan in up top. (Tsukamoto)

Kozol Nomotl the Turbulent

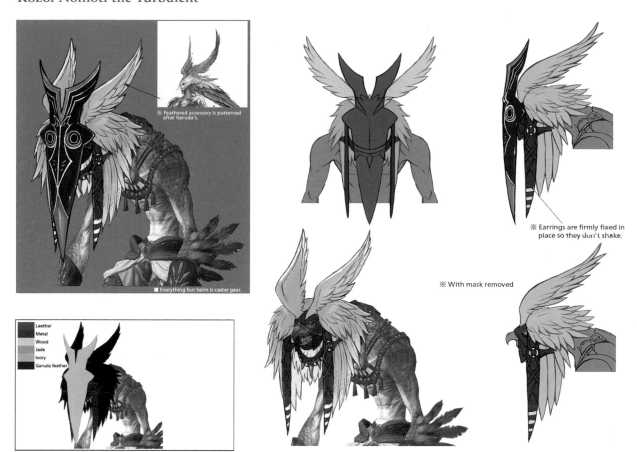

※ Feathered accessory is patterned after Garuda's.

■ Everything but helm is caster gear.

Leather
Metal
Wood
Jade
Ivory
Garuda feather

※ Earrings are firmly fixed in place so they don't shake.

※ With mask removed

The mask was designed with an African tribal motif in mind. (Mihara)

Yarr the Wavefiend

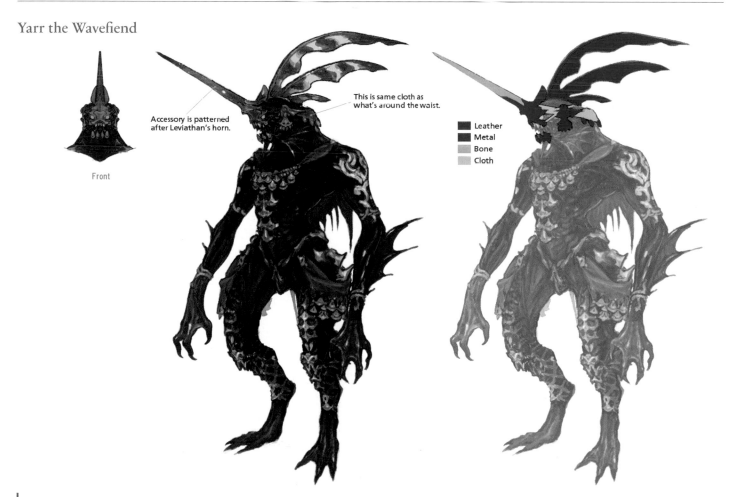

Front

Accessory is patterned after Leviathan's horn.

This is same cloth as what's around the waist.

Leather
Metal
Bone
Cloth

I designed him so that you could tell him apart from other Sahagin at a glance. The horn is a marlin's, and the bridle-like headdress has a lionfish's dorsal fin motif. (Nagamine)

Siren

Designed to combine FFVIII's Siren and Garuda. Has many of the same features as Garuda, but differs as below.

Garuda
• Wider oblong silhouette
• Sharp, aggressive

Siren
• Longer oblong silhouette
• Curved, defensive (feminine)
• Attacks indirectly with harp

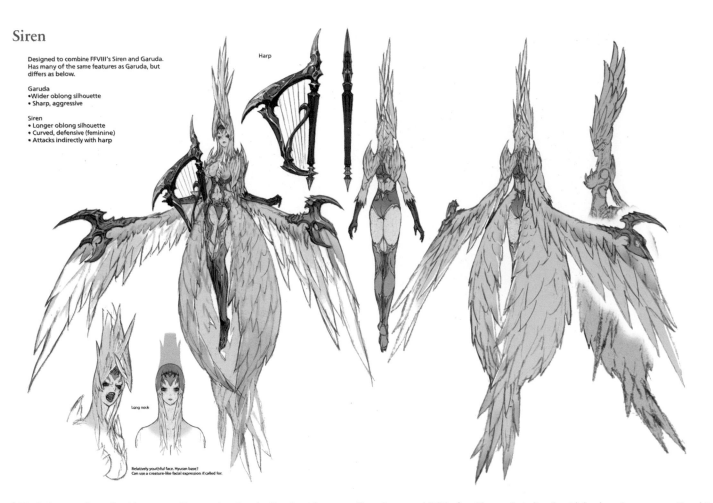

Harp

Long neck

Relatively youthful face. Hyuran base? Can use a creature-like facial expression if called for.

My design was chosen for this creature. Compared to Garuda, Siren has a longer profile and a more childlike face. She attacks indirectly with her harp, in contrast to Garuda's more aggressive behavior. (Masao)

Zu

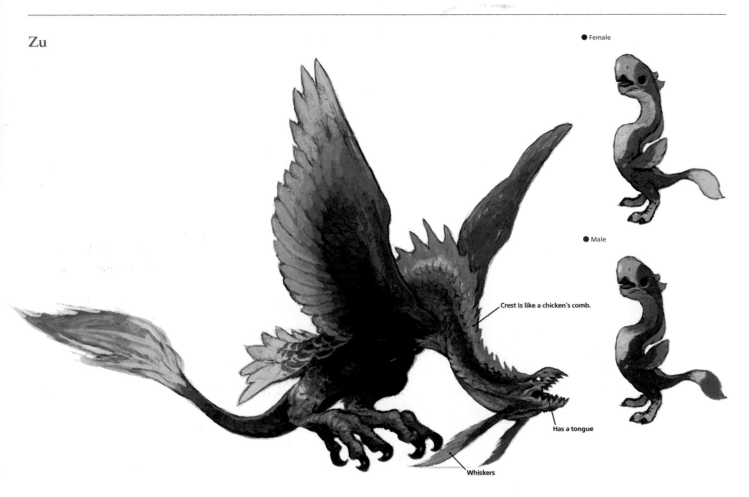

● Female

● Male

Crest is like a chicken's comb.

Has a tongue

Whiskers

The design was based on the *FFV* sprite. I made its legs large enough to conceivably grab a player during combat. (Nagamine)

Succubus and Halicarnassus

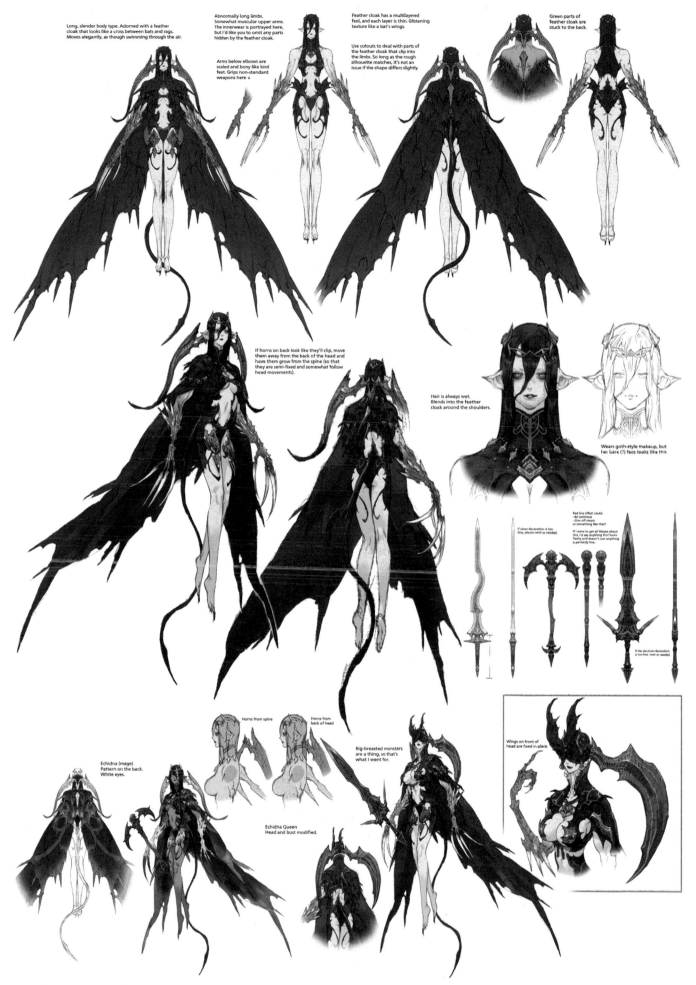

Since bondage gear doesn't mesh with the world setting, I cut down on the manufactured elements and tried to give the rest a more organic appearance, like the clothing that could arguably be wings. Although it retains traditional elements, I'd like to think I created a different flavor of succubus. (Masao)

Ash

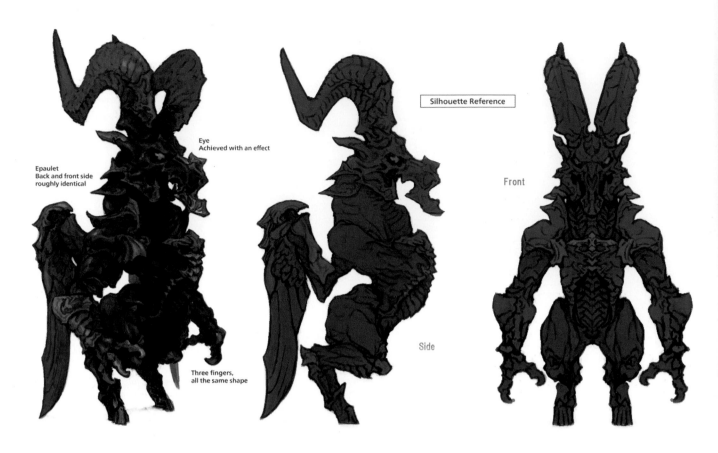

Epaulet
Back and front side
roughly identical

Eye
Achieved with an effect

Three fingers,
all the same shape

Silhouette Reference

Front

Side

The goat's head gives it a demonic appearance. To make it even more imposing, I made the head unnaturally large. (Nagamine)

Diabolos

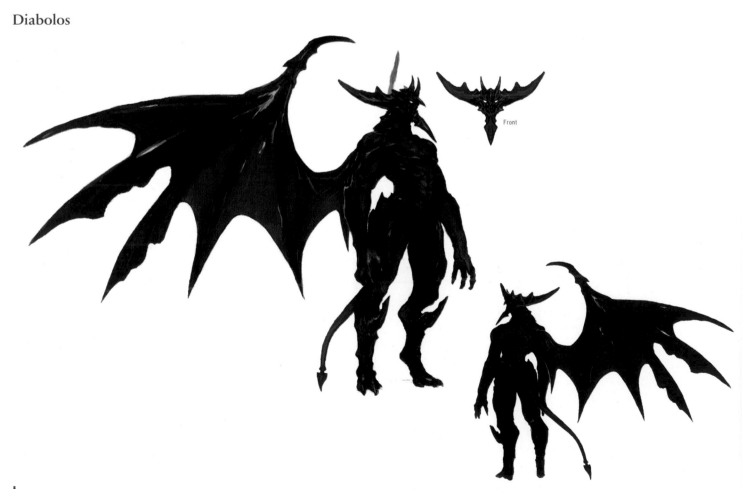

Front

We decided to emulate the *FFVIII* design. His introduction before the fight was also a reimagining of this version. (Nagamine)

Arioch

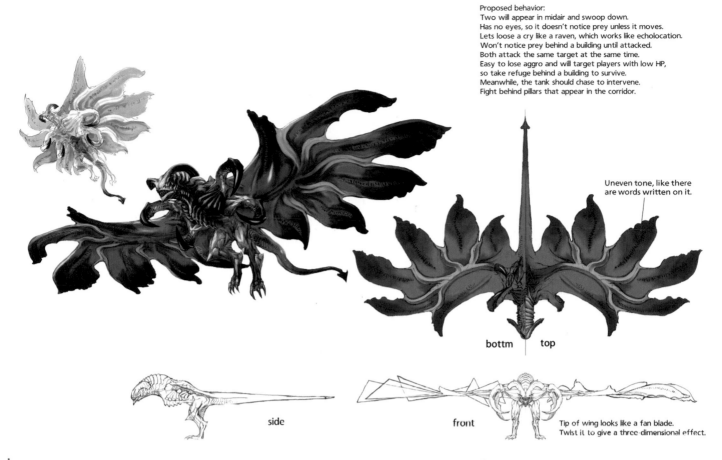

Proposed behavior:
Two will appear in midair and swoop down.
Has no eyes, so it doesn't notice prey unless it moves.
Lets loose a cry like a raven, which works like echolocation.
Won't notice prey behind a building until attacked.
Both attack the same target at the same time.
Easy to lose aggro and will target players with low HP,
so take refuge behind a building to survive.
Meanwhile, the tank should chase to intervene.
Fight behind pillars that appear in the corridor.

Uneven tone, like there are words written on it.

bottm | top

side

front

Tip of wing looks like a fan blade.
Twist it to give a three-dimensional effect.

At first, I envisioned this as a blood-red demon, and when the wind howled it would gather like a murder of crows. (Tsukamoto)

Decaying Gourmand

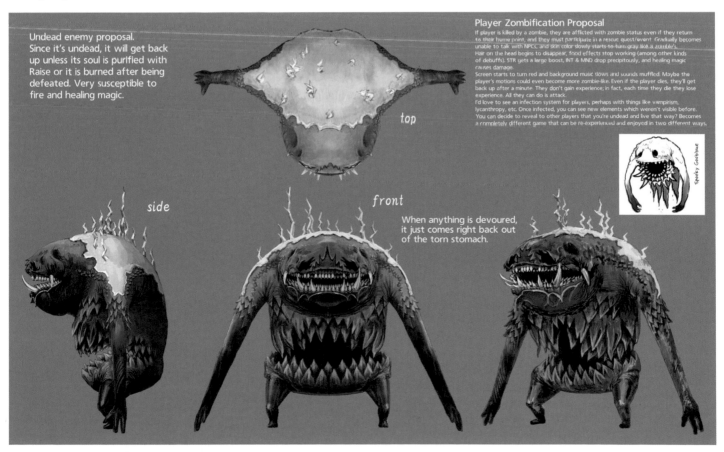

Undead enemy proposal.
Since it's undead, it will get back up unless its soul is purified with Raise or it is burned after being defeated. Very susceptible to fire and healing magic.

Player Zombification Proposal
If player is killed by a zombie, they are afflicted with zombie status even if they return to their home point, and they must participate in a rescue quest/event. Gradually becomes unable to talk with NPCs, and skin color slowly starts to turn gray like a zombie's. Hair on the head begins to disappear, food effects stop working (among other kinds of debuffs), STR gets a large boost, INT & MIND drop precipitously, and healing magic causes damage.
Screen starts to turn red and background music slows and sounds muffled. Maybe the player's motions could even become more zombie-like. Even if the player dies, they'll get back up after a minute. They don't gain experience; in fact, each time they die they lose experience. All they can do is attack.
I'd love to see an infection system for players, perhaps with things like vampirism, lycanthropy, etc. Once infected, you can see new elements which weren't visible before. You can decide to reveal to other players that you're undead and live that way? Becomes a completely different game that can be re-experienced and enjoyed in two different ways.

top

side

front

When anything is devoured, it just comes right back out of the torn stomach.

This zombie goobbue was chosen in an internal design contest. At first, I imagined a player encountering an oddly colored goobbue facing a wall, and when they attacked, it would turn around to reveal its true form. (Tsukamoto)

151

Baalzephon

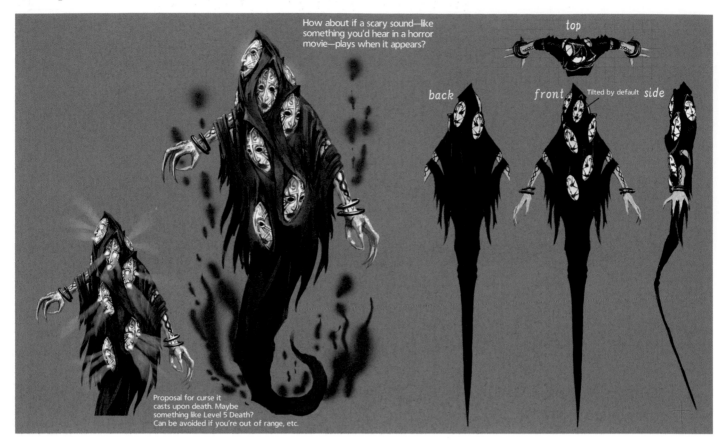

How about if a scary sound—like something you'd hear in a horror movie—plays when it appears?

top

back front Tilted by default side

Proposal for curse it casts upon death. Maybe something like Level 5 Death? Can be avoided if you're out of range, etc.

This many-faced spirit of death was chosen in an internal design contest. Although it leaves quite an impression the first time you face it, it loses something with subsequent appearances—unless you died to it before, perhaps? (Tsukamoto)

Gremlin, Hecteyes, and Mimic

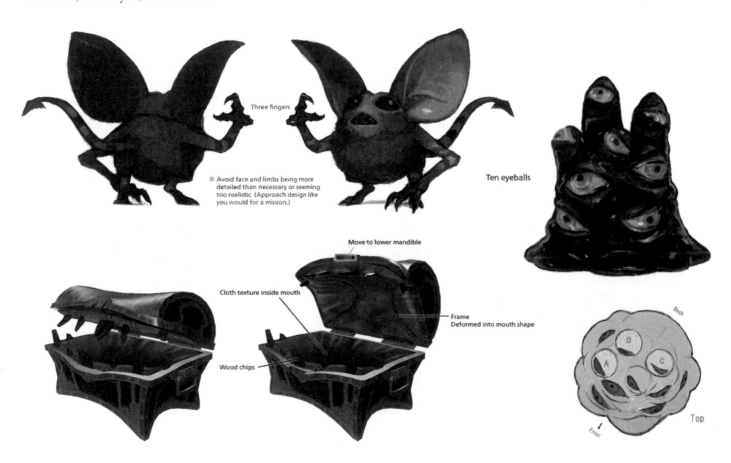

Three fingers

※ Avoid face and limbs being more detailed than necessary or seeming too realistic. (Approach design like you would for a minion.)

Ten eyeballs

Move to lower mandible

Cloth texture inside mouth

Frame
Deformed into mouth shape

Wood chips

Back

B

A C

Front Top

Narasimha

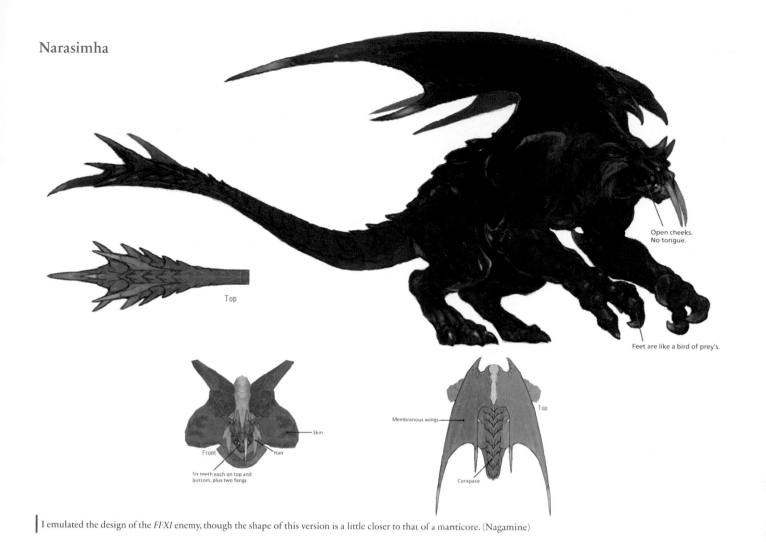

Open cheeks.
No tongue.

Feet are like a bird of prey's.

Top

Skin

Front

Hair

Six teeth each on top and bottom, plus two fangs

Membranous wings

Top

Carapace

I emulated the design of the *FFXI* enemy, though the shape of this version is a little closer to that of a manticore. (Nagamine)

Pyracmon

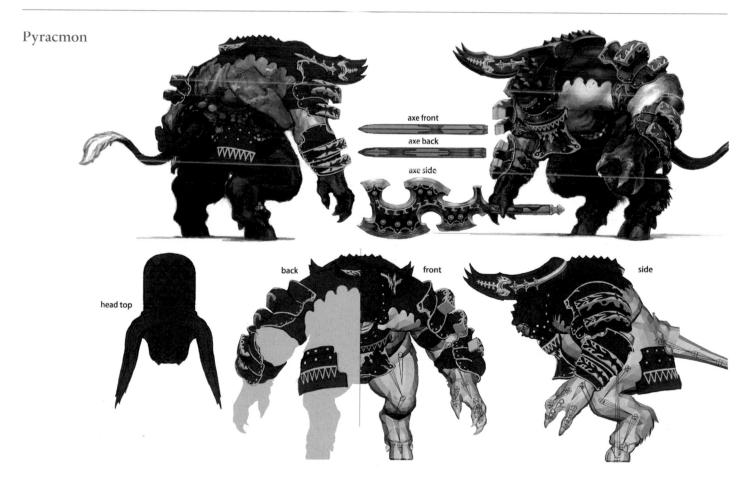

axe front

axe back

axe side

head top

back

front

side

I was asked to create a cyclops wearing Ul'dahn armor, so I designed this extravagant black and gold armor. Of course, when you're fighting him, you don't have time to appreciate the design. (Tsukamoto)

Catoblepas

Side

Gold Bear

Hyuran(Man)
174cm

Compare with PC

Use different color shades to create fur pattern.

Eorzean Bear
has layered fur.

Sometimes it stands
on hind legs to attack.

Gobmachine G-VI

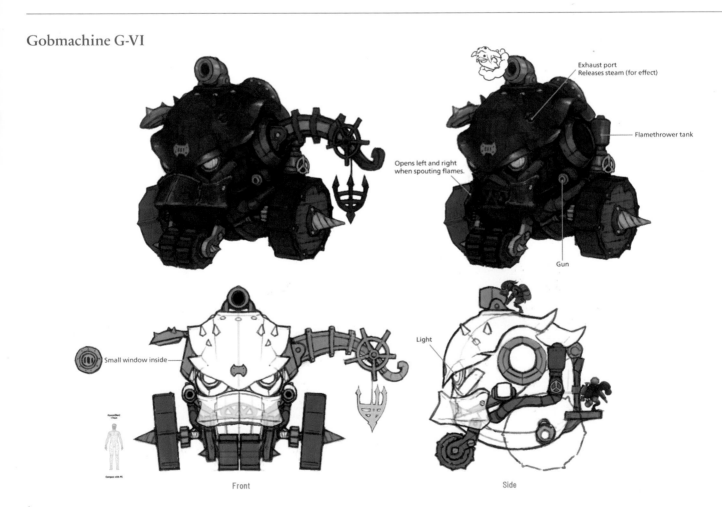

Exhaust port
Releases steam (for effect)

Flamethrower tank

Opens left and right
when spouting flames.

Gun

Small window inside

Light

Hyuran(Man)
174cm

Compare with PC

Front

Side

The tank was designed with a goblin face motif. I also took inspiration from the Hi Ho Tank that appears in *Chrono Cross*. (Nagamine)

Magitek Vangob G-III

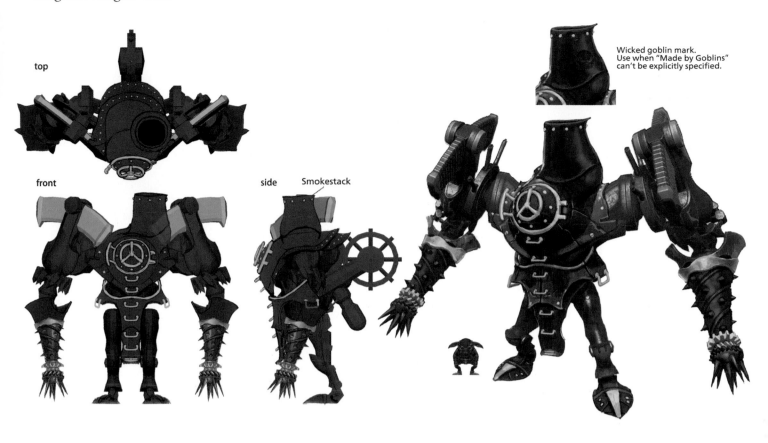

top

front

side Smokestack

Wicked goblin mark.
Use when "Made by Goblins"
can't be explicitly specified.

It originally had a face like the Gobmachine G-VI. If you look closely, you can still see the vague outline of it. (Tsukamoto)

Illuminati Marksman and Glider

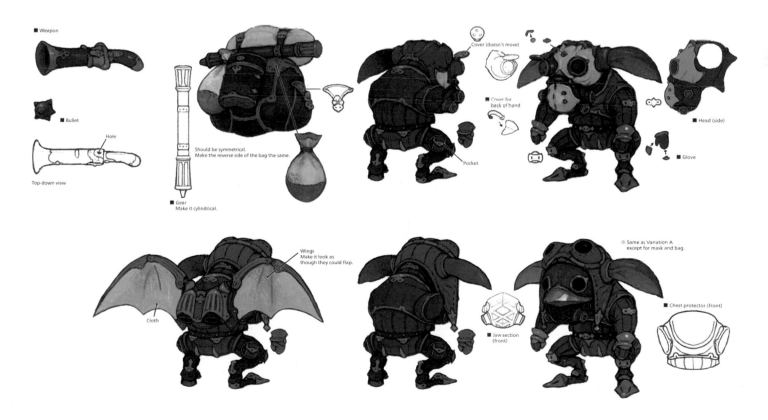

■ Weapon

■ Bullet

Hole

Top-down view

Should be symmetrical.
Make the reverse side of the bag the same.

■ Gear
Make it cylindrical.

Cover (doesn't move)

■ Cover for
back of hand

Pocket

■ Head (side)

■ Glove

Wings
Make it look as
though they could flap.

Cloth

※ Same as Variation A
except for mask and bag.

■ Jaw section
(front)

■ Chest protector (front)

We received other ideas from the character team as well, including one for an Illuminati diver. I hope we can use them someday. (Nagamine)

Kraken

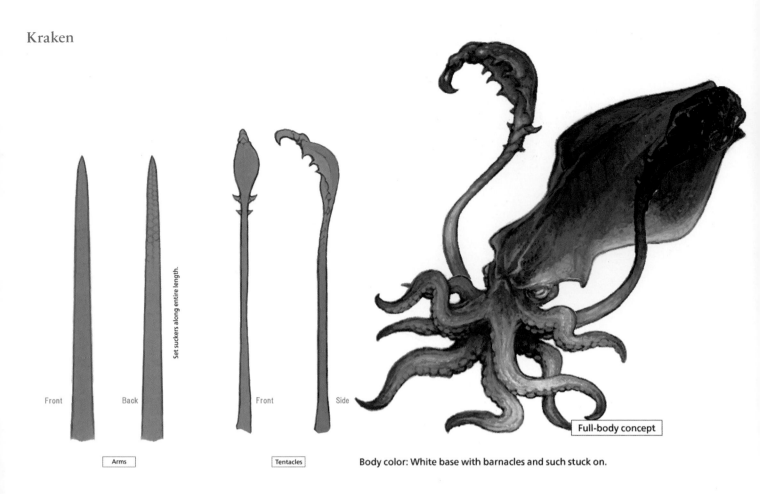

Front Back

Set suckers along entire length.

Front Side

Arms

Tentacles

Full-body concept

Body color: White base with barnacles and such stuck on.

Since it was planned that the Kraken would fight only with its arms, we didn't flesh out its design as much as other creatures. As a whole, it resembles a normal squid. (Nagamine)

Sasquatch

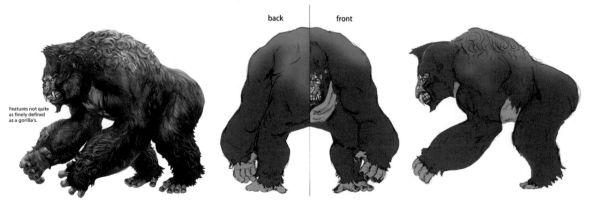

back front

Features not quite as finely defined as a gorilla's.

Harpeia

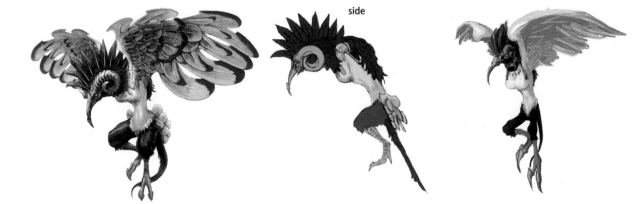

side

Avere Bravearm

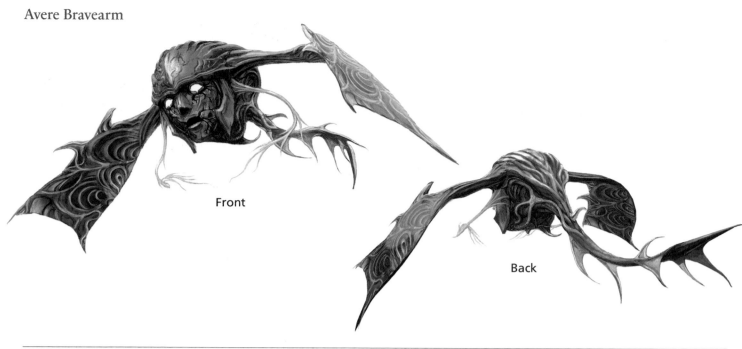

Front

Back

Giruveganaus

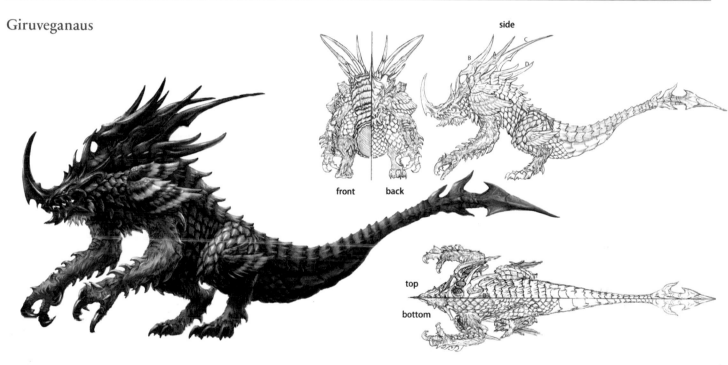

side

B A C
 D

front back

top

bottom

Cuca Fera

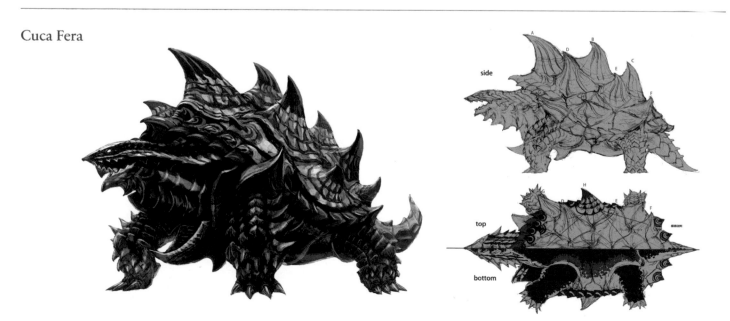

A
 D B
side E C
 F

top
 G H
 D E F

bottom

157

Phlegethon

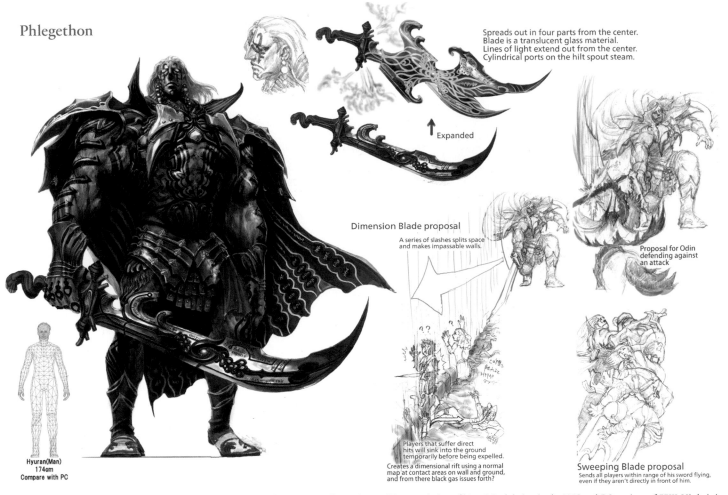

Spreads out in four parts from the center.
Blade is a translucent glass material.
Lines of light extend out from the center.
Cylindrical ports on the hilt spout steam.

Expanded

Dimension Blade proposal

A series of slashes splits space
and makes impassable walls.

Proposal for Odin
defending against
an attack

Players that suffer direct
hits will sink into the ground
temporarily before being expelled.
Creates a dimensional rift using a normal
map at contact areas on wall and ground,
and from there black gas issues forth?

Sweeping Blade proposal
Sends all players within range of his sword flying,
even if they aren't directly in front of him.

Hyuran(Man)
174cm
Compare with PC

FFXIV's Phlegethon, who was a revolutionary leader, was based on Amano's illustrations and is an evolution of his original design in the NES and DS versions of *FFIII*. His hair is longer now, though. (Tsukamoto)

Emperor Xande

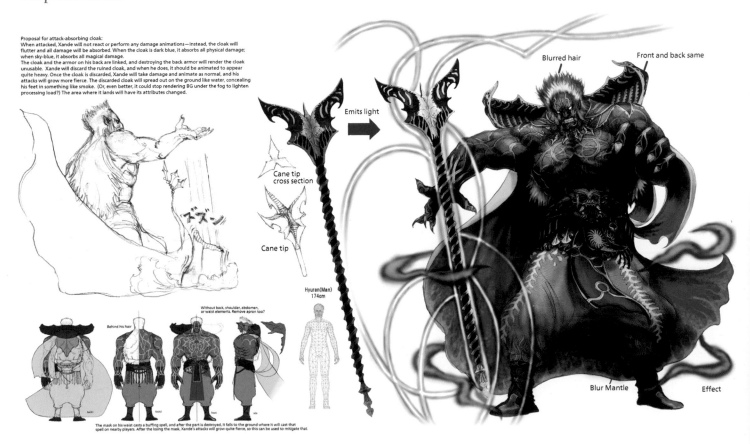

Proposal for attack-absorbing cloak:
When attacked, Xande will not react or perform any damage animations—instead, the cloak will flutter and all damage will be absorbed. When the cloak is dark blue, it absorbs all physical damage; when sky-blue, it absorbs all magical damage.
The cloak and the armor on his back are linked, and destroying the back armor will render the cloak unusable. Xande will discard the ruined cloak, and when he does, it should be animated to appear quite heavy. Once the cloak is discarded, Xande will take damage and animate as normal, and his attacks will grow more fierce. The discarded cloak will spread out on the ground like water, concealing his feet in something like smoke. (Or, even better, it could stop rendering BG under the fog to lighten processing load?) The area where it lands will have its attributes changed.

Blurred hair

Front and back same

Emits light

Cane tip
cross section

Cane tip

Hyuran(Man)
174cm

Blur Mantle

Effect

Without back, shoulder, abdomen,
or waist elements. Remove apron too?

Behind his hair

The mask on his waist casts a buffing spell, and after the part is destroyed, it falls to the ground where it will cast that spell on nearby players. After the losing the mask, Xande's attacks will grow quite fierce, so this can be used to mitigate that.

This version of Xande is a combination of his *FFIII* NES design and two Amano illustrations from *Dawn: The Worlds of Final Fantasy*. Even so, I was quite unsure about how to handle Xande's hairline. His entire body radiates a powerful aura. (Tsukamoto)

Glasya Labolas

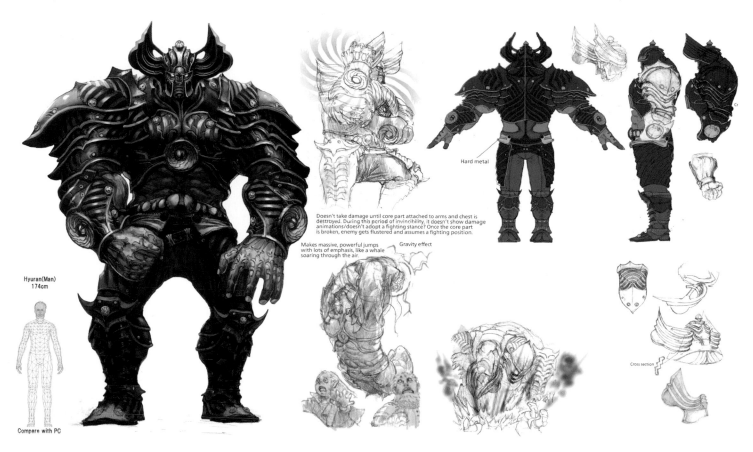

Hyuran(Man)
174cm

Compare with PC

Hard metal

Doesn't take damage until core part attached to arms and chest is destroyed. During this period of invincibility, it doesn't show damage animations/doesn't adopt a fighting stance? Once the core part is broken, enemy gets flustered and assumes a fighting position.

Makes massive, powerful jumps with lots of emphasis, like a whale soaring through the air.

Gravity effect

Cross section

I based the design on the Guardian, a green giant from the NES version of *FFIII*. At one stage, it was proposed that he have special cores in his arms and torso that players would need to destroy to defeat him, so I added armor for this reason. He looks like he'd chase you down and beat you senseless, but he only bothers to attack the main tank most of the time. (Tsukamoto)

Amon

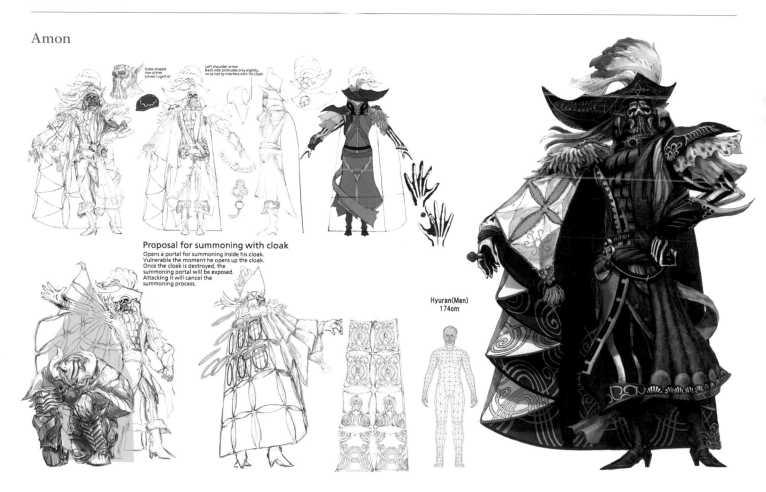

Scale-shaped iron plates joined together

Left shoulder armor. Back side protrudes only slightly, so as not to interfere with his cloak.

Proposal for summoning with cloak
Opens a portal for summoning inside his cloak. Vulnerable the moment he opens up the cloak. Once the cloak is destroyed, the summoning portal will be exposed. Attacking it will cancel the summoning process.

Hyuran(Man)
174cm

Since we were unable to use human bones due to various issues, I added cloth to his goggles to hide his face. In *FFXIV*, Amon is a rather psychotic character, and Scylla is one of his victims. (Tsukamoto)

Scylla

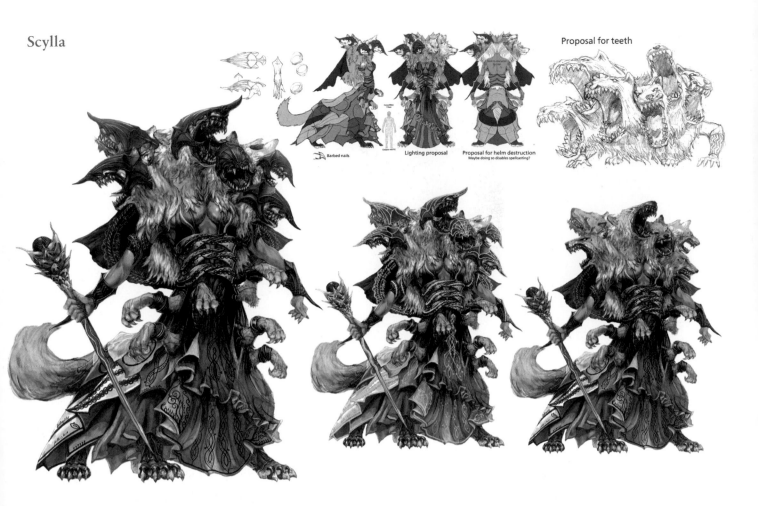

Barbed nails

Lighting proposal

Proposal for helm destruction
Maybe doing so disables spellcasting?

Proposal for teeth

It was proposed at one point that Scylla's masks be destructible, like Glasya Labolas's cores. As was the case for all Crystal Tower bosses, I had to add neon coloring. (Tsukamoto)

Yellow Dragon

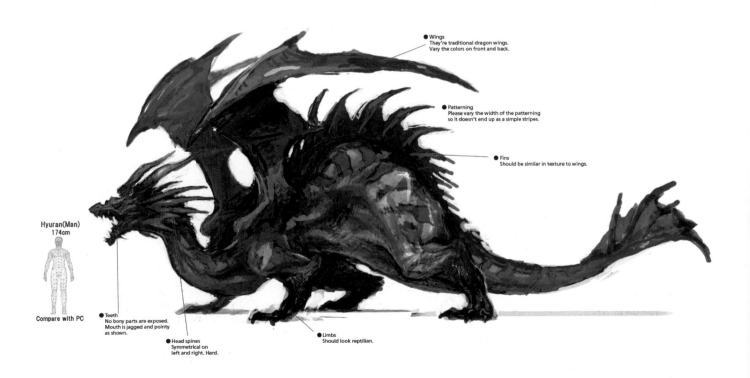

● Wings
They're traditional dragon wings.
Vary the colors on front and back.

● Patterning
Please vary the width of the patterning
so it doesn't end up as a simple stripes.

● Fins
Should be similar in texture to wings.

Hyuran(Man)
174cm

Compare with PC

● Teeth
No bony parts are exposed.
Mouth is jagged and pointy
as shown.

● Head spines
Symmetrical on
left and right. Hard.

● Limbs
Should look reptilian.

I strove for a traditional design and drew this dragon in the image of classic *FF* creations. (Nagamine)

Oceanus

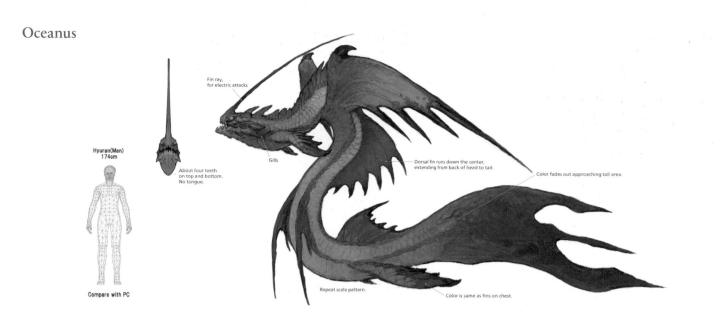

Hyuran(Man)
174cm

Compare with PC

Fin ray,
for electric attacks

Gills

About four teeth
on top and bottom.
No tongue.

Dorsal fin runs down the center,
extending from back of head to tail.

Color fades out approaching tail area.

Repeat scale pattern.

Color is same as fins on chest.

An aquatic dragon whose face resembles that of a Sahagin. Maybe they share a common ancestor? (Nagamine)

Twintania

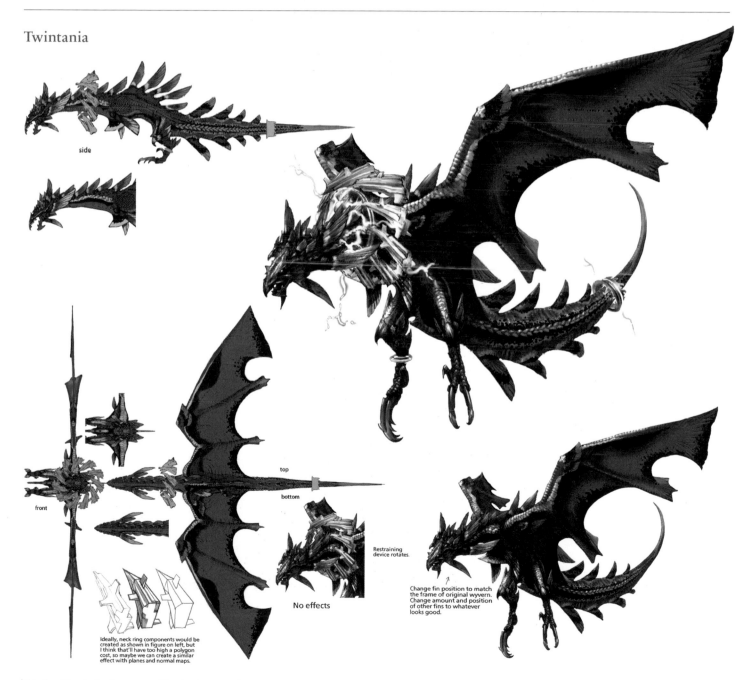

side

front

top

bottom

No effects

Restraining
device rotates.

Change fin position to match
the frame of original wyvern.
Change amount and position
of other fins to whatever
looks good.

Ideally, neck ring components would be
created as shown in figure on left, but
I think that'll have too high a polygon
cost, so maybe we can create a similar
effect with planes and normal maps.

I had no idea the battle team would make the Turn 5 fight that difficult! Maybe they were going through a phase? I wish they had thought more about their coworkers who play the game... (Tsukamoto)

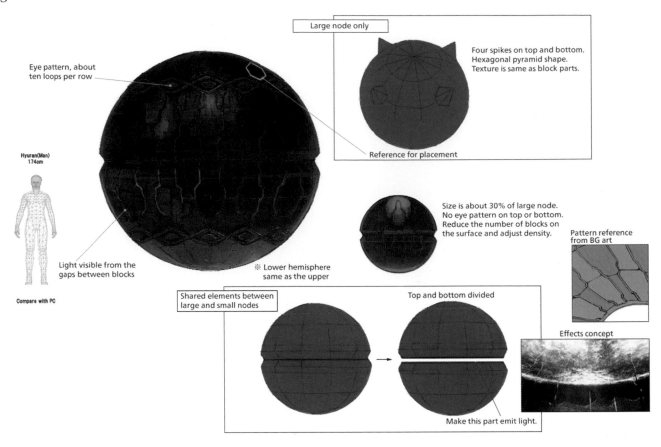

Large node only

Eye pattern, about ten loops per row

Four spikes on top and bottom.
Hexagonal pyramid shape.
Texture is same as block parts.

Reference for placement

Hyuran(Man)
174cm

Size is about 30% of large node.
No eye pattern on top or bottom.
Reduce the number of blocks on
the surface and adjust density.

Pattern reference
from BG art

Light visible from the
gaps between blocks

※ Lower hemisphere
same as the upper

Compare with PC

Shared elements between
large and small nodes

Top and bottom divided

Effects concept

Make this part emit light.

This is a refined version of an idea that came about when we were designing Dalamud. It's a simple and easily recognizable design. (Nagamine)

Nael deus Darnus

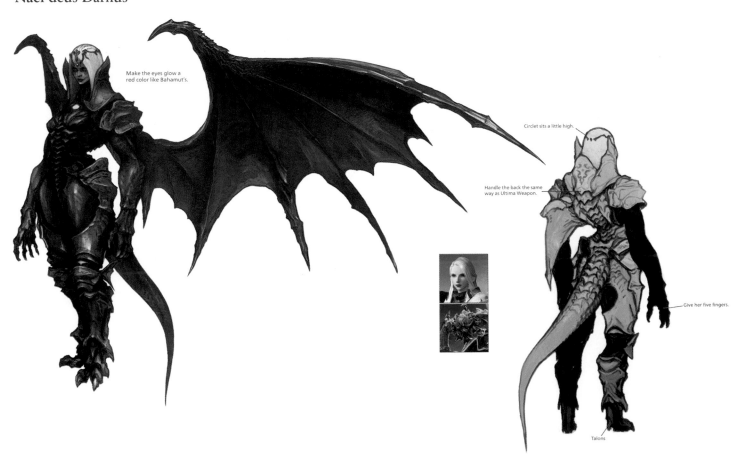

Make the eyes glow a
red color like Bahamut's.

Circlet sits a little high.

Handle the back the same
way as Ultima Weapon.

Give her five fingers.

Talons

This was a complete realization of our vision, from the winged shape reminiscent of Bahamut to the face beneath the mask. (Nagamine)

162

Rafflesia

■ Rafflesia Concept
- A plant with sharp thorns on its body and vines. Utilizes poisons and pollen befitting the Rafflesia concept. Causes undesirable status effects. Combines all the unpleasantness of poison plants and thorny plants.
- Its special body fluid can control insects like bees, etc., in addition to other plants.
- Emits poison from its large mouth, and sucks up and eats all kinds of things.
- Sticks dark matter to other creatures and causes abnormalities.
- Scatters seeds, which then grow into thorny ground.
- Carnivorous rather than herbivorous. Though it typically moves sluggishly, it moves very quickly when capturing prey.

■ Rafflesia Attacks
This is still tentative, but in general, Rafflesia will use the following attacks.
- Bloody Caress: Wide-range frontal attack with ivy
- Rampage: Goes berserk and attacks vicinity with ivy.
- Devour: Eats players and monsters by inhaling them.
- Spit: Spits out whatever it ate.
- Leafstorm: Damages the entire area with a storm of leaf petals.
- Briary Growth: Plants bulbs in the ground that grow and spread thorns in a wider and wider area.
- Sap: Applies sap to targets.
- Blighted Bouquet: Puts a deadly poison on the target that kills them if they move.
- Bug: Causes insects to follow the target. If they don't move, they die.

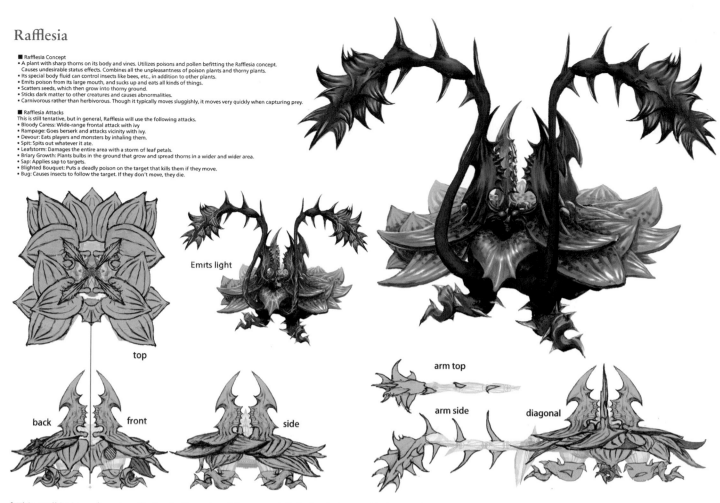

This seedkin is a subspecies of ochu. In fact, when I first started designing it, it resembled a cross between an ochu and a rose, but I gradually made it more menacing. (Tsukamoto)

The Avatar

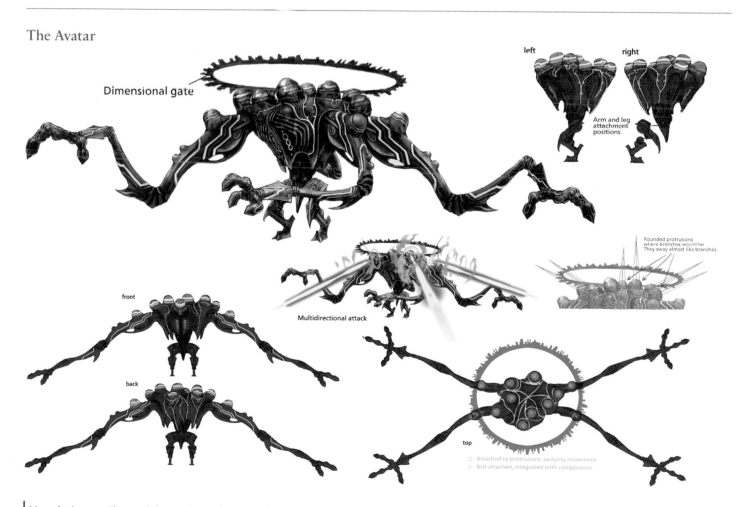

It's a robotic treant. The rounded protrusions at the top are akin to the buds from which branches grow. (Tsukamoto)

Gilgamesh and Enkidu

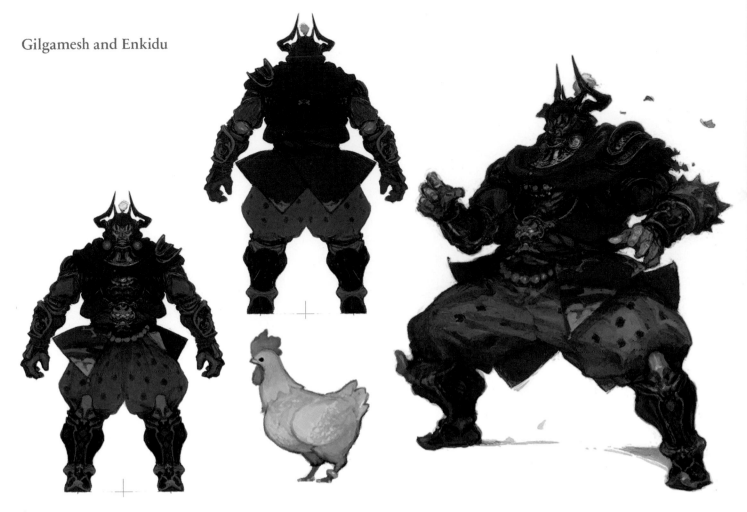

I was greatly influenced by Amano's Gilgamesh design, which I tried to recreate. On Enkidu's leg you'll see a bangle like the one worn by his *FFV* counterpart. (Nagamine)

The Mandragoras

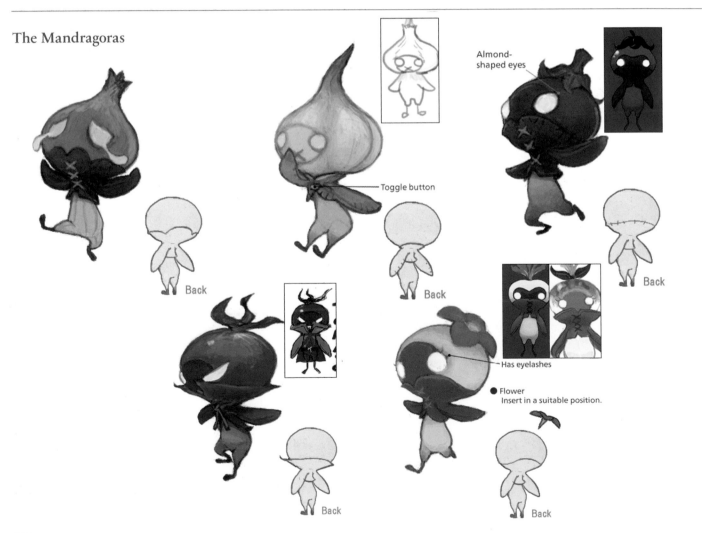

Almond-shaped eyes

Toggle button

Back

Back

Back

Has eyelashes

● Flower
Insert in a suitable position.

Back

Back

Magic Pot

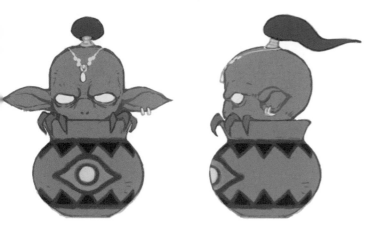

Brickman

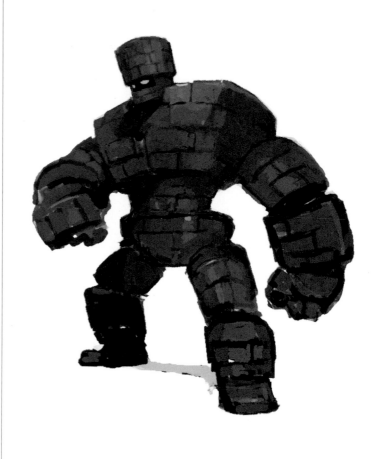

Tonberry

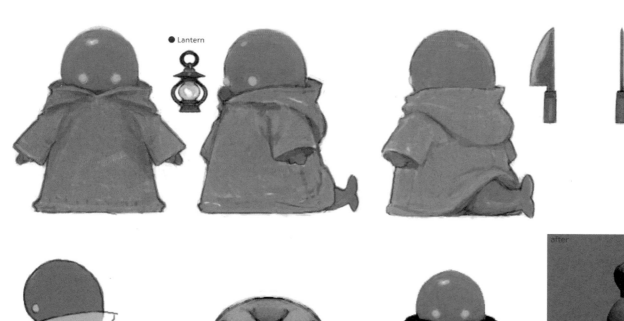

● Lantern

● Beneath robe

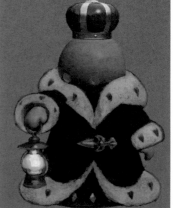

after

Demon Wall

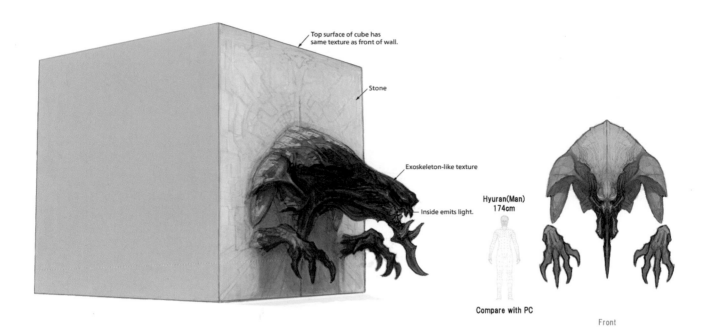

Top surface of cube has same texture as front of wall.

Stone

Exoskeleton-like texture

Inside emits light.

Hyuran(Man)
174cm

Compare with PC

Front

The wall became more cube-like when implemented, and the demon brick minion's design followed suit. (Nagamine)

Tiamat

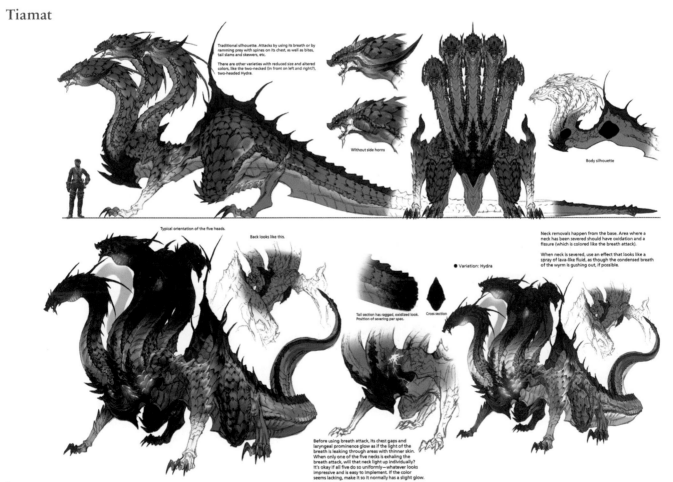

Traditional silhouette. Attacks by using its breath or by ramming prey with spines on its chest, as well as bites, tail slams and skewers, etc.

There are other varieties with reduced size and altered colors, like the two-necked (in front on left and right?), two-headed Hydra.

Without side horns

Body silhouette

Typical orientation of the five heads.

Back looks like this.

Neck removals happen from the base. Area where a neck has been severed should have oxidation and a fissure (which is colored like the breath attack).

When neck is severed, use an effect that looks like a spray of lava-like fluid, as though the condensed breath of the wyrm is gushing out, if possible.

Tail section has ragged, oxidized look. Position of severing per spec.

Cross section

● Variation: Hydra

Before using breath attack, its chest gaps and laryngeal prominence glow as if the light of the breath is leaking through areas with thinner skin. When only one of the five necks is exhaling the breath attack, will that neck light up individually? It's okay if all five do so uniformly—whatever looks impressive and is easy to implement. If the color seems lacking, make it so it normally has a slight glow.

My draft was chosen for this creature. The light shining through the gaps in its scales is from the deadly breath within its lungs. The shape, however, is fairly traditional. (Masao)

Dhorme Chimera

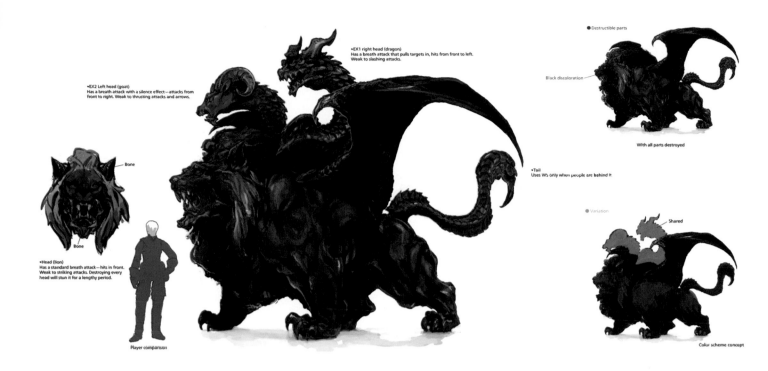

•EX2 Left head (goat)
Has a breath attack with a silence effect—attacks from front to right. Weak to thrusting attacks and arrows.

•EX1 right head (dragon)
Has a breath attack that pulls targets in, hits from front to left. Weak to slashing attacks.

Bone

Bone

•Head (lion)
Has a standard breath attack—hits in front. Weak to striking attacks. Destroying every head will stun it for a lengthy period.

Player comparison

● Destructible parts

Black discoloration

With all parts destroyed

•Tail
Uses WS only when people are behind it

● Variation

Shared

Color scheme concept

Since the chimera is an amalgamation of multiple creatures, the colors I chose and the textures I created were intended to evoke an overall feeling of irregularity. (Nagamine)

Behemoth

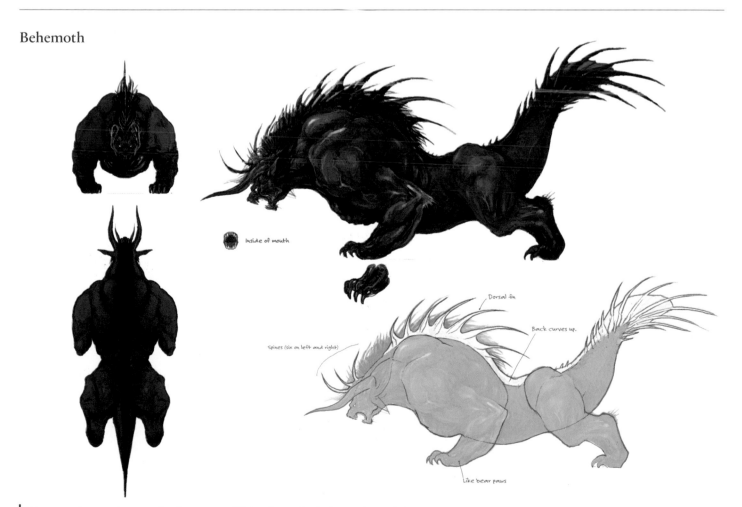

Inside of mouth

Dorsal fin

Back curves up.

Spines (six on left and right)

Like bear paws

This creature is present in many other *FF* games, so I didn't make any drastic changes. (Nagamine)

Gaius van Baelsar

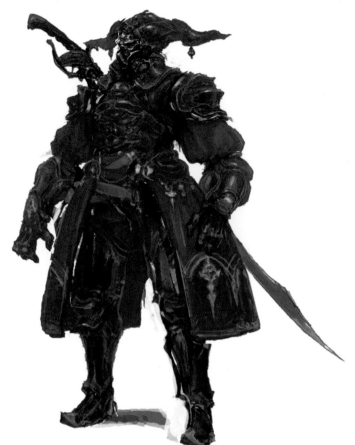

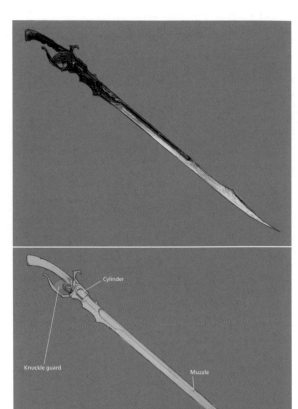

Cylinder

Knuckle guard

Muzzle

For the color scheme, I chose red and black, like the Gestahlian Empire in *FFVI*. The armor is based on the design of Odin from *FFXI*. (Nagamine)

Nael van Darnus

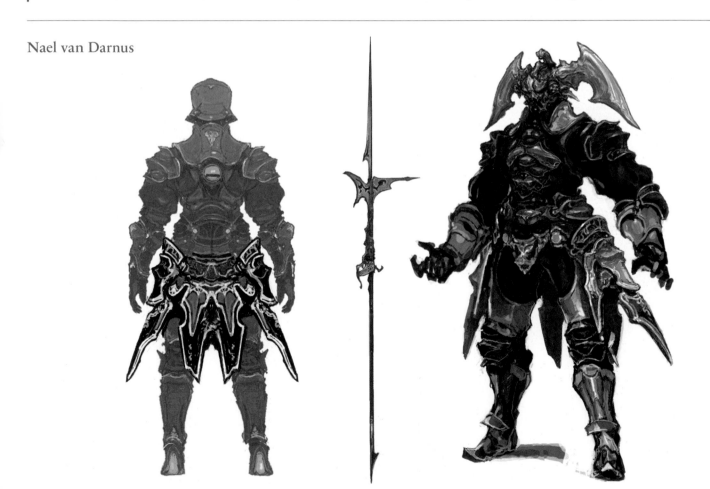

I worked very hard on this, as the character was so critical to the story leading up to *A Realm Reborn*. Since the dominant color was to be white, I made the design a little feminine. I'm rather fond of it, so I was happy to see it return in *A Realm Reborn*. (Nagamine)

Imperial Legati

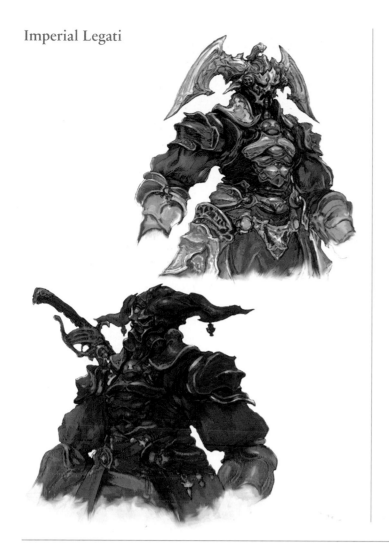

Emperor Solus zos Galvus

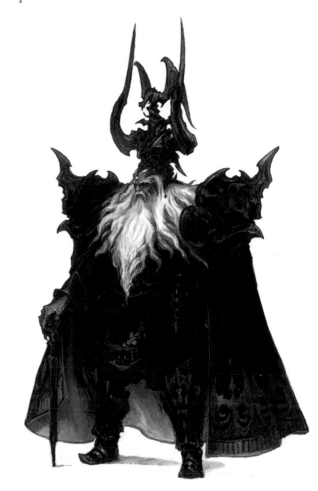

Imperial Centurion

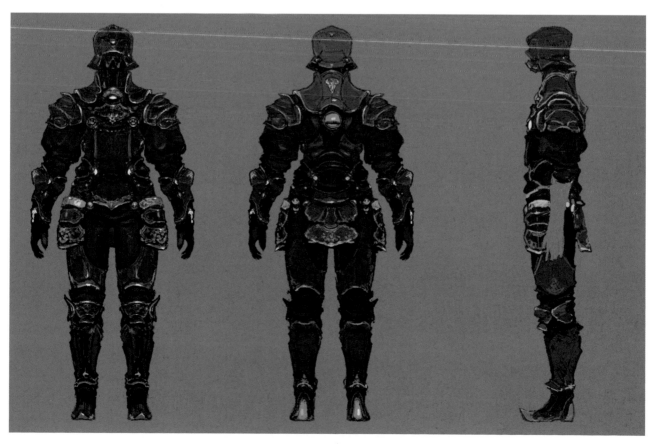

Imperial Commander Helms

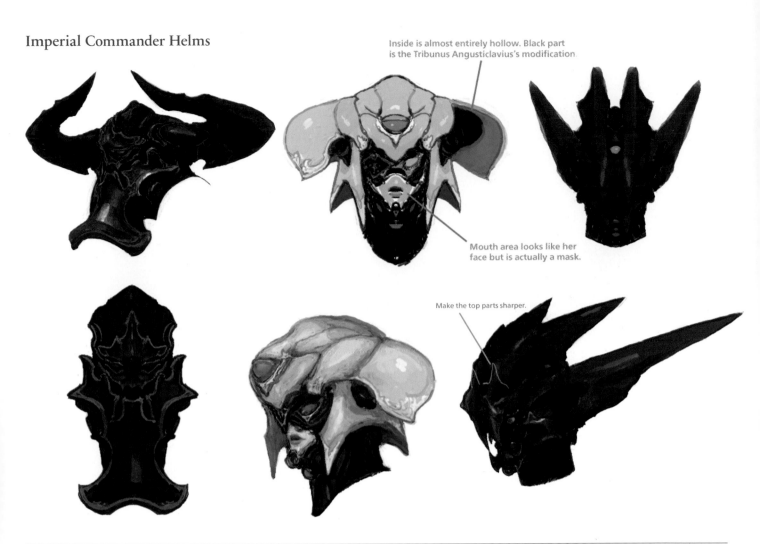

Inside is almost entirely hollow. Black part is the Tribunus Angusticlavius's modification.

Mouth area looks like her face but is actually a mask.

Make the top parts sharper.

Imperial Commander Arms

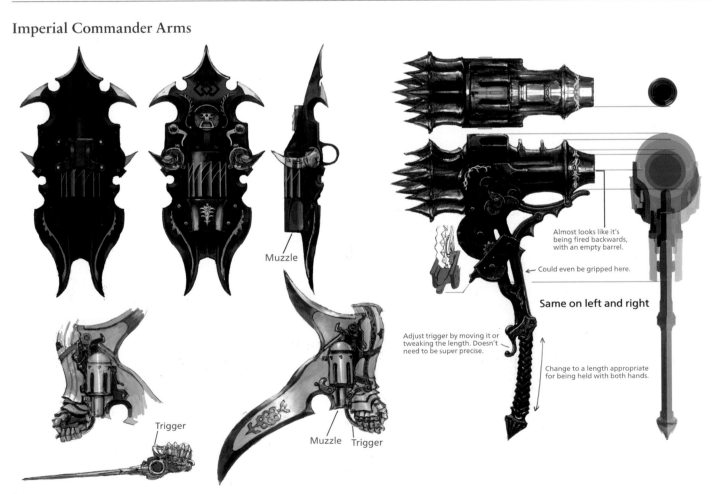

Muzzle

Trigger

Muzzle Trigger

Almost looks like it's being fired backwards, with an empty barrel.

Could even be gripped here.

Same on left and right

Adjust trigger by moving it or tweaking the length. Doesn't need to be super precise.

Change to a length appropriate for being held with both hands.

Ultimately, these weapons weren't made available to players. All three have gun barrels attached. (Tsukamoto)

Magitek Vanguard

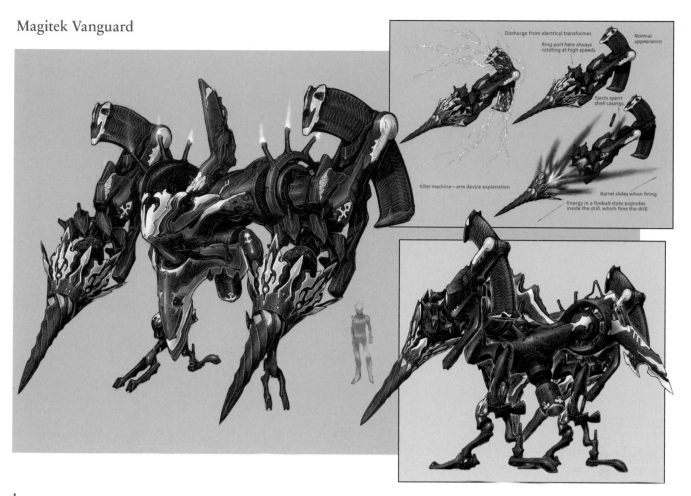

Discharge from electrical transformer.

Ring part here always rotating at high speeds.

Normal appearance

Ejects spent shell casings.

Killer machine—arm device explanation

Barrel slides when firing.

Energy in a fireball state explodes inside the drill, which fires the drill.

I received specific instructions to create a stout unit with a well-armored front, exposed mechanical systems in the rear, and drills for hands. This was the result. (Nakazawa)

Magitek Reaper

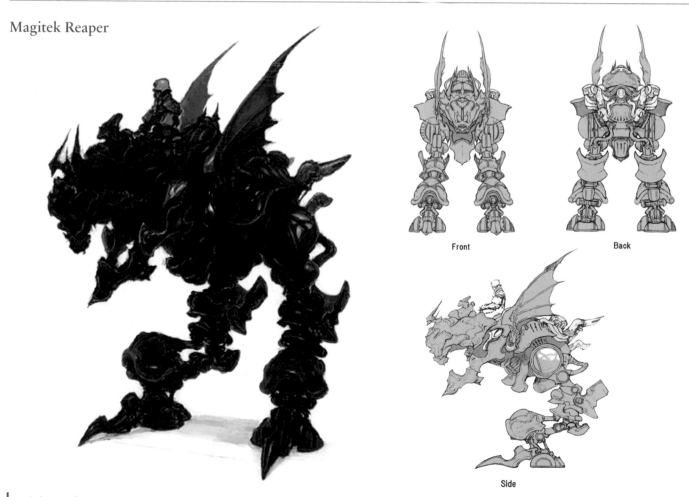

Front

Back

Side

Magitek armor first appeared in *FFVI*. I designed our version while studying the design of older illustrations. (Nagamine)

Magitek Colossus

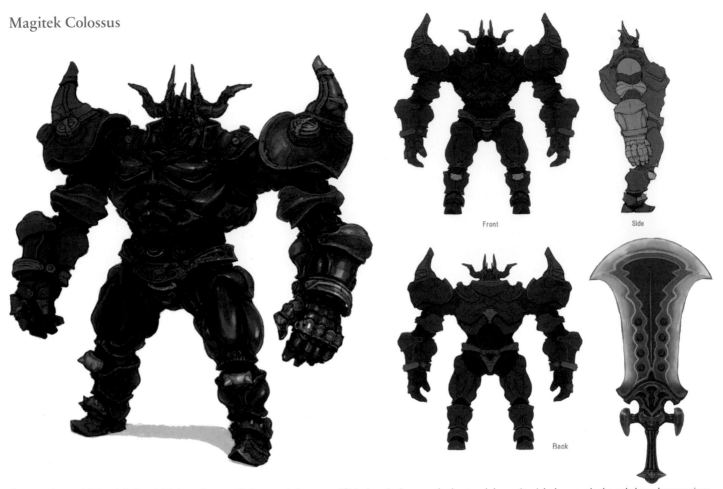

Front

Side

Back

In accordance with lore, I designed this iron giant as a Garlean magitek weapon. If I had made the upper body a touch larger, it might have made the unbalanced proportions more appealing... (Nagamine)

Magitek Death Claw

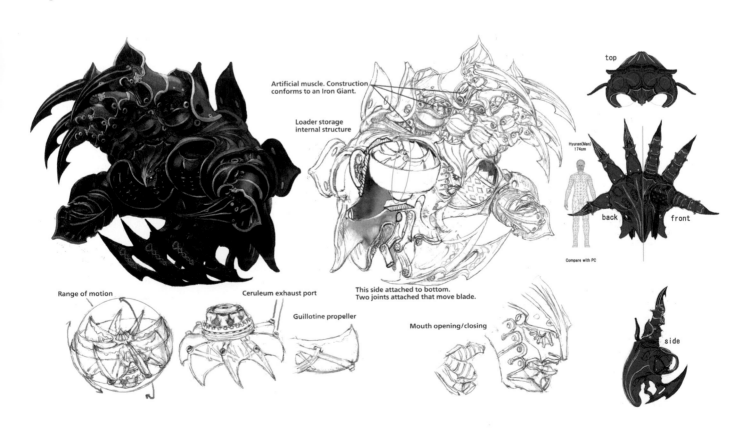

Artificial muscle. Construction conforms to an Iron Giant.

Loader storage internal structure

top

Hyuran(Man) 174cm

back front

Compare with PC

Range of motion

Ceruleum exhaust port

Guillotine propeller

This side attached to bottom.
Two joints attached that move blade.

Mouth opening/closing

side

This is the first enemy I designed after moving from the *FFXIII* team to this one, which is probably why it retains an *FFXIII* feel. I was asked to create a floating robotic enemy. (Tsukamoto)

The Ultima Weapon

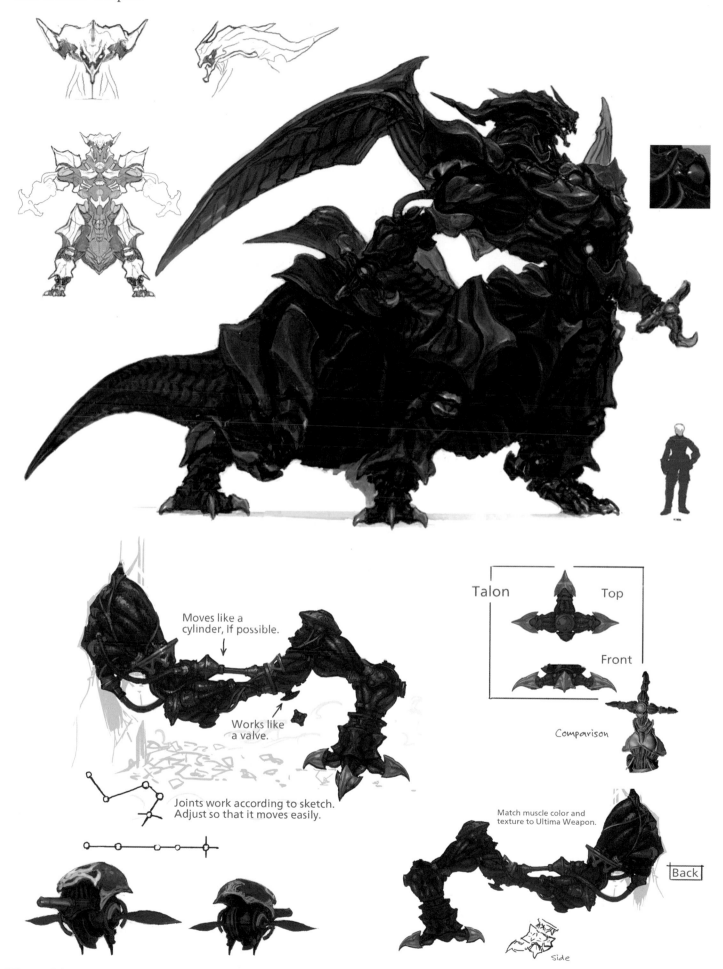

Moves like a cylinder, If possible.

Works like a valve.

Joints work according to sketch. Adjust so that it moves easily.

Talon Top

Front

Comparison

Match muscle color and texture to Ultima Weapon.

Back

Side

The overall design is based on the Ultima Weapon from *FFVII*. Adding armor to sections similar to Gaius's helped convey that this is an ancient Allagan weapon reconstructed with Garlean technology. (Nagamine)

Since the Proto-Ultima arm unit is a prototype, I made its design more chaotic and villanous than the original. (Kasuya)

Lahabrea

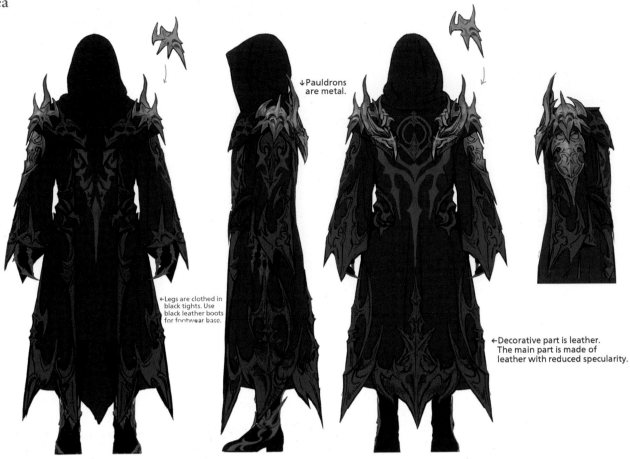

↓Pauldrons are metal.

←Legs are clothed in black tights. Use black leather boots for footwear base.

←Decorative part is leather. The main part is made of leather with reduced specularity.

I tried to bring out his otherworldly nature with a combination of black, purple, and organic ornamentation. (Kasuya)

Elidibus

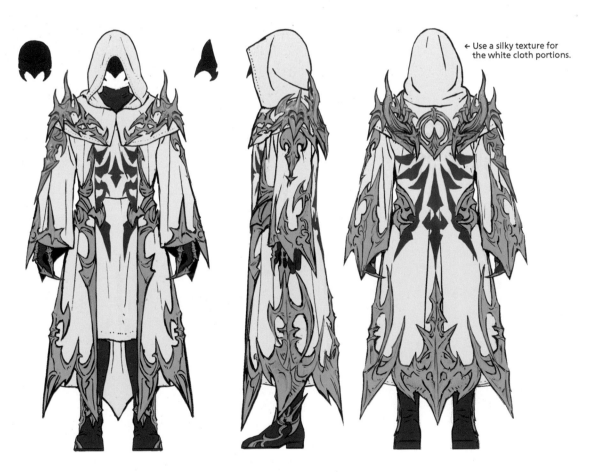

← Use a silky texture for the white cloth portions.

With feather-like patterns set against white, I designed him in opposition to black. (Kasuya)

MOUNTS & MINIONS

FINAL FANTASY XIV: A Realm Reborn
The Art of Eorzea -Another Dawn-

Barded Chocobo

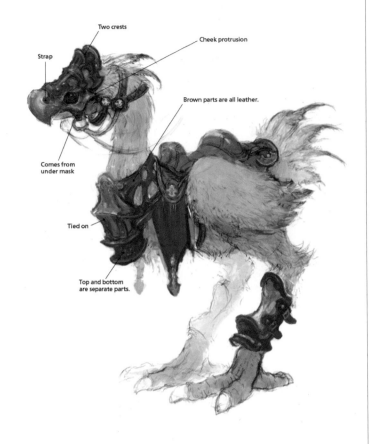

Two crests

Cheek protrusion

Strap

Brown parts are all leather.

Comes from
under mask

Tied on

Top and bottom
are separate parts.

Draught Chocobo

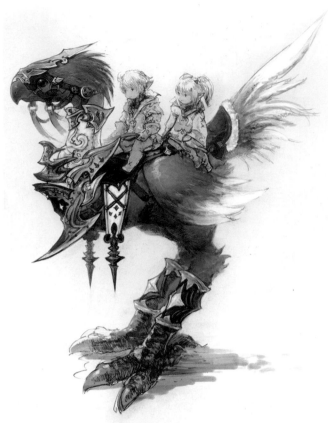

Since this chocobo was designed to carry two passengers, we added two stars to the legs and chest barding. (Takahashi)

Chocobo Barding

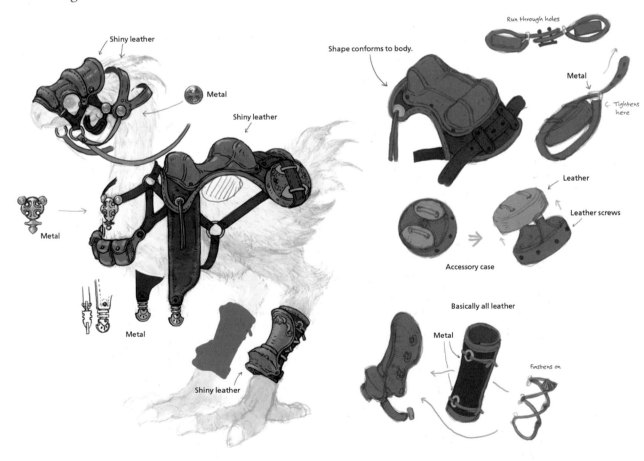

Shiny leather

Metal

Shiny leather

Metal

Metal

Metal

Shiny leather

Run through holes

Shape conforms to body.

Metal

Tightens here

Leather

Leather screws

Accessory case

Basically all leather

Metal

Fastens on

Legacy Chocobo

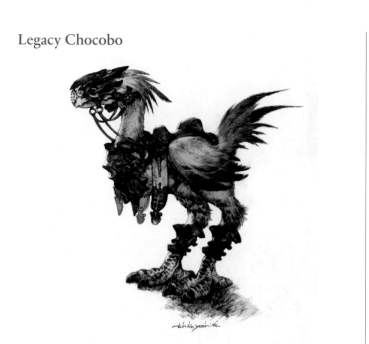

Chocobo Helms

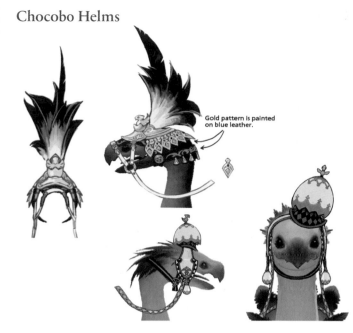

Gold pattern is painted on blue leather.

Grand Company Barding

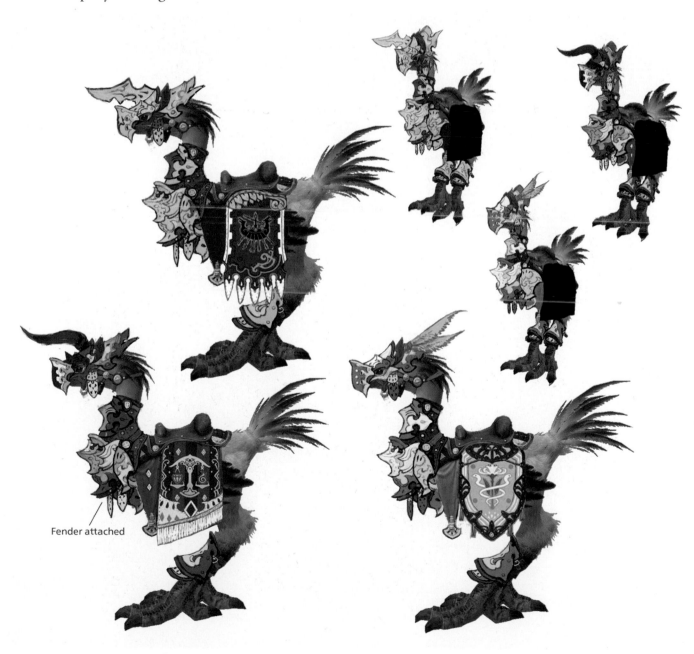

Fender attached

177

Paladin Barding

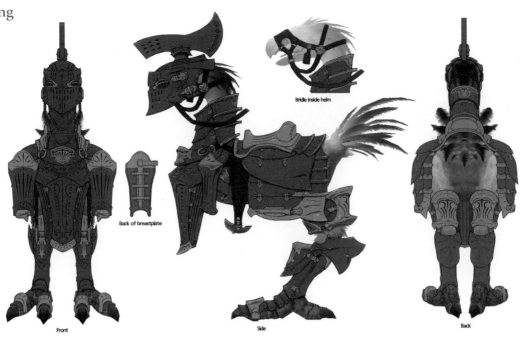

Back of breastplate

Bridle inside helm

Front

Side

Back

Dragoon Barding

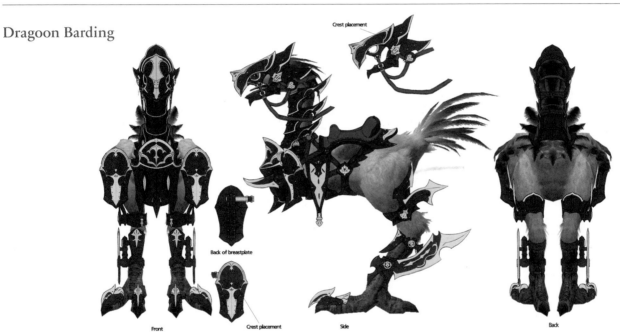

Crest placement

Back of breastplate

Crest placement

Front

Side

Back

White Mage Barding

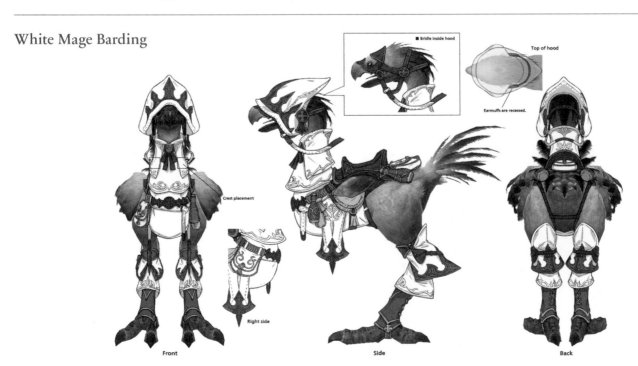

■ Bridle inside hood

Top of hood

Earmuffs are recessed.

Crest placement

Right side

Front

Side

Back

Black Mage Barding

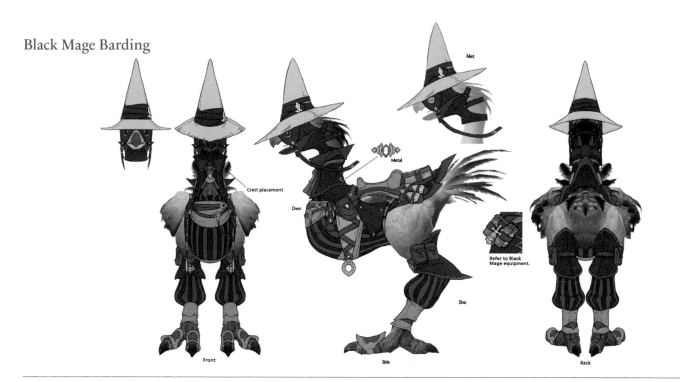

Met

Crest placement

Metal

Dwn

Refer to Black Mage equipment.

Sho

Front

Side

Back

Barding of Light

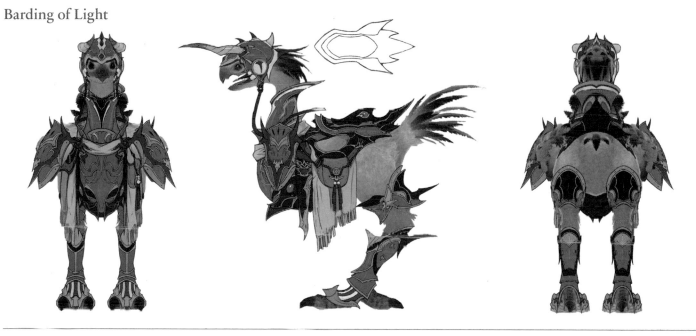

Behemoth Barding

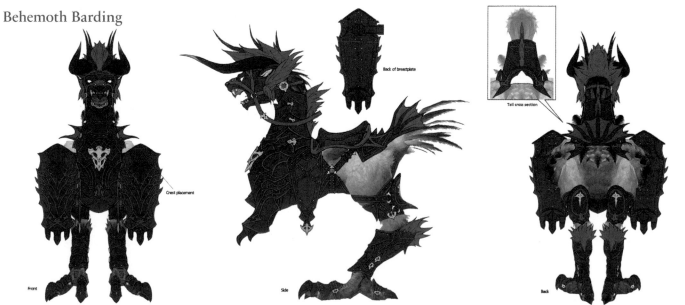

Back of breastplate

Crest placement

Tail cross section

Front

Side

Back

Designing chocobo equipment involved quite a few limitations, but the concepts were creative and inspired, so I was able to have fun with them. In-game, this face is frightening to behold. (Mihara)

Sleipnir Barding

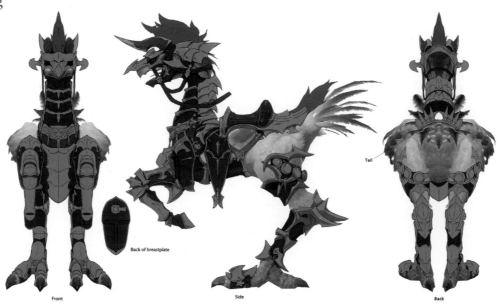

Back of breastplate

Front

Side

Tail

Back

Tidal Barding

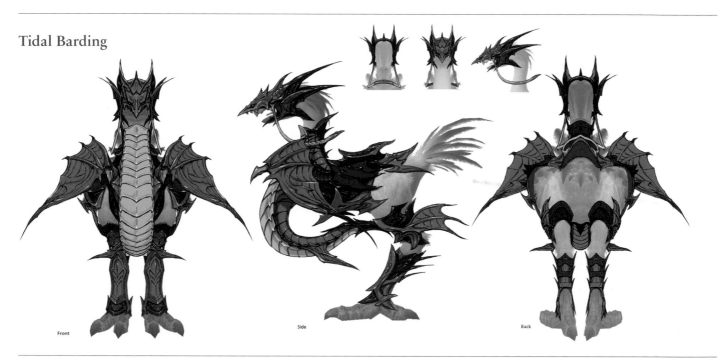

Front

Side

Back

Levin Barding

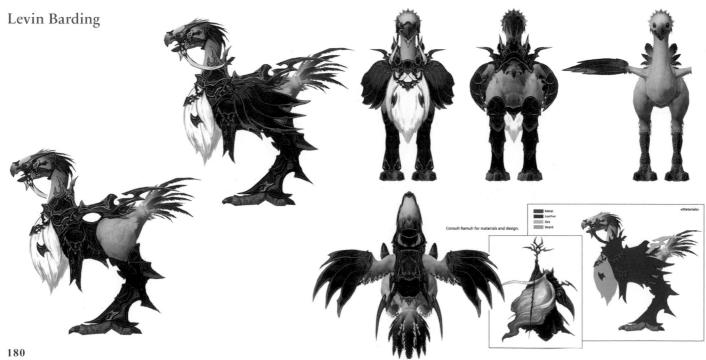

Consult Ramuh for materials and design.

<Materials>
Metal
Leather
Ore
Beard

Fat Chocobo

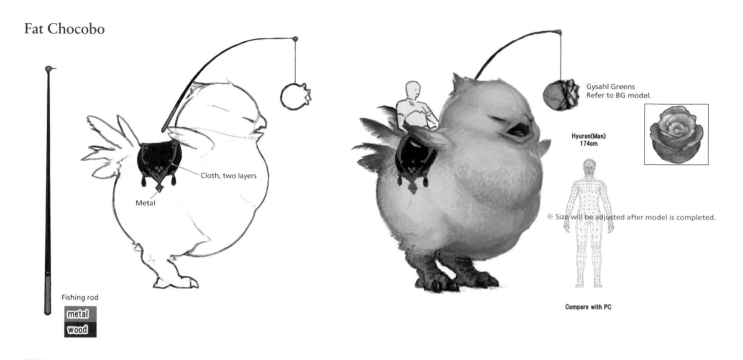

Cloth, two layers

Metal

Fishing rod

metal
wood

Gysahl Greens
Refer to BG model.

Hyuran(Man)
174cm

※ Size will be adjusted after model is completed.

Compare with PC

Unicorn

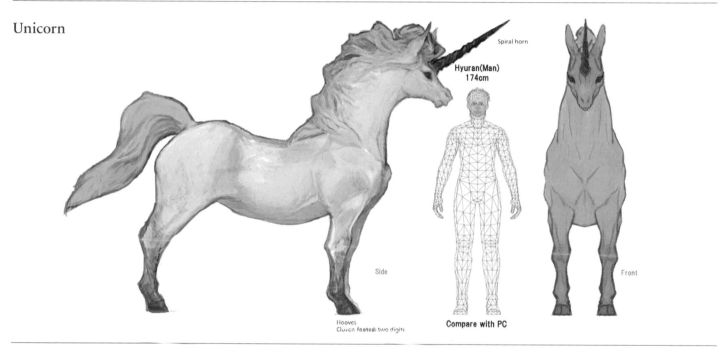

Spiral horn

Hyuran(Man)
174cm

Side

Front

Hooves
Cloven footed: two digits

Compare with PC

Warsteed

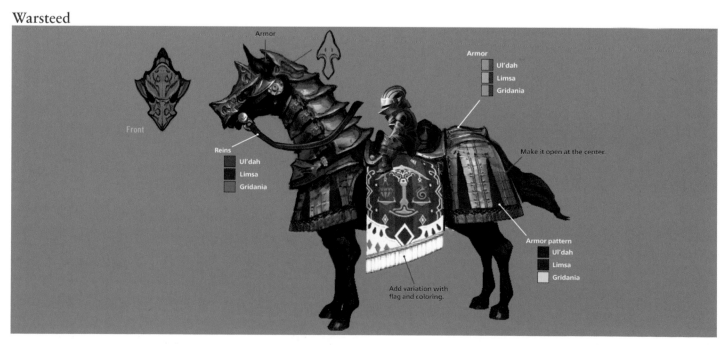

Armor

Front

Reins

Ul'dah
Limsa
Gridania

Armor

Ul'dah
Limsa
Gridania

Make it open at the center.

Add variation with
flag and coloring.

Armor pattern

Ul'dah
Limsa
Gridania

Behemoth

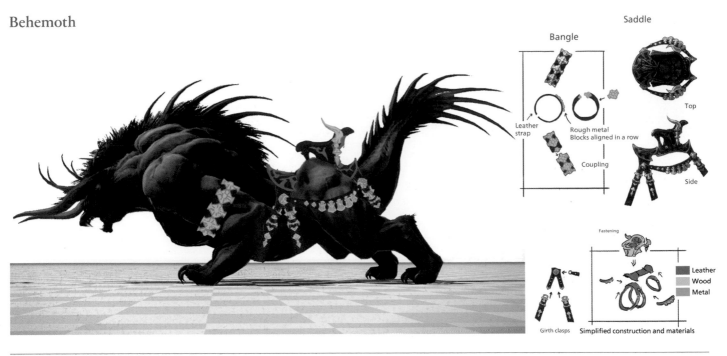

Bangle

Leather strap

Rough metal Blocks aligned in a row

Coupling

Saddle

Top

Side

Fastening

Girth clasps

Simplified construction and materials

Leather
Wood
Metal

Bomb Palanquin

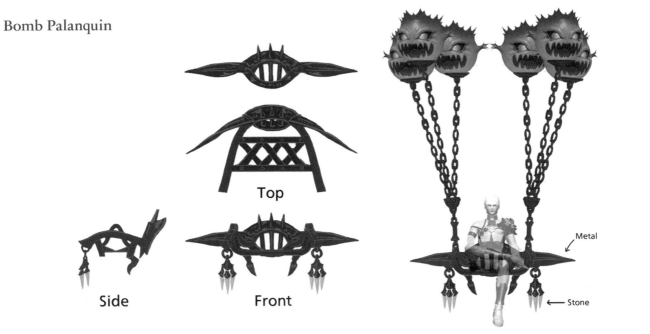

Top

Side

Front

Metal

Stone

Elbst

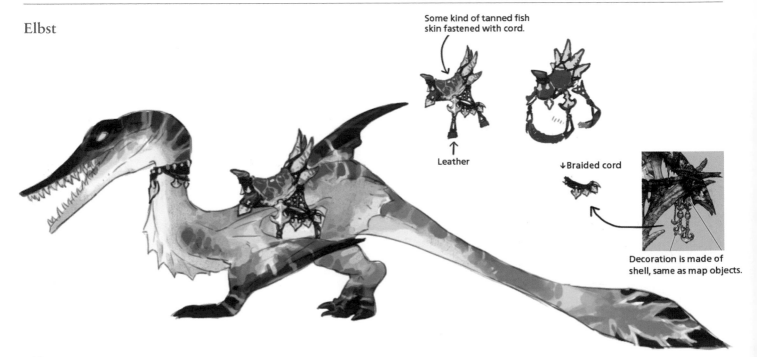

Some kind of tanned fish skin fastened with cord.

Leather

↓Braided cord

Decoration is made of shell, same as map objects.

Chocobo Hatchlings

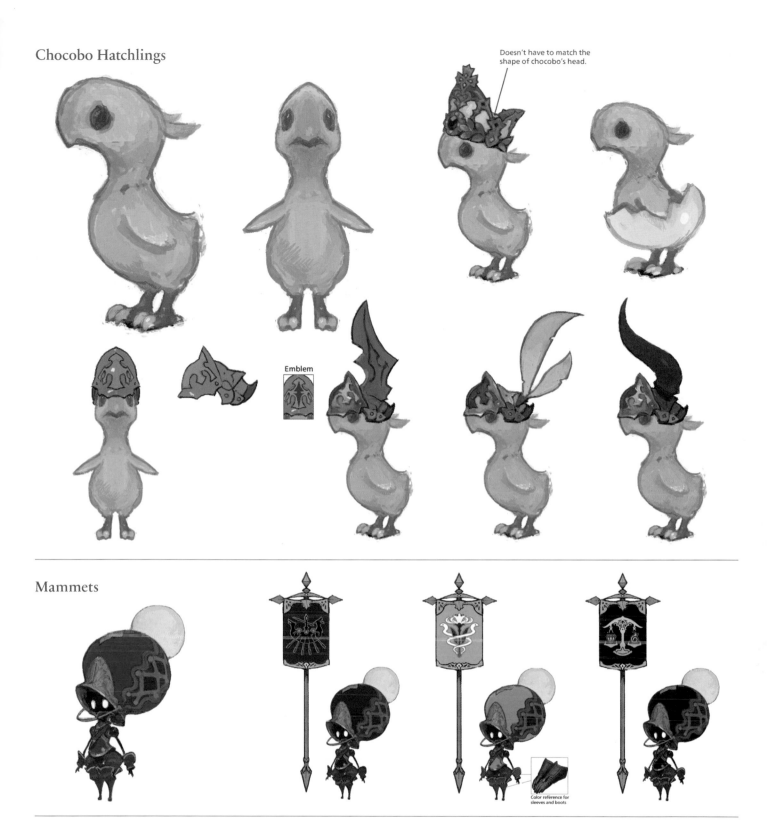

Doesn't have to match the shape of chocobo's head.

Emblem

Mammets

Color reference for sleeves and boots

Cherry Bomb

Wide-eyed Fawn

Wolf Pup

Coeurl Kitten

Bluebird

Baby Opo-opo

Wind-up Aldgoat

Bell (cloth)

Mini Mole

Minute Mindflayer

Tiny Tapir

Blend color on the body as shown here.

Nutkin

Always has an acorn.

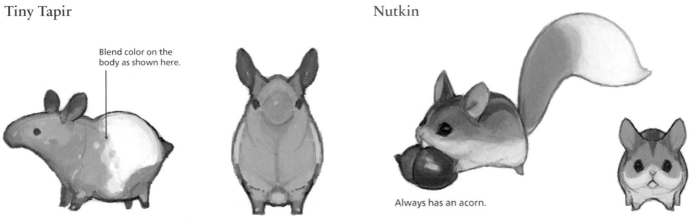

Gigantpole

Chigoe Larva

Baby Bun

Infant Imp

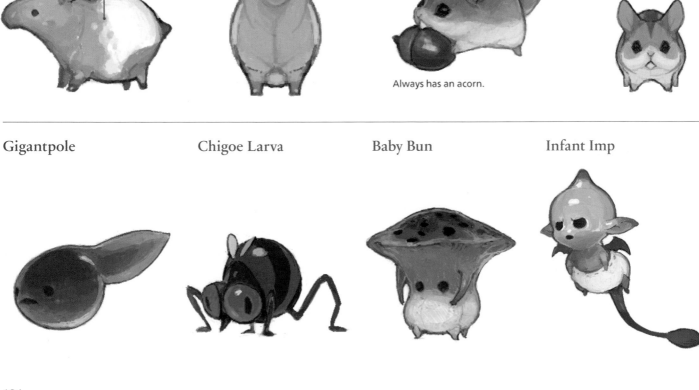

Baby Raptor

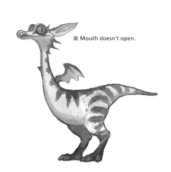

※ Mouth doesn't open.

Pudgy Puk

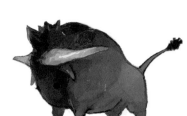

Floats just above the ground.

Buffalo Calf

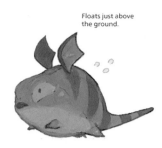

Fledgling Dodo

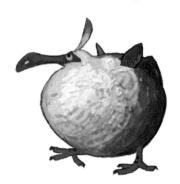

Coblyn Larva

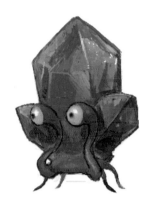

Goobbue Sproutling

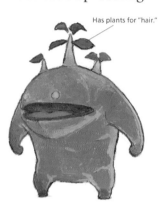

Has plants for "hair."

Morbol Seedling

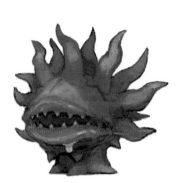

Naughty Nanka

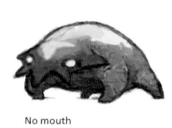

No mouth

Bite-sized Pudding

Demon Brick

Wind-up Succubus

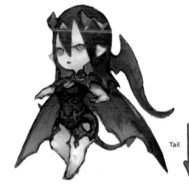

Tail

Cactuar Cutting

Wind-up Tonberry

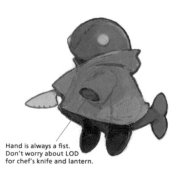

Hand is always a fist.
Don't worry about LOD
for chef's knife and lantern.

Kidragora

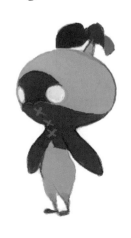

Wind-up Qiqirn

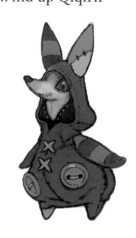

Wind-up Sylph

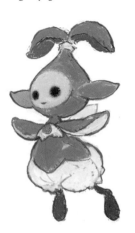

Wind-up Amalj'aa

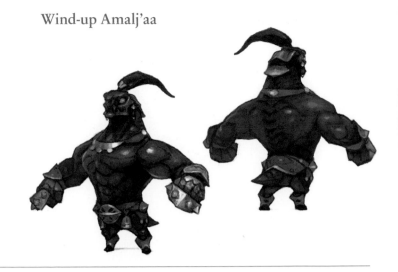

Wind-up Ixal

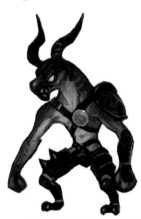

Mouth doesn't
open and close.

Side

Wind-up Kobold

Wind-up Sahagin

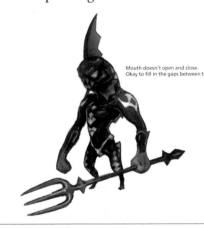

Mouth doesn't open and close.
Okay to fill in the gaps between teeth.

Side

Miniature Minecart

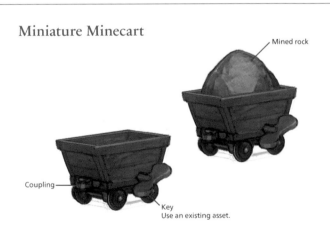

Mined rock

Coupling

Key
Use an existing asset.

Wind-up Airship

Magic Broom

Wind-up Onion Knight

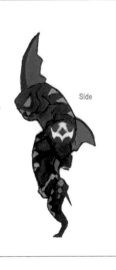

Visor
Doesn't move.

Clasp
Front

Cloak
Shoulder pad is same as Warrior's.

Wind-up Shantotto

Wind-up Edvya

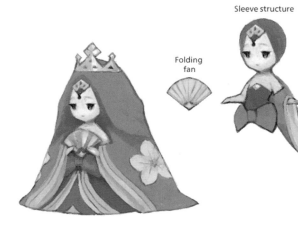

Folding fan

Sleeve structure

Wind-up Leader

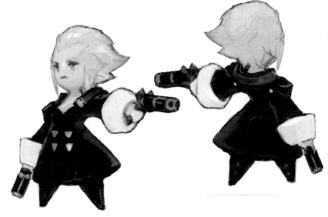

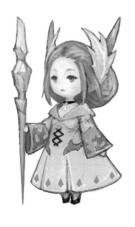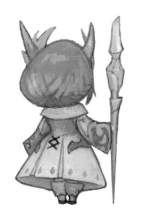

Tattoo

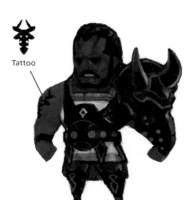

Minion of Light

187

Wind-up Cursor

Beady Eye

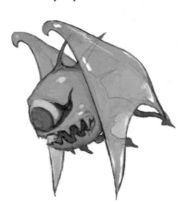

Wind-up Odin

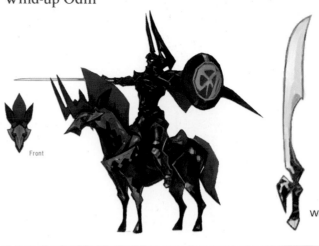

Front

Weapon

Wind-up Warrior of Light

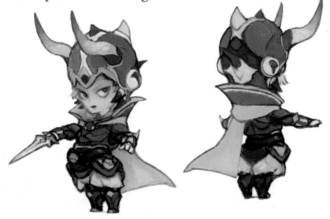

Wind-up Goblin

Baby Behemoth

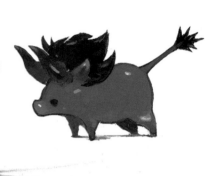

Cait Sith Doll

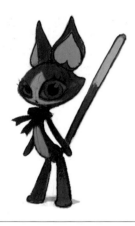

Wind-up Moogle

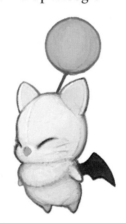

Wind-up Dalamud

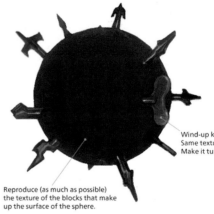

Wind-up key
Same texture as regular key.
Make it turnable.

Reproduce (as much as possible)
the texture of the blocks that make
up the surface of the sphere.

Wind-up Bahamut

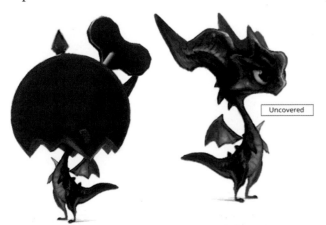

Uncovered

Model *Enterprise*

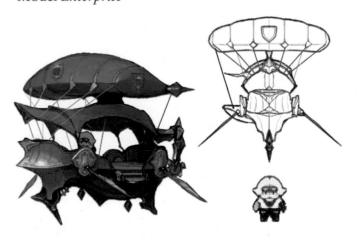

188

HOUSING

FINAL FANTASY XIV: A Realm Reborn
The Art of Eorzea -Another Dawn-

Mist I

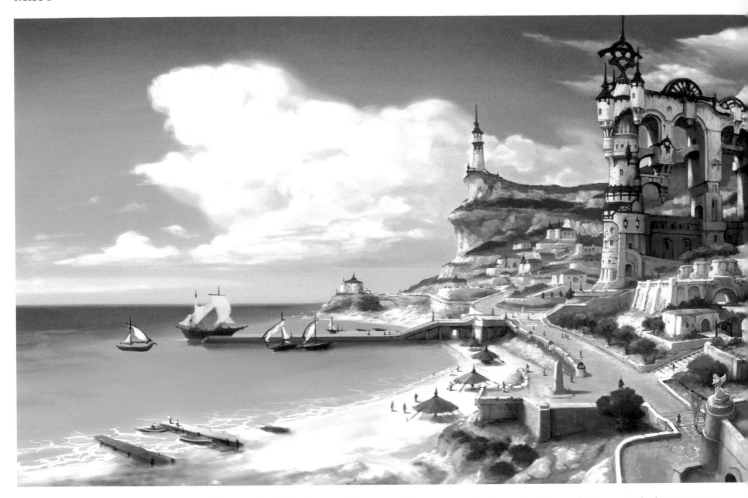

This was the very first piece of concept art I had drawn up for the housing areas. My request to the art team contained a number of keywords: European-style, the ocean, resort area, chalk-white houses, blue sky. It's an important piece that established the overall artistic direction for all the housing areas. (Yoshi-P)

Mist III

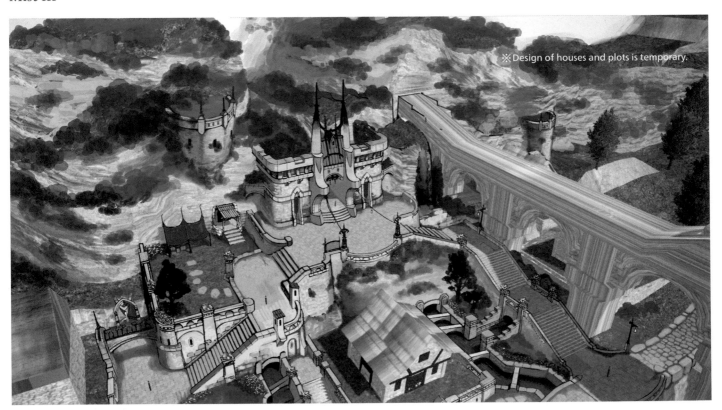

※ Design of houses and plots is temporary.

A conceptual layout for the entrance to Mist. I worked in stairs and a waterway. (Saito)

Mist II

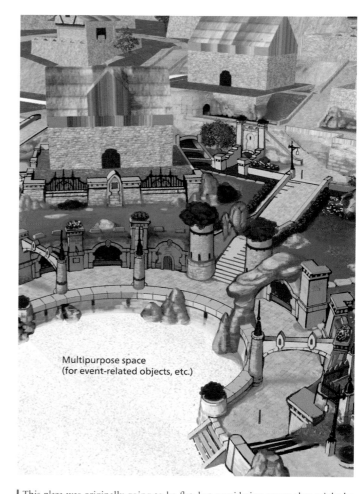

Multipurpose space
(for event-related objects, etc.)

This plaza was originally going to be flat, but considering events that might be held here, we opted for this design with a lower level in the middle. I think it'd be perfect for a fireworks show. (Saito)

Mist IV

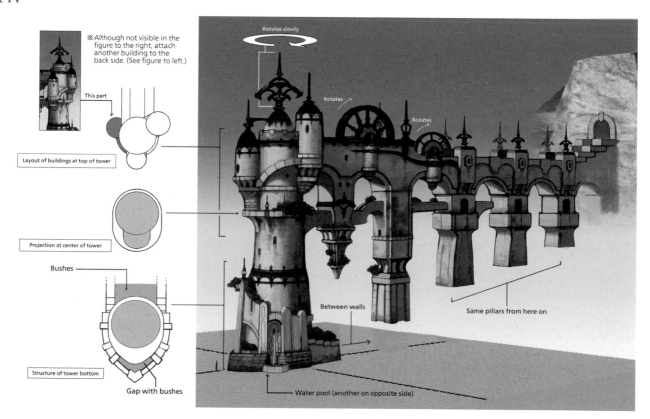

※Although not visible in the figure to the right, attach another building to the back side. (See figure to left.)

This part

Layout of buildings at top of tower

Projection at center of tower

Bushes

Structure of tower bottom

Gap with bushes

Rotates slowly

Rotates

Rotates

Between walls

Same pillars from here on

Water pool (another on opposite side)

A design for the aqueduct that runs through the center of Mist. I added this to give each residential area its own distinctive feel. It supplies water to each of the houses. (Saito)

Riviera Mansion (Wood)

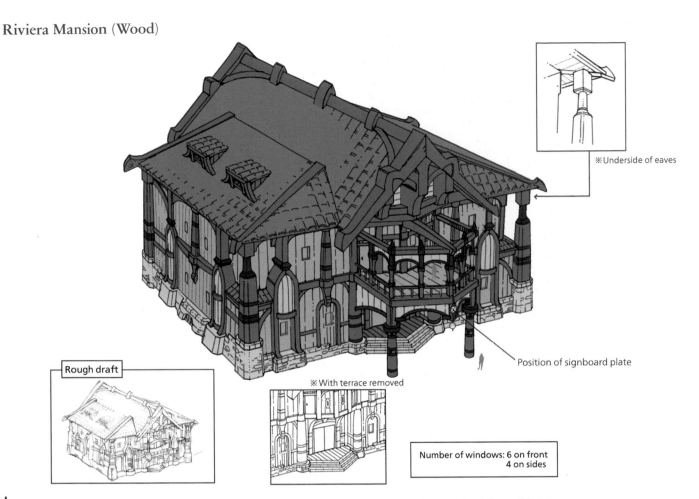

Rough draft

※Underside of eaves

Position of signboard plate

※With terrace removed

Number of windows: 6 on front
4 on sides

I tried to give the Mist residences a fresh and breezy atmosphere befitting an oceanside resort. This estate has a wood and tile motif. (Saito)

Riviera Mansion (Composite)

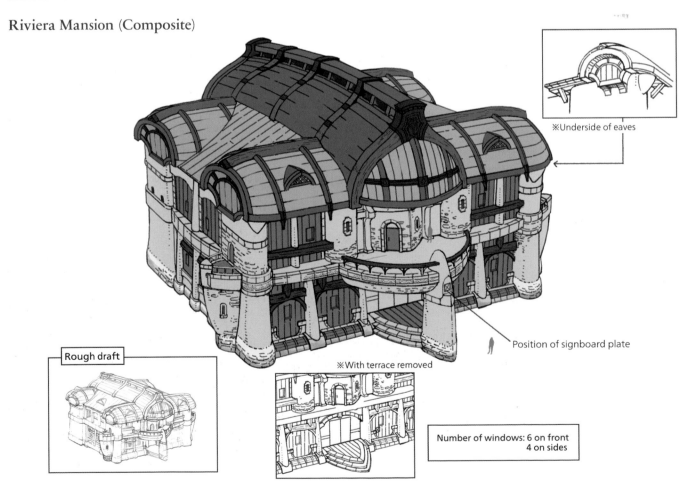

Rough draft

※Underside of eaves

Position of signboard plate

※With terrace removed

Number of windows: 6 on front
4 on sides

This design features white stone walls in the La Noscean style, with a roof shaped like the underside of a ship. (Saito)

Riviera Mansion (Stone)

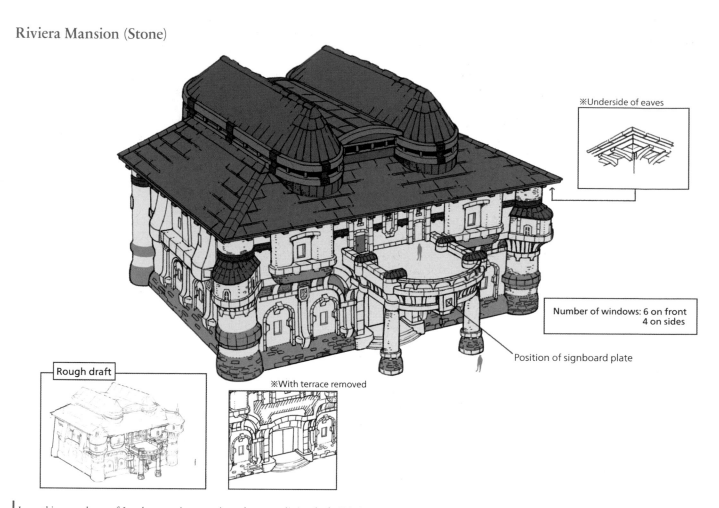

Rough draft

※Underside of eaves

Number of windows: 6 on front
4 on sides

Position of signboard plate

※With terrace removed

I gave this one a slate roof. I took great pains to to give each estate a distinct look. (Saito)

Large Estate Hall (Mist)

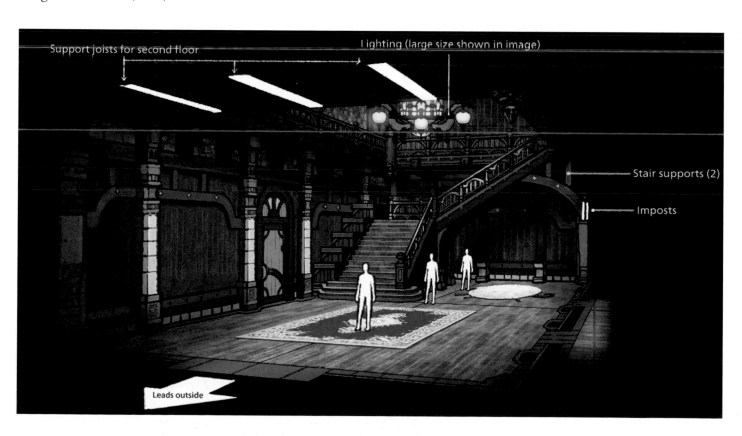

Support joists for second floor

Lighting (large size shown in image)

Stair supports (2)

Imposts

Leads outside

An early image of the foyer. The actual implementation changed later on, so what you see in the game is a bit more spacious. (Saito)

Lavender Beds I

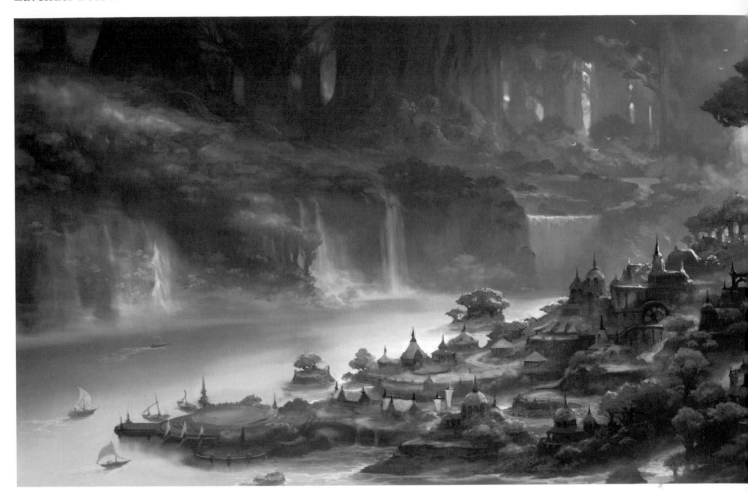

The second piece of housing area concept art I ordered, following Limsa. My request was straightforward: a forest with a massive tree, and the land nestling up to it. In the modeling stage, it turned out a bit too plain, giving us quite a challenge. (Yoshi-P)

Lavender Beds III

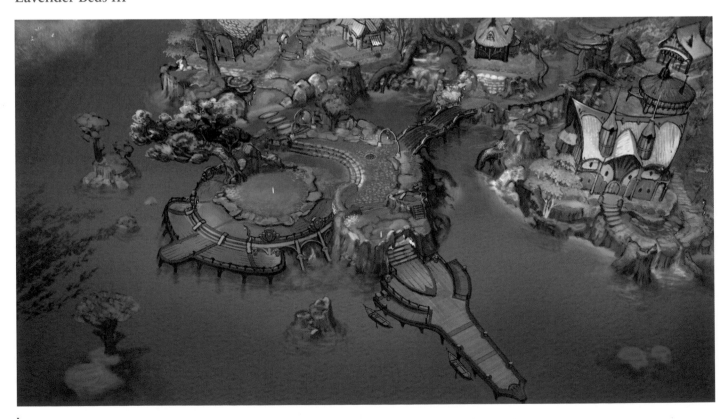

A plaza atop a giant tree stump. I really wanted to be able to walk across the stepping stones, so I was glad that made it in. (Saito)

Lavender Beds II

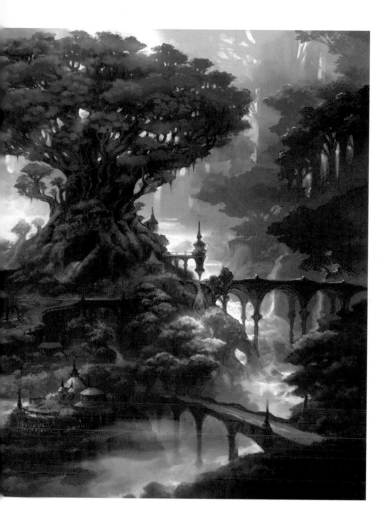

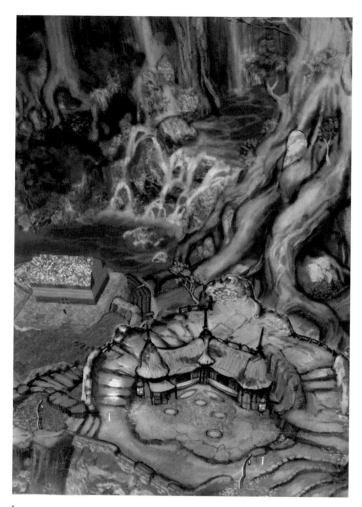

Here are the roots of the giant tree that is the symbol of this area. (Saito)

Lavender Beds IV

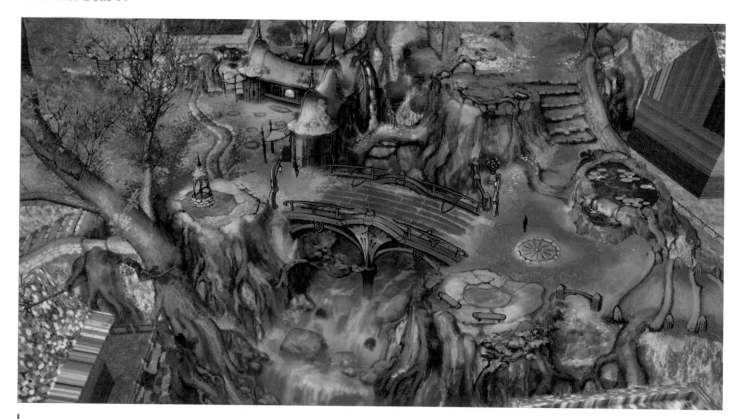

A street corner in the Lavender Beds. In the game, the ground has tiles, giving it quite an opulent feel. (Saito)

Glade Mansion (Wood)

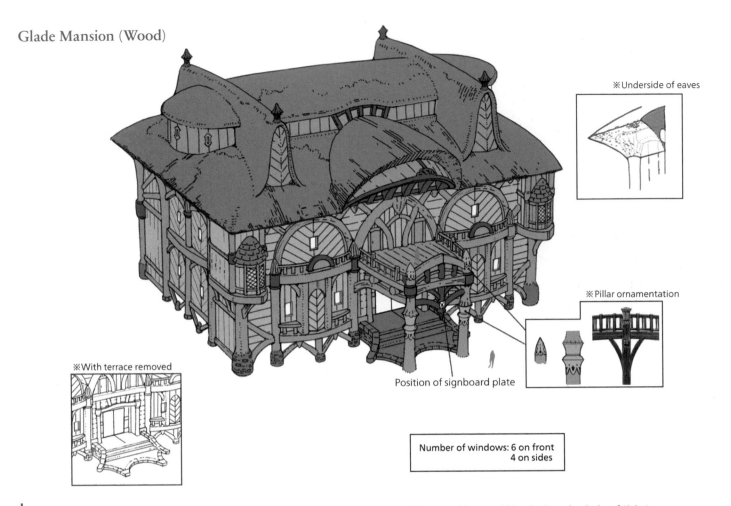

※Underside of eaves

※Pillar ornamentation

Position of signboard plate

※With terrace removed

Number of windows: 6 on front
4 on sides

As the Lavender Beds are surrounded by lush greenery and water, I went for designs that conveyed harmony with nature. This estate has a thatched roof. (Saito)

Glade Mansion (Composite)

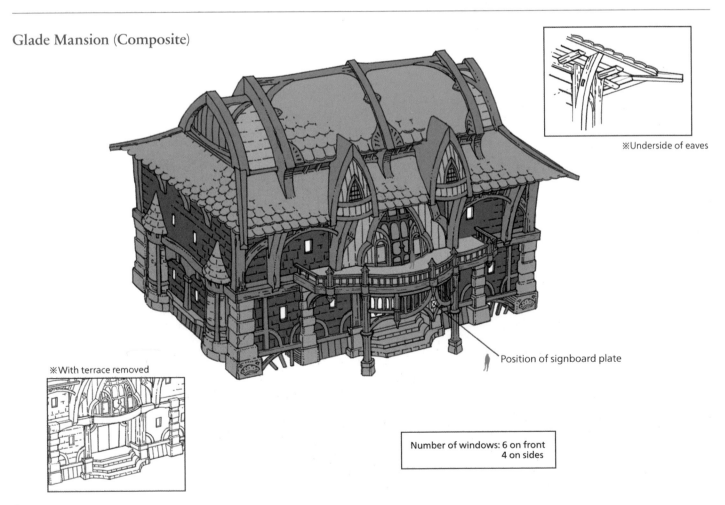

※Underside of eaves

Position of signboard plate

※With terrace removed

Number of windows: 6 on front
4 on sides

I considered a number of designs for the composite mansion before finally settling on this one featuring wooden tiles. (Saito)

Glade Mansion (Stone)

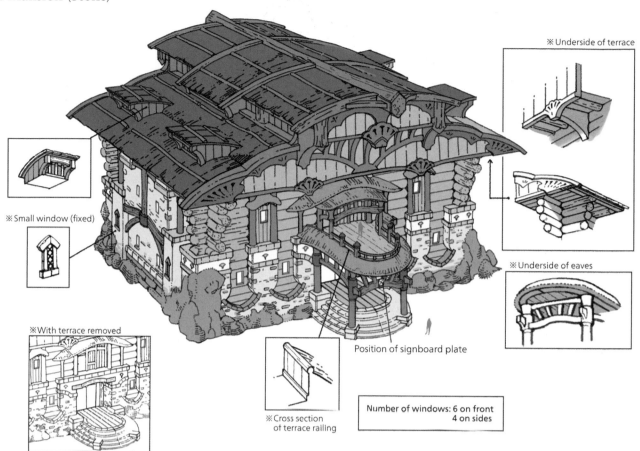

※ Underside of terrace

※ Small window (fixed)

※ With terrace removed

Position of signboard plate

※ Cross section
of terrace railing

Number of windows: 6 on front
4 on sides

※ Underside of eaves

System limitations required that the number and location of windows be the same for each model. We had to add variety elsewhere, which was quite a daunting task. (Saito)

Large Estate Hall (Lavender Beds)

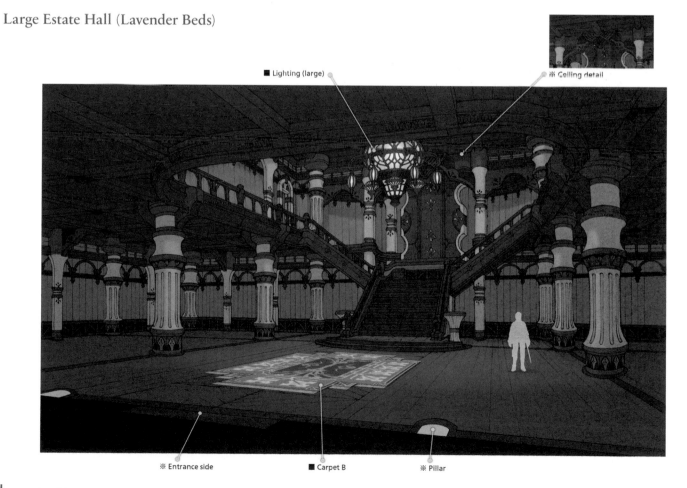

■ Lighting (large)

※ Ceiling detail

※ Entrance side

■ Carpet B

※ Pillar

I gave a lot of thought to how to balance a rustic forest look with the colorful decorative elements characteristic of Gridania. (Hama)

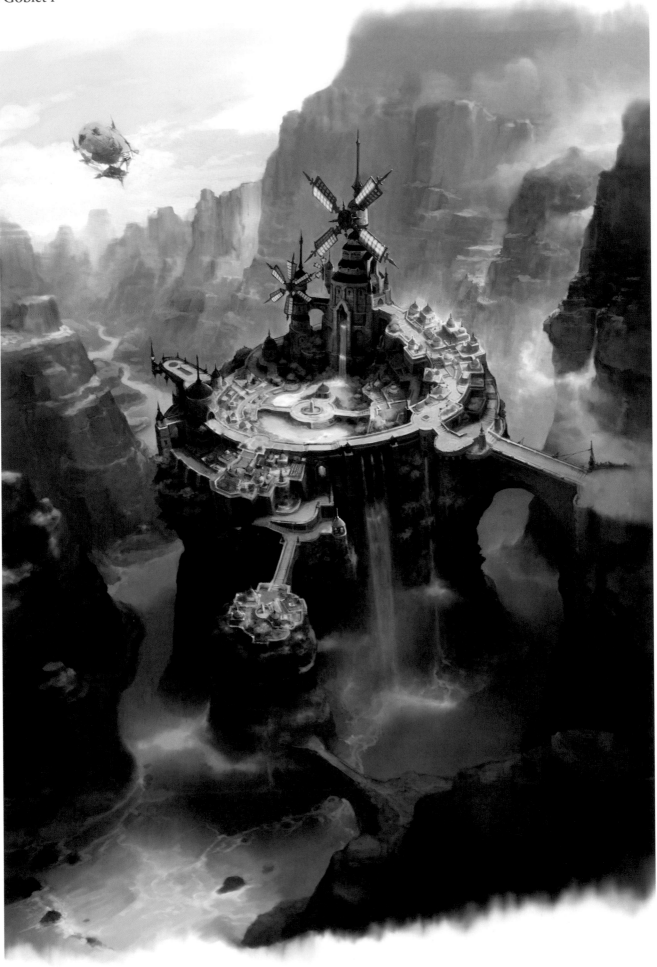

Ul'dah was the final piece of concept art I ordered for the housing areas. I was worried that players wouldn't want to live in a bleak desert region ("I hung my laundry out to dry and now it's covered in sand!"), so we added windmills and waterfalls. It wasn't easy. (Yoshi-P)

The Goblet II

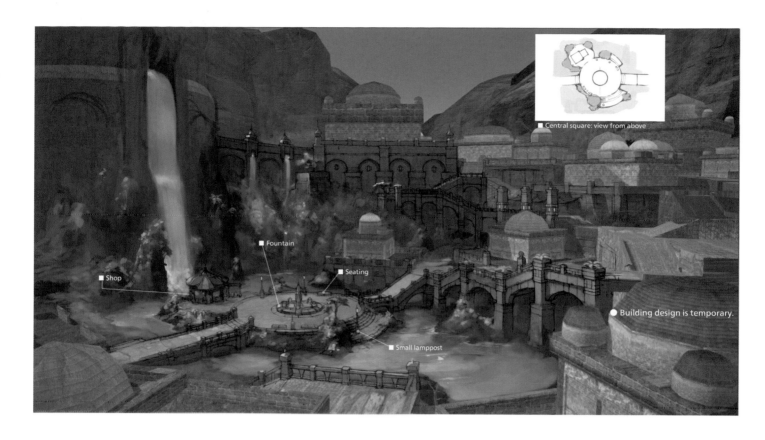

Central square: view from above

■ Fountain

■ Seating

■ Shop

■ Small lamppost

● Building design is temporary.

While I was drawing this, I hoped it would be a place of relaxation and refreshment, like an oasis in the desert. (Kenta Tanaka)

The Goblet III

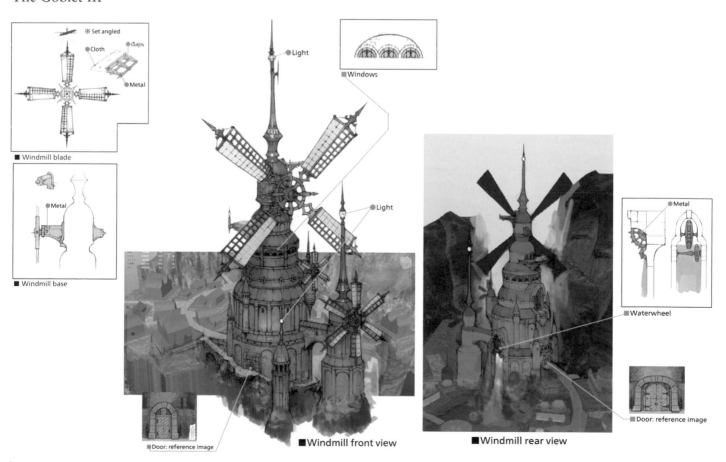

※ Set angled

● Cloth

● Gaps

● Metal

■ Windmill blade

● Metal

■ Windmill base

● Light

■ Windows

● Light

● Metal

■ Waterwheel

■ Door: reference image

■ Windmill front view

■ Windmill rear view

■ Door: reference image

This giant windmill draws up water from the ravine. I personally like the back roads. (Kenta Tanaka)

Oasis Mansion (Wood)

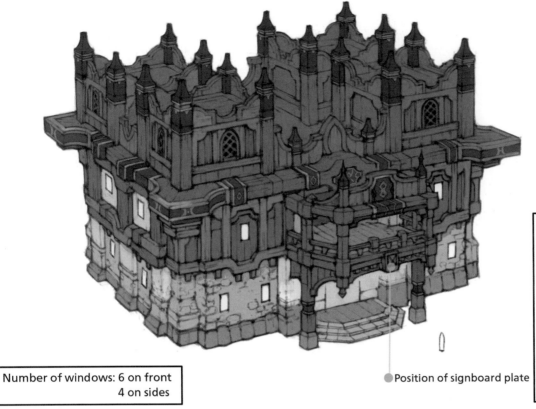

■ Roof underside

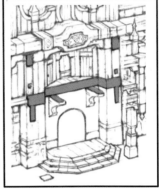

● Position of signboard plate

■ With terrace removed

Number of windows: 6 on front
4 on sides

My inspiration for this was a military fort with a wood motif. Wooden buildings are rare in Ul'dah, so it was a challenge. (Kenta Tanaka)

Oasis Mansion (Composite)

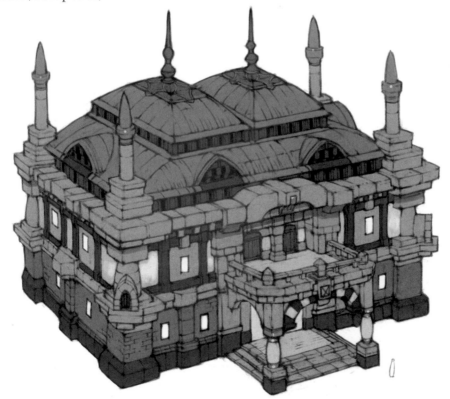

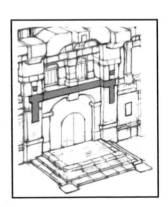

■ With terrace removed

Number of windows: 6 on front
4 on sides

A mansion of wood and stone. I went for an angular look to distinguish it from the rounded edges of the stone model. (Kenta Tanaka)

Oasis Mansion (Stone)

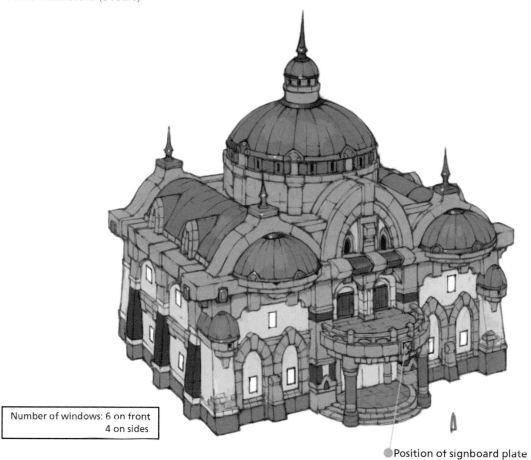

■Roof underside

■With terrace removed

Number of windows: 6 on front
4 on sides

Position of signboard plate

Made predominantly of stone, this mansion has a palatial feel that is perhaps the most typically Ul'dahn of the three. (Kenta Tanaka)

Large Estate Hall (The Goblet)

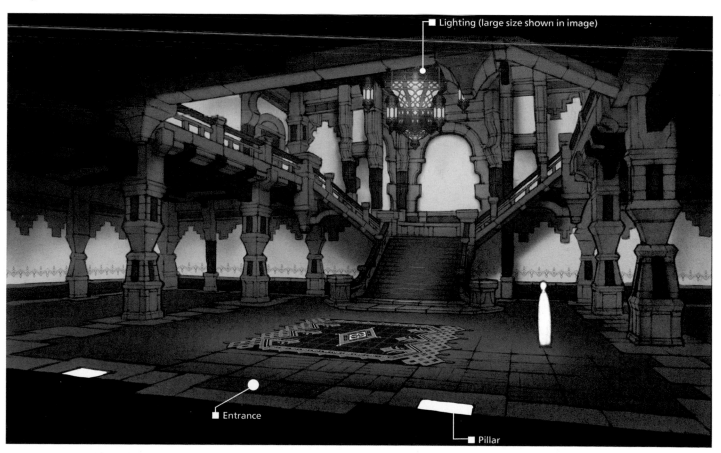

Lighting (large size shown in image)

Entrance

Pillar

The general layout of the interior was already set, so it was difficult to differentiate it from the other city-states. (Kenta Tanaka)

Counters

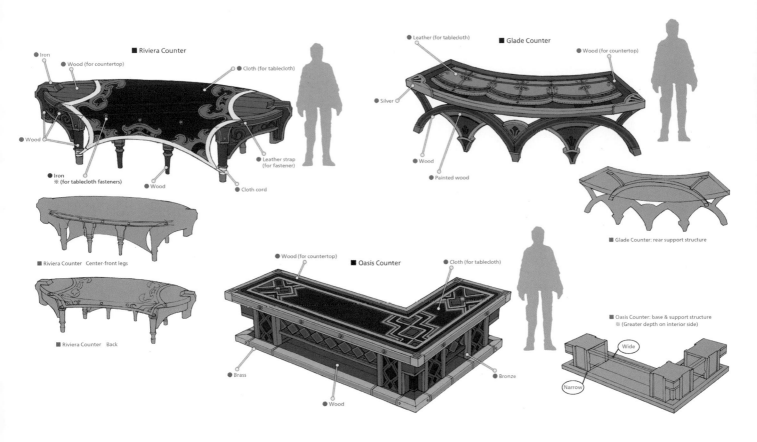

Riviera Counter
- Iron
- Wood (for countertop)
- Cloth (for tablecloth)
- Wood
- Iron ※ (for tablecloth fasteners)
- Wood
- Leather strap (for fastener)
- Cloth cord

■ Riviera Counter Center-front legs

■ Riviera Counter Back

Glade Counter
- Leather (for tablecloth)
- Wood (for countertop)
- Silver
- Wood
- Painted wood

■ Glade Counter: rear support structure

Oasis Counter
- Wood (for countertop)
- Cloth (for tablecloth)
- Brass
- Wood
- Bronze

■ Oasis Counter: base & support structure
※ (Greater depth on interior side)
- Wide
- Narrow

> We experimented with various shapes and lavish designs to allow players to play shop. (Hama)

Armchairs and Couches

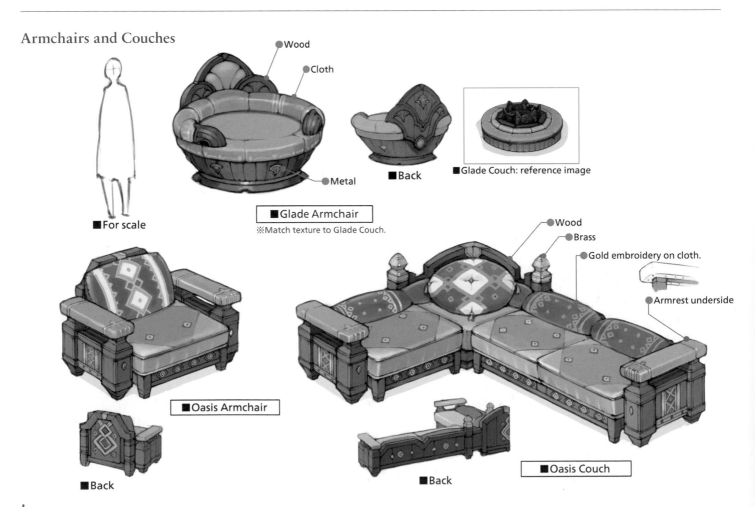

- Wood
- Cloth
- Metal

■ For scale

■ Glade Armchair
※Match texture to Glade Couch.

■ Back

■ Glade Couch: reference image

■ Oasis Armchair

■ Back

- Wood
- Brass
- Gold embroidery on cloth.
- Armrest underside

■ Back

■ Oasis Couch

> I designed the kind of chair that I'd like to relax in at home. (Kenta Tanaka)

Bookshelves

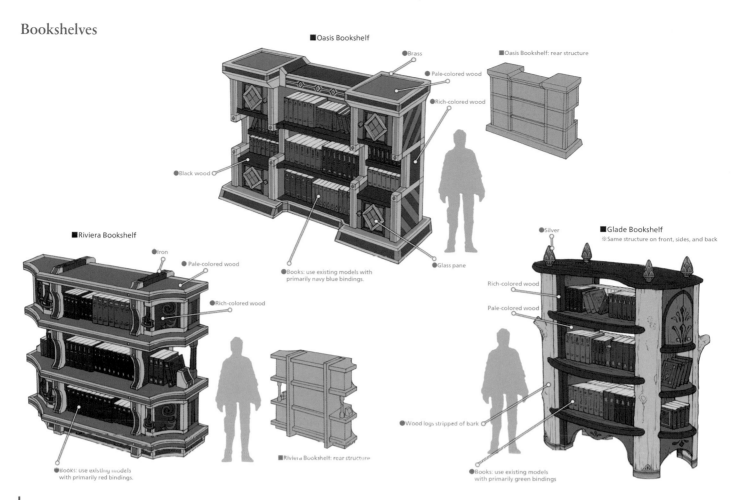

■Oasis Bookshelf

● Brass

● Pale-colored wood

● Rich-colored wood

● Black wood

● Books: use existing models with primarily navy blue bindings.

● Glass pane

■Oasis Bookshelf: rear structure

■Riviera Bookshelf

● Iron

● Pale-colored wood

● Rich-colored wood

● Books: use existing models with primarily red bindings.

■Riviera Bookshelf: rear structure

● Silver

■Glade Bookshelf
※ Same structure on front, sides, and back

● Rich-colored wood

● Pale-colored wood

● Wood logs stripped of bark

● Books: use existing models with primarily green bindings

I thought it would have been interesting if Ul'dah had something sophisticated, like a rotating bookshelf. (Hama)

Bathtubs

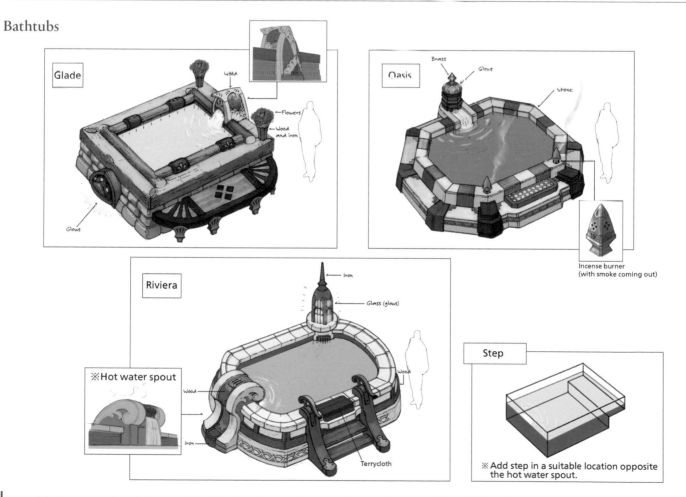

Glade

Wood

Flowers

Wood and iron

Glows

Oasis

Brass

Glows

Stone

Incense burner
(with smoke coming out)

Riviera

Iron

Glass (glows)

※Hot water spout

Wood

Wood

Iron

Terrycloth

Step

※ Add step in a suitable location opposite the hot water spout.

I wanted the designs to evoke each city-state while still looking like something you could take a nice long bath in. I added a Lalafell-friendly stepping stair. (Saito)

203

Ahriman Furnishings

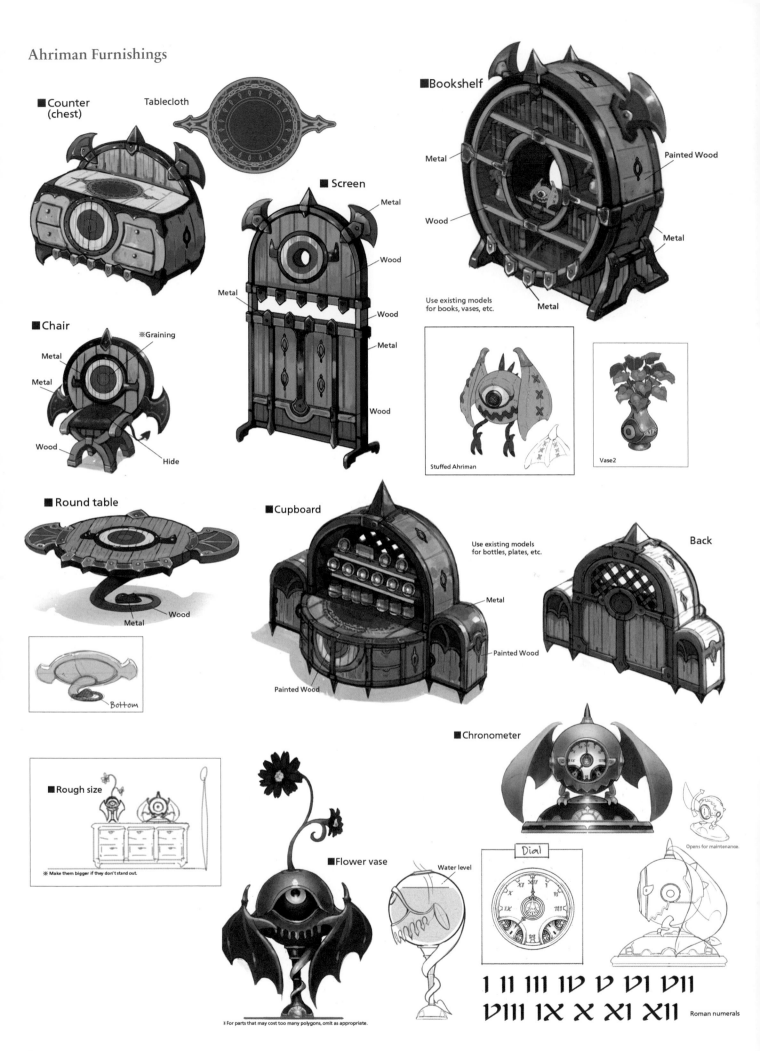

■Counter (chest)

Tablecloth

■Bookshelf

Metal

Wood

Painted Wood

Metal

Metal

Use existing models for books, vases, etc.

■Chair

Metal

Metal

Wood

※Graining

Hide

■Screen

Metal

Wood

Metal

Wood

Metal

Wood

Stuffed Ahriman

Vase2

■Round table

Metal

Wood

Bottom

■Cupboard

Metal

Painted Wood

Use existing models for bottles, plates, etc.

Back

Painted Wood

■Rough size

※ Make them bigger if they don't stand out.

■Flower vase

※ For parts that may cost too many polygons, omit as appropriate.

■Chronometer

Water level

Dial

Opens for maintenance.

I II III IV V VI VII
VIII IX X XI XII Roman numerals

It's all round, befitting the Ahriman motif. The single-flower vase just might have been inspired by an anime I was watching at the time. (Yamate)

Tonberry Furnishings

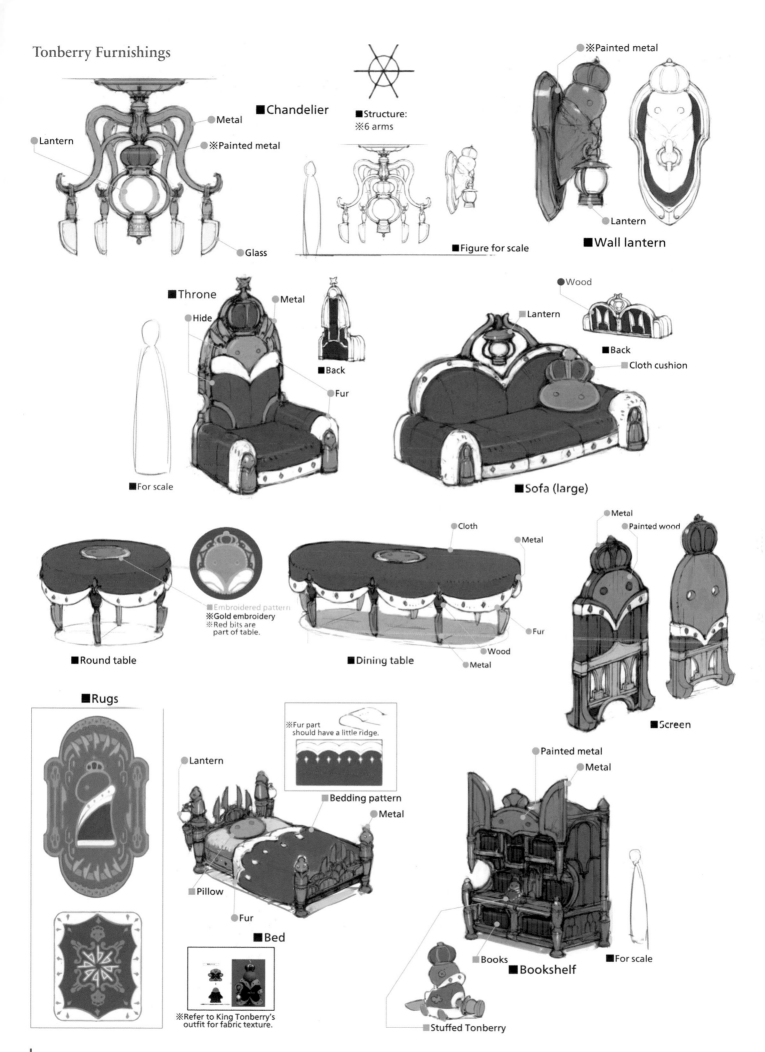

■Chandelier

■Lantern

■Metal

■※Painted metal

■Glass

■Structure:
　※6 arms

■Figure for scale

■※Painted metal

■Lantern

■Wall lantern

■Throne

■Hide

■Metal

■Back

■Fur

■For scale

■Wood

■Lantern

■Back

■Cloth cushion

■Sofa (large)

■Embroidered pattern
※Gold embroidery
※Red bits are
　part of table.

■Round table

■Cloth

■Metal

■Fur

■Wood

■Metal

■Dining table

■Metal

■Painted wood

■Screen

■Rugs

■Lantern

※Fur part
should have a little ridge.

■Bedding pattern

■Metal

■Pillow

■Fur

■Bed

※Refer to King Tonberry's
outfit for fabric texture.

■Painted metal

■Metal

■Books

■For scale

■Bookshelf

■Stuffed Tonberry

It was quite a challenge to capture the distinctive tonberry look through furniture. (Kenta Tanaka)

Sylphic Furnishings

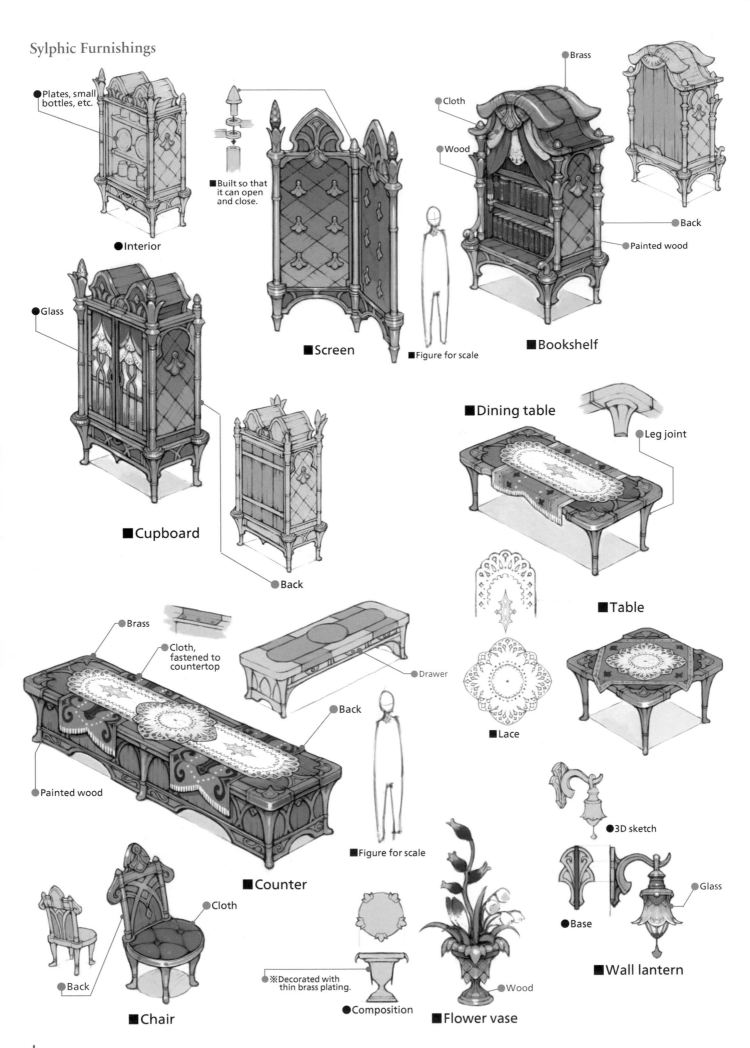

●Plates, small bottles, etc.

●Interior

■Built so that it can open and close.

■Screen

■Figure for scale

●Brass

●Cloth

●Wood

●Back

●Painted wood

■Bookshelf

●Glass

■Cupboard

●Back

■Dining table

Leg joint

■Table

■Lace

●Brass

Cloth, fastened to countertop

Drawer

●Back

●Painted wood

■Figure for scale

■Counter

Cloth

●Back

■Chair

※Decorated with thin brass plating.

●Composition

Wood

●Flower vase

●3D sketch

●Base

●Glass

■Wall lantern

I tried to preserve a sylphic quality while designing something that would be crafted by men. (Kenta Tanaka)

Morbol Furnishings

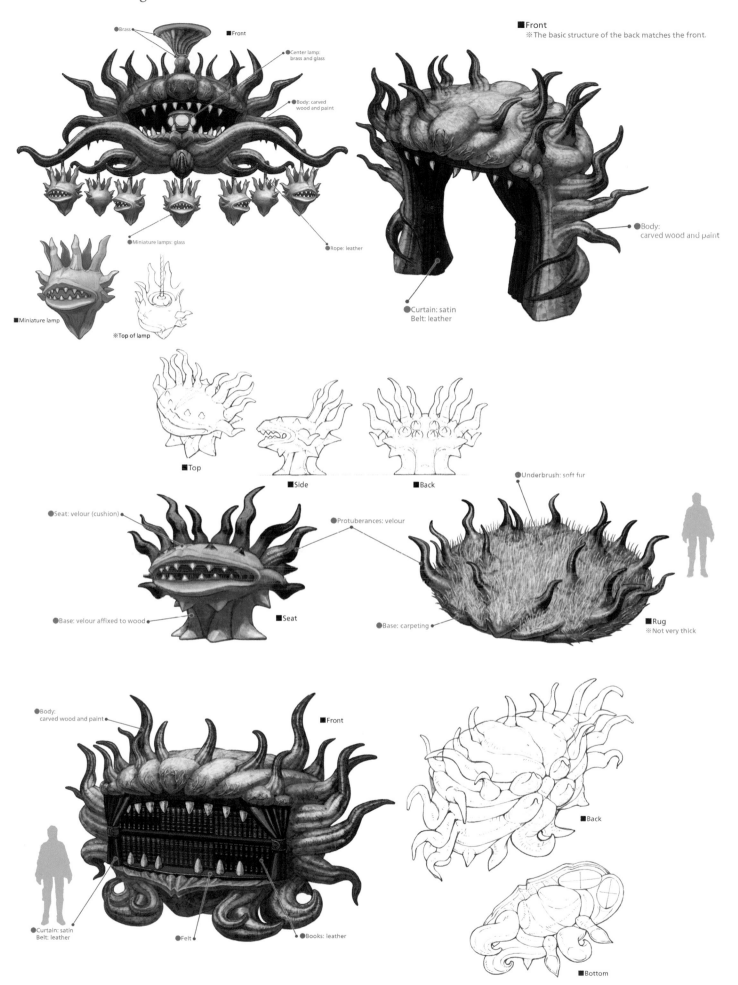

●Brass

■Front

●Center lamp:
brass and glass

●Body: carved
wood and paint

●Miniature lamps: glass

●Rope: leather

■Miniature lamp

※Top of lamp

■Front
※The basic structure of the back matches the front.

●Body:
carved wood and paint

●Curtain: satin
Belt: leather

■Top

■Side

■Back

●Seat: velour (cushion)

●Protuberances: velour

●Underbrush: soft fur

●Base: velour affixed to wood

■Seat

●Base: carpeting

■Rug
※Not very thick

●Body:
carved wood and paint

■Front

■Back

●Curtain: satin
Belt: leather

●Felt

●Books: leather

■Bottom

The planning team's internal name for this set was "I love morbols!" That was the first—and last—time I'd seen a name like that. (Hama)

207

Carbuncle Furnishings

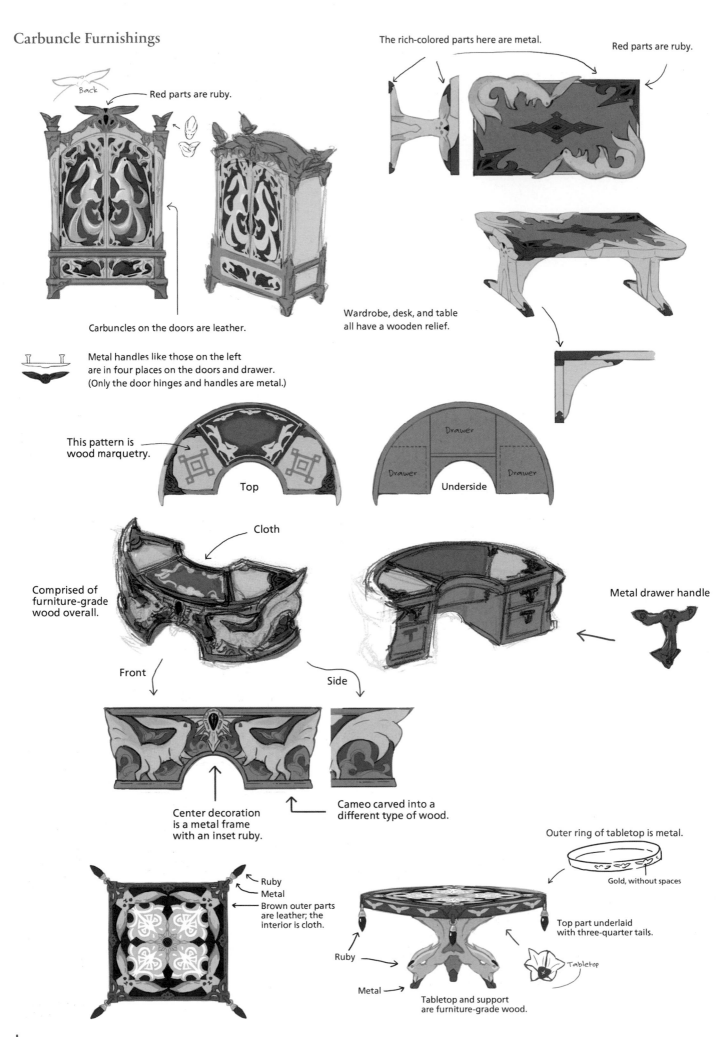

Back

Red parts are ruby.

The rich-colored parts here are metal.

Red parts are ruby.

Carbuncles on the doors are leather.

Wardrobe, desk, and table all have a wooden relief.

Metal handles like those on the left are in four places on the doors and drawer. (Only the door hinges and handles are metal.)

This pattern is wood marquetry.

Top

Drawer

Drawer

Drawer

Underside

Cloth

Comprised of furniture-grade wood overall.

Metal drawer handle

Front

Side

Center decoration is a metal frame with an inset ruby.

Cameo carved into a different type of wood.

Outer ring of tabletop is metal.

Gold, without spaces

Ruby
Metal
Brown outer parts are leather; the interior is cloth.

Ruby

Metal

Top part underlaid with three-quarter tails.

Tabletop

Tabletop and support are furniture-grade wood.

It's hard to tell from these sketches, but I went for a soothing look befitting Carbuncle. (Kasuya)

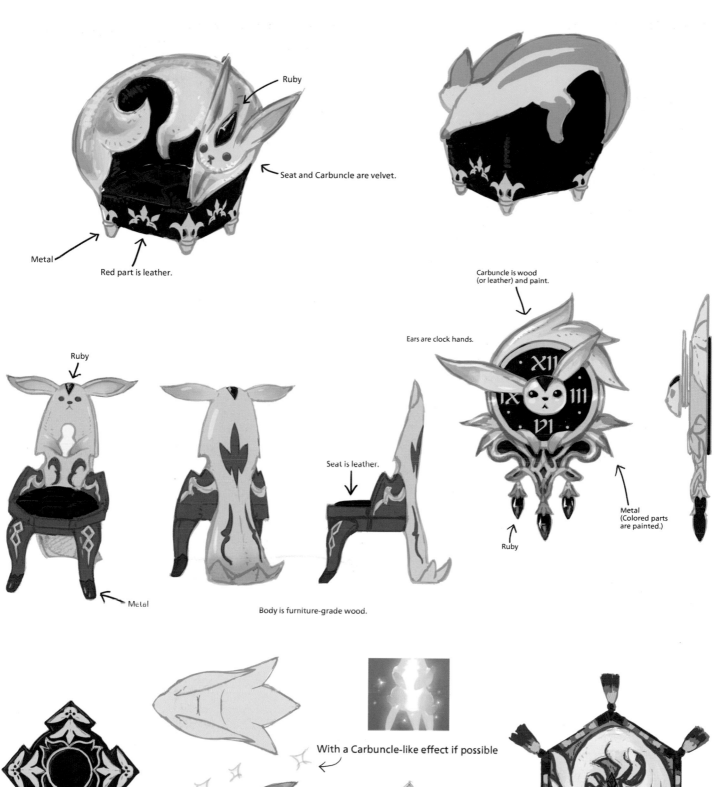

Ruby

Seat and Carbuncle are velvet.

Metal

Red part is leather.

Carbuncle is wood (or leather) and paint.

Ears are clock hands.

Ruby

Ruby

Seat is leather.

Metal

Metal (Colored parts are painted.)

Ruby

Body is furniture-grade wood.

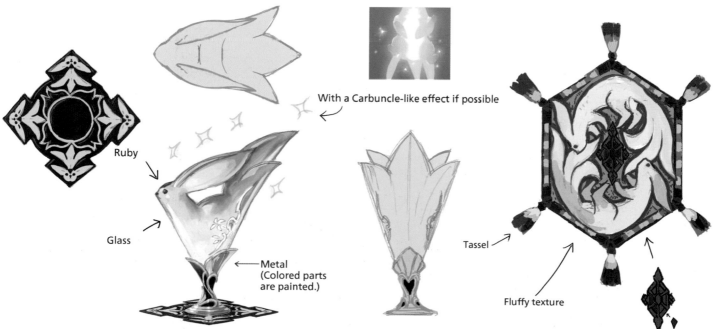

With a Carbuncle-like effect if possible

Ruby

Glass

Metal (Colored parts are painted.)

Tassel

Fluffy texture

Flat-cut rubies are inset in the leather.

209

Illumination Module

Structure of lower section

Projector

Projected pattern ※Originally planned to function as a clock (but doesn't in reality).

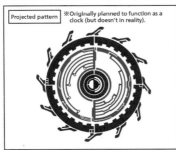

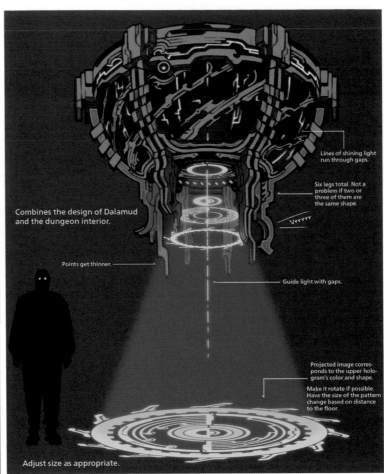

Combines the design of Dalamud and the dungeon interior.

Points get thinner.

Lines of shining light run through gaps.

Six legs total. Not a problem if two or three of them are the same shape.

Guide light with gaps.

Projected image corresponds to the upper hologram's color and shape.

Make it rotate if possible. Have the size of the pattern change based on distance to the floor.

Adjust size as appropriate.

The idea was that the projected pattern would move and function as a timepiece, something which unfortunately didn't make it into the game. (Saito)

Seating and Diagnostics Modules

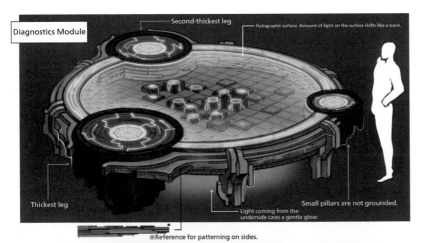

Diagnostics Module

Second-thickest leg

Holographic surface. Amount of light on the surface shifts like a wave.

Thickest leg

Light coming from the underside casts a gentle glow.

Small pillars are not grounded.

※Reference for patterning on sides.

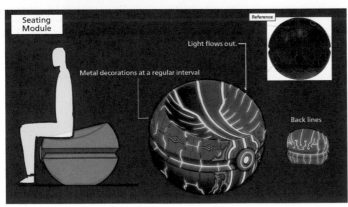

Seating Module

Light flows out.

Metal decorations at a regular interval

Reference

Back lines

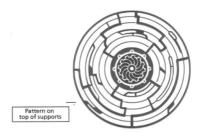

Pattern on top of supports

Underside

Cross section

Without hologram

Pillars in center portion protrude to various degrees; sides are red.

Lines on top plate

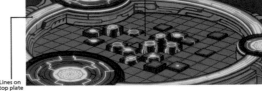

A table and chair with a holographic look reminiscent of a sci-fi movie. The chair is modeled after the spheres in the Binding Coil. (Saito)

Projection Module

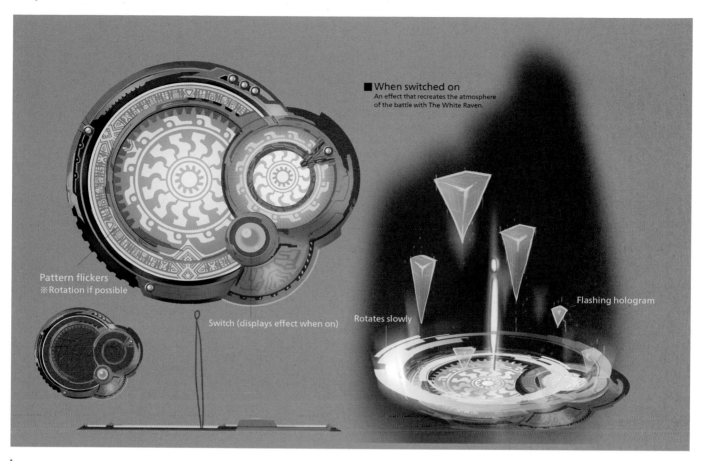

■ When switched on
An effect that recreates the atmosphere of the battle with The White Raven.

Pattern flickers
※Rotation if possible

Switch (displays effect when on)

Rotates slowly

Flashing hologram

A piece of Allagan technology that evokes the mood of the final battle of Version 1.0 when you step on it. (Yamate)

Purification Module

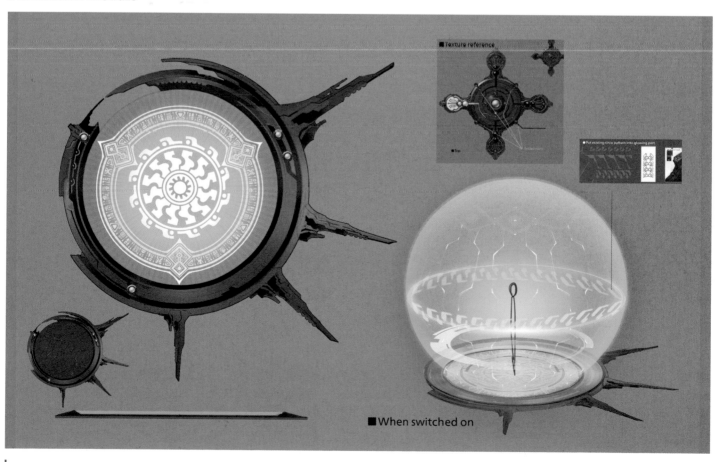

■ Texture reference

■ Top

● Put existing circle pattern into glowing part.

■ When switched on

This design was originally rejected, but eventually made it in. Step inside and imagine how Bahamut felt when he was imprisoned inside Dalamud. (Yamate)

Llymlaen's Embrace

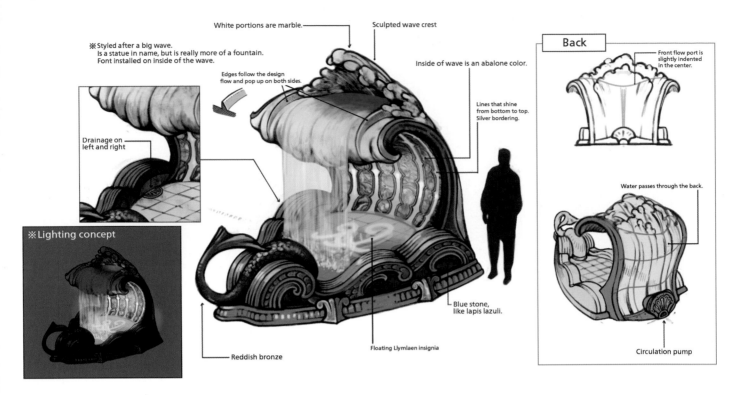

※Styled after a big wave.
Is a statue in name, but is really more of a fountain.
Font installed on inside of the wave.

White portions are marble.

Sculpted wave crest

Inside of wave is an abalone color.

Edges follow the design flow and pop up on both sides.

Lines that shine from bottom to top. Silver bordering.

Drainage on left and right

※Lighting concept

Reddish bronze

Floating Llymlaen insignia

Blue stone, like lapis lazuli.

Back

Front flow port is slightly indented in the center.

Water passes through the back.

Circulation pump

A compact fountain. The water in the pool is circulated back up through the back side to fall again. (Saito)

Inferno Wall Lamp

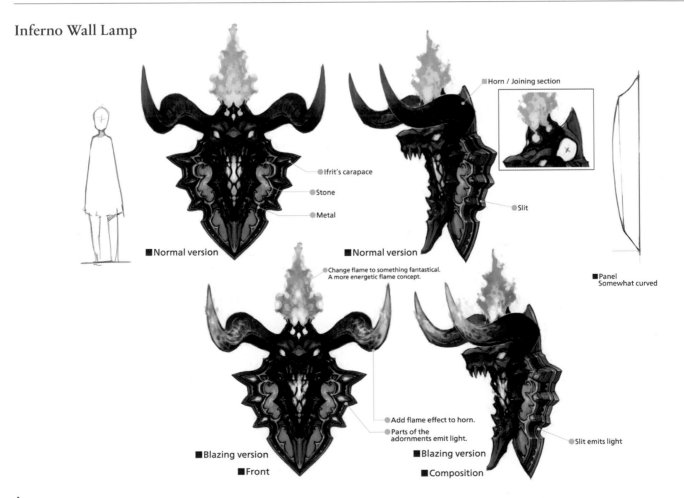

Ifrit's carapace

Stone

Metal

■Normal version

Horn / Joining section

Slit

■Normal version

■Panel
Somewhat curved

Change flame to something fantastical.
A more energetic flame concept.

Add flame effect to horn.

Parts of the adornments emit light.

■Blazing version

■Front

Slit emits light

■Blazing version

■Composition

I tried to capture the immense might of Ifrit with this design. (Kenta Tanaka)

Vortex Couch

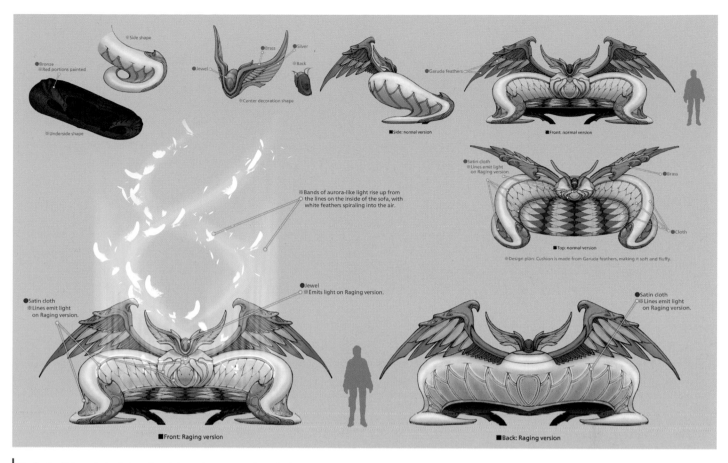

■Underside shape
※Bronze
※Red portions painted

※Side shape

●Jewel
●Brass
●Silver
※Center decoration shape
※Back

■Side: normal version

●Garuda feathers

■Front: normal version

●Satin cloth
※Lines emit light on Raging version.

●Brass
●Cloth

■Top: normal version

※Design plan: Cushion is made from Garuda feathers, making it soft and fluffy.

※Bands of aurora-like light rise up from the lines on the inside of the sofa, with white feathers spiraling into the air.

●Jewel
※Emits light on Raging version.

●Satin cloth
※Lines emit light on Raging version.

■Front: Raging version

●Satin cloth
※Lines emit light on Raging version.

■Back: Raging version

To give it a light and airy feel, I reduced the surface area touching the floor and tried to give the cover material a fluffy, soft-to-the-touch look. (Hama)

Cragsoul Lamp

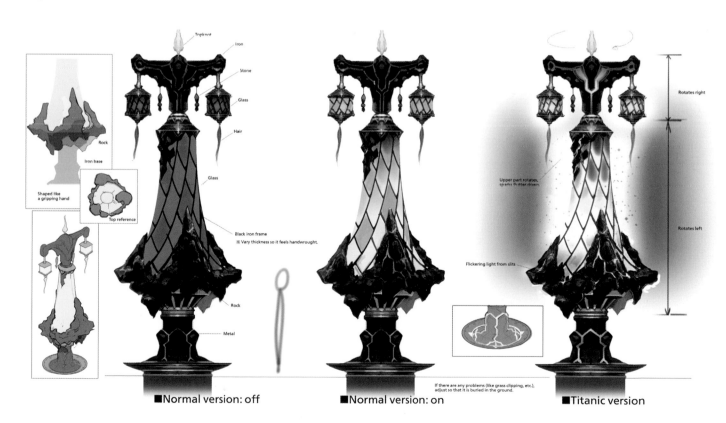

Shaped like a gripping hand

Rock
Iron base

Top reference

Topknot
Iron
Stone
Glass
Hair
Glass

Black iron frame
※ Vary thickness so it feels handwrought.

Rock
Metal

■Normal version: off

If there are any problems (like grass clipping, etc.), adjust so that it is buried in the ground.

■Normal version: on

Rotates right

Upper part rotates, sparks flutter down.

Rotates left

Flickering light from slits

■Titanic version

The idea here was of Titan's hand grasping the lantern. I added a bit of Eastern flair. (Yamate)

Moogle Letter Box

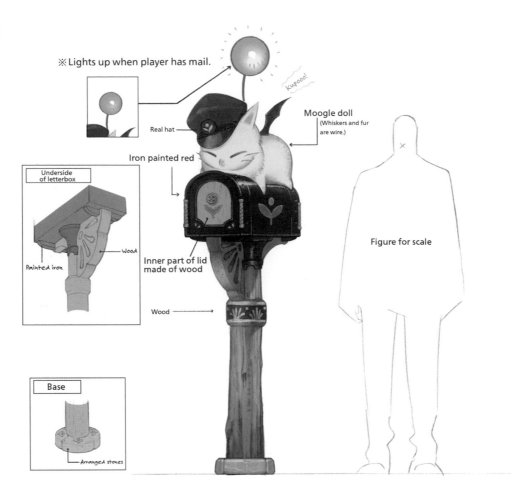

※Lights up when player has mail.

Real hat

Kupooo!

Moogle doll
(Whiskers and fur are wire.)

Iron painted red

Underside of letterbox

Wood

Painted iron

Inner part of lid made of wood

Wood

Figure for scale

Base

Arranged stones

I went for the simple, rustic look of a moogle doll attached to a mailbox. (Saito)

Regal Letter Box

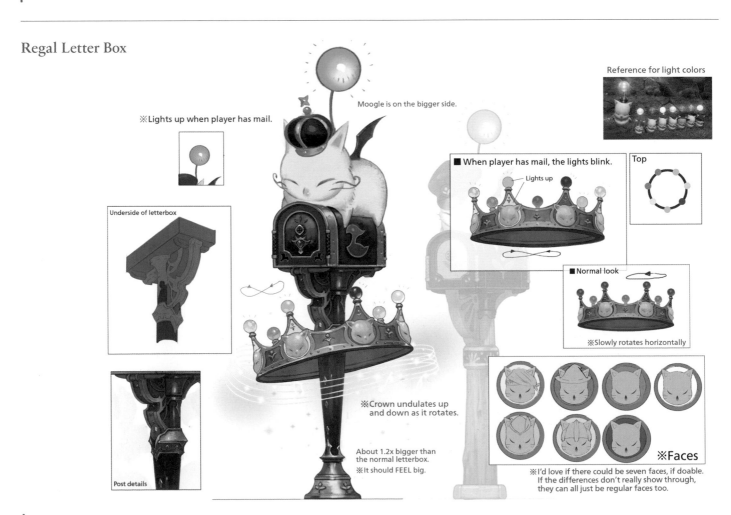

※Lights up when player has mail.

Moogle is on the bigger side.

Reference for light colors

■ When player has mail, the lights blink.

Lights up

Top

Underside of letterbox

■ Normal look

※Slowly rotates horizontally

※Crown undulates up and down as it rotates.

About 1.2x bigger than the normal letterbox.
※It should FEEL big.

Post details

※Faces

※I'd love if there could be seven faces, if doable. If the differences don't really show through, they can all just be regular faces too.

This design featuring the Good King is a personal favorite. Note the faces of his Mogglesguard on the crown. (Yamate)

Wavesoul Fount

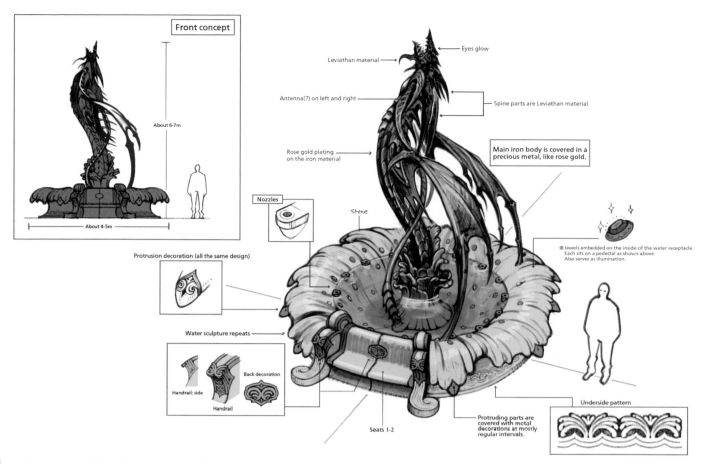

Front concept

About 6-7m

About 4-5m

Eyes glow

Leviathan material

Antenna(?) on left and right

Rose gold plating
on the iron material

Spine parts are Leviathan material.

Main iron body is covered in a
precious metal, like rose gold.

Nozzles

Stone

※ Jewels embedded on the inside of the water receptacle.
Each sits on a pedestal as shown above.
Also serves as illumination.

Protrusion decoration (all the same design)

Water sculpture repeats

Back decoration

Handrail: side

Handrail

Seats 1-2

Protruding parts are
covered with metal
decorations at mostly
regular intervals.

Underside pattern

I tried to capture the feeling of Leviathan bursting forth from the waves with a great splash. (Saito)

Plasma Lamp

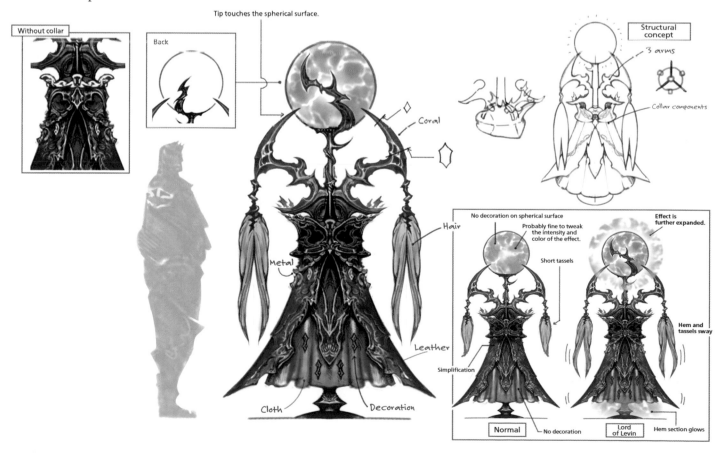

Without collar

Back

Tip touches the spherical surface.

Structural
concept

3 arms

Collar components

Coral

Hair

Metal

Leather

Cloth

Decoration

No decoration on spherical surface

Probably fine to tweak
the intensity and
color of the effect.

Short tassels

Effect is
further expanded.

Simplification

Hem and
tassels sway

Normal

No decoration

Lord
of Levin

Hem section glows

The white tassels dangling from each side were modeled after Ramuh's beard. (Saito)

Behemoth Wall Trophy

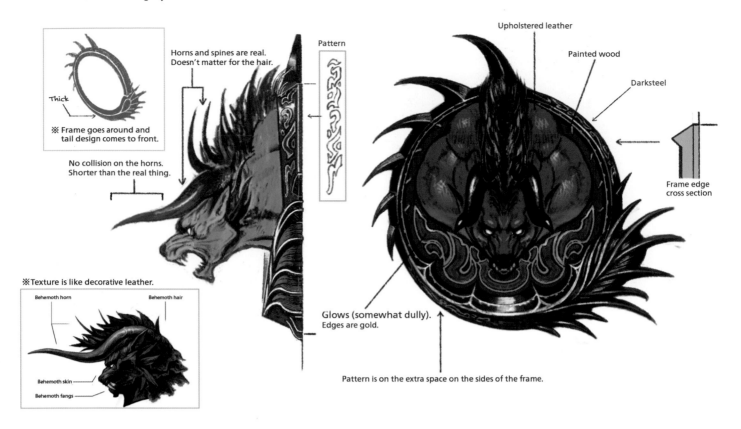

Thick

※ Frame goes around and tail design comes to front.

No collision on the horns.
Shorter than the real thing.

Horns and spines are real.
Doesn't matter for the hair.

Pattern

Upholstered leather

Painted wood

Darksteel

Frame edge
cross section

※Texture is like decorative leather.

Behemoth horn

Behemoth hair

Behemoth skin

Behemoth fangs

Glows (somewhat dully).
Edges are gold.

Pattern is on the extra space on the sides of the frame.

A behemoth coming forth from the wall. The frame is modeled after the beast's tail. (Saito)

Dark Divinity Falleth

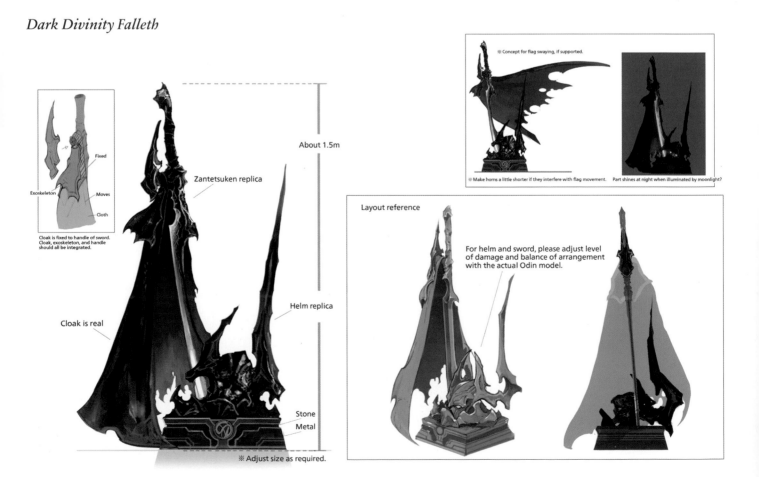

Fixed

Exoskeleton

Moves

Cloth

Cloak is fixed to handle of sword.
Cloak, exoskeleton, and handle
should all be integrated.

About 1.5m

Zantetsuken replica

Cloak is real

Helm replica

Stone

Metal

※ Adjust size as required.

※ Concept for flag swaying, if supported.

※ Make horns a little shorter if they interfere with flag movement. Part shines at night when illuminated by moonlight?

Layout reference

For helm and sword, please adjust level
of damage and balance of arrangement
with the actual Odin model.

I designed this thinking it would make a nice figurine. An alternate concept called for a sword splitting a moon in two. (Yamate)

Savage Arc of Triumph

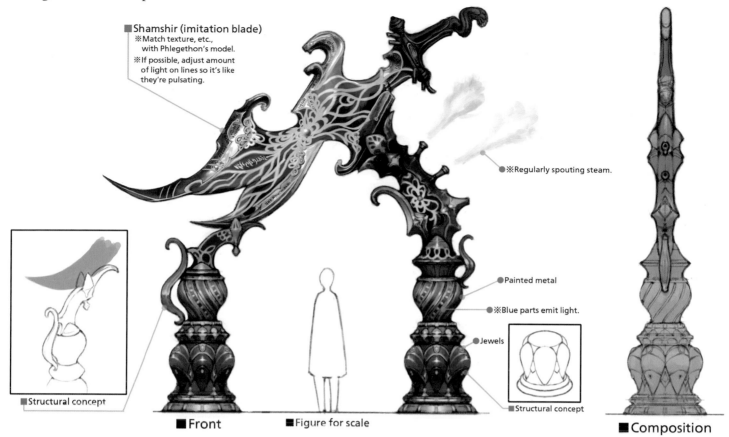

■ Shamshir (imitation blade)
※Match texture, etc., with Phlegethon's model.
※If possible, adjust amount of light on lines so it's like they're pulsating.

※Regularly spouting steam.

Painted metal

※Blue parts emit light.

Jewels

■Structural concept

■Front

■Figure for scale

■Structural concept

■Composition

The order called for a triumphal arch using Phlegethon's Dimension Blade. I opted for a straightforward approach... (Kenta Tanaka)

Emperor's Throne

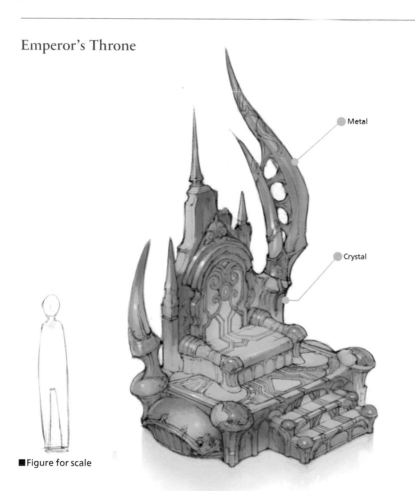

Metal

Crystal

■Figure for scale

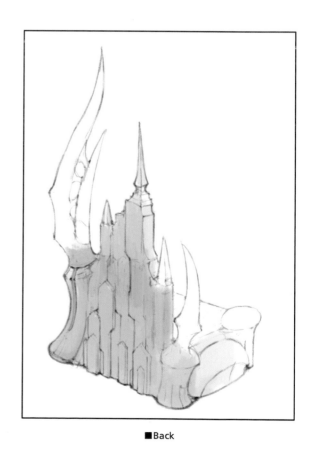

■Back

I took the throne from the Crystal Tower and added a few flourishes. Have a seat and you'll feel just like Emperor Xande! (Kenta Tanaka)

Chronometers

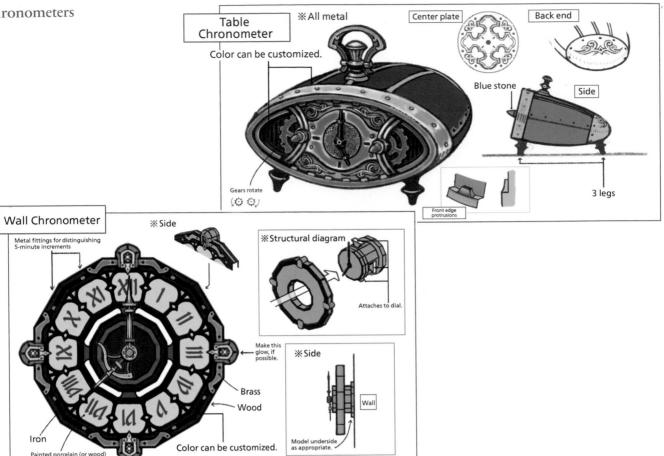

Table Chronometer ※All metal

Color can be customized.

Center plate

Back end

Blue stone

Side

Gears rotate

Front edge protrusions

3 legs

Wall Chronometer

※Side

Metal fittings for distinguishing 5-minute increments

※Structural diagram

Attaches to dial.

Make this glow, if possible.

Brass

Wood

Iron

Painted porcelain (or wood)

Color can be customized.

※Side

Wall

Model underside as appropriate.

I had a number of ideas before finally settling on one tabletop and one wall-mounted piece. These are personal favorites of mine—I wish I had them at home. (Saito)

Rugs

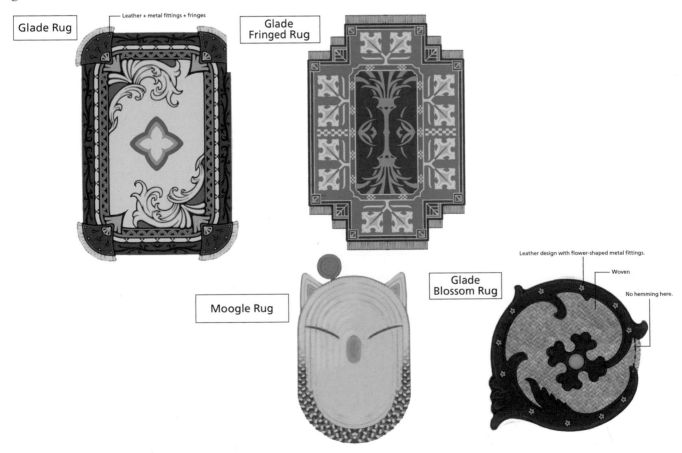

Glade Rug

Leather + metal fittings + fringes

Glade Fringed Rug

Moogle Rug

Glade Blossom Rug

Leather design with flower-shaped metal fittings.

Woven

No hemming here.

I went for designs that looked like they could be made in real life. What I wouldn't give for my own moogle mat! (Saito)

Mandragora Floor Lamp

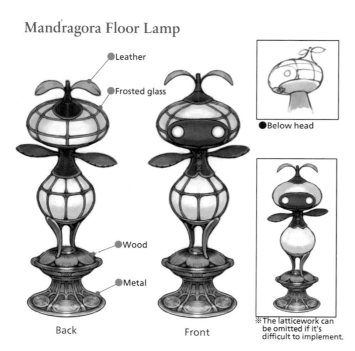

Leather

Frosted glass

Wood

Metal

Back

Front

● Below head

※The latticework can be omitted if it's difficult to implement.

Amigo Cactus Floor Lamp

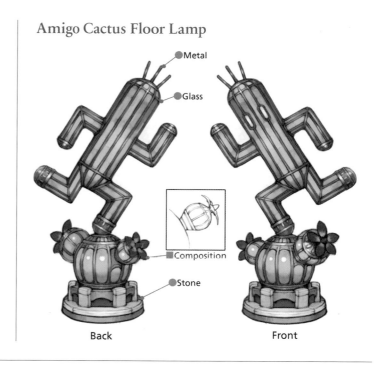

Metal

Glass

■ Composition

Stone

Back

Front

Tonberry Floor Lamp

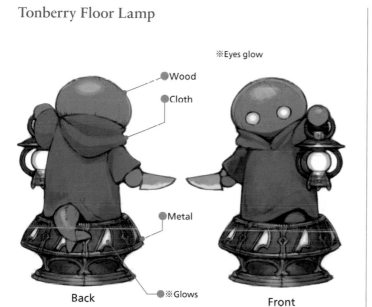

※Eyes glow

Wood

Cloth

Metal

Back

Front

● ※Glows

Stuffed Moogle

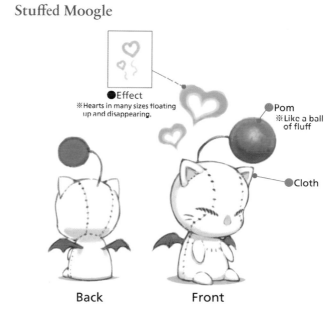

● Effect
※Hearts in many sizes floating up and disappearing.

Pom
※Like a ball of fluff

Cloth

Back

Front

Stuffed Chocobo

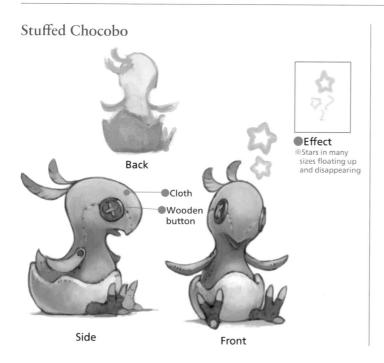

Back

Cloth

Wooden button

Side

Front

● Effect
※Stars in many sizes floating up and disappearing

Miniature Magitek Reaper

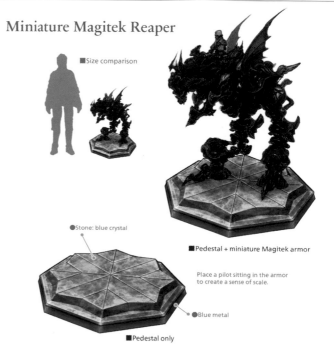

■ Size comparison

● Stone: blue crystal

■ Pedestal + miniature Magitek armor

Place a pilot sitting in the armor to create a sense of scale.

● Blue metal

■ Pedestal only

Drinking Apkallu

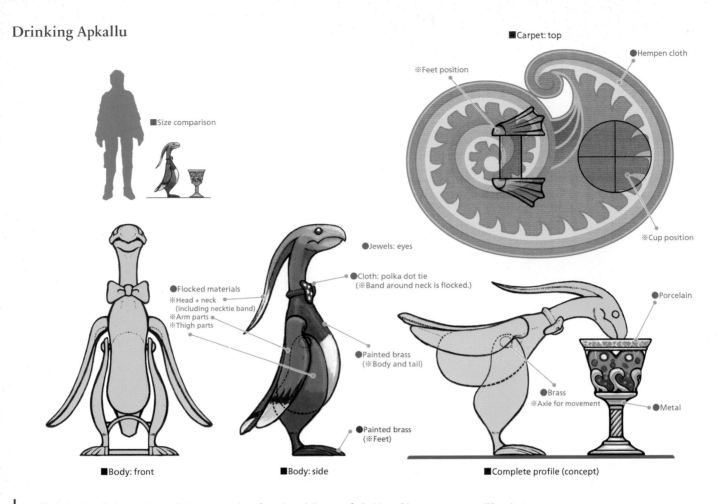

■ Size comparison

■ Carpet: top

※ Feet position

● Hempen cloth

※ Cup position

● Jewels: eyes

● Cloth: polka dot tie
(※ Band around neck is flocked.)

● Flocked materials
※ Head + neck
(including necktie band)
※ Arm parts
※ Thigh parts

● Painted brass
(※ Body and tail)

● Painted brass
(※ Feet)

● Porcelain

● Brass
※ Axle for movement

● Metal

■ Body: front

■ Body: side

■ Complete profile (concept)

For this design, I recalled a certain nostalgic ornament that often adorned the tops of televisions thirty-or-so years ago. (Hama)

Commissioned Portraits

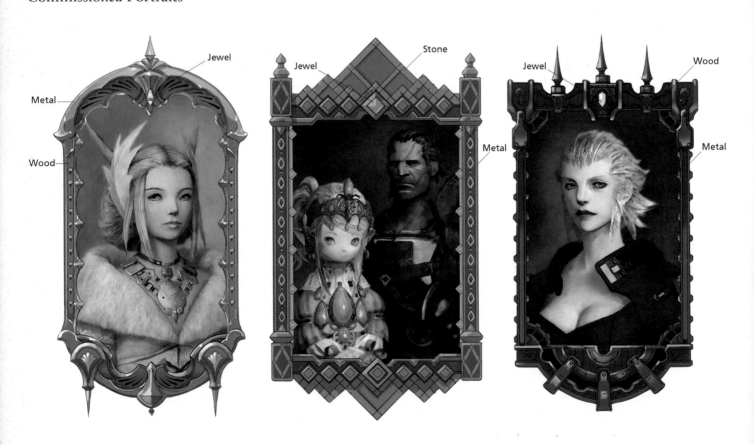

Jewel

Metal

Wood

Jewel

Stone

Metal

Jewel

Wood

Metal

The extravagant frames were designed to capture the feeling of each city-state. The portraits were painted by Tamai. (Yamate)

WORLD

FINAL FANTASY XIV: A Realm Reborn
The Art of Eorzea —Another Dawn—

Limsa Lominsa

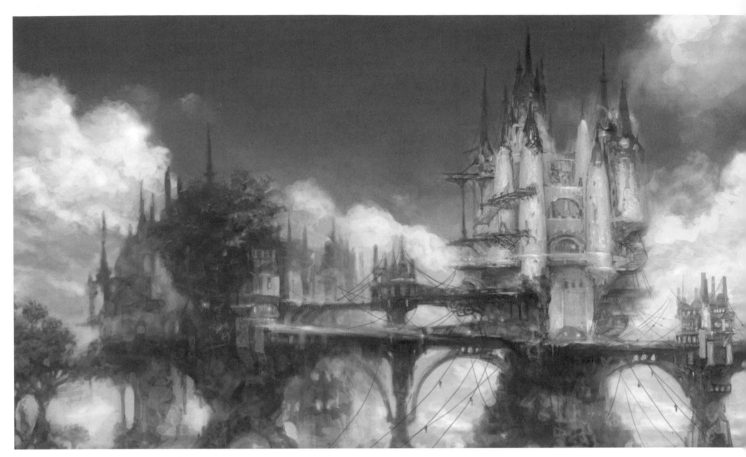

I took care to make Limsa breezy and refreshing, while preserving a certain rough-hewn Roegadyn quality. I also had the idea of adding a restaurant with a view of the bay. (Takahashi)

Gridania

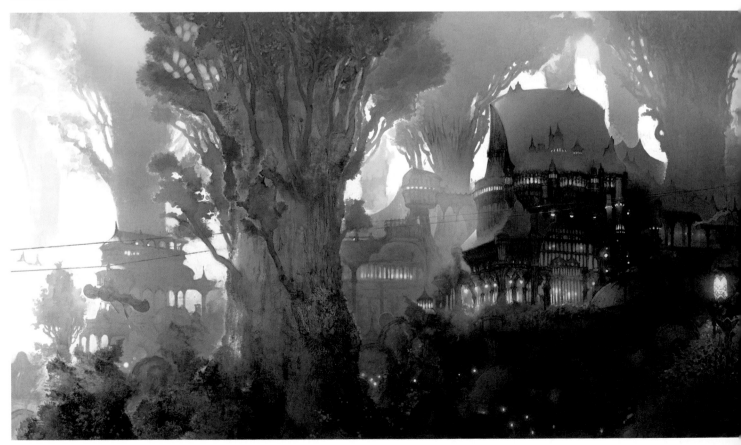

Concept art for Gridania from the original *FFXIV*. It left quite an impression on me, and I remember thinking that if we could pull off this look in-game, *FFXIV* would be just fine. The artist, Arai, also did art for 3.0 depicting...oops, I'll stop there! (Yoshi-P)

Lominsan Architecture

Pattern reference

Attach adornments identically on the left and right.

Storehouse door (does not open). Use a generic door.

Sloped

Generic building on Limsa terrain

A close-up of the Fishermens' Guild. I worked fish motifs into the ornaments. (Yamate)

Gridanian Architecture

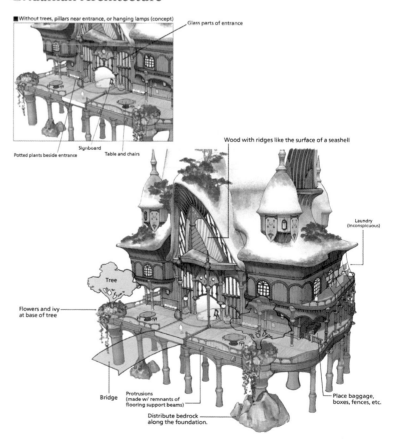

■ Without trees, pillars near entrance, or hanging lamps (concept)

Glass parts of entrance

Signboard

Potted plants beside entrance

Table and chairs

Wood with ridges like the surface of a seashell

Laundry (Inconspicuous)

Tree

Flowers and ivy at base of tree

Bridge

Protrusions (made w/ remnants of flooring support beams)

Distribute bedrock along the foundation.

Place baggage, boxes, fences, etc.

The inn at Fallgourd Float. In the game, the second floor is as far as you can go, but the concept calls for a set of stairs in the back leading to a third-floor dining area. (Saito)

Ul'dah

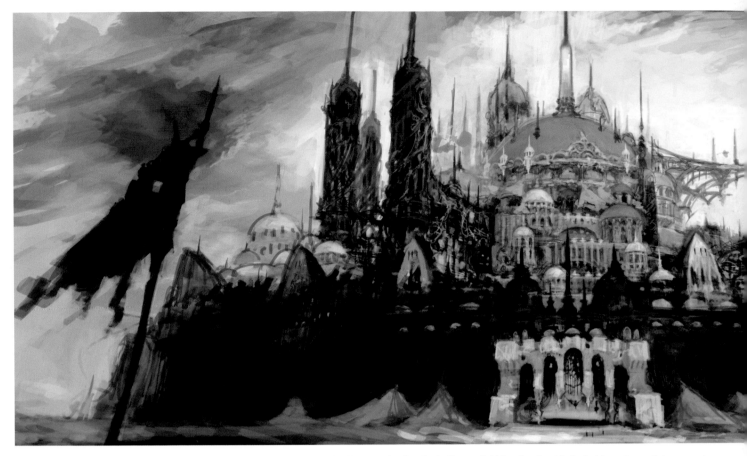

Ul'dah's appeal lies in the juxtaposition of splendor and shadow. I contrasted the illuminated cellars, back alleys, and thick red walls with the lavish opulence of the upper tier. (Takahashi)

Ishgard

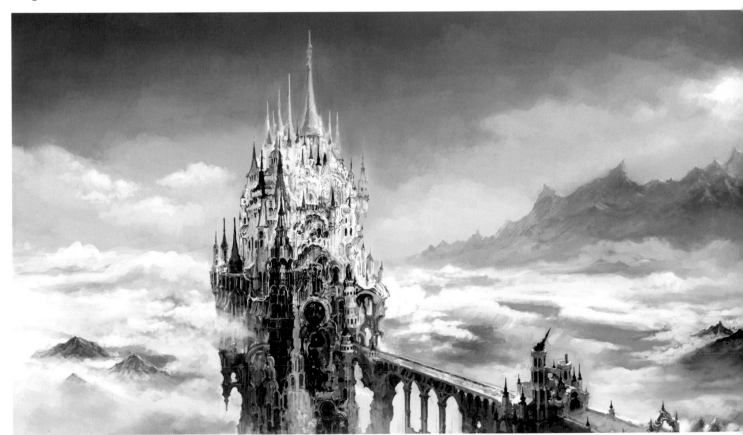

This panorama of Ishgard was drawn during production of 1.0. This is one of many Ishgard pieces we have, and we hope to show them all to you one day. What great adventures await you beyond this sea of clouds? This piece really stirs the imagination. (Yoshi-P)

Ul'dahn Architecture

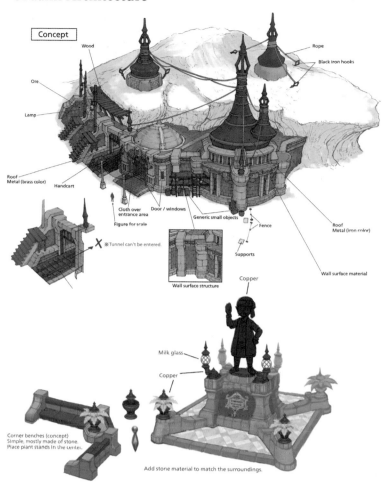

Concept

Wood
Ore
Lamp
Rope
Black iron hooks
Roof Metal (brass color)
Handcart
Cloth over entrance area
Figure for scale
Door / windows
Generic small objects
Fence
Supports
Wall surface material
Roof Metal (iron color)
※Tunnel can't be entered.
Wall surface structure
Copper

Milk glass
Copper
Copper

Corner benches (concept)
Simple, mostly made of stone.
Place plant stands in the center.

Add stone material to match the surroundings.

Ishgardian Architecture

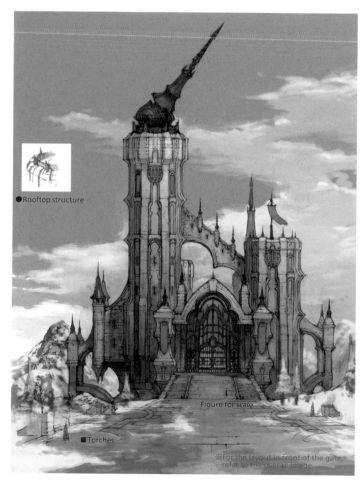

●Rooftop structure

■Torches

Figure for scale

※For the layout in front of the gate, refer to the overall image.

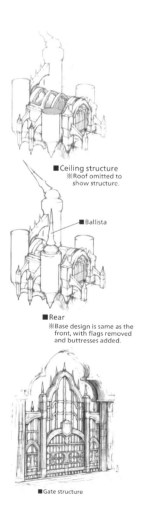

■Ceiling structure
※Roof omitted to show structure.

●Ballista

■Rear
※Base design is same as the front, with flags removed and buttresses added.

■Gate structure

Mor Dhona

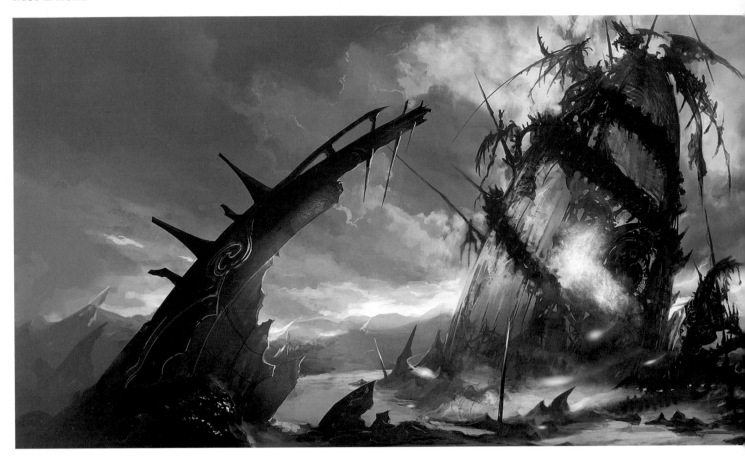

I drew this from a sketch by Takahashi. To add flair to the fallen Garlean airship, I worked in the skeleton and crystals. It's a personal favorite of mine. (Yamate)

Ala Mhigo

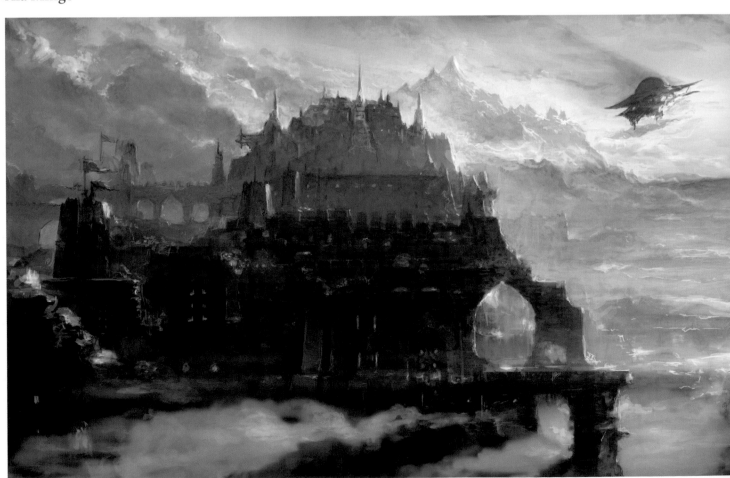

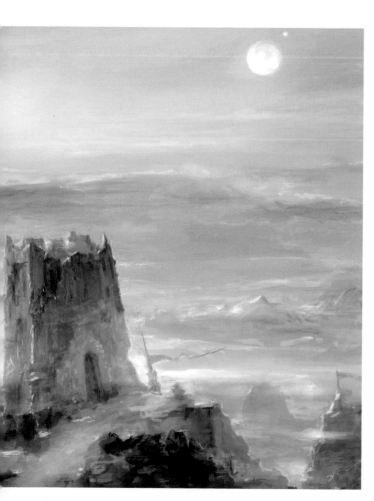

■Central lake idea. Cliff on waterfall side (water is dried up or very low). Orichalcum crystals grow and swallow up the rocks.

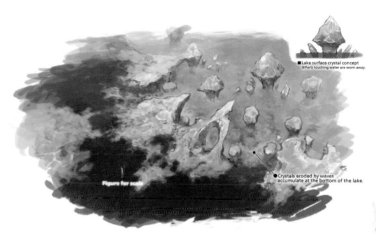

■Lake surface crystal concept
■Parts touching water are worn away.

●Crystals eroded by waves accumulate at the bottom of the lake.

Figure for scale

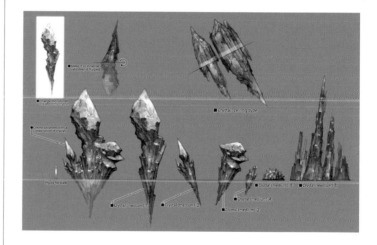

●Make it so it can be used even if flipped.

●Change the color of the material for life.

●Create variations with a combination of crystals.

■Crystal (ceiling) type

Figure for scale

■Crystal (medium) (1) ■Crystal (medium) (2) ■Crystal (medium) (3) ■Crystal (medium) (5) ■Crystal (medium) (6)

■Crystal (medium) (4)

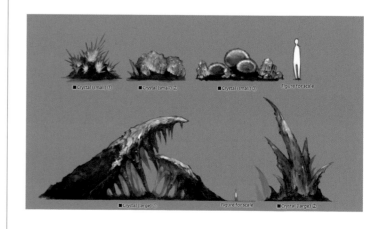

■Crystal (small) (1) ■Crystal (small) (2) ■Crystal (small) (3) Figure for scale

■Crystal (large) (1) Figure for scale ■Crystal (large) (2)

Moraby Drydocks

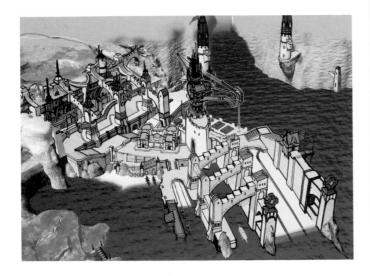

I have a bunch of sketches of individual buildings, but we only had room for this one picture. Too bad! (Saito)

Meteor Crater (La Noscea)

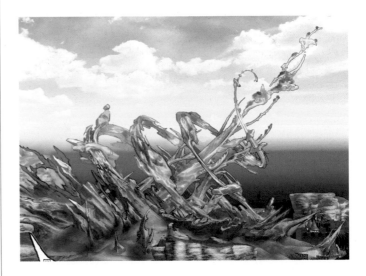

With the meteor fragment rotating rapidly as it slammed into the ground, the crater took on this shape. (Saito)

Camp Bronze Lake

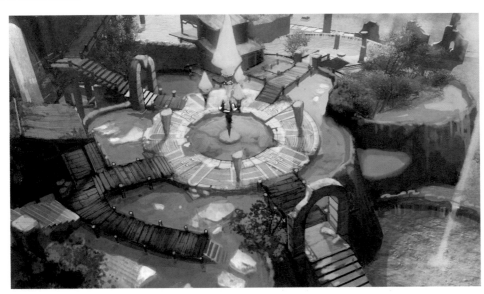

Pillar details

The Wolves' Den

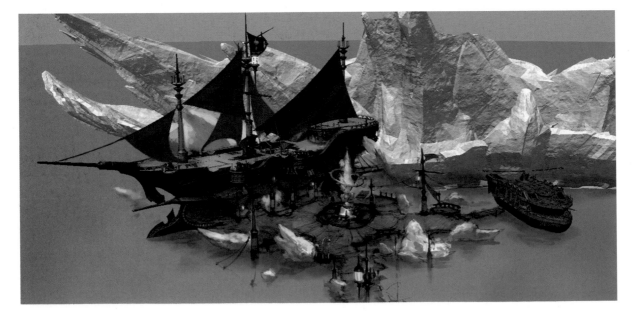

The Wanderer's Palace

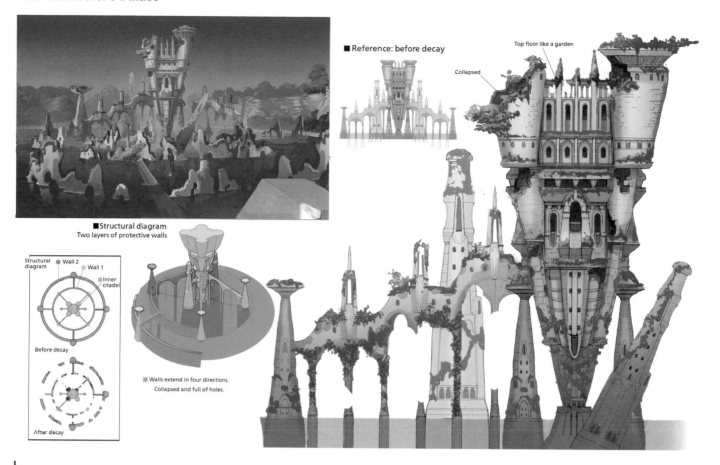

The concept mentioned it resembling the build of a Roegadyn, so I went for this reverse triangle design. It kind of looks like a rocket stuck head-first in the ground. (Yamate)

Sapsa Spawning Grounds

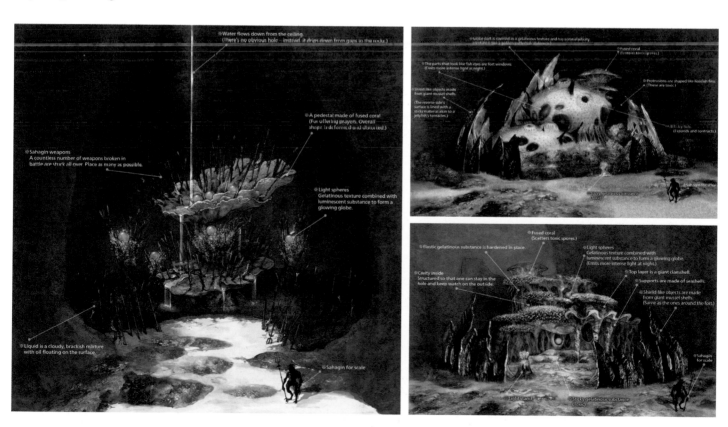

I envisioned this as a place where the weapons of the Sahagin, imbued with the memories of countless battles, would come to rest. (Hama)

Fallgourd Float

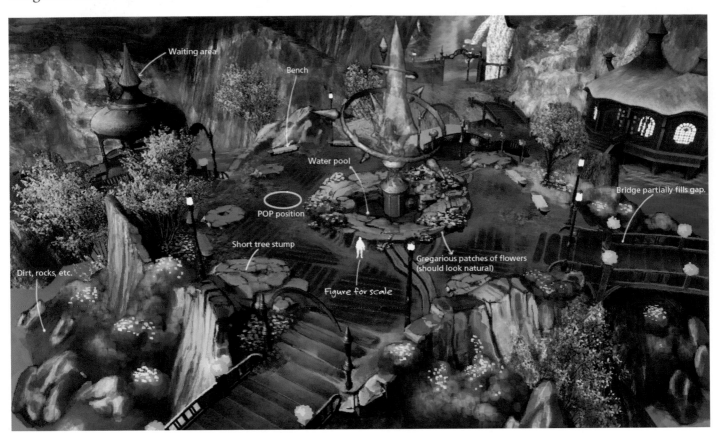

Waiting area

Bench

Water pool

POP position

Bridge partially fills gap.

Short tree stump

Gregarious patches of flowers
(should look natural)

Figure for scale

Dirt, rocks, etc.

This aetheryte stands atop a giant tree stump and a bed of soil. I'd love to get some rest and relaxation at a place like this. (Saito)

Moogle's Gift Mounts

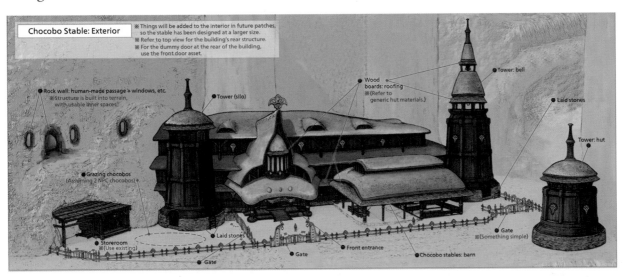

Chocobo Stable: Exterior
※ Things will be added to the interior in future patches, so the stable has been designed at a larger size.
※ Refer to top view for the building's rear structure.
※ For the dummy door at the rear of the building, use the front door asset.

Rock wall: human-made passage + windows, etc.
※Structure is built into terrain, with usable inner spaces.

Tower (silo)

Wood boards: roofing
※(Refer to generic hut materials.)

Tower: bell

Laid stones

Tower: hut

Grazing chocobos
(Assuming 2 NPC chocobos)

Storeroom
※(Use existing)

Laid stones

Gate

Gate

Gate

Front entrance

Chocobo stables: barn

Gate
※(Something simple)

Structure concept

Structure concept

Figure for scale

Wood Iron Keyhole Gate

Figure for scale Fence Simple version

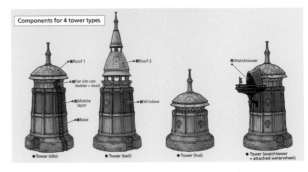

Components for 4 tower types

Roof 1

Roof 2

Watchtower

For silo use (ladder + door)

Middle layer

Window

Base

◆Tower (silo) ◆Tower (bell) ◆Tower (hut) ◆Tower (watchtower + attached waterwheel)

I approached this design with the idea that there were actual chocobos stabled inside, checking against a scale-model mockup of the building as I ironed out the details. (Hama)

Sanctum of the Twelve

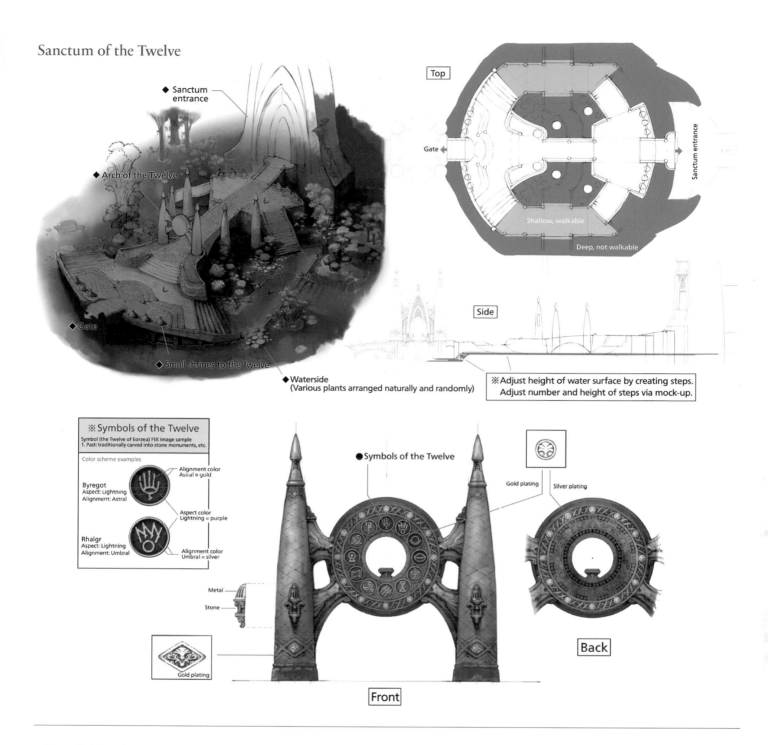

◆ Sanctum entrance

◆ Arch of the Twelve

◆ Gate

◆ Small shrines to the Twelve

◆ Waterside
(Various plants arranged naturally and randomly)

Top

Gate

Sanctum entrance

Shallow, walkable

Deep, not walkable

Side

※Adjust height of water surface by creating steps.
Adjust number and height of steps via mock-up.

※ Symbols of the Twelve

Symbol (the Twelve of Eorzea) FIX image sample
1. Past: traditionally carved into stone monuments, etc.

Color scheme examples

Byregot
Aspect: Lightning
Alignment: Astral

Alignment color
Astral = gold

Aspect color
Lightning = purple

Rhalgr
Aspect: Lightning
Alignment: Umbral

Alignment color
Umbral = silver

● Symbols of the Twelve

Gold plating

Silver plating

Metal

Stone

Gold plating

Front

Back

The Sylphlands

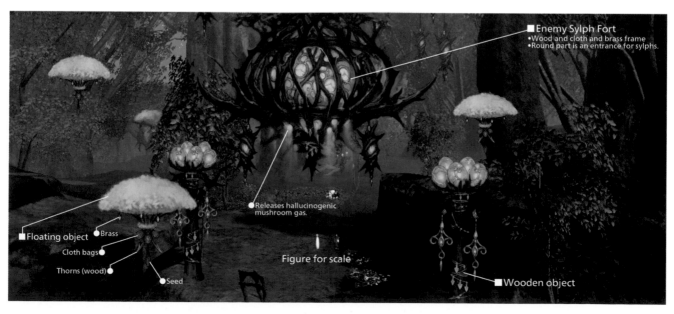

■ Enemy Sylph Fort
•Wood and cloth and brass frame
•Round part is an entrance for sylphs.

●Releases hallucinogenic mushroom gas.

■ Floating object
●Brass
Cloth bags
Thorns (wood)
●Seed

Figure for scale

■ Wooden object

The Coffer & Coffin

Watchtower

A small plaza
If possible, add a bonfire and some boxes.

Windmill

Signboard

Dummy door
※Guard station

Figure for scale

Guidepost

Black Brush Station

The Invisible City

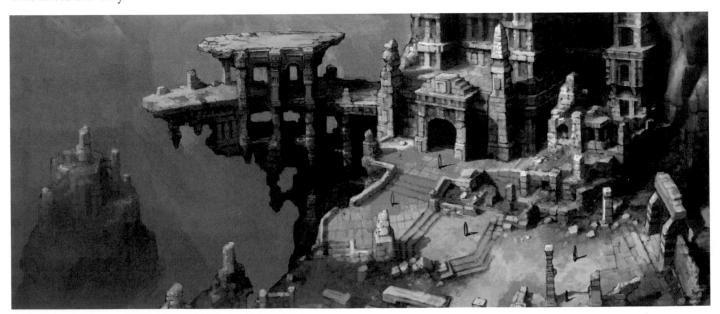

Ceruleum Field

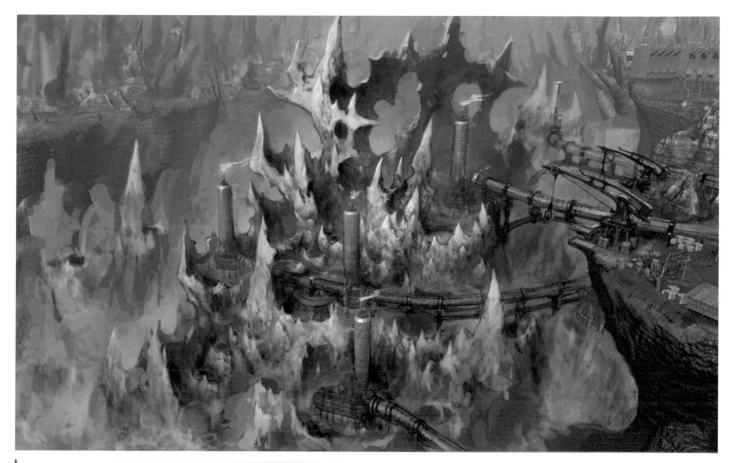

A hazardous area where ceruleum spurts from the ground in abundance. Open flames strictly prohibited! (Kenta Tanaka)

Ceruleum Crane

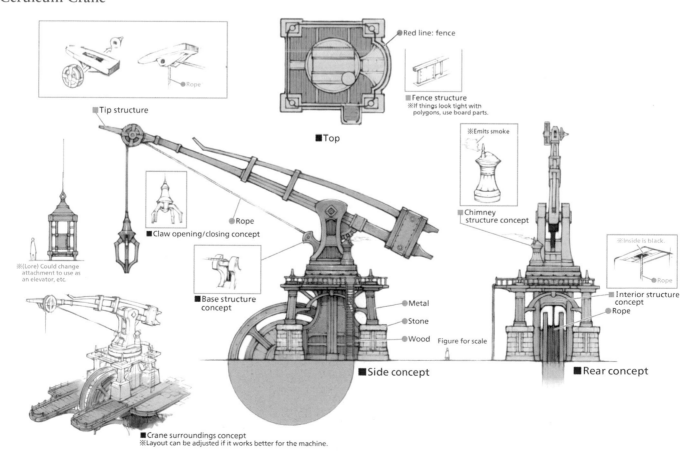

■Top

Red line: fence

■Fence structure
※If things look tight with polygons, use board parts.

■Tip structure

※(Lore) Could change attachment to use as an elevator, etc.

Rope

■Claw opening/closing concept

■Base structure concept

Metal
Stone
Wood
Figure for scale

■Side concept

※Emits smoke

■Chimney structure concept

※Inside is black.

■Interior structure concept
Rope

■Rear concept

■Crane surroundings concept
※Layout can be adjusted if it works better for the machine.

The idea here was of a crane used to lower workers and materials down to the gorge floor where ceruleum is mined. (Kenta Tanaka)

Observatorium Pub

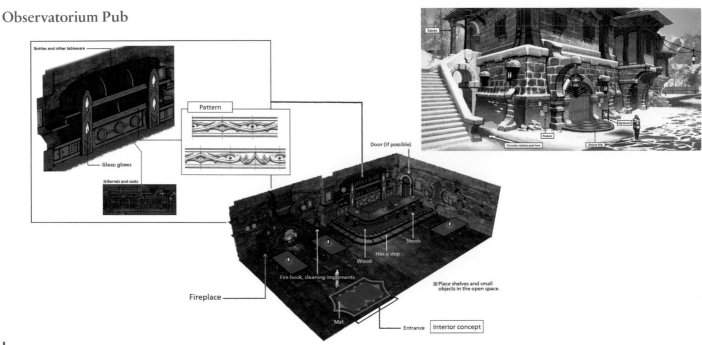

Bottles and other tableware

Glass: glows

※Barrels and casks

Pattern

Door (if possible)

Stools

Wood

Has a step

Fire hook, cleaning implements

※Place shelves and small objects in the open space.

Fireplace

Mat

Entrance

Interior concept

Eaves

Posters

Chocobo stables past here

Signboard

Stone tile

I'm fond of the sign depicting a flagon of mead. I tried to evoke the contrast between the cold outdoors and the warmth inside. (Saito)

Observatorium Astroscope

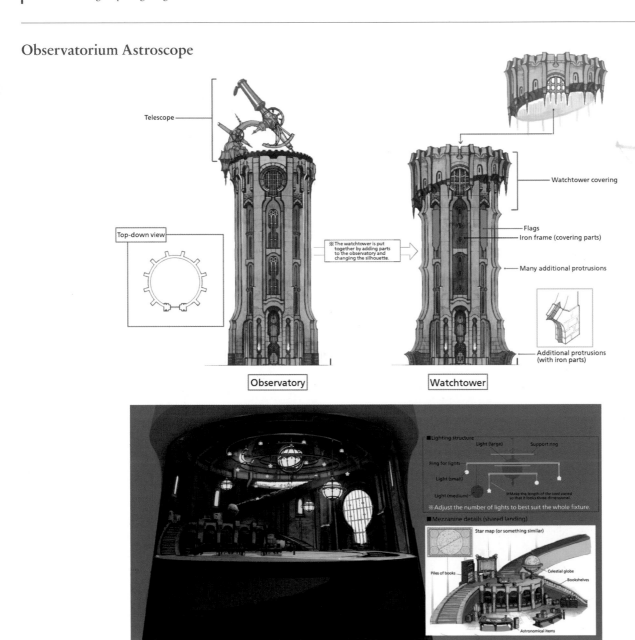

Telescope

Top-down view

※The watchtower is put together by adding parts to the observatory and changing the silhouette.

Observatory

Watchtower

Watchtower covering

Flags

Iron frame (covering parts)

Many additional protrusions

Additional protrusions (with iron parts)

■Lighting structure

Light (large) Support ring

Ring for lights

Light (small)

Light (medium)

※Make the length of the cord varied so that it looks three-dimensional.

※Adjust the number of lights to best suit the whole fixture.

■Mezzanine details (shared landing)

Star map (or something similar)

Piles of books

Celestial globe

Bookshelves

Astronomical items

The great astroscope atop the Observatorium was designed to be rotated in all directions by sliding it atop the jagged rails. (Saito)

Steel Vigil

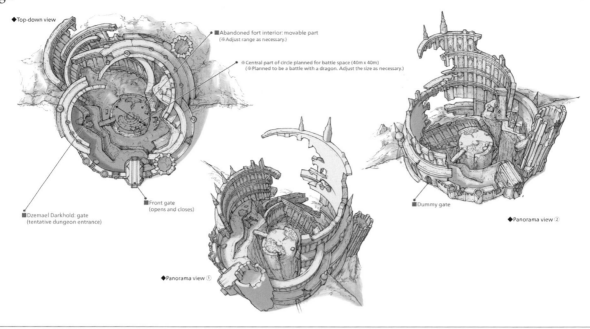

◆Top-down view

■Abandoned fort interior: movable part
(※Adjust range as necessary.)

※Central part of circle planned for battle space (40m x 40m)
(※Planned to be a battle with a dragon. Adjust the size as necessary.)

■Front gate
(opens and closes)

■Dzemael Darkhold: gate
(tentative dungeon entrance)

■Dummy gate

◆Panorama view ②

◆Panorama view ①

Saint Coinach's Find

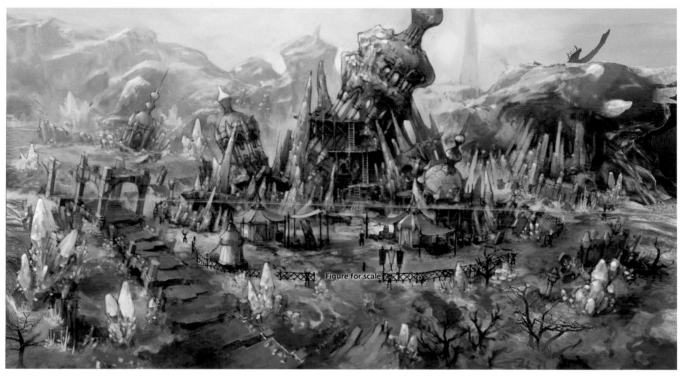

Figure for scale

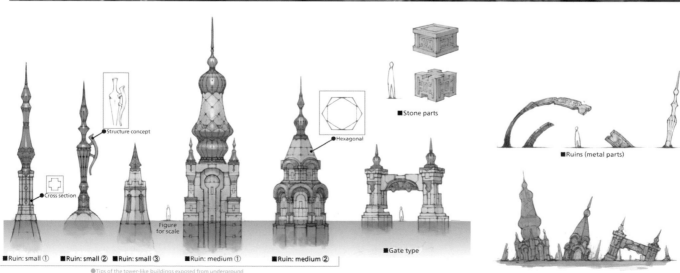

■Structure concept

■Stone parts

■Cross section

Figure
for scale

■Hexagonal

■Ruins (metal parts)

■Ruin: small ① ■Ruin: small ② ■Ruin: small ③ ■Ruin: medium ① ■Ruin: medium ② ■Gate type

●Tips of the tower-like buildings exposed from underground

Crystal Gate

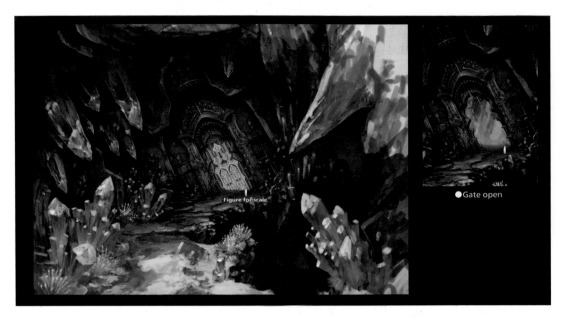

Figure for scale

●Gate open

Aetheryte

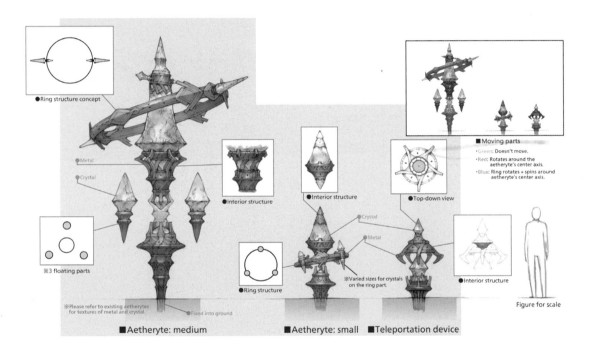

●Ring structure concept

●Metal

●Crystal

※3 floating parts

※Please refer to existing aetherytes for textures of metal and crystal.

●Fixed into ground

■Aetheryte: medium

●Interior structure

●Interior structure

●Ring structure

●Crystal

●Metal

※Varied sizes for crystals on the ring part.

■Aetheryte: small

●Top-down view

■ Moving parts

· Green: Doesn't move.
· Red: Rotates around the aetheryte's center axis.
· Blue: Ring rotates + spins around aetheryte's center axis.

●Interior structure

■Teleportation device

Figure for scale

Market Board & Company Chest

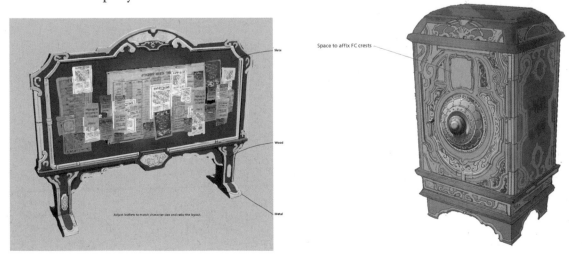

Slate

Wood

Metal

Adjust leaflets to match character size and redo the layout.

Space to affix FC crests

Copperbell Mines

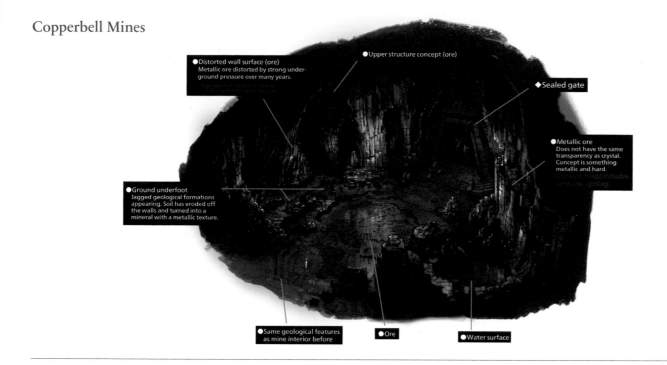

●Distorted wall surface (ore)
Metallic ore distorted by strong under-
ground pressure over many years.

●Upper structure concept (ore)

◆Sealed gate

●Metallic ore
Does not have the same
transparency as crystal.
Concept is something
metallic and hard.

●Ground underfoot
Jagged geological formations
appearing. Soil has eroded off
the walls and turned into a
mineral with a metallic texture.

●Same geological features
as mine interior before

●Ore

●Water surface

Halatali

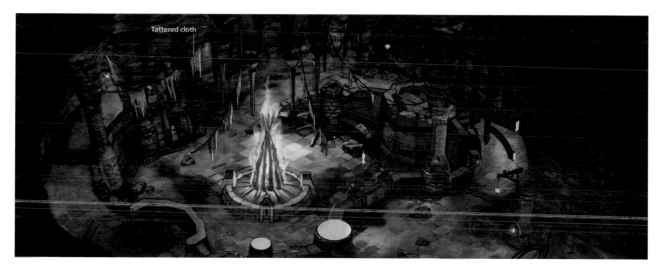

Tattered cloth

I tried to give Halatali a brutal atmosphere, evocative of the sour odor of sweat. (Saito)

The Thousand Maws of Toto-Rak

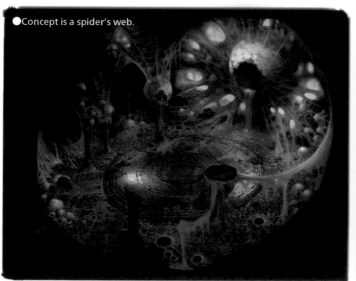

●Concept is a spider's web.

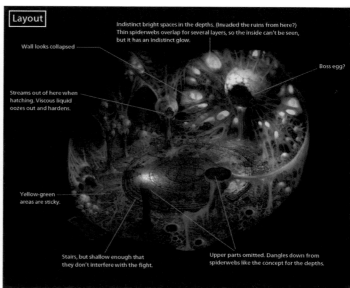

Layout

Indistinct bright spaces in the depths. (Invaded the ruins from here?)
Thin spiderwebs overlap for several layers, so the inside can't be seen,
but it has an indistinct glow.

Wall looks collapsed

Boss egg?

Streams out of here when
hatching. Viscous liquid
oozes out and hardens.

Yellow-green
areas are sticky.

Stairs, but shallow enough that
they don't interfere with the fight.

Upper parts omitted. Dangles down from
spiderwebs like the concept for the depths.

Haukke Manor

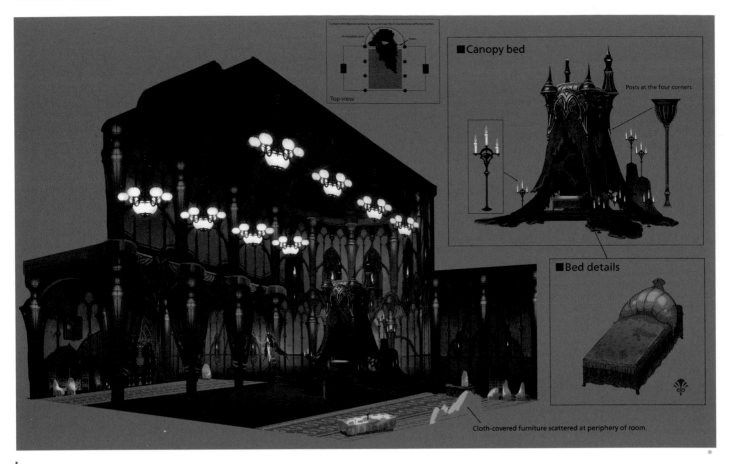

■Canopy bed

Posts at the four corners

■Bed details

Cloth-covered furniture scattered at periphery of room.

I took inspiration from European mansions. The tattered fabrics of the canopy bed can appear skeletal, with the red rug evoking a pool of blood. (Yamate)

Brayflox's Longstop

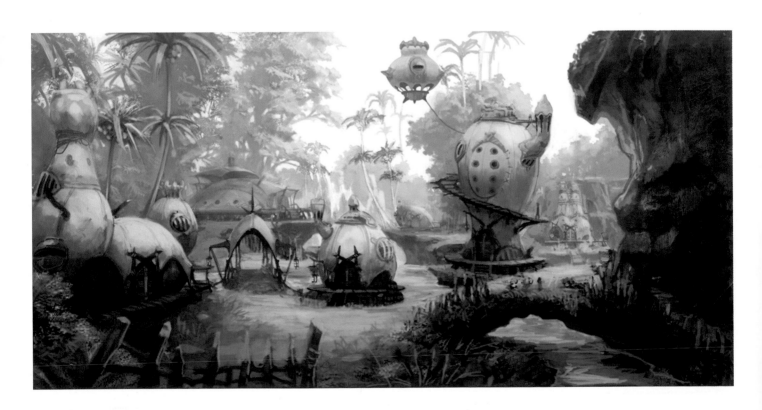

I remember getting all excited when Akihiko Yoshida approved this design on the first take. They displayed a model at the *Final Fantasy* 25th Anniversary exhibit, and I went to see it for myself. (Yamate)

The Sunken Temple of Qarn

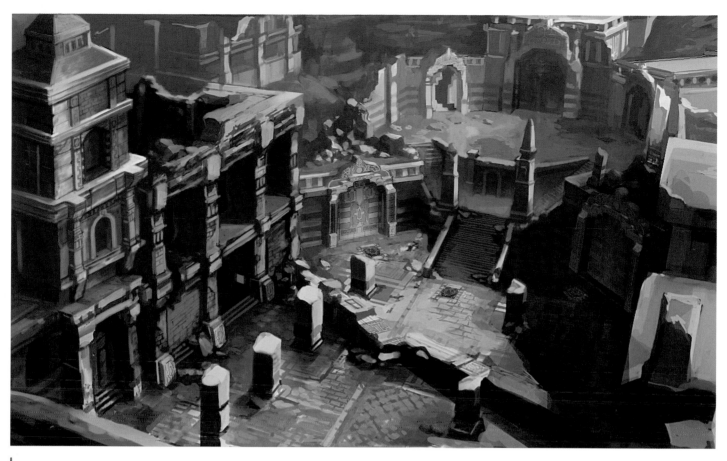

I designed the inside of the temple to match its exterior. There was a lot of yellow overall, so I used the wall paintings and pillars to add a colorful accent. (Yamate)

Dzemael Darkhold

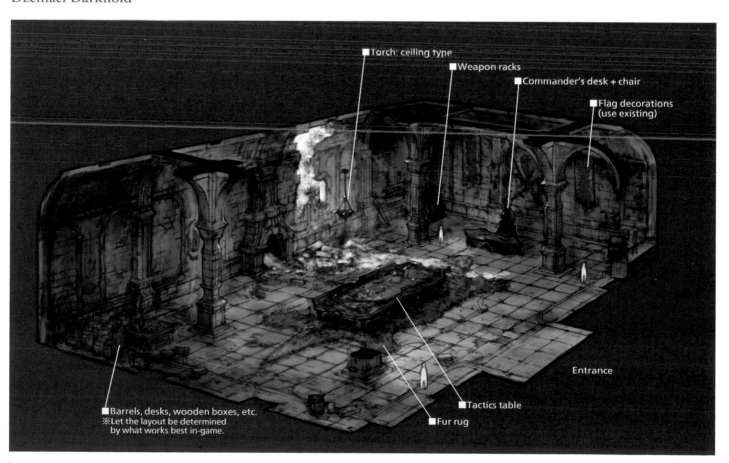

Torch: ceiling type

Weapon racks

Commander's desk + chair

Flag decorations
(use existing)

Entrance

Tactics table

Fur rug

Barrels, desks, wooden boxes, etc.
※Let the layout be determined
by what works best in-game.

I envisioned that this was a war room before the Darkhold was abandoned. (Kenta Tanaka)

Castrum Meridianum

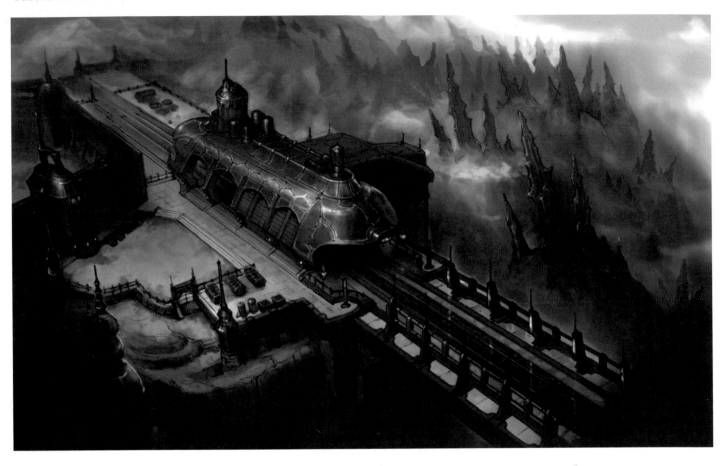

The Praetorium, Porta Decumana

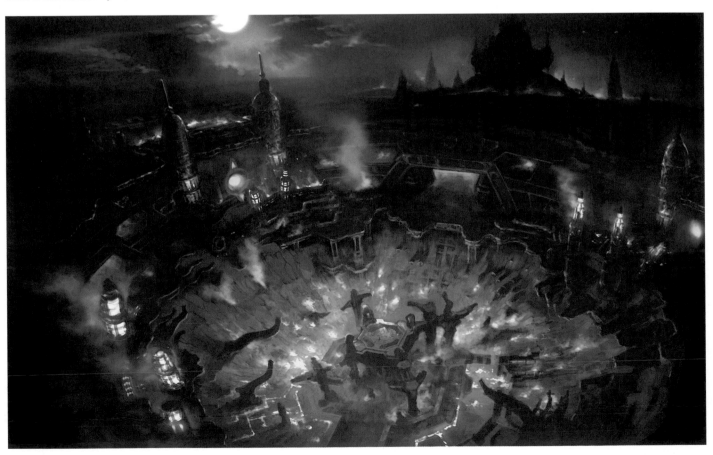

The Wanderer's Palace

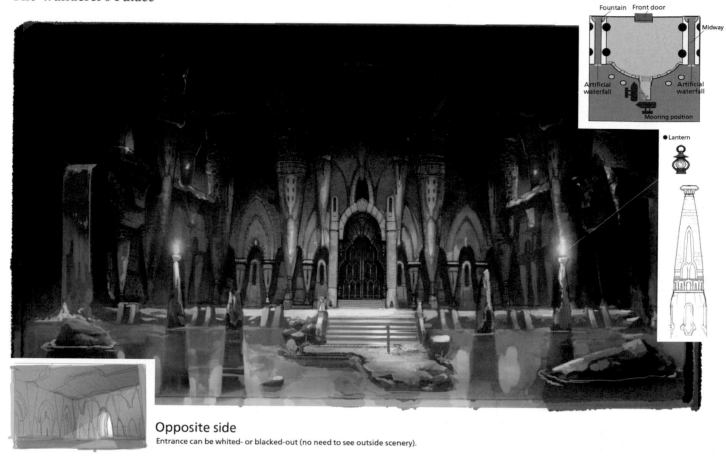

Fountain Front door

Midway

Artificial waterfall

Artificial waterfall

Mooring position

●Lantern

Opposite side

Entrance can be whited- or blacked-out (no need to see outside scenery).

I asked the background team to add little touches like cracks in the roof to let sunlight in, and pulleys to carry water. I think it turned out great. (Yamate)

Amdapor Keep

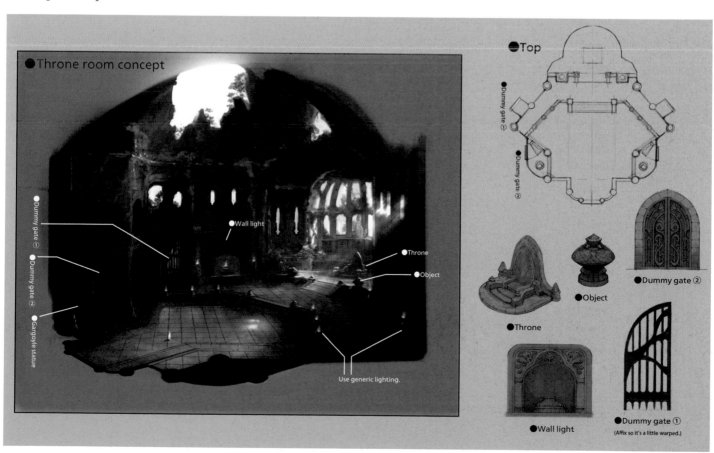

●Throne room concept

●Dummy gate ①
●Dummy gate ②
●Gargoyle statue

Wall light

Throne
Object

Use generic lighting.

●Top

●Dummy gate ②

●Dummy gate ②

●Object

●Dummy gate ②

●Throne

●Wall light

●Dummy gate ①
(Affix so it's a little warped.)

Pharos Sirius

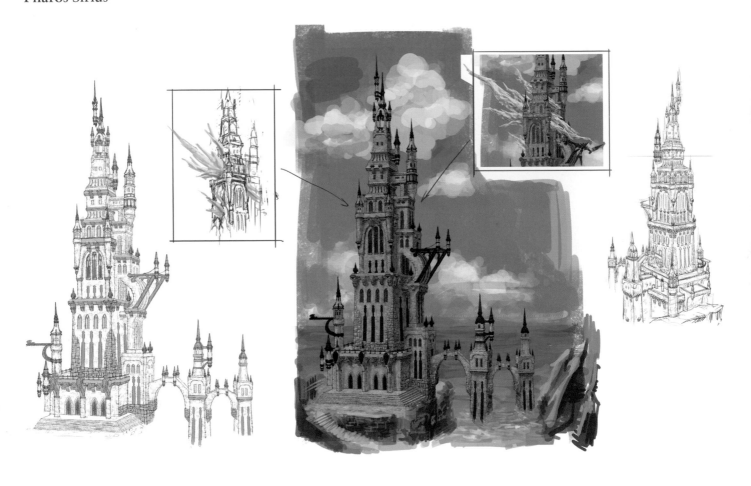

Beacon Chamber

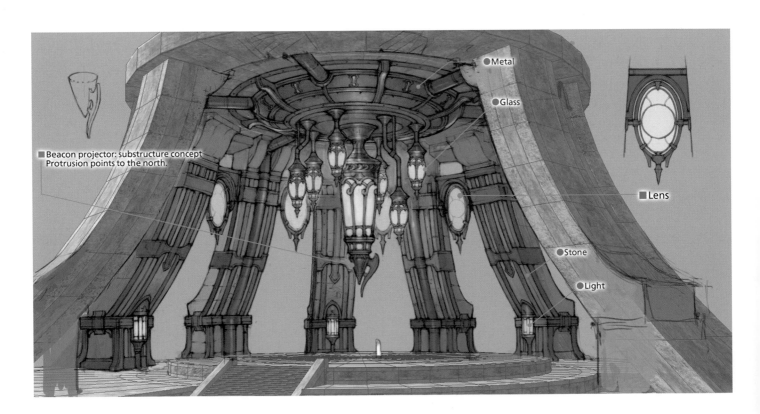

● Metal

● Glass

■ Lens

● Stone

● Light

■ Beacon projector: substructure concept
Protrusion points to the north.

I gave the lighthouse an extravagant-looking lamp, but in the game it's out of sight for the most part... (Kenta Tanaka)

The Lost City of Amdapor

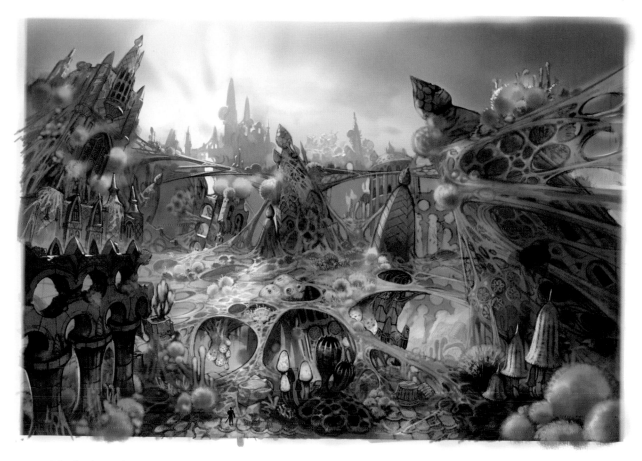

This is a conceptual sketch I drew before receiving an official order. I went for the feeling of buildings struggling to withstand collapse. (Saito)

The Waking Nightmare

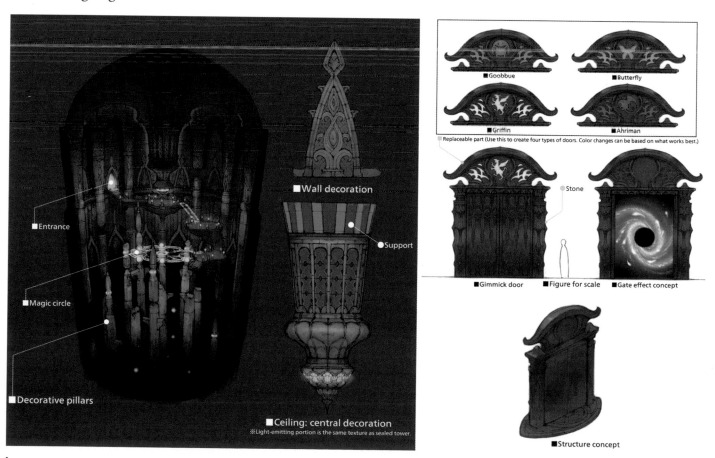

The chamber where the mages of Amdapor sealed away Diabolos. The rows of towers and magicked circles on the battlefield are remnants of that age. (Kenta Tanaka)

The Navel

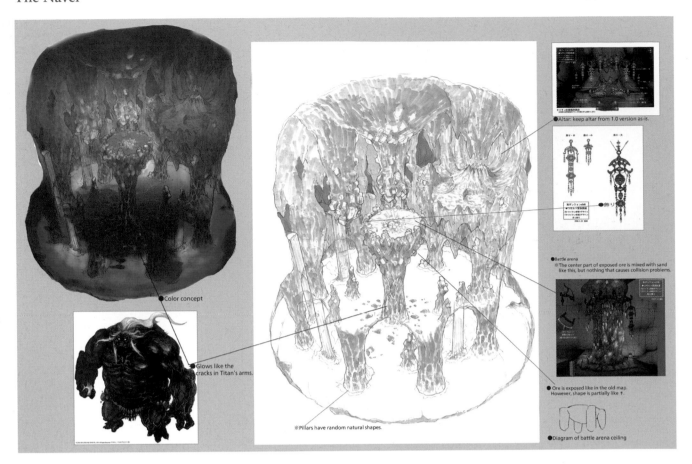

●Color concept

●Glows like the cracks in Titan's arms.

●Altar: keep altar from 1.0 version as-is.

飾り

●Battle arena
※The center part of exposed ore is mixed with sand like this, but nothing that causes collision problems.

●Ore is exposed like in the old map. However, shape is partially like ↑.

●Diagram of battle arena ceiling

※Pillars have random natural shapes.

The *Whorleater*

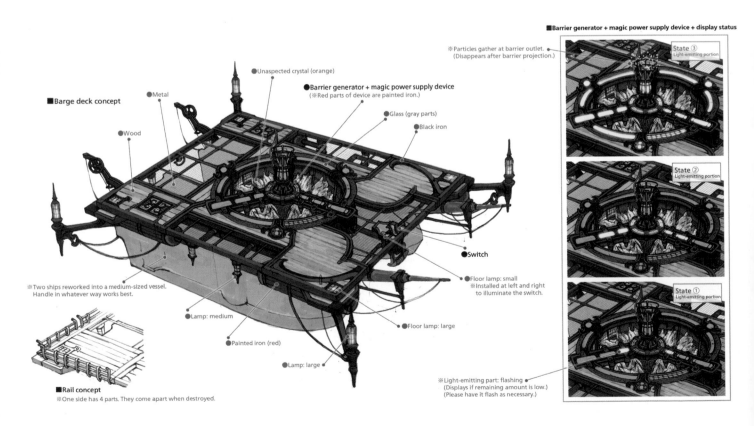

■Barrier generator + magic power supply device + display status

■Barge deck concept

●Metal

●Wood

●Unaspected crystal (orange)

●Barrier generator + magic power supply device
(※Red parts of device are painted iron.)

●Glass (gray parts)

●Black iron

※Particles gather at barrier outlet.
(Disappears after barrier projection.)

State ③
Light-emitting portion

State ②
Light-emitting portion

State ①
Light-emitting portion

●Switch

●Floor lamp: small
※Installed at left and right to illuminate the switch.

※Two ships reworked into a medium-sized vessel. Handle in whatever way works best.

●Lamp: medium

●Painted iron (red)

●Lamp: large

●Floor lamp: large

※Light-emitting part: flashing ●
(Displays if remaining amount is low.)
(Please have it flash as necessary.)

■Rail concept
※One side has 4 parts. They come apart when destroyed.

The battle called for a rectangular ship. I added decorations and details to the floor so players would be able to keep their bearings in the heat of battle. (Hama)

Labyrinth of the Ancients

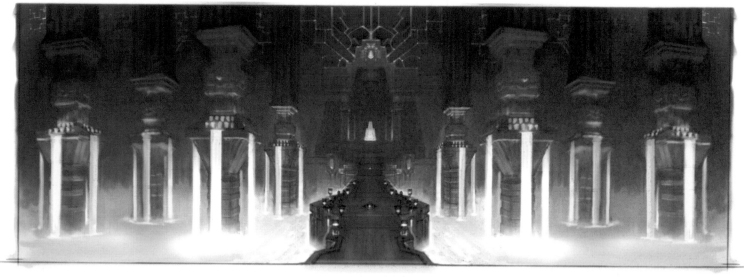

◆ Refer to generic lights.

◆ Refer to passage details.

● Gate to elevator room

● Generic gate

Opening mechanism

If undecided whether this entrance will be used. Planner to be used in other area.

Hall of the Inexorable

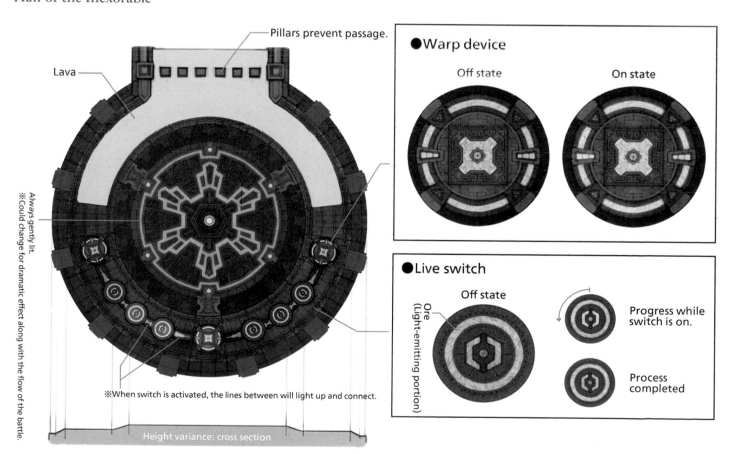

Pillars prevent passage.

Lava

Always gently lit.
※ Could change for dramatic effect along with the flow of the battle.

※ When switch is activated, the lines between will light up and connect.

Height variance: cross section

● Warp device

Off state

On state

● Live switch

Off state

Ore
(Light-emitting portion)

Progress while switch is on.

Process completed

Syrcus Tower

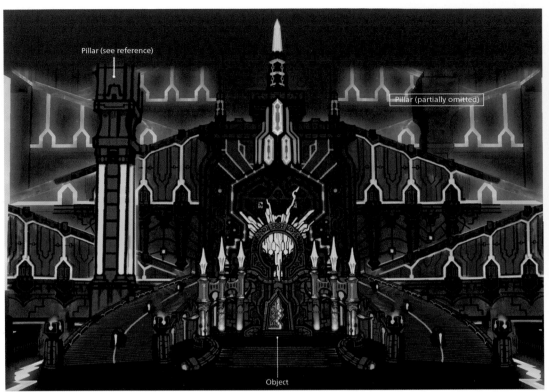

Pillar (see reference)

Pillar (partially omitted)

Object

Without monuments

I tried to create a feeling of space befitting the entrance to a massive tower. The engravings of a man and woman in the door depict an ancient king and his queen. (Saito)

Syrcus Tower – The Braid

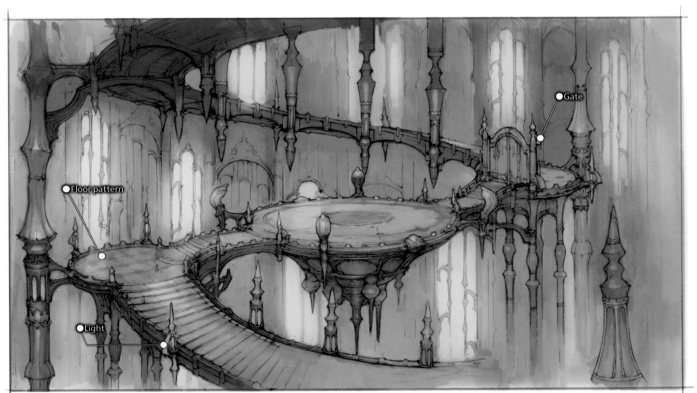

Gate

Floor pattern

Light

※Let structure be dictated by what works best in-game.

To give the Crystal Tower a unique atmosphere, I opted for a traditional fantasy approach unlike anything we'd used in *FFXIV* to that point. (Kenta Tanaka)

Syrcus Tower – The Final Curtain

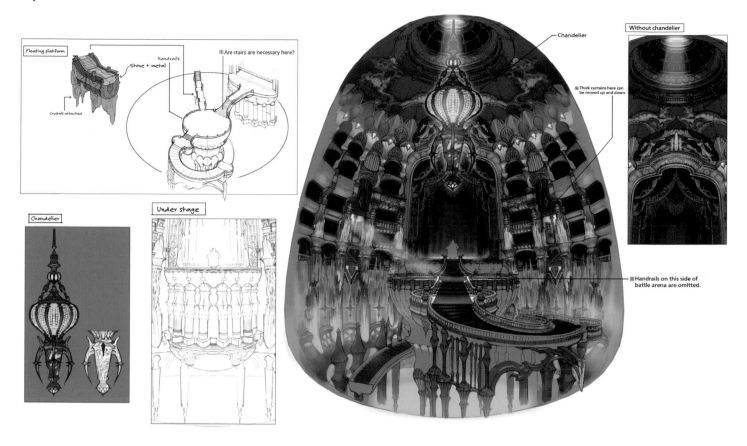

I drew all the way to the top, but only a portion of this is visible in-game. I strove for an unearthly feeling, with a crystal structure giving way to a realistic opera house. (Saito)

Syrcus Tower – The Emperor's Throne

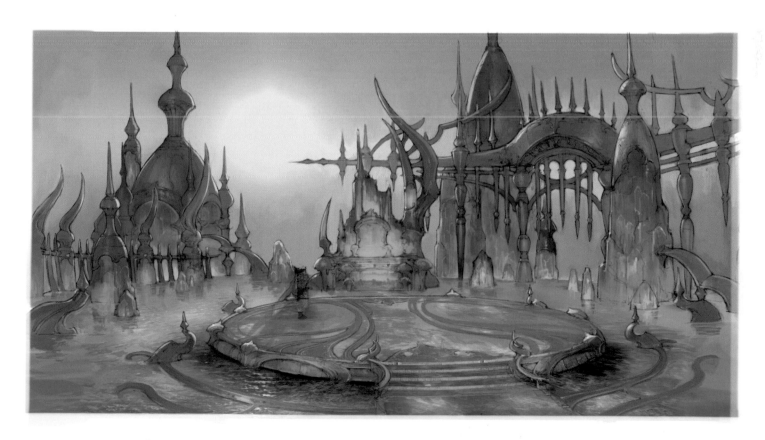

My instructions called for an epic showdown at sunset, so I tried to give the scene an elegant and grandiose feel. (Kenta Tanaka)

Upper Aetheroacoustic Exploratory Site

Lower Aetheroacoustic Exploratory Site

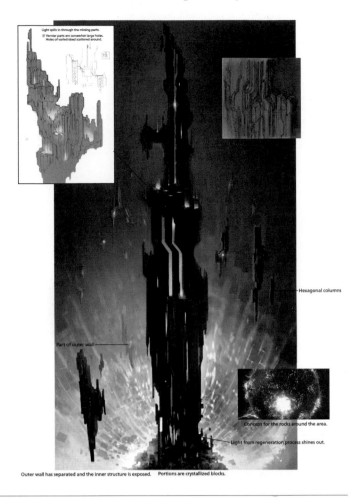

The Ragnarok

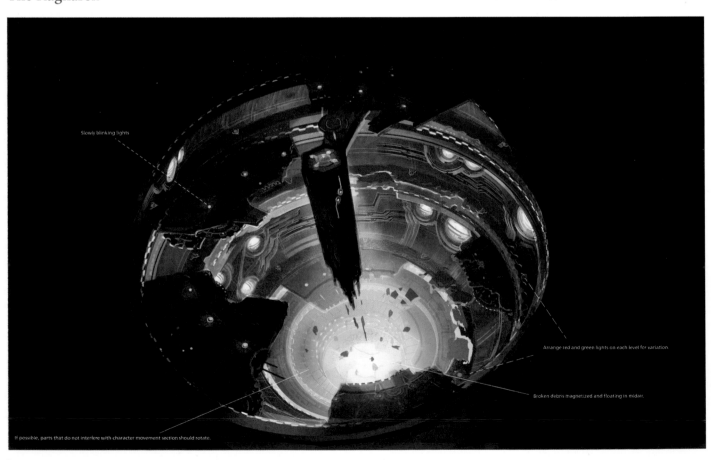

A rendition of the inside of the Ragnarok's engine. I modeled it after the Allagan gear series. (Yamate)

Ragnarok Drive Cylinder

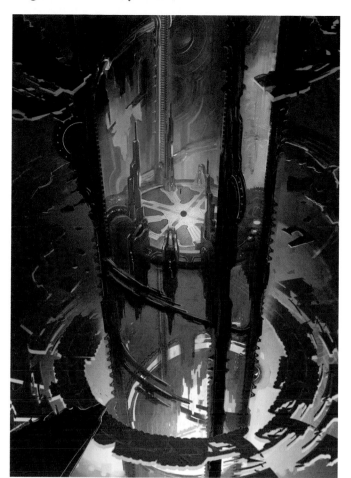

Ragnarok Central Core

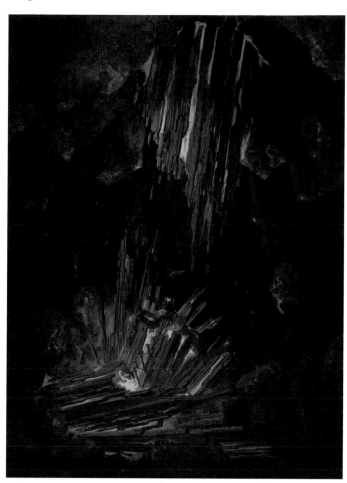

The Binding Coil of Bahamut – Bahamut Bound

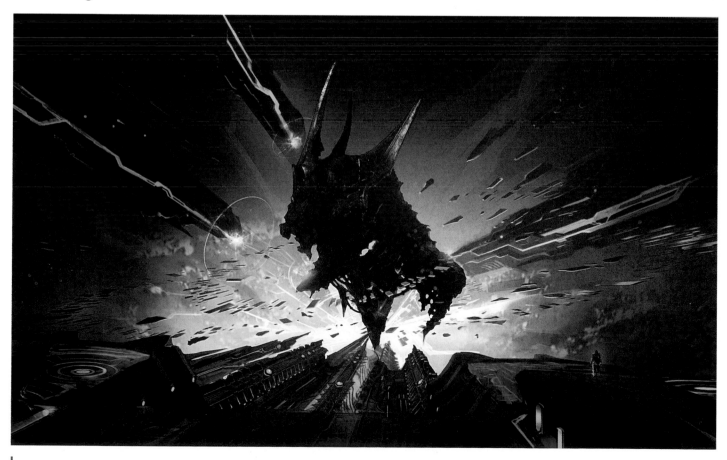

The final scene of this endgame battle. I got excited just thinking of the players who would be the first to see this after the relaunch. (Yamate)

The Outer Coil

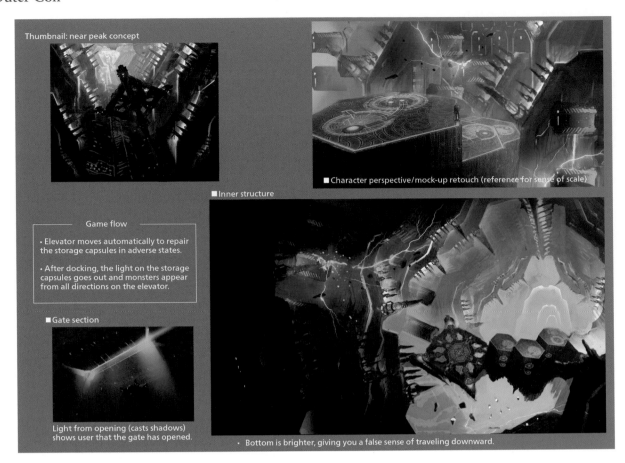

Thumbnail: near peak concept

■ Character perspective/mock-up retouch (reference for sense of scale)

■ Inner structure

Game flow

• Elevator moves automatically to repair the storage capsules in adverse states.

• After docking, the light on the storage capsules goes out and monsters appear from all directions on the elevator.

■ Gate section

Light from opening (casts shadows) shows user that the gate has opened.

• Bottom is brighter, giving you a false sense of traveling downward.

Inside the walls are capsules housing countless chimeric beasts. I imagined the elevator was used to transport these capsules. (Yamate)

Central Decks

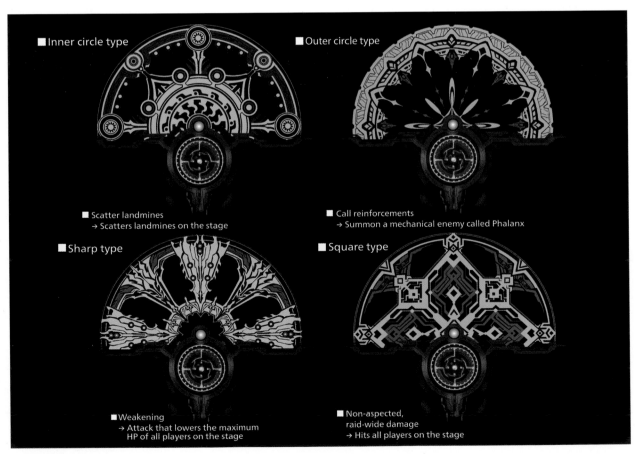

■ Inner circle type

■ Outer circle type

■ Scatter landmines
→ Scatters landmines on the stage

■ Call reinforcements
→ Summon a mechanical enemy called Phalanx

■ Sharp type

■ Square type

■ Weakening
→ Attack that lowers the maximum HP of all players on the stage

■ Non-aspected, raid-wide damage
→ Hits all players on the stage

I was asked to create patterns that were at once stylish, easily recognizable, and easily explained...my toughest task, all told. In the end, I had special effects added to make them stand out even more. (Yamate)

Ascian Hall

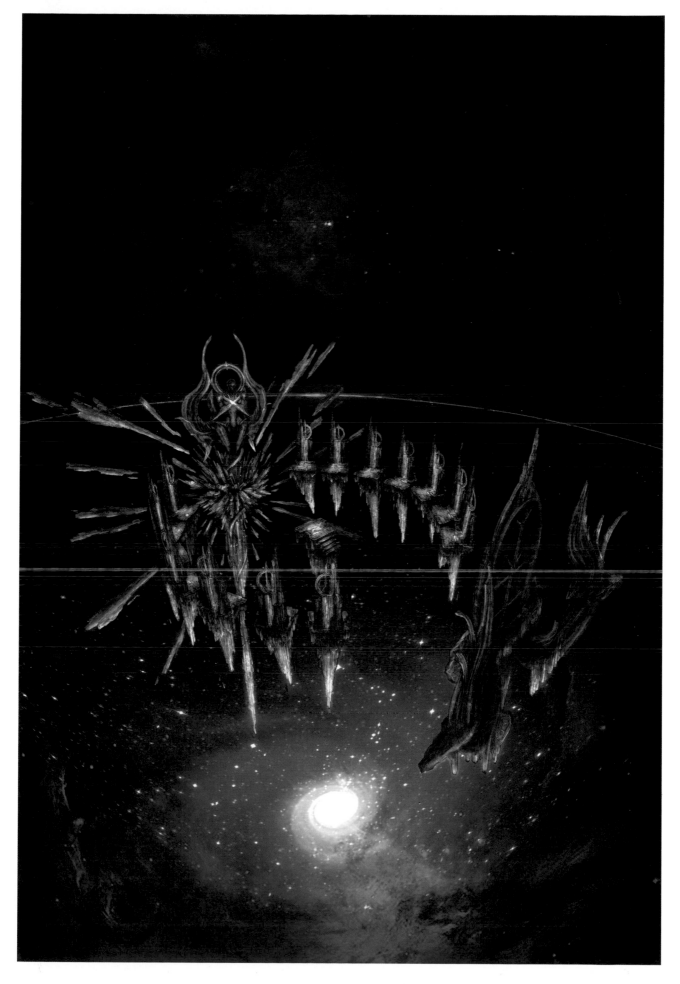

The concept was for a dark alternate dimension formed from the thoughts of the Ascians. Using black and purple tones, I envisioned a form that would be well-defined where the mind was strong, and unraveling where the mind was weak. (Hama)

Ascian Hall Statue

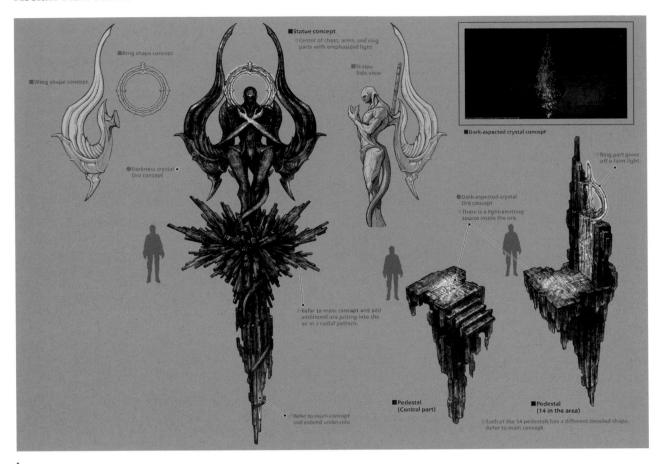

■Wing shape concept

■Ring shape concept

■Statue concept
※Center of chest, arms, and ring parts with emphasized light

■Statue
Side view

●Darkness crystal
Ore concept

■Dark-aspected crystal concept

●Dark-aspected crystal
Ore concept
※There is a light-emitting source inside the ore.

Ring part gives off a faint light.

※Refer to main concept and add additional ore jutting into the air in a radial pattern.

※Refer to main concept and extend underside.

■Pedestal
(Central part)

■Pedestal
(14 in the area)

※Each of the 14 pedestals has a different detailed shape. Refer to main concept.

The ring-shaped design on the statue's back is a motif that I used extensively. The half-ring atop the pedestal is also designed to evoke an Ascian feel. (Hama)

Ascian Hall Door

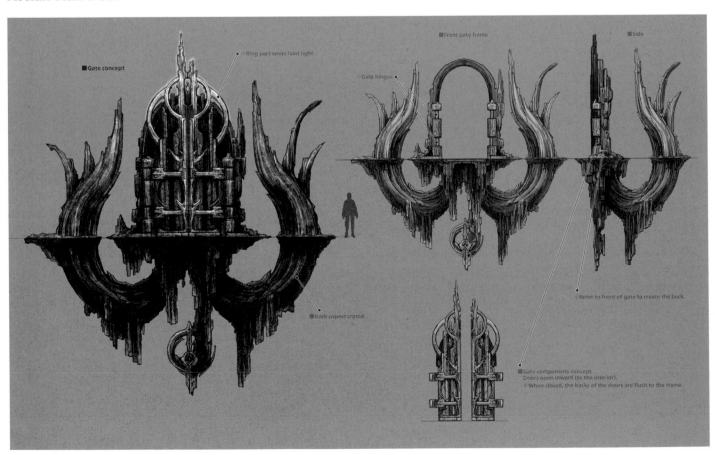

■Gate concept

Ring part emits faint light.

■Front gate frame

■Side

※Gate hinges

●Dark-aspect crystal

※Refer to front of gate to create the back.

■Gate components concept
Doors open inward (to the interior).
※When closed, the backs of the doors are flush to the frame.

Doors represent boundaries. I placed the ring motif below in contrast to the statue to emphasize a sense of separation from this place. (Hama)

Imperial Airships

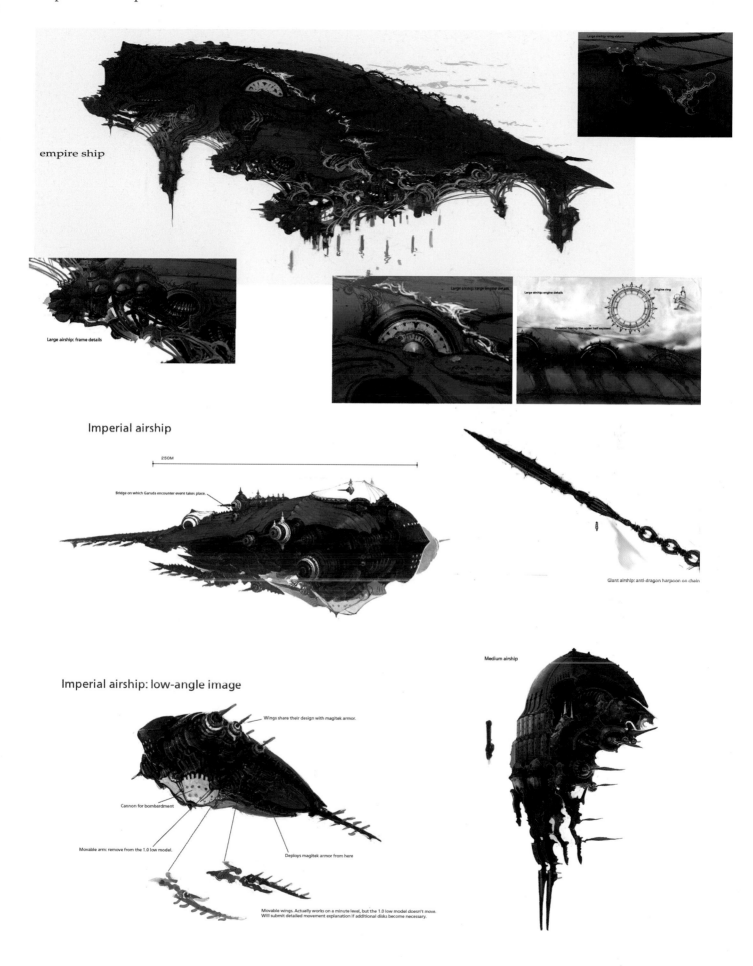

empire ship

Large airship: frame details

Large airship: large engine details

Large airship: engine details

Engine ring

Consider having the upper half exposed

Imperial airship

250M

Bridge on which Garuda encounter event takes place.

Giant airship: anti-dragon harpoon on chain

Medium airship

Imperial airship: low-angle image

Wings share their design with magitek armor.

Cannon for bombardment

Movable arm: remove from the 1.0 low model.

Deploys magitek armor from here

Movable wings. Actually works on a minute level, but the 1.0 low model doesn't move.
Will submit detailed movement explanation if additional disks become necessary.

Treasure Coffers

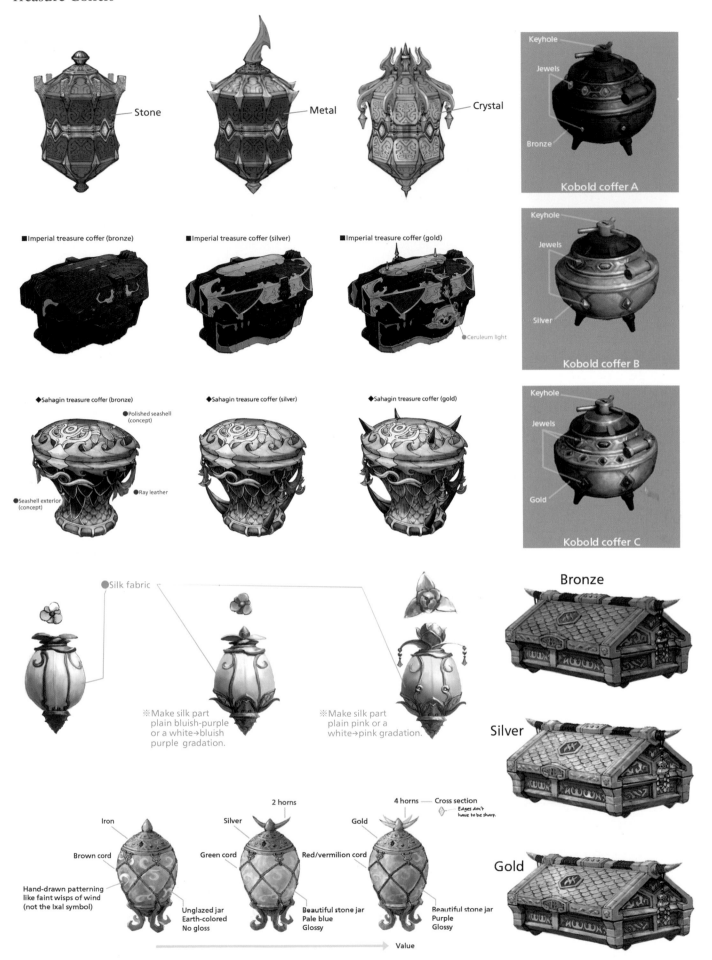

Stone

Metal

Crystal

Keyhole
Jewels
Bronze

Kobold coffer A

■Imperial treasure coffer (bronze)

■Imperial treasure coffer (silver)

■Imperial treasure coffer (gold)

●Ceruleum light

Keyhole
Jewels
Silver

Kobold coffer B

◆Sahagin treasure coffer (bronze)

●Polished seashell (concept)

●Seashell exterior (concept)

●Ray leather

◆Sahagin treasure coffer (silver)

◆Sahagin treasure coffer (gold)

Keyhole
Jewels
Gold

Kobold coffer C

●Silk fabric

※Make silk part plain bluish-purple or a white→bluish purple gradation.

※Make silk part plain pink or a white→pink gradation.

Bronze

Silver

Gold

Iron

Brown cord

Hand-drawn patterning like faint wisps of wind (not the Ixal symbol)

Silver

Green cord

Unglazed jar Earth-colored No gloss

2 horns

Red/vermilion cord

Beautiful stone jar Pale blue Glossy

Gold

4 horns — Cross section

Edges don't have to be sharp.

Beautiful stone jar Purple Glossy

Value

Achieving a unique look while capturing the traits of each beast tribe and making the various grades distinguishable at a glance...this was a deceptively challenging design. (Kenta Tanaka)

Lominsan Standard

Gridanian Standard

Ul'dahn Standard

Ishgardian Standard

Imperial Standard

Crystal Brave Standard

The Harbor Herald Logo

The Raven Logo

The Mythril Eye Logo

Marks of the Beast Tribes

Hildibrand Logo

Symbols of the Twelve

Azeyma the Warden [Ꮓꭱꮛᴩꭱꮐ] -Radiant Sun- (Fire – Astral)	**Nophica the Matron** [Ꮑꮻꮐ�885] -Spring Leaf- (Earth – Astral)	**Thaliak the Scholar** [ᎢꭾꭰᏞꮟꮝꮖ] -Scroll- (Water – Astral)	**Llymlaen the Navigator** [ᏞꮟᴩꭰᏞꮛꭱꮩ] -Wave- (Wind – Astral)	**Halone the Fury** [ꮋꭱᏞꮻꮐꭱ] -Three Spears- (Ice – Astral)	**Byregot the Builder** [ᏸᏢꭱꮐꮻꮖ] -Hand- (Lightning – Astral)

Nald'thal the Trader [ᏁꭱᏞꮖ'ᎢꭾꭱᏞ] -Cowry- (Fire – Umbral)	**Althyk the Keeper** [ᏸᏞꮖꭱᴩᴩ] -Hourglass- (Earth – Umbral)	**Nymeia the Spinner** [Ꮑꮩᴩꭱꮟꭱ] -Spinning Wheel- (Water – Umbral)	**Oschon the Wanderer** [ꮻꮝꭰꮋꮻꮩ] -Walking Stick- (Wind – Umbral)	**Menphina the Lover** [ꭰꭱꮩꮲꮋꮟꮐꭱ] -Full Moon- (Ice – Umbral)	**Rhalgr the Destroyer** [ᎡꭾꭱᏞꮐᏢ] -Streaking Meteor- (Lightning – Umbral)

256

SKETCHES

FINAL FANTASY XIV: A Realm Reborn
The Art of Eorzea –Another Dawn–

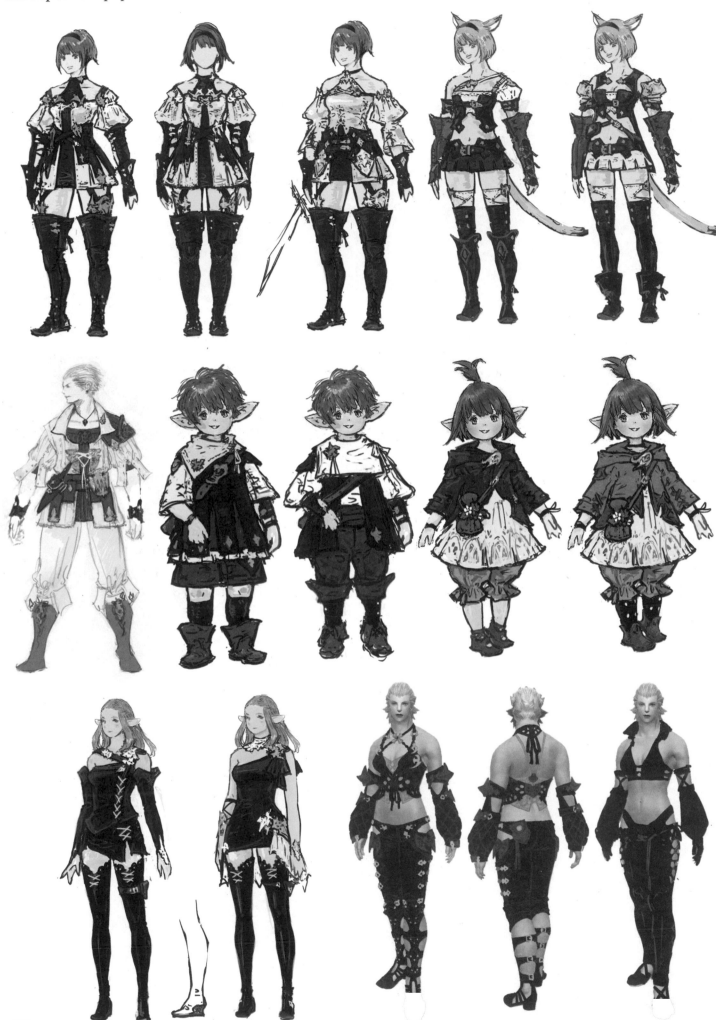

Hairstyles I

Silver accessories

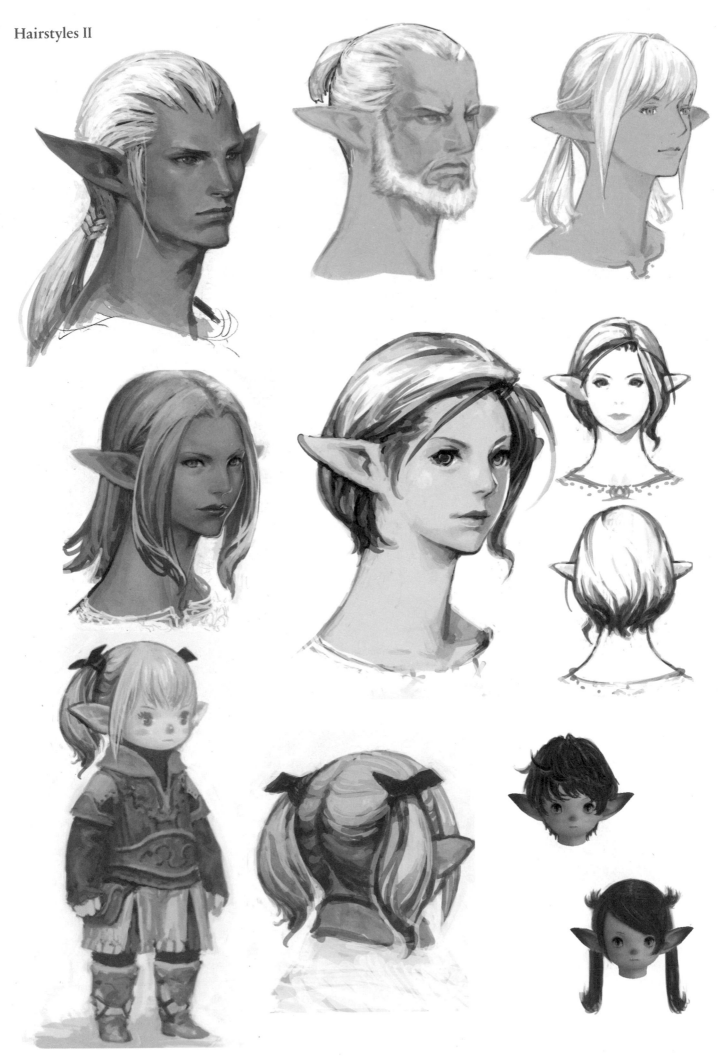

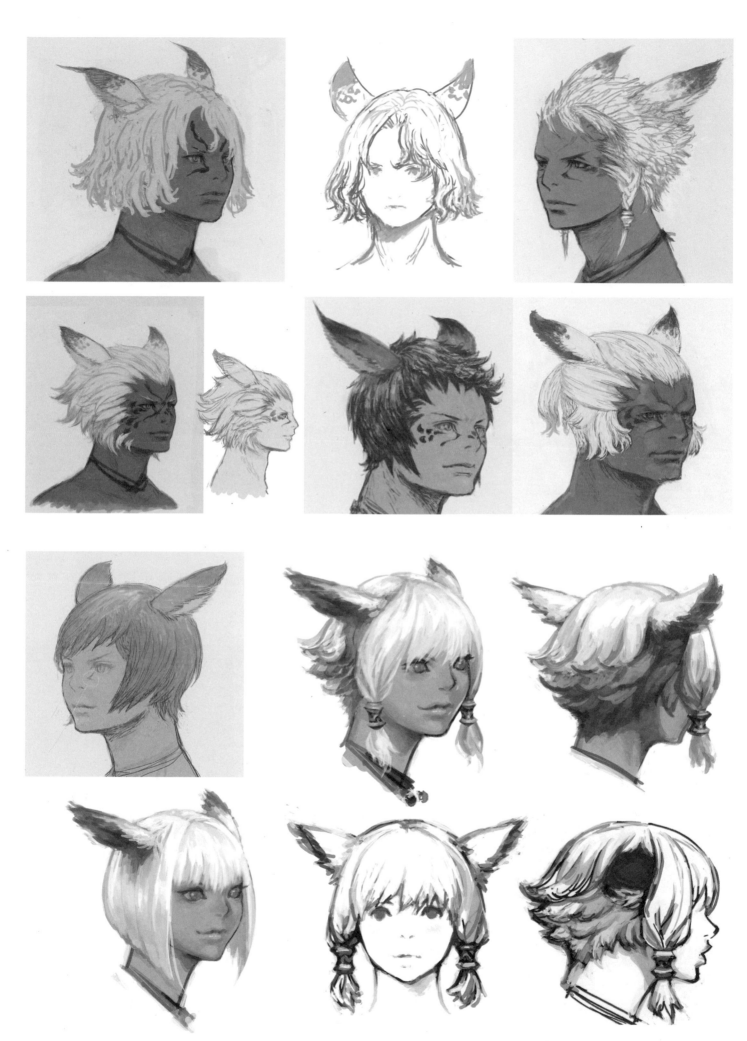

Hairstyles III

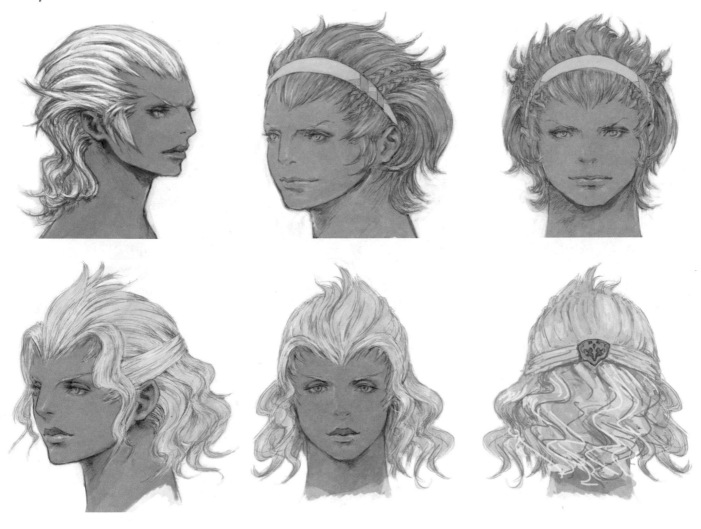

Chocobo Sketches

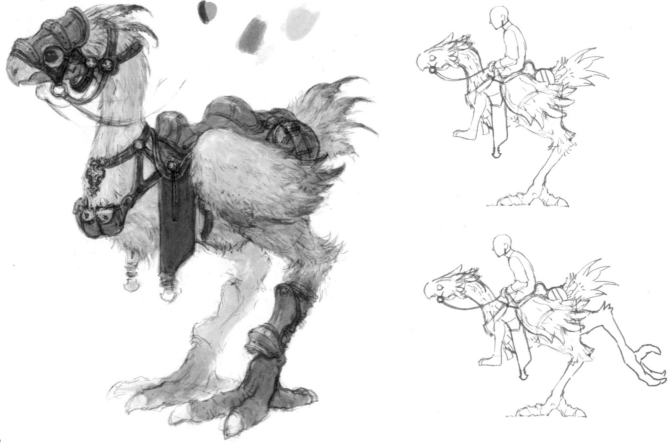

Minfilia's Attire

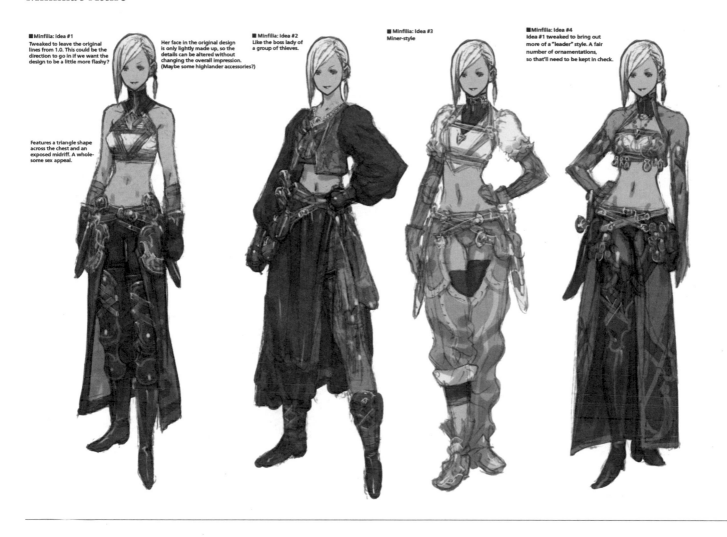

■ Minfilia: Idea #1
Tweaked to leave the original lines from 1.0. This could be the direction to go in if we want the design to be a little more flashy?

Features a triangle shape across the chest and an exposed midriff. A wholesome sex appeal.

Her face in the original design is only lightly made up, so the details can be altered without changing the overall impression. (Maybe some highlander accessories?)

■ Minfilia: Idea #2
Like the boss lady of a group of thieves.

■ Minfilia: Idea #3
Miner-style

■ Minfilia: Idea #4
Idea #1 tweaked to bring out more of a "leader" style. A fair number of ornamentations, so that'll need to be kept in check.

Alphinaud's Attire

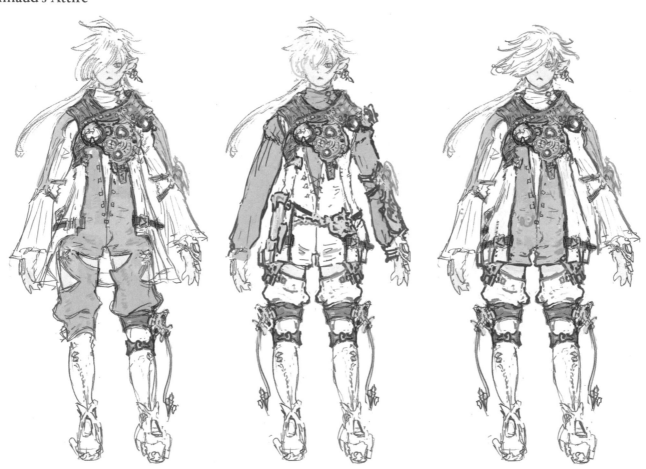

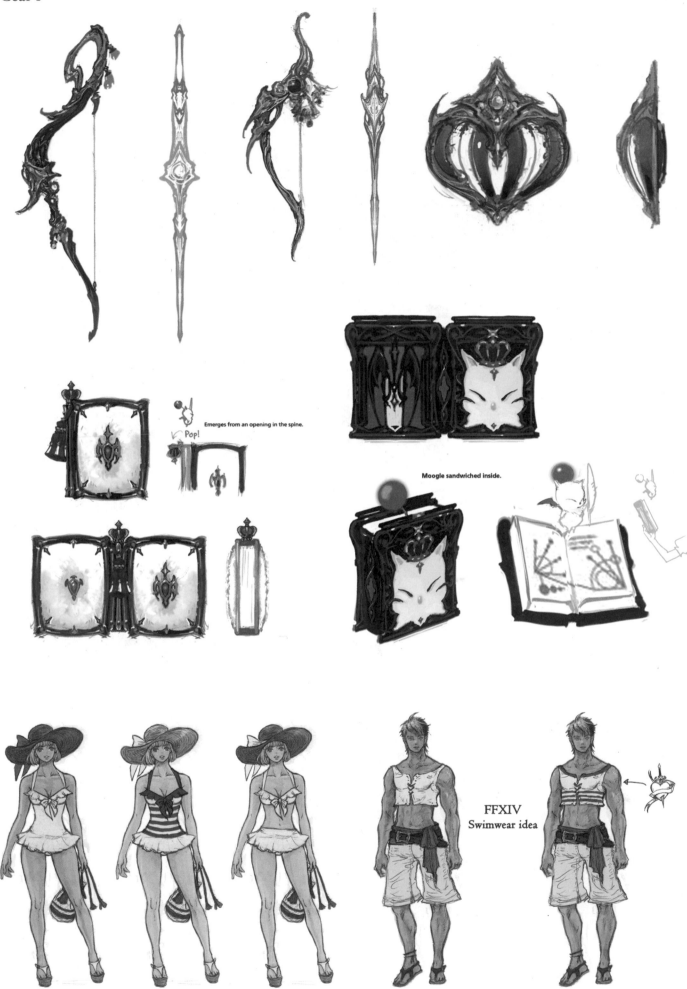

Emerges from an opening in the spine.

Pop!

Moogle sandwiched inside.

FFXIV
Swimwear idea

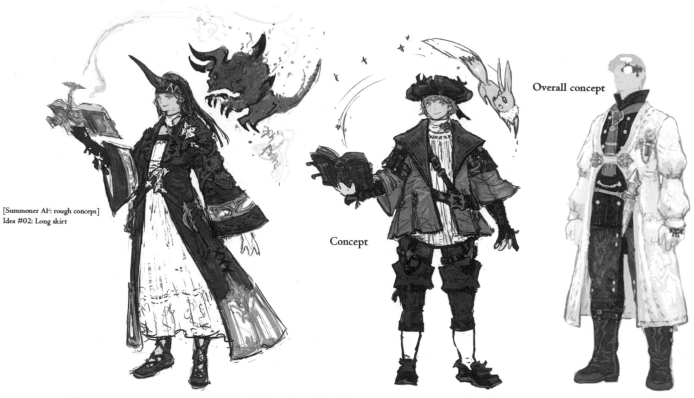

[Summoner AI: rough concept]
Idea #02: Long skirt

Concept

Overall concept

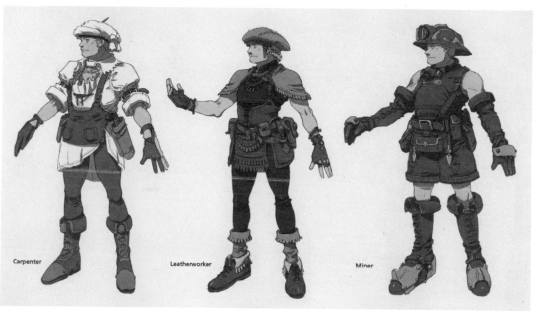

Carpenter

Leatherworker

Miner

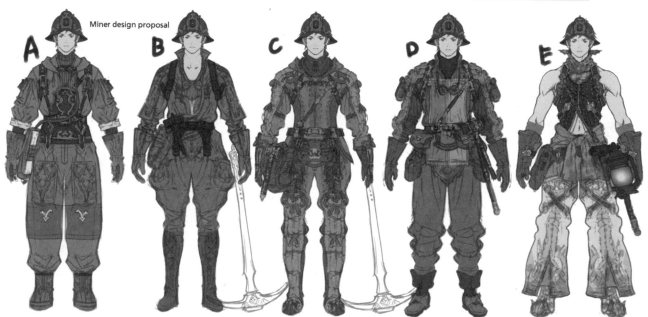

Miner design proposal

A

B

C

D

E

Gear II

Overall concept
(temporary)

Concept
Designer with cutting-edge style
※Rough concept, not finalized

※ Rough concept, not finalized

Concept 01

Concept 02

Top
Anglophilic style
Asymmetric jacket
Pincushion
Sewing pouch
Cutting shears

Male: Pâtissier clothes

Female: Dress with apron

FF14
idea:St. Valentine

☆Top – apron dress
☆Met – like a chef's toque
☆Dwn – retainer's color change
☆Glv – designed like oven mitts
☆Sho – Gothic Lolita shoes, rocking horse style

St. Valentine

Phenyl
group

Tree
of life

Ritual
crystal

Concept

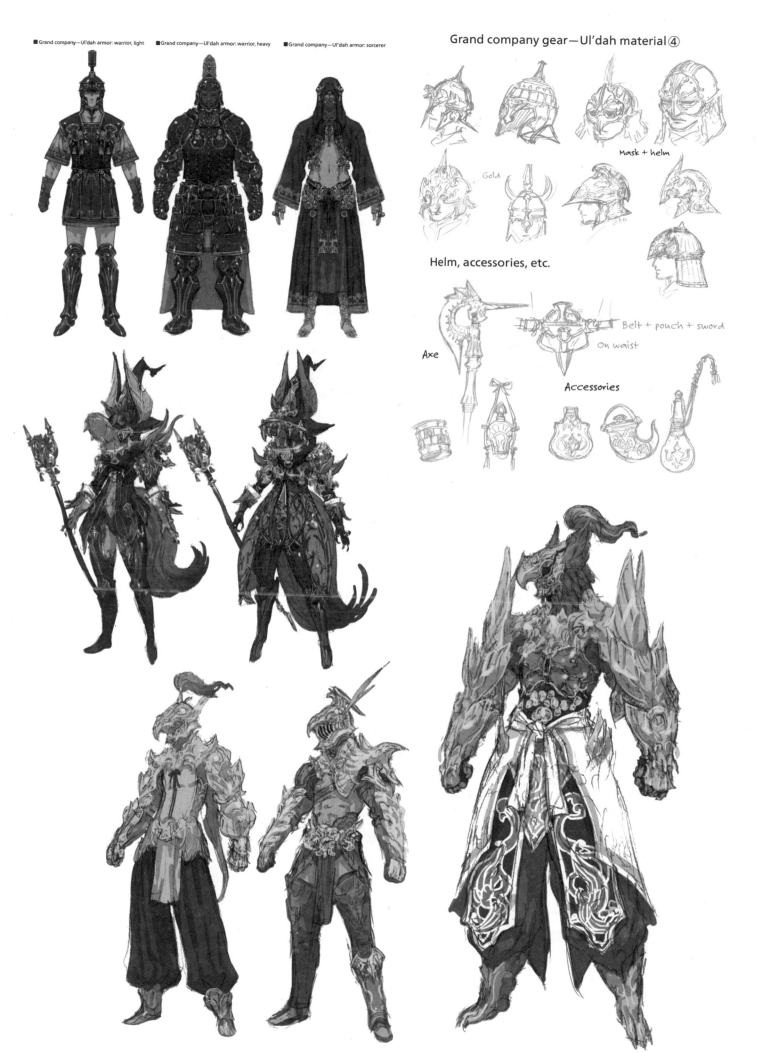

■ Grand company—Ul'dah armor: warrior, light ■ Grand company—Ul'dah armor: warrior, heavy ■ Grand company—Ul'dah armor: sorcerer

Grand company gear—Ul'dah material ④

Mask + helm

Gold

Helm, accessories, etc.

Axe

Belt + pouch + sword

On waist

Accessories

Enemies

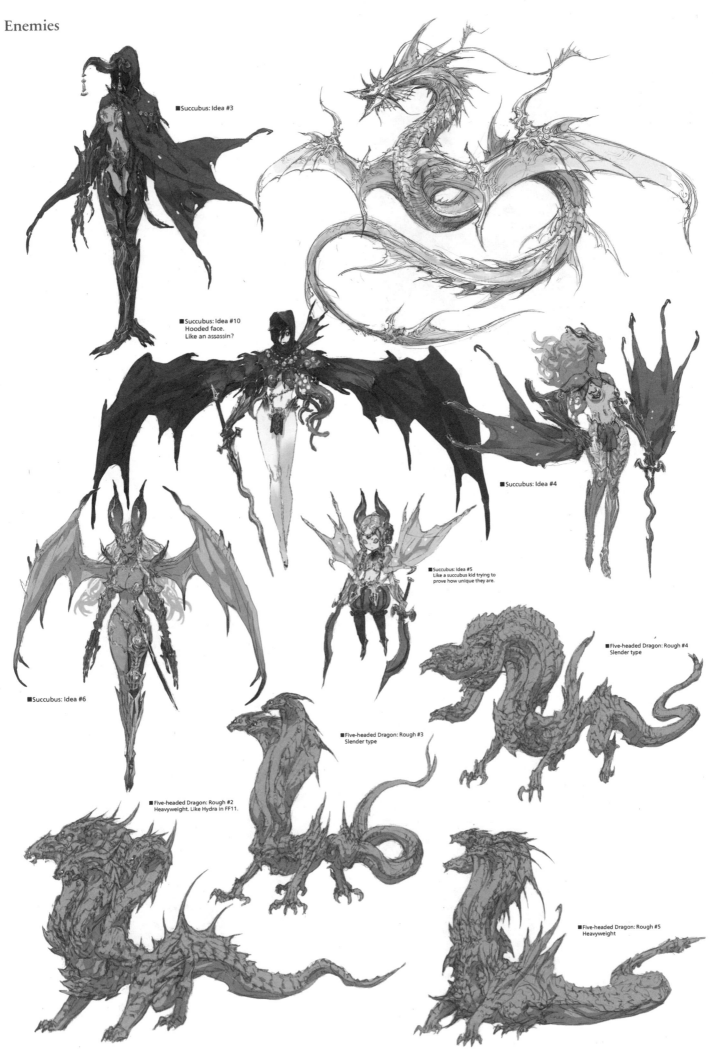

■Succubus: Idea #3

■Succubus: Idea #10
Hooded face.
Like an assassin?

■Succubus: Idea #4

■Succubus: Idea #5
Like a succubus kid trying to
prove how unique they are.

■Succubus: Idea #6

■Five-headed Dragon: Rough #4
Slender type

■Five-headed Dragon: Rough #3
Slender type

■Five-headed Dragon: Rough #2
Heavyweight. Like Hydra in FF11.

■Five-headed Dragon: Rough #5
Heavyweight

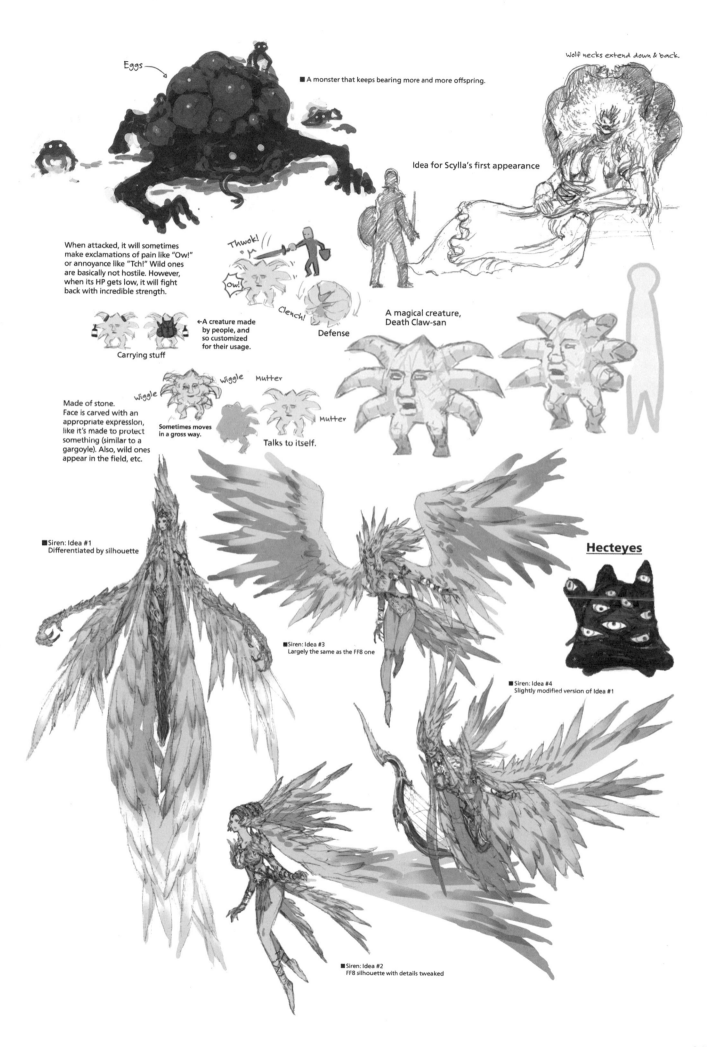

Eggs

■ A monster that keeps bearing more and more offspring.

Wolf necks extend down & back.

Idea for Scylla's first appearance

When attacked, it will sometimes make exclamations of pain like "Ow!" or annoyance like "Tch!" Wild ones are basically not hostile. However, when its HP gets low, it will fight back with incredible strength.

Thwok!

Ow!

Clench!

Defense

←A creature made by people, and so customized for their usage.

Carrying stuff

A magical creature, Death Claw-san

Made of stone.
Face is carved with an appropriate expression, like it's made to protect something (similar to a gargoyle). Also, wild ones appear in the field, etc.

Wiggle

Wiggle

Mutter

Mutter

Sometimes moves in a gross way.

Talks to itself.

■Siren: Idea #1
Differentiated by silhouette

Hecteyes

■Siren: Idea #3
Largely the same as the FF8 one

■Siren: Idea #4
Slightly modified version of Idea #1

■Siren: Idea #2
FF8 silhouette with details tweaked

269

City-states

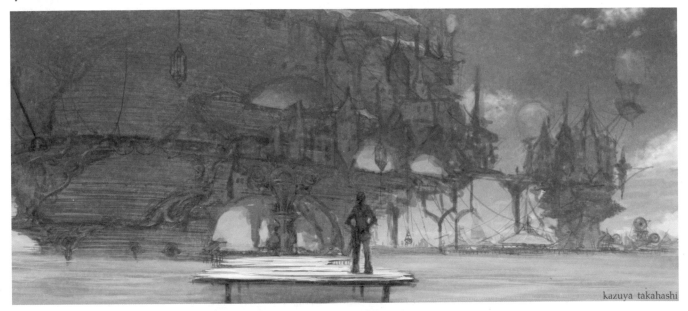

kazuya takahashi

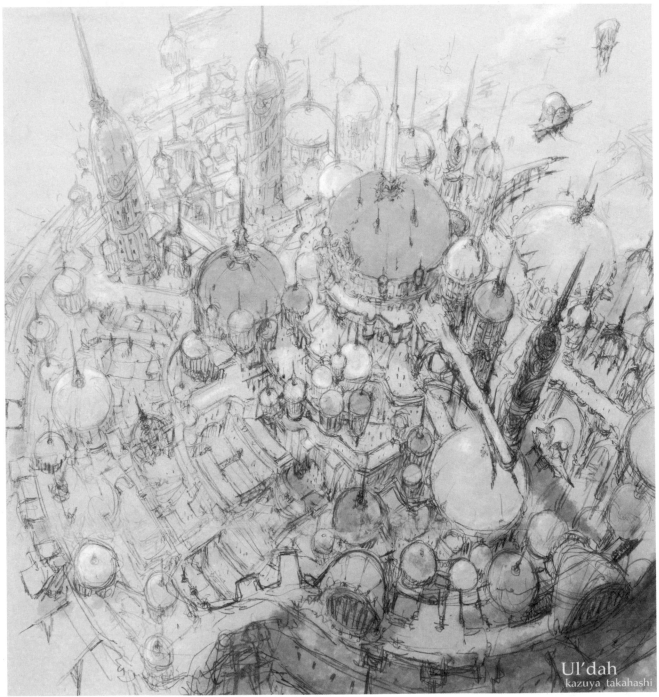

Ul'dah
kazuya takahashi

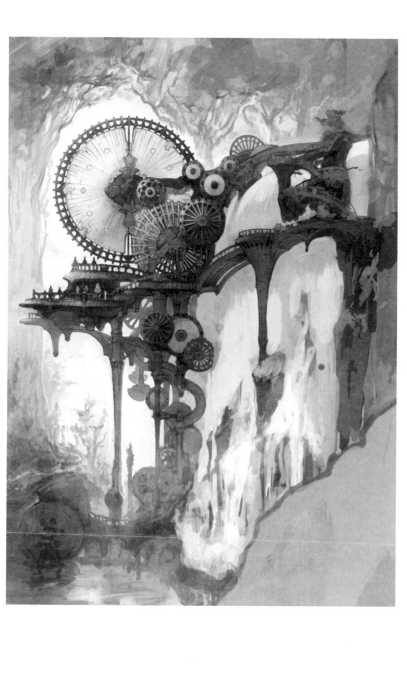

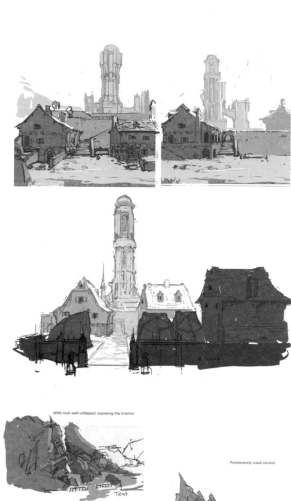

With rock wall collapsed, exposing the interior

Exposed Allagan ruins

Exposed by crystal projections

Prominently sized version

Crystals stuck to tower

Tent

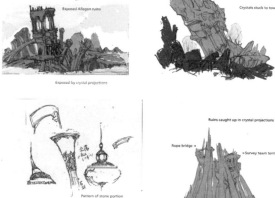

Pattern of stone portion

Ruins caught up in crystal projections

Rope bridge →

← +Survey team tent

A.

B.

C.

Console

La Noscea

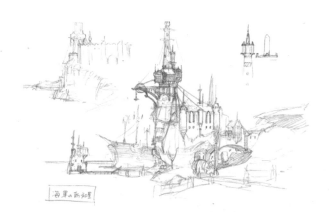

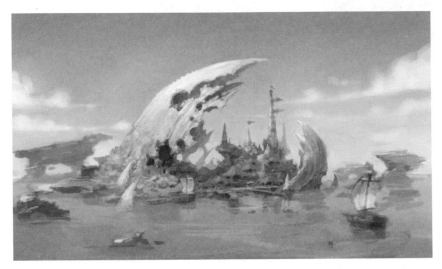

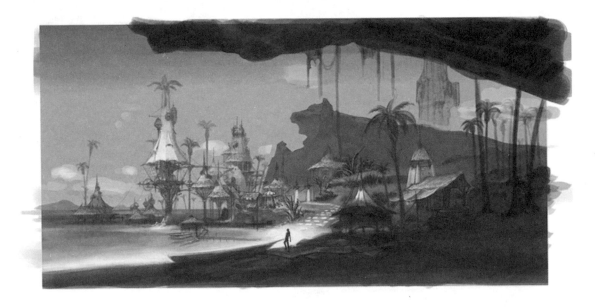

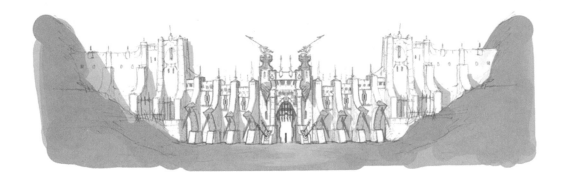

Shipbuilding town

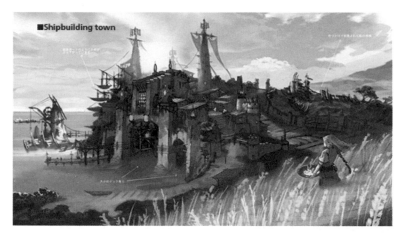

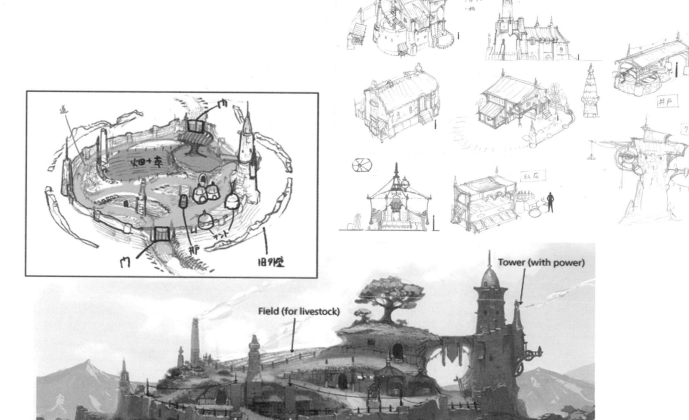

Field (for livestock)

Tower (with power)

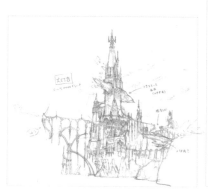

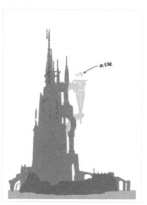

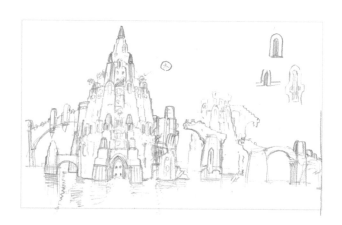

Kobold Architecture

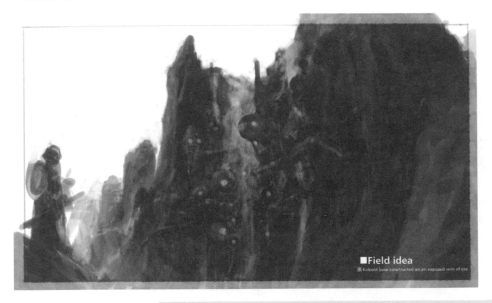

■Field idea
※ Kobold base constructed on an exposed vein of ore

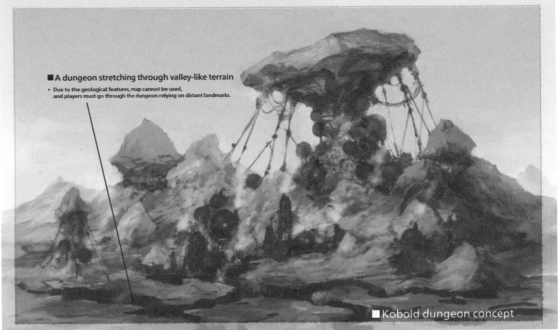

■A dungeon stretching through valley-like terrain
• Due to the geological features, map cannot be used,
 and players must go through the dungeon relying on distant landmarks.

■Kobold dungeon concept

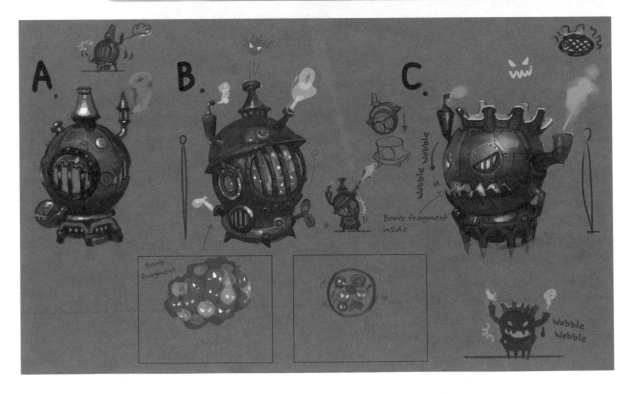

A.

B.

Bomb fragment inside

C.

Wobble Wobble

Bomb Fragment

Wobble Wobble

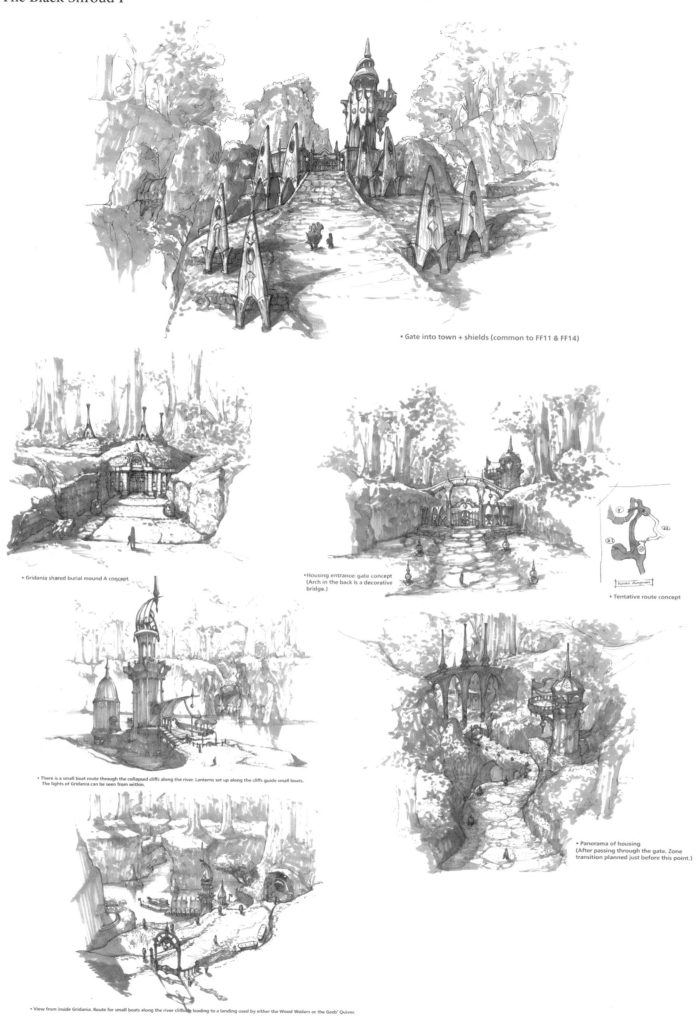

- Gate into town + shields (common to FF11 & FF14)

- Gridania shared burial mound A concept

- Housing entrance: gate concept
 (Arch in the back is a decorative
 bridge.)

- Tentative route concept

- There is a small boat route through the collapsed cliffs along the river. Lanterns set up along the cliffs guide small boats.
 The lights of Gridania can be seen from within.

- Panorama of housing
 (After passing through the gate. Zone
 transition planned just before this point.)

- View from inside Gridania. Route for small boats along the river cliffside leading to a landing used by either the Wood Wailers or the Gods' Quiver.

The Black Shroud II

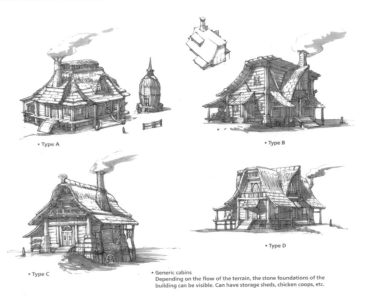

• Type A

• Type B

• Type C

• Type D

• Generic cabins
Depending on the flow of the terrain, the stone foundations of the
building can be visible. Can have storage sheds, chicken coops, etc.

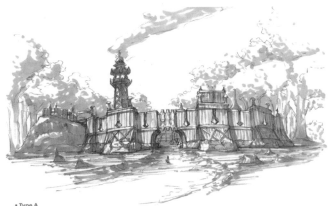

• Type A

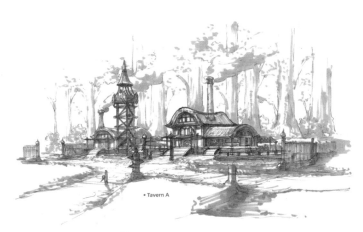

• Type B

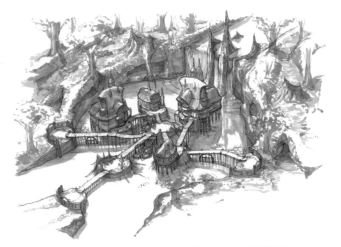

• A village built on top of a giant tree root submerged in the river. Serves a combined role as a checkpoint and a fishery.
(Gridanian bridges will be changed to arched bridges.)

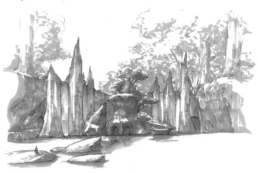

• Waterfalls concept (Like waterfalls flowing down from gaps between giant trees.)

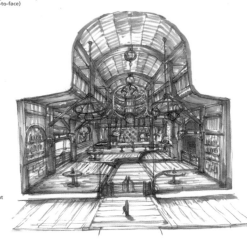

• Tavern A

• Tavern environs concept: adjacent buildings
(About three buildings face-to-face)

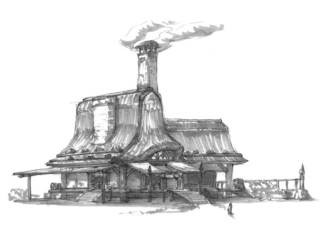

• Tavern C

• Tavern interior concept

Sylphic Architecture

※ Originally served as a habitat for the friendly sylphs, but was abandoned due to the conflict with the hostile sylphs. Has since slowly been reclaimed by nature. Sylph dwellings have fallen to the ground, guideposts have rotted away, and the whole area is slowly returning to the earth.
• Halfway point: Marks the border between the territory of the hostile sylphs and the friendly sylphs.

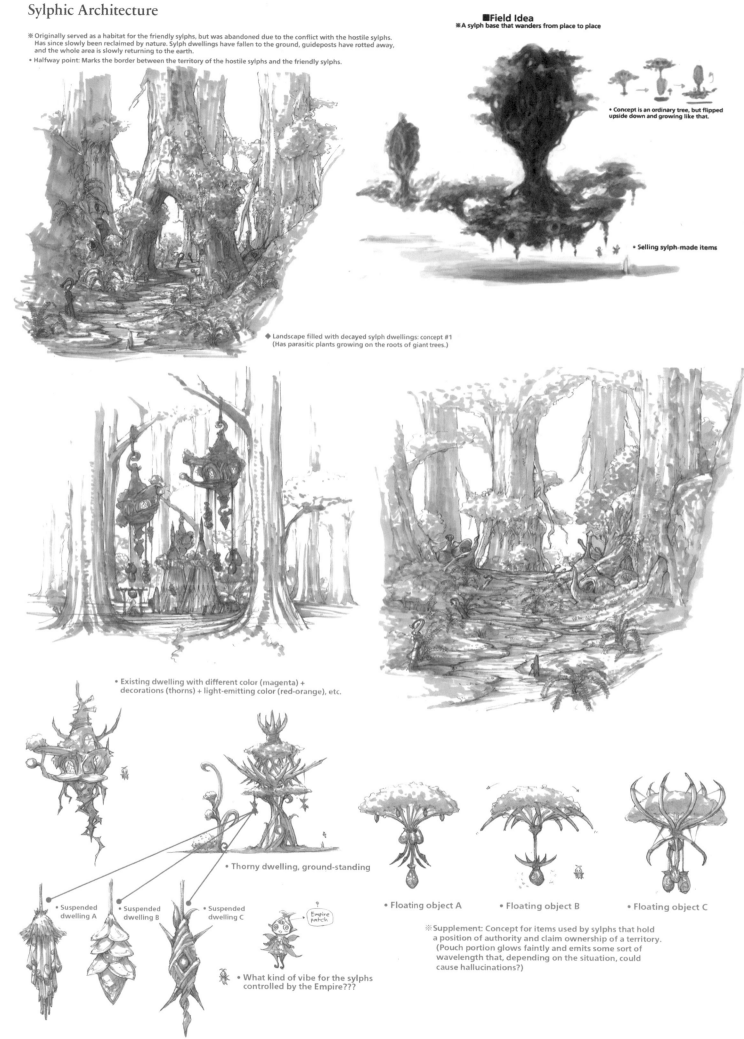

■Field Idea
※A sylph base that wanders from place to place

• Concept is an ordinary tree, but flipped upside down and growing like that.

• Selling sylph-made items

◆ Landscape filled with decayed sylph dwellings: concept #1
(Has parasitic plants growing on the roots of giant trees.)

• Existing dwelling with different color (magenta) + decorations (thorns) + light-emitting color (red-orange), etc.

• Thorny dwelling, ground-standing

• Suspended dwelling A
• Suspended dwelling B
• Suspended dwelling C

Empire patch

• What kind of vibe for the sylphs controlled by the Empire???

• Floating object A
• Floating object B
• Floating object C

※Supplement: Concept for items used by sylphs that hold a position of authority and claim ownership of a territory. (Pouch portion glows faintly and emits some sort of wavelength that, depending on the situation, could cause hallucinations?)

Thanalan

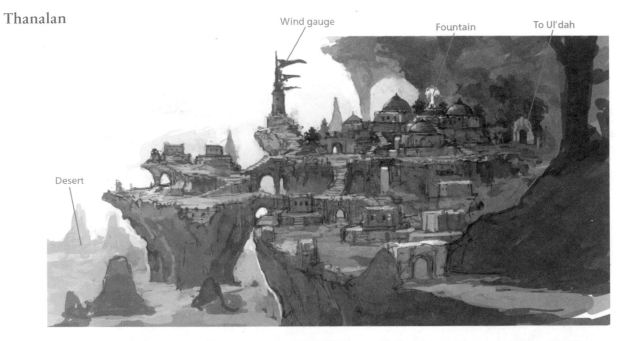

Desert Wind gauge Fountain To Ul'dah

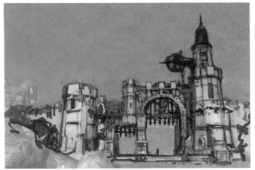

Type A

• A gate with additions made over time, which gives it a patchwork look.

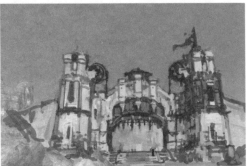

Type B • In the middle of construction with wood material

■ **Outer wall bazaar **

• It would look beautiful in the dark if lanterns were hung on cords overhead.

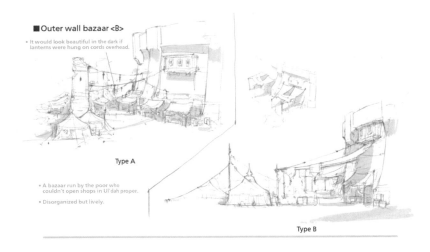

Type A

• A bazaar run by the poor who couldn't open shops in Ul'dah proper.

• Disorganized but lively.

Type B

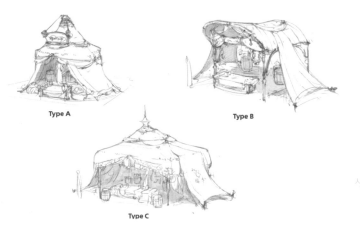

Type A

Type B

Type C

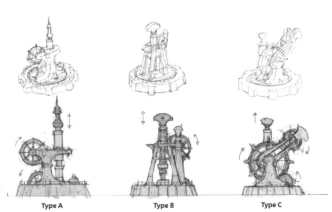

Type A Type B Type C

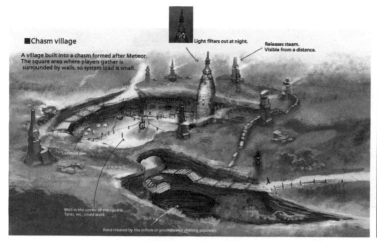

■Chasm village

A village built into a chasm formed after Meteor.
The square area where players gather is
surrounded by walls, so system load is small.

Light filters out at night.

Releases steam.
Visible from a distance.

Livestock pen

Well in the center of the square.
Tents, etc. could work.

Pond created by the inflow of groundwater (rising possible).

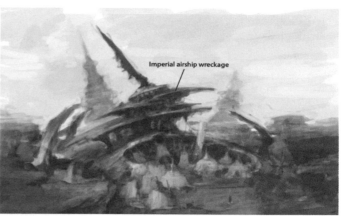

Imperial airship wreckage

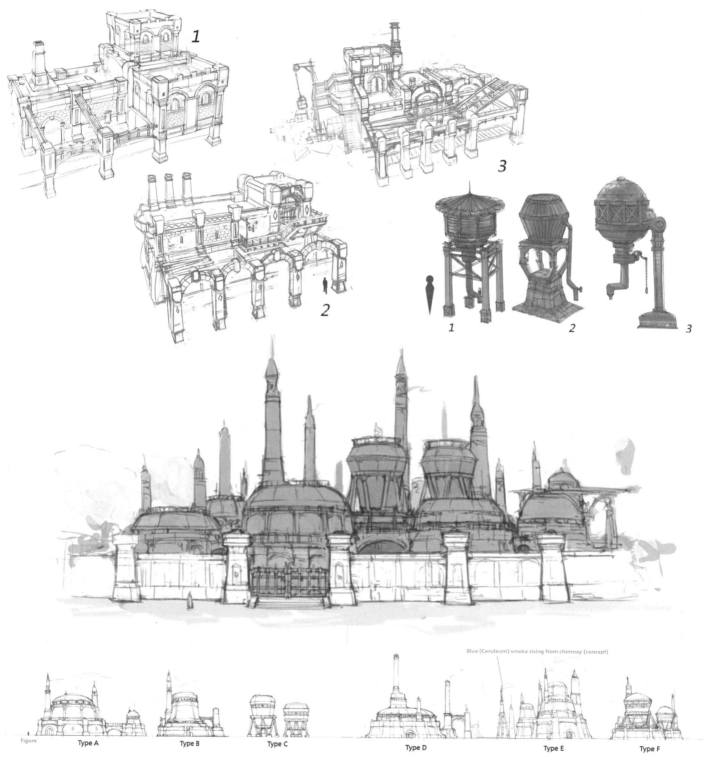

1

3

2

1

2

3

Blue (Ceruleum) smoke rising from chimney (concept)

Figure

Type A

Type B

Type C

Type D

Type E

Type F

Amalj'aa Architecture

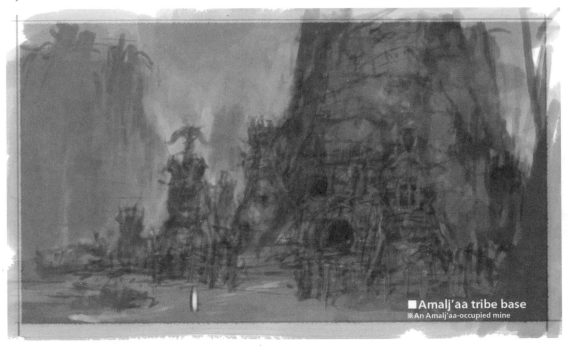

■Amalj'aa tribe base
※An Amalj'aa-occupied mine

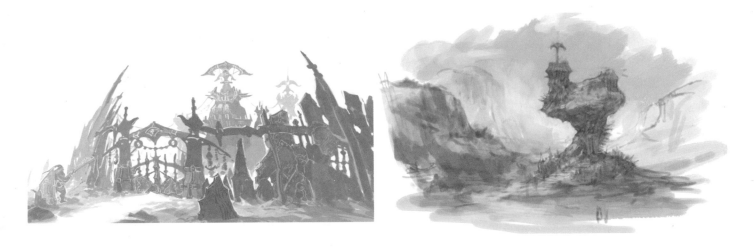

Ixali Architecture I

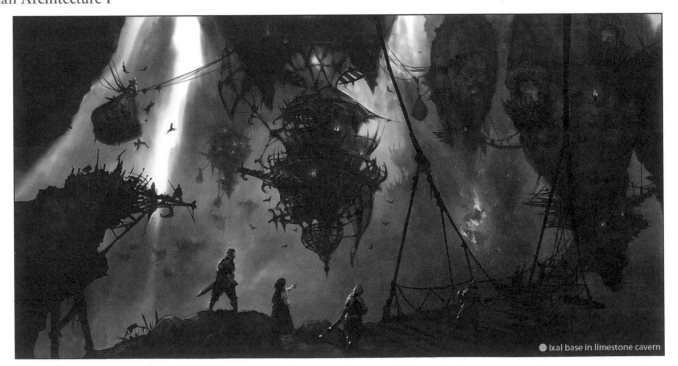

●Ixal base in limestone cavern

Ixali Architecture II

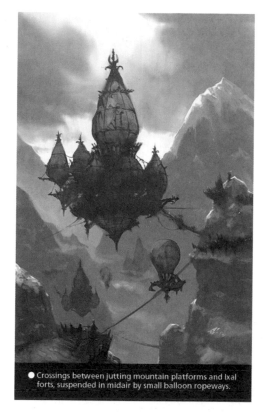

● Crossings between jutting mountain platforms and Ixal forts, suspended in midair by small balloon ropeways.

Other Regions I

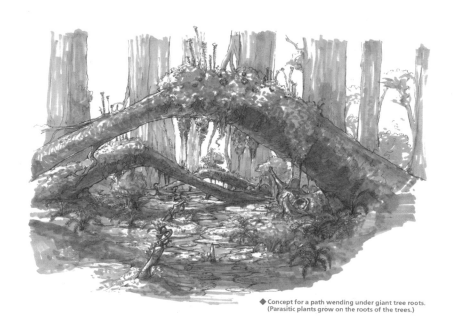

◆ Concept for a path wending under giant tree roots. (Parasitic plants grow on the roots of the trees.)

Other Regions II

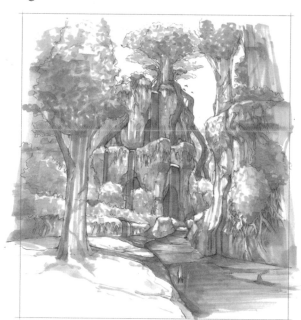

• Path + swamp + waterfalls of differing heights

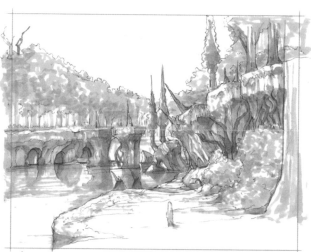

• Collapsed path + waterside + bleached trees

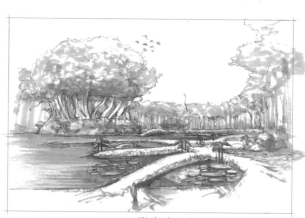

• Wetland terrain + giant tree roots + lotus

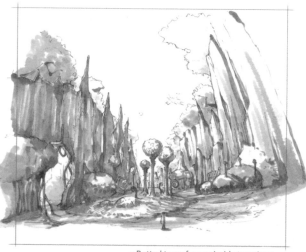

• Rotted trees: fungus inside tree rings

Dungeon Ideas I

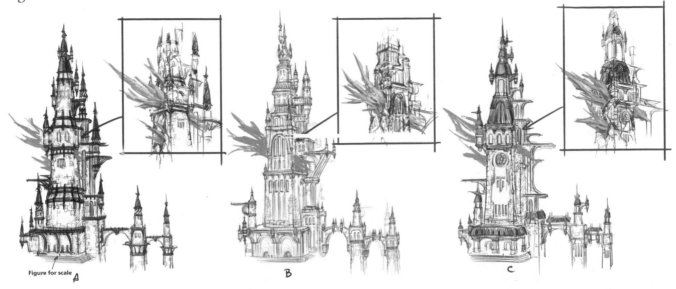

Figure for scale A

B

C

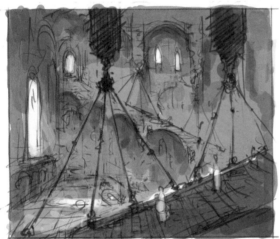

■Interior concept

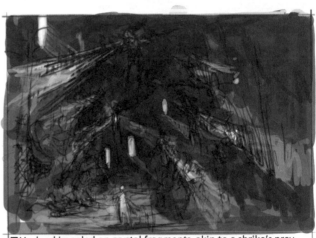

■Undead impaled on crystal fragments, akin to a shrike's prey.

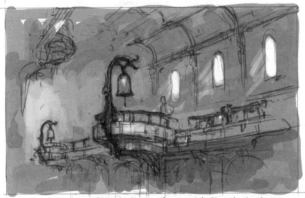

■Fog bell; sound of the bell interferes with Siren's singing.

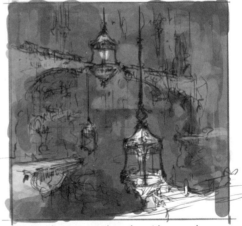

■One side goes up, the other side goes down.

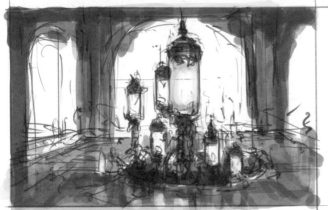

■If one of the tower's broken light sources is repaired, it drives away the undead.

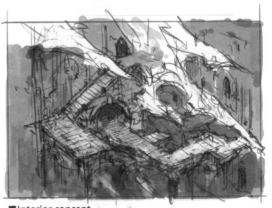

■Interior concept

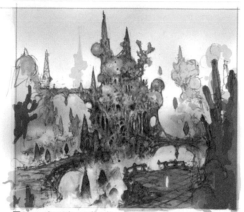

■ Rotted castle with a lower town area
that can't be entered if the gas is dense.

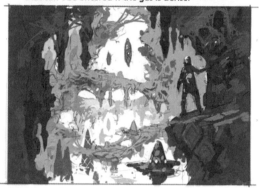

■ Collapsed town area

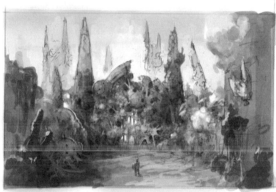

■ Castle gate covered by hyphae

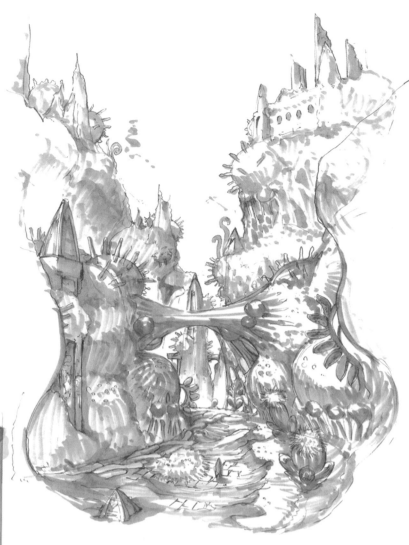

• Buildings (ruins) swallowed up by a sea of rot
A location created through an ongoing process, involving Meteor →
terrain change + ruins exposed → plant ecosystem changed due to Meteor influence.

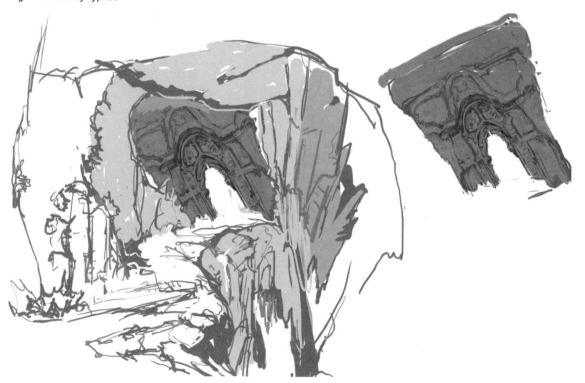

Dungeon Ideas II

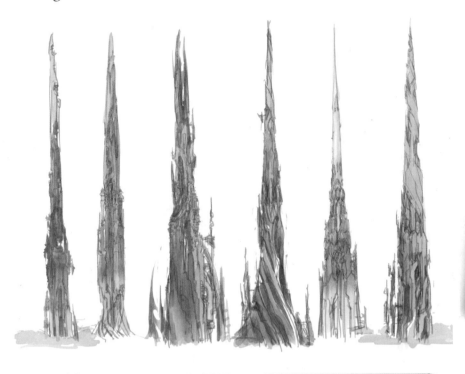

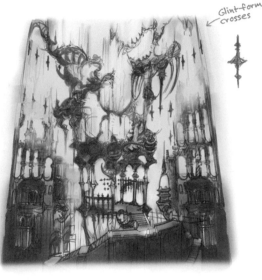

Glint-form crosses

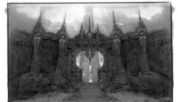

Without 4 Fangs, you'll get zapped!!

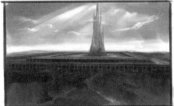

After passing through gate successfully

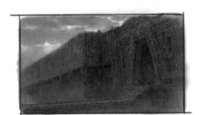

Entrance

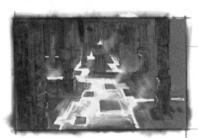

Floor blocks moving

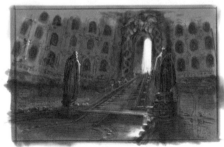

...Passage→out→passage→out→long stairs→boss

From the world of humans to the world of gods

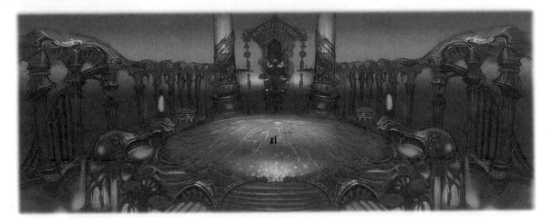

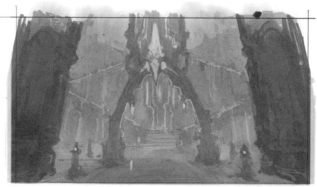

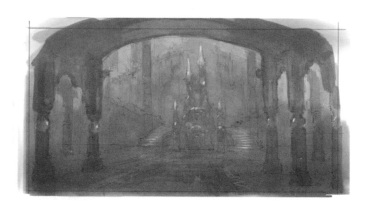

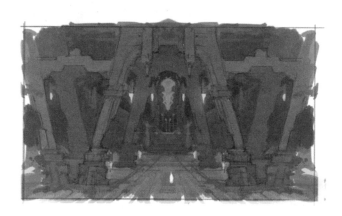

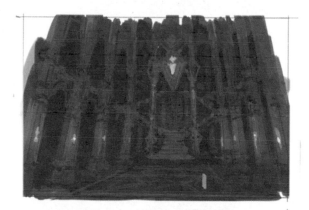

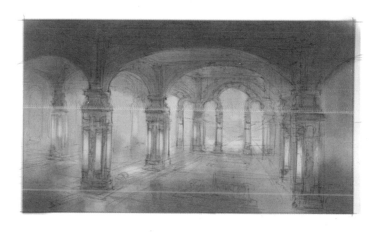

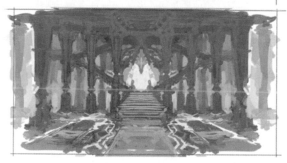

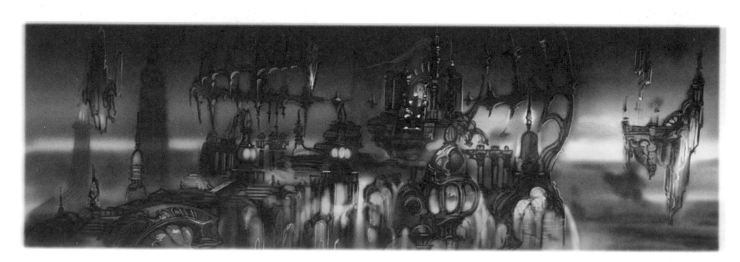

Imperial Architecture

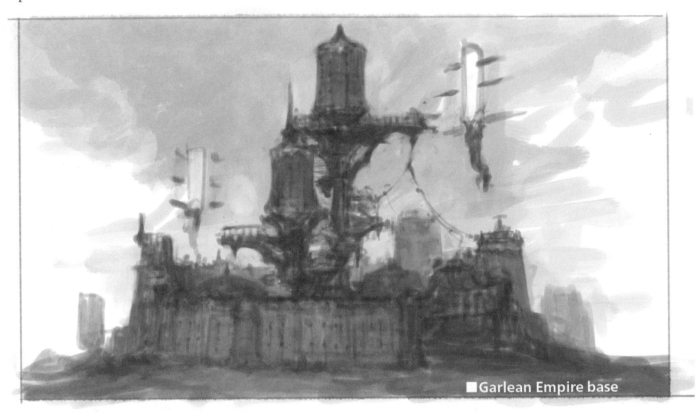

■Garlean Empire base

◆**Imperial large-scale mining machine** ···This concept shows it in a wasteland, but similar devices will be scattered all over the place, or they'll show up somewhere and then move elsewhere.

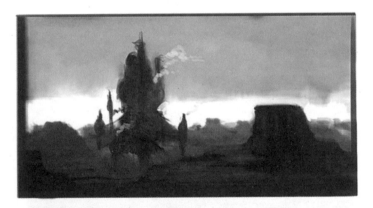 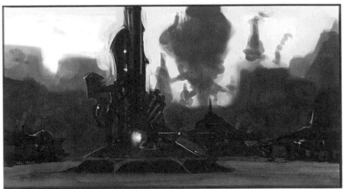

 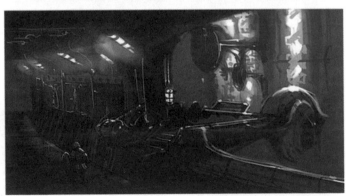

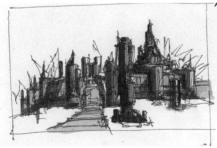 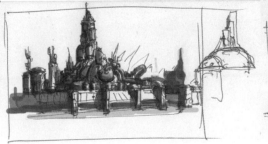 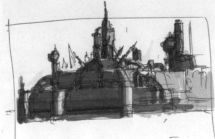

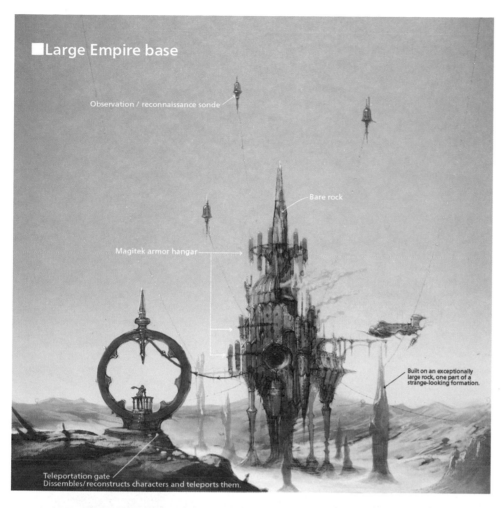

Large Empire base

Observation / reconnaissance sonde

Bare rock

Magitek armor hangar

Built on an exceptionally large rock, one part of a strange-looking formation.

Teleportation gate
Dissembles/reconstructs characters and teleports them.

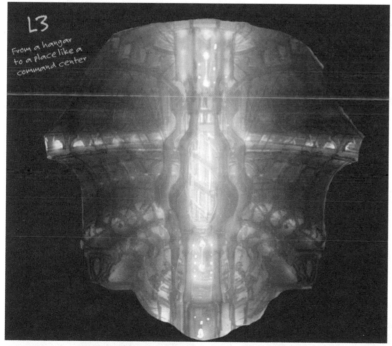

L3
From a hangar to a place like a command center

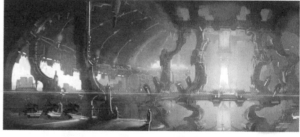

Cylinder contents (part of Ultima Weapon)

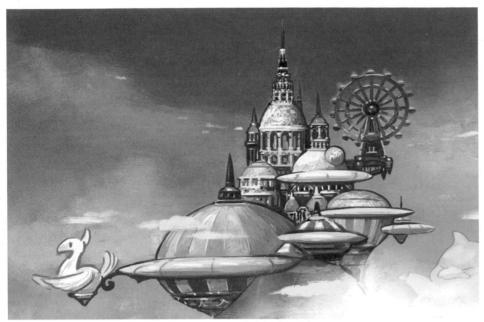

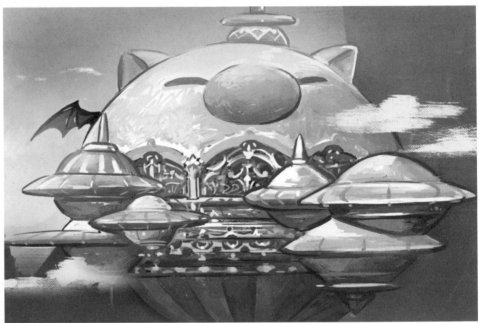

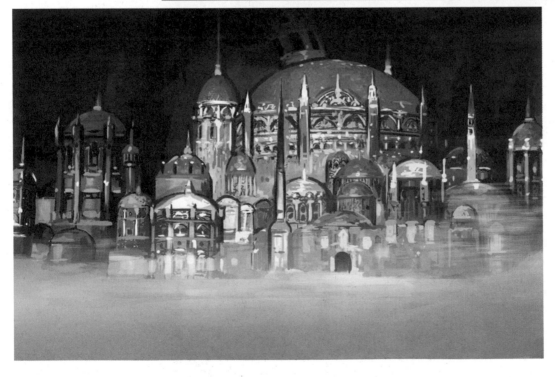

ADDITIONAL ART

FINAL FANTASY XIV: A Realm Reborn
The Art of Eorzea −Another Dawn−

Little Ladies' Day 2011

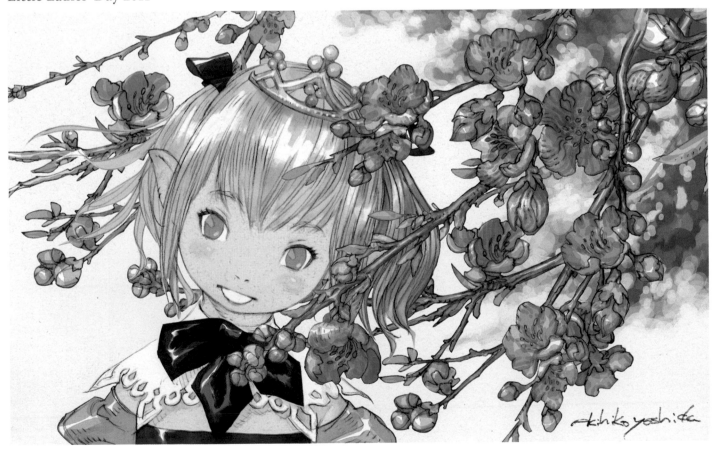

Here you have my best attempt at a cute, anime-style design! Er...didn't quite pull it off, eh? (Akihiko Yoshida)

Hatching-tide 2011

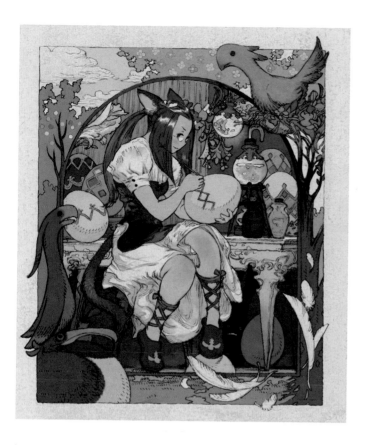

Look at the meat on those legs! This one's a personal favorite. (Akihiko Yoshida)

Moonfire Faire 2011

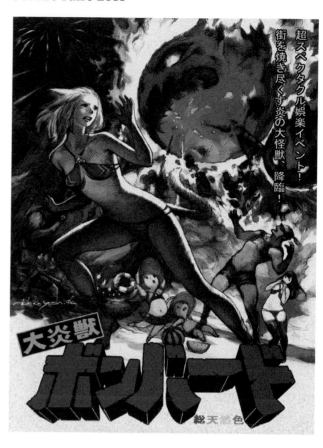

超スペクタクル娯楽イベント！
街を焼き尽くす炎の大怪獣、降臨！

大炎獣
ボンバード
総天然色

I went for an intentionally cheesy look for this one, reminiscent of a poster for a low-budget horror movie. (Akihiko Yoshida)

Hunter's Moon 2011

Foundation Day 2011

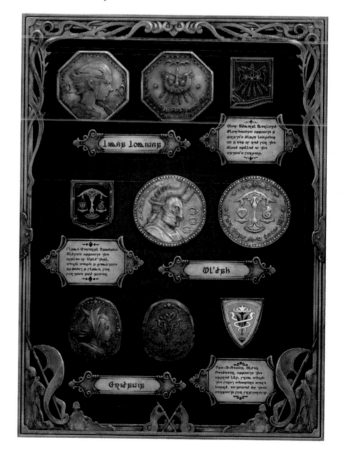

I drew this so each coin would evoke the cultural background of its city-state. (Kenta Tanaka)

All Saints' Wake 2011

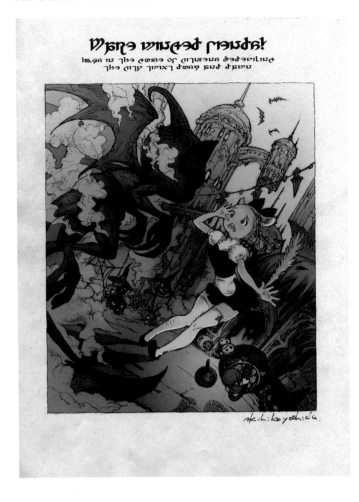

Starlight Celebration 2011

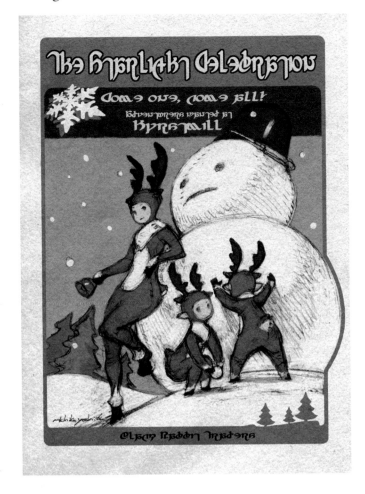

New Year 2012

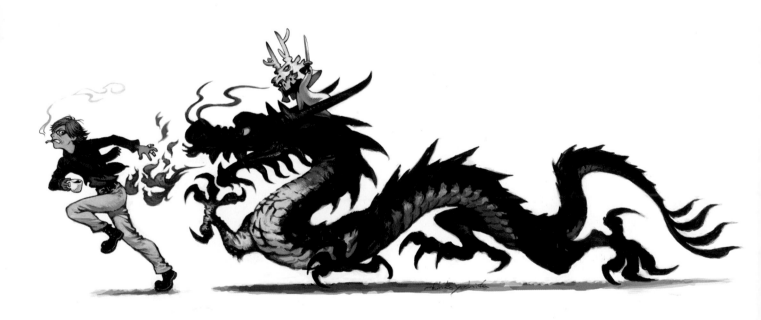

Yoshi-P with the *FFXIV: ARR* development dragon breathing fire down his back. Apparently, coffee and cigarettes are essential. Can you find the hidden characters for "rebirth"? (Akihiko Yoshida)

Heavensturn 2012

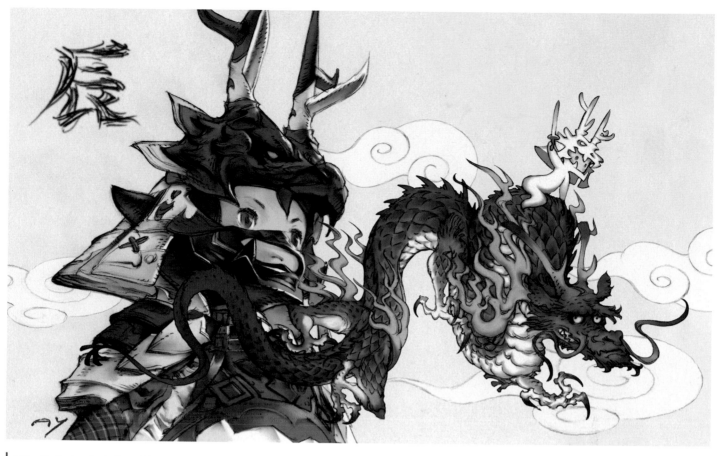

A New Year's piece for the Year of the Dragon paying homage to the old *Folktales from Japan* anime series. (Akihiko Yoshida)

Valentione's Day 2012

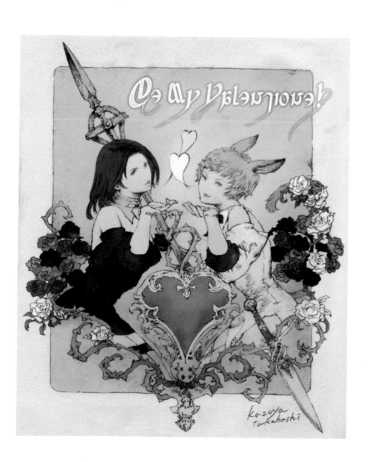

Little Ladies' Day 2012

Moonfire Faire 2012

Foundation Day 2012

Same concept as last year, this time with a Japanese touch! (Akihiko Yoshida)

Maelstrom Poster

I envisioned the dashing bravery of pirates when drawing this poster. (Kenta Tanaka)

Order of the Twin Adder Poster

The woman isn't Kan-E-Senna, but rather the goddess Nophica. That said, I drew her in a manner that would call to mind the Order of the Twin Adder's leader. (Saito)

Immortal Flames Poster

The original order called for heroic fantasy, but I felt a one-sided assault against the Amalj'aa would be too brutal, so I drew it with a whimsical, pop art touch. (Hama)

The Elements

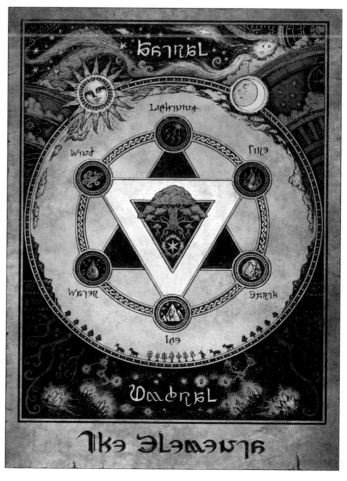

Garuda Battle

Ifrit Battle

Good King Moggle Mog XII

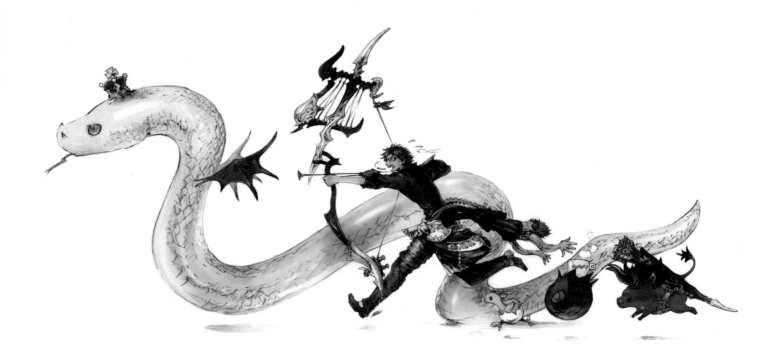

Same theme as 2012. Yoshi-P is as busy as ever! (Takahashi)

All Saints' Wake 2013

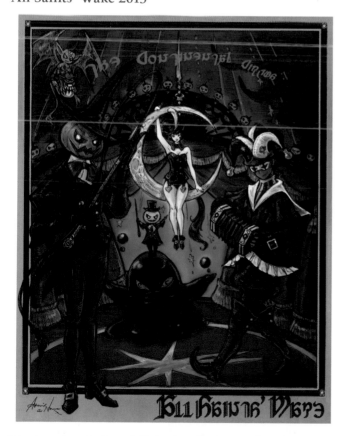

As a huge circus fan, I was thrilled to have the chance to draw my own circus troupe! The Miqo'te character was my own creation, but the event team was kind enough to create an NPC based on my art and work it into the game. I almost cried for joy! (Namae)

Materia

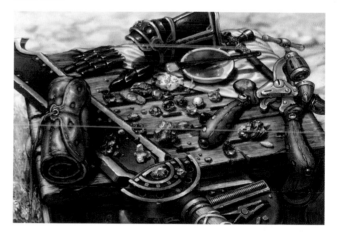

Grand Company Seals

Starlight Celebration 2013

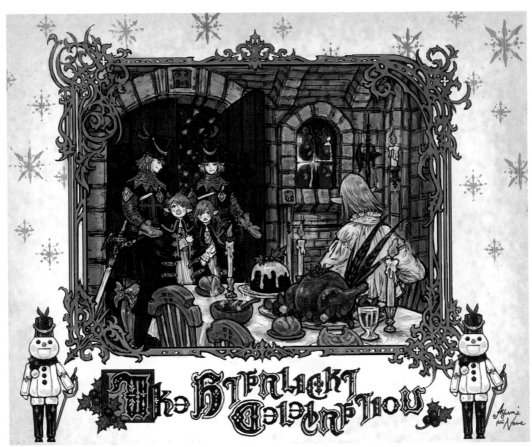

The Starlight Celebration comes from a tale that is at once tragic and heartwarming. I tried to convey the happiness of being indoors on a cold winter's day, in the picture book style reminiscent of a holiday card. (Namae)

New Year 2014

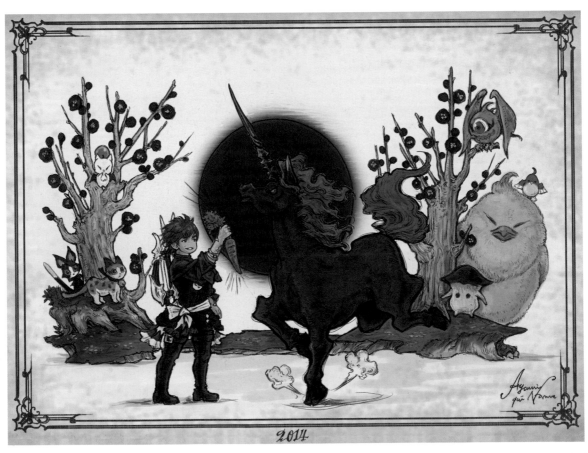

The droopy eyes and cat mouth are Yoshi-P's trademark! So said Ms. Kuboki, *FFXIV* caricature artist extraordinaire. The fat chocobo and various minions look on as Yoshi-P battles a nightmare. (Namae)

Heavensturn 2014

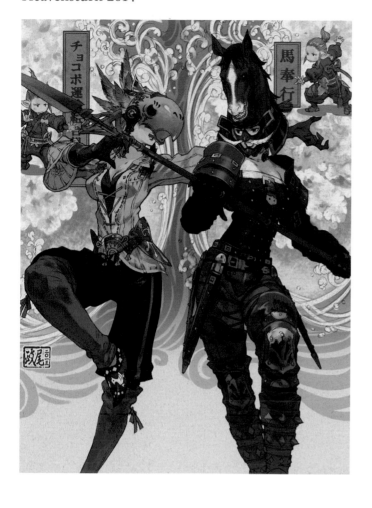

Valentione's Day 2014

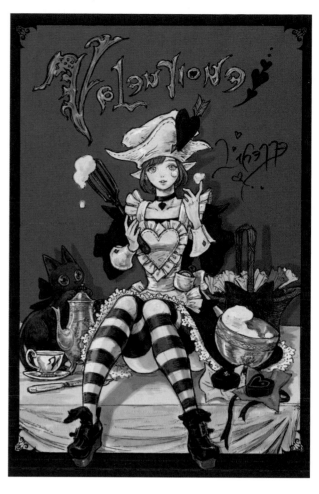

Little Ladies' Day 2014

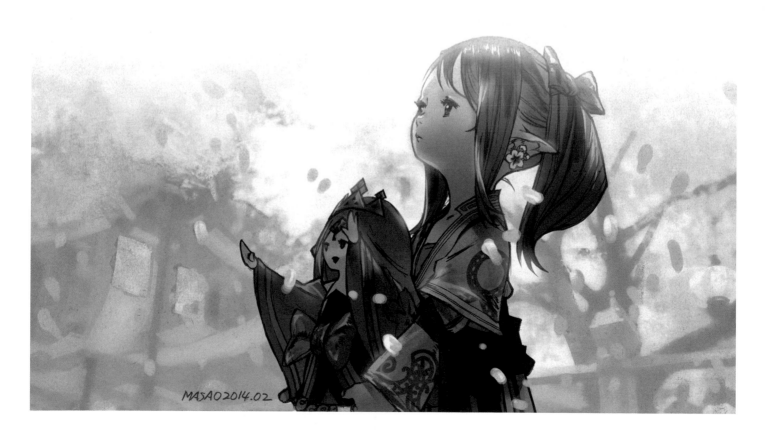

This Lalafell seems pensive, doesn't she? I tried to set a certain mood with this piece. I'm pleased with her long and slender profile. (Masao)

Hatching-tide 2014

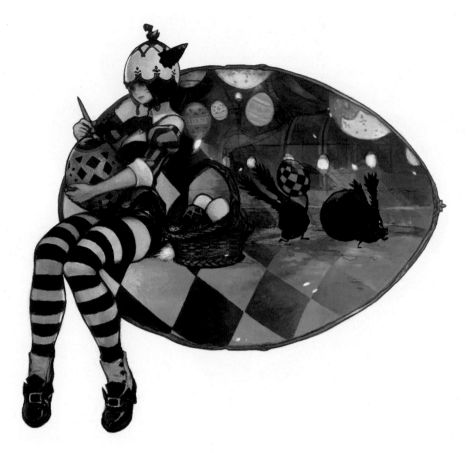

It was a challenge to depict Jihli Aliapoh, her eggs, and the spriggans that stole them in a single illustration. (Nagamine)

Moonfire Faire 2014

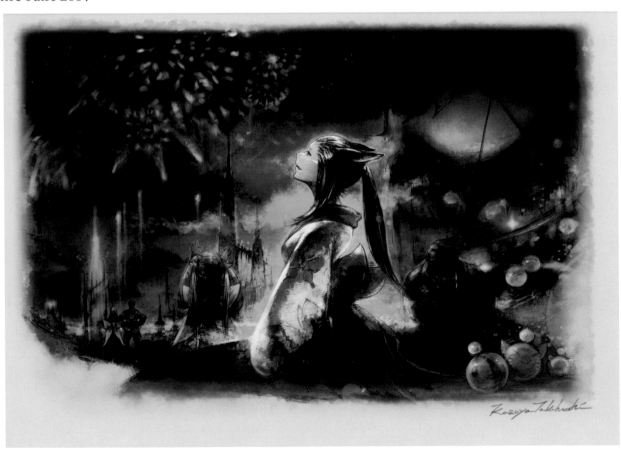

Set in the sky with Pharos Polaris, Lominsan fireworks are truly a sight to behold. (Takahashi)

Launch Event II

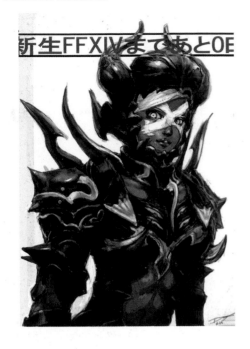

First Anniversary Event

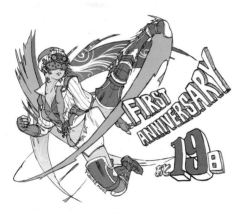
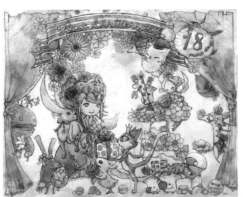
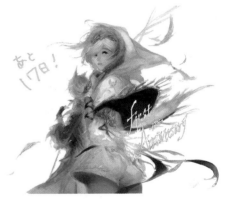

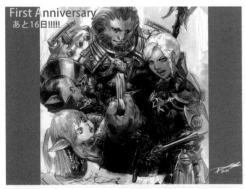
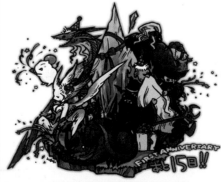
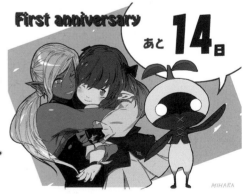

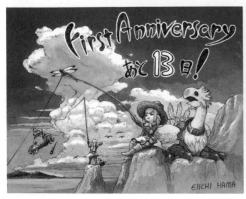
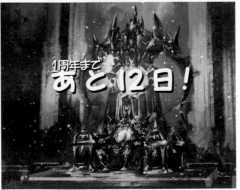

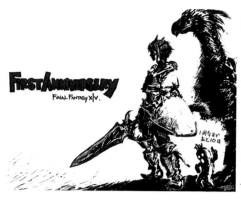

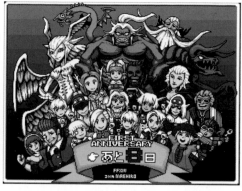

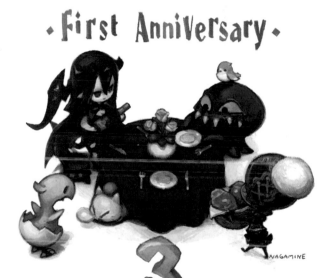

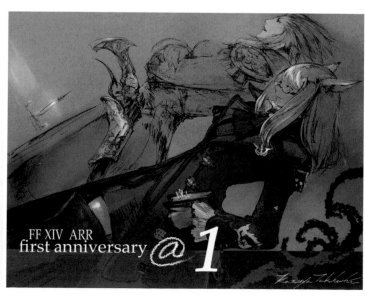

FINAL FANTASY XIV: A Realm Reborn
The Art of Eorzea –Another Dawn–

Planning & Production
Square Enix Co., Ltd.
Editor-in-Chief: Kazuhiro Ooya
Editors: Masaki Kurosaki, Tomoko Hatakeyama, Takuji Tada
Production: Toru Karasawa, Toshihiro Ohoka

Layout Editing
QBIST Inc. (QBIST)
Hideki Kawamura, Yuki Kurashima, Tomotaka Otani

Book Design & DTP
QBIST Inc. (QBIST)
Yukiko Yamada, Taichi Suzuki, Kaori Tanimoto

Cover Design
METAMO CO., LTD (ｍｅｔａｍｏ)
Gaku Watanabe

Cover Illustration
Square Enix Co., Ltd.
Kazuya Takahashi

Supervision
Square Enix Co., Ltd.
FINAL FANTASY XIV Development Team
Producer & Director Naoki Yoshida

Special Thanks
Mineloader Software CO., LTD.
WINKING ENTERTAINMENT LTD.

English Edition Design: Christopher Kallini
English Edition Editing: Leyla Aker
English Caption Translations: Stephen Meyerink

Library of Congress Cataloging-in-Publication data is on file with
the publisher.

ISBN: 978-1-64609-132-4

Printed in China
First printing, February 2022
10 9 8 7 6 5 4 3 2 1

SQUARE ENIX
BOOKS
www.square-enix-books.com

[North America]
Square Enix, Inc.
999 N Sepulveda Blvd., 3rd Floor
El Segundo, CA 90245, USA

For questions, concerns or comments, please contact:
http://support.na.square-enix.com

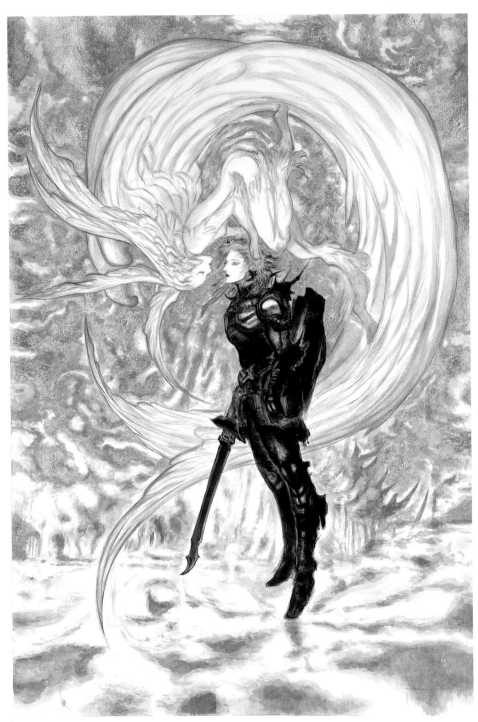